Conservation and
Restoration of Pictorial Art

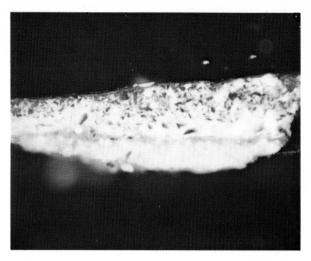

The Crucifixion, *Accademia Gallery, Venice, Bright blue drapery.* See Figure 2.19E

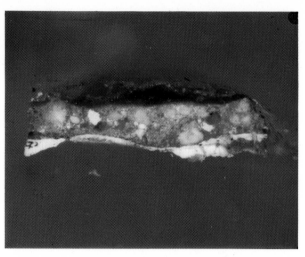

Transportation of the Body of St Mark, *Accademia Gallery, Venice. Dark red shadow of pink sleeve.* See Figure 2.19J

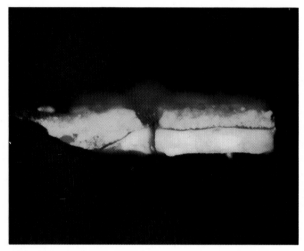

Worship of the Golden Calf, *Church of the Madonna dell'Orto, Venice. Bright yellow dress.* See Figure 2.20D

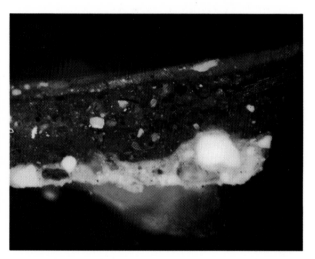

Last Judgment, *Church of the Madonna dell'Orto, Venice. Highlight on water.* See Figure 2.20G

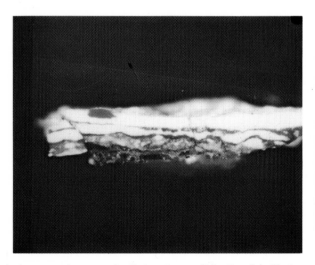

The Ascension, *Scuola di San Rocco (Sala Grande), Venice. White highlight on wing of angel.* See Figure 2.21E

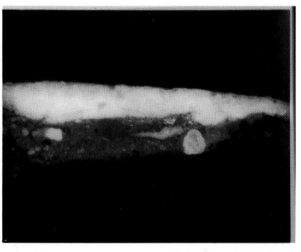

Origin of the Milky Way, *National Gallery, London. White of bed-sheet.* See Figure 2.21I

Photomicrographs of cross-sections of paint samples from pictures by Tintoretto (Chapter 2). Photographed by reflected light at 150X magnification (magnification on the printed page 115X).

Conservation and Restoration of Pictorial Art

Edited by NORMAN BROMMELLE
and PERRY SMITH

The International Institute
for Conservation of
Historic and Artistic Works

BUTTERWORTHS

LONDON – BOSTON
Sydney–Wellington–Durban–Toronto

THE BUTTERWORTH GROUP

UNITED KINGDOM

Butterworth & Co (Publishers) Ltd
London: 88 Kingsway, WC2B 6AB

NEW ZEALAND

Butterworths of New Zealand Ltd
Wellington: T & W Young Building
 77—85 Customhouse Quay, 1,
 CPO Box 472

AUSTRALIA

Butterworths Pty Ltd
Sydney: 586 Pacific Highway, Chatswood,
 NSW 2067
Also at Melbourne, Brisbane, Adelaide
 and Perth

CANADA

Butterworth & Co (Canada) Ltd
Toronto: 2265 Midland Avenue,
 Scarborough, Ontario, M1P 4S1

SOUTH AFRICA

Butterworth & Co (South Africa) (Pty) Ltd
Durban: 152—154 Gale Street

USA

Butterworth (Publishers) Inc
Boston: 19 Cummings Park,
 Woburn, Mass. 01801

First published 1976
Reprinted 1978

ISBN 0 408 70712 7

Library of Congress Cataloging in Publication Data
Main entry under title:

Conservation and restoration of pictorial art.

 "Consist[s] substantially of papers presented at a congress in Lisbon of the International Institute for Conservation of Historic and Artistic Works in October 1972."
 Includes bibliographical references and index.
 1. Paintings—Conservation and restoration—Addresses, essays, lectures. I. Brommelle, Norman. II. Smith, Perry. III. International Institute for Conservation of Historic and Artistic Works.
ND1640.C57 751.6 75—32570
ISBN 0—408—70712—7

Text set in 10/11pt IBM Journal, printed by photolithography,
and bound in Great Britain at Chapel River Press, Andover

Preface

The chapters of this book consist substantially of papers presented at a Congress in Lisbon of the International Institute for Conservation of Historic and Artistic Works in October 1972 on Conservation of Paintings and the Graphic Arts. As such, the book does not cover systematically the two fields of conservation represented in the title. The IIC international Congresses, of which this was the sixth, are organized on the principle of selecting aspects of a particular subject in which there is active current development or interest, and inviting the leading exponents to contribute reports of recent research or up-to-date reviews. It is always the intention, which has been borne out in practice, that the collected papers or publications arising from them should take their place in the essential literature of the subjects concerned.

Surprisingly, in view of the pre-eminent position which easel paintings hold in the technical field of the fine arts, the only previous conference on the subject took place as far back as 1930, in Rome, twenty years before the foundation of IIC, some of whose founder members were in fact speakers at the 1930 conference. The 1930 conference covered the whole of what was then a much smaller subject. In 1972, with greatly increased specialization and advances in the application of science, we had to concentrate on the paint and varnish layers, despite the importance of the canvas or wood support for a total view of deterioration and treatment. One reason for this limitation was the need to find a place for the expanding subject of the technical history of painting methods, where the observations of restorers combine with the study of original documents and the application of modern methods of chemical analysis. The technical history of painting includes a study of the stratification of the separate paint layers, both pigments and media. Study of the pigments was already in full swing in 1930 and is now a specialist's subject with an extensive literature of its own. That of the paint medium or vehicle lagged behind through lack of methods of chemical analysis. Recently developed analytical methods have led to rapid advances and it is this aspect of the paint film to which attention is mainly paid, with pigments only considered in relation to technical history. The parts devoted to practical picture restoration deal with special techniques, making the assumption that the conference delegates, and the readers of this book, were and are respectively aware of the standard methods now common everywhere.

Surface coatings, i.e. varnishes, applied for both protective and aesthetic reasons, have advanced with industrial developments and now come close in properties to the list of criteria long established but hitherto far from realization. The practical aspects of their application from a restorer's and indeed from an artist's point of view are covered. The main pre-occupation of the delegates to the 1930 conference was a controversy not on varnishes but on their removal when aged, a process comprehensively described in *The Cleaning of Paintings**. Over the years the heat has become dissipated and the subject only finds its place here under the title of *Solvent Action,*

* Ruhemann, H., *The Cleaning of Paintings — Problems and Potentialities,* Faber and Faber, London (1968).

v

a dispassionate review of more recent scientific studies. The conservation of works of art on paper and related materials overlaps that of easel paintings, particularly in the field of adhesives where the application of modern technology to problems of lamination and reinforcement is discussed. In addition, modern methods of treating graphic art material, with their specific problems of cleaning, deacidification and biological control, are dealt with from different points of view. Needless to say, there is much here in common with the problems of library and archival material, which are, however, not dealt with *sui generis*. The conservation of Japanese paintings is of great interest to Western curators in view of the special nature of the objects and of the techniques of Oriental conservators. The Congress itself was enhanced and enlivened by a film and practical demonstrations from a leading Oriental practitioner working in the U.S.A. The reader cannot have this good fortune, but may be content with supporting papers covering the field, with wider comments on materials and the implication of the techniques for Western practice.

The comprehensive lists of references at the end of many chapters, which would not ordinarily call for comment in a technical treatise, should be particularly mentioned because this is a field in which there are few standard reference books and the material is in general widely scattered over a range of publications. Even its most concentrated sources, the IIC periodicals, now require a specialist to pinpoint particular sources of information.

The Institute, from its very nature and organization (*see* page xi) is able to call for advice from its international pool of members, and in preparing the Congress from which this book is drawn many people were consulted whose help is here gratefully acknowledged. The subjects had sub-groups under 'session leaders' and to these — Dr Robert L. Feller, Mme Françoise Flieder, the late Mr Rutherford J. Gettens, Dr John S. Mills, Miss Joyce Plesters, Dr Nathan Stolow and Dr A. E. Werner — we are particularly indebted. The Editors of the preprints, IIC's General Editor Mr Garry Thomson, and Miss Anne Moncrieff, had the difficult task of processing the material which, coming — often belatedly — from different countries and touching upon a variety of practical and scientific fields, taxed even Miss Moncrieff's customary vigour and enthusiasm.

The present Editors, in preparing this material for its final publication, continued to make use of the patient help of the session leaders, with powerful reinforcement from Mr A. D. Baynes-Cope on the sections dealing with the graphic arts.

Norman Brommelle

Perry Smith

Acknowledgement

The inclusion of the colour plates in this volume was made possible by the generosity of the Trustees of the National Gallery, London (Frontispiece), Universitetets Oldsaksamling, Oslo (Chapter 4), and Mr Herbert Lank (Chapter 14).

Contributors

Prof. Norbert S. Baer
New York University
Conservation Center of the Institute of Fine Arts
1 East 78 Street
New York, N.Y. 10021
U.S.A.

Gustav A. Berger
Berger Art Conservation, Inc.
1014 Madison Avenue
New York, N.Y. 10021
U.S.A.

Klaus Biemann
Massachusetts Institute of Technology
Cambridge, Mass. 02139
U.S.A.

G. Z. Bykova
Central Research Laboratory for Conservation
and Restoration of Art Objects (VZNILKR)
Krestyanskaya pl. 10
Moscow 1091272
U.S.S.R.

Suzy Delbourgo
Laboratoire de Recherche des Musées de France
Palais du Louvre
75001 Paris
France

Dr Robert L. Feller
National Gallery of Art Research Project
Carnegie—Mellon Institute of Research
4400 Fifth Avenue
Pittsburgh, Pa. 15213
U.S.A.

Françoise Flieder
Centre de Recherches sur la Conservation des Docu-
 ments Graphiques
Muséum National d'Histoire Naturelle
36 Rue Geoffroy-St-Hilaire
75005 Paris
France

Prof. Mojmir S. Frinta
Department of Art History
State University of New York
Albany, N.Y. 12203
U.S.A.

Dr Fausta Gallo
Istituto di Patologia del Libro
Via Milano 76
00184 Rome
Italy

Marie Christine Gay
Laboratoire de Recherche des Musées de France
Palais du Louvre
75001 Paris
France

CONTRIBUTORS

Rutherford J. Gettens (deceased)
Freer Gallery of Art
Smithsonian Institution
Washington, D.C. 20560
U.S.A.

Dr J. A. van de Graaf
Prins Hendriklaan 79
Utrecht
Netherlands

Dr Rosamond D. Harley
Gateshead Technical College
Durham Road
Gateshead NE9 5BN
England

Dr Eric C. Hulmer
R.D. 1
Harmony, Pa. 16037
U.S.A.

Prof. Norman Indictor
Chemistry Department
Brooklyn College
City University of New York
Brooklyn, N.Y. 11210
U.S.A.

A. V. Ivanova
Central Research Laboratory for Conservation
and Restoration of Art Objects (VZNILKR)
Krestyanskaya pl. 10
Moscow 1091272
U.S.S.R.

Abraham Joel
New York University
Conservation Center of the Institute of Fine Arts
1 East 78 Street
New York, N.Y. 10021
U.S.A.

Ben B. Johnson
Conservation Center
Los Angeles County Museum of Art
5905 Wilshire Boulevard
Los Angeles, Cal. 90036
U.S.A.

Antoinette G. King
Museum of Modern Art
11 West 53 Street
New York, N.Y. 10019
U.S.A.

Herbert Lank
Hamilton Kerr Institute
Whittlesford
Cambridge CB2 4LE
England

Lorenzo Lazzarini
Laboratorio di S. Gregorio
Dorsodoro 170
Venice
Italy

Dr Tasso Margaritoff
25 Ekostis Pemptis Martiou Street
Holargos
Athens
Greece

Liliane Masschelein-Kleiner
Institut Royal du Patrimoine Artistique
1 Parc du Cinquantenaire
Avenue de la Renaissance
B—1040 Brussels
Belgium

Dr John S. Mills
Scientific Department
National Gallery
Trafalgar Square
London WC2N 5DN
England

I. P. Mokretzova
Central Research Laboratory for Conservation
and Restoration of Art Objects (VZNILKR)
Krestyanskaya pl. 10
Moscow 1091272
U.S.S.R.

Jim Murrell
Conservation Department
Victoria and Albert Museum
South Kensington
London SW7 2RL
England

Monique de Pas
Centre de Recherches sur la Conservation des Documents Graphiques
Muséum National d'Histoire Naturelle
36 Rue Geoffroy-St-Hilaire
75005 Paris
France

Viola Pemberton-Pigott
15 Edna Street
London SW11 3DP
England

Leif Einar Plahter
Nasjonalgalleriet
Postboks 8157
Oslo 1
Norway

Unn Plahter
Universitetets Oldsaksamling
Fredriksgt. 2
Oslo
Norway

Joyce Plesters
Scientific Department
National Gallery
Trafalgar Square
London WC2N 5DN
England

Bernard Rabin
Rear of 38 Halsey Street
Newark, N.J. 07102
U.S.A.

Vera Radosavljevic
Narodna Biblioteka
Skerlićera 1
Belgrade
Yugoslavia

George deWitt Rogers
Canadian Conservation Institute
National Museums of Canada
Ottawa, Ontario K1A 0M8
Canada

Dr Nathan Stolow
Canadian Conservation Institute
National Museums of Canada
Ottawa, Ontario K1A 0M8
Canada

Margaret Watherston
153 East 87 Street
New York, N.Y. 10028
U.S.A.

Marilyn Kemp Weidner
612 Spruce Street
Philadelphia, Pa. 19106
U.S.A.

Dr Norman R. Weiss
286 Waverley Avenue
Newton, Mass. 02158
U.S.A.

Raymond White
Scientific Department
National Gallery
Trafalgar Square
London WC2N 5DN
England

William K. Wilson
Paper Evaluation Section
U.S. Department of Commerce
National Bureau of Standards
Washington, D.C. 20234
U.S.A.

Dr Mariagrazia Zappalà-Plossi
Istituto di Patologia del Libro
Via Milano 76
00184 Rome
Italy

The International Institute for Conservation of Historic and Artistic Works

SCOPE OF THE INSTITUTE

The Institute is concerned with the whole field of inanimate objects worthy of preservation, whether in museums and libraries or exposed externally, their structure, composition, deterioration and conservation.

STRUCTURE AND ORGANIZATION

The Institute is administered by an international Council of 20 members, including its President, up to five Vice-Presidents, an honorary Secretary-General and an honorary Treasurer. There are four categories of membership: Fellow, Associate, Supporting Institution and Honorary Fellow. Fellows, who are conservators of standing, scientists in the field of conservation, or administrators with a special concern for conservation, are elected by ballot of the existing Fellows. Members of Council are elected by the Fellows and serve for periods of three years, with a possibility of re-election for two further terms. Associateship is open to anybody who is interested in conservation. Institutional membership is available to museums and interested corporate bodies. Honorary Fellowship is awarded by the Council to senior Fellows for conspicuous services to conservation over a long period.

PUBLICATIONS

There are two principal journals: *Studies in Conservation,* published quarterly, and *Art and Archaeology*

Technical Abstracts — IIC, published twice-yearly. *Studies in Conservation,* which has an established place among the world's technical journals, was first published in 1952. It contains original work and reviews on advances in conservation and restoration, covering both practical and scientific aspects, together with technical research on materials and methods of fabrication. *Art and Archaeology Technical Abstracts — IIC (AATA),* first published in 1955 as *IIC Abstracts,* contains abstracts of the world's technical literature, not only in the field of conservation but also on science and technology generally, where relevant. A bi-monthly newsletter (the *Bulletin),* summarizes current information on congresses, meetings and educational courses in the world, together with news of the activities of members. The Institute also publishes books on aspects of conservation, mainly in connection with its international congresses (see below), and also sponsors books on specialized subjects within its field.

REGIONAL GROUPS

With the approval of the Council, Regional Groups with their own structure and bye-laws operate autonomously in the United Kingdom, Poland, Canada, the Scandinavian countries, Mexico and the Netherlands. The former American Group has been independently incorporated for legal and other reasons while retaining its links with the parent body. Other Groups are in the process of formation. These Groups form centres

for the exchange of professional information between members and hold periodic meetings, whose proceedings are circulated.

INTERNATIONAL CONGRESSES

At intervals of two or three years, international congresses are held in appropriate centres. At these congresses, papers commissioned from leading specialists within a chosen field are read and discussed. The general aims of the congresses are: firstly, to summarize the present position of technical progress in the particular field, both for advanced specialists and as educational material for younger members; secondly, to present recent advances and research. The subjects of previous congresses have been: 'Recent Advances in Conservation' (Rome, 1961), later published as a book; 'Textiles' (Delft, 1964), which led eventually to the publication of a book *Textile Conservation;* 'Museum Climatology' (London, 1967); 'Stone and Wood' (New York, 1970); and 'Paintings and the Graphic Arts' (Lisbon, 1972). Preprints of the last three have been published. The sixth Congress, held in Stockholm in 1975 in co-operation with the Nordic Group of IIC (Nordisk Konservatorforbund), covered selected topics under the general title 'Conservation in Archaeology and the Applied Arts.'

COLLABORATION WITH THE OTHER INTERNATIONAL ORGANIZATIONS

Collaboration is primarily assured by the joint membership that inevitably occurs in a region of professional specialization. Some members of the Directorates of the ICOM Committee for Conservation and of the International Centre for Conservation (Rome) are, as individuals, members of the Council of IIC. Joint discussions take place from time to time on publications and congress programmes, and reports of the work of subcommittees of ICOM's Committee for Conservation may be submitted to the Editor of *Studies in Conservation.* Those plenary sessions of the ICOM Committee's reunion in Madrid in 1972 which referred to paintings and the graphic arts were in fact held at the immediately succeeding IIC Congress on those subjects at Lisbon.

An important function of IIC is that it includes in its membership professional conservators working independently, outside the ambit of governments and institutions. They are enabled to keep abreast of technical advances and in personal contact with their colleagues at home and overseas through IIC's publications, congresses and groups. This service is particularly valuable for members in geographical isolation.

Contents

CONTENTS

Note
It should be noted that whereas the Editors have cleared obscure points in their manuscripts with the respective authors, the responsibility for statements of fact and opinion rests with the latter.

PAINTING METHODS AND MATERIALS

I

Painting Methods and Materials: A Brief Survey of Published Work from 1961 to 1972

JOYCE PLESTERS

INTRODUCTION

Information about the techniques and materials of painters of the past is gained in two ways, firstly from documentary sources and secondly from examination of the pictures themselves and the materials of which they are made. It seems an appropriate moment to look back at what progress has been made in each of these fields of knowledge since the Rome Conference of 1961, the last IIC Conference to include the subject of easel paintings on the programme. The following does not pretend to be a comprehensive survey, but aims merely to indicate recent trends.

DOCUMENTARY SOURCES

The amount of research in this field and the number of persons engaged in it is unfortunately very small by comparison with art history on the one hand and scientific examination on the other. Even so, the past 10–15 years have seen some results. The excuse I make for stepping back a little outside the allotted time span to refer to van de Graaf's exemplary edition of the *De Mayerne MS.* is that we have since been given a tempting glimpse of a more recently discovered and hitherto unpublished part of it[1]. It is an invaluable source for the technique of Rubens, Van Dyck and other seventeenth century painters. Two new editions and translations of Theophilus' *De Diversis Artibus* have appeared[2], the first English translations since that of Hendrie published in 1847. Although much of Theophilus concerns metals, it is important for its

pre-Van Eyck reference to painting in oil. The *De Clarea MS.* in Berne (alternatively referred to as the *Anonymus Bernensis*), and probably of the eleventh century, has been newly translated into German and the original manuscript reproduced in full for the first time, accompanied by a useful commentary[3]. It has interesting matter concerning pigments and egg tempera media. What appears to be the oldest surviving manual on painting techniques in the German language, the *Strasburg MS.*, considered to date from the fifteenth century, was destroyed in a fire in 1870, but before that Sir Charles Eastlake had a copy made which is in the library of the National Gallery, London, and from this copy a new edition and English translation have been prepared[4].

I am sorry to have to point out that all but a part of one of the primary sources mentioned above had already been discovered and previously published in the nineteenth or first years of the twentieth century. A rich hoard of manuscripts on painting materials and techniques may lie hidden in the libraries of Europe, but for the most part we lack the modern equivalent of an Eastlake, Merrifield or Berger to unearth and interpret them. A rare exception is Rosamond Harley, who has not only recently compiled a useful reference list of manuscripts (mainly sixteenth and seventeenth century) in the British Museum Library[5], but is also responsible for one of the most fully researched books on the subject of the history of pigments ever to be published[6]. Compared with what we know about pigments or even media, from either a historical or an experimental approach, our present knowledge of old varnishes is rather scanty. The somewhat heated ex-

change of views which appeared in print in 1962–63[7] at least had the merit of disinterring a good deal of interesting documentary material and enabling it to be looked at afresh.

THE EXPERIMENTAL APPROACH

The first questions we ask ourselves on being confronted with a painting for technical examination are: 'What is it made of?' and 'How was it painted?' The first questions the art-historian will probably ask himself are: 'By whom was it painted?', 'When was it painted?', and 'Where was it painted?' That answers to the first two questions may help in finding answers to the other three is slowly coming to be recognized. A mark of this recognition was that in 1969 the Rembrandt Research Project and the Central Research Laboratory for Objects of Art and Science together organized in Amsterdam a Symposium on Technical Aspects of Rembrandt Paintings to which specialists from all over the world contributed. So far only abstracts of the papers have been circulated, but future publication is expected.

Scientific examination of paintings has been going on since the time of Faraday, yet most of the work has been on individual pictures or small groups of pictures, or on specific problems generally connected with conservation, or, more rarely, authentication. For every well-known painter, and many lesser-known, there exist monographs and *catalogues raisonnés* written from an art-historical standpoint, yet so far as can be recalled there has been only one publication which attempts to assess the materials and techniques of virtually the entire work of a particular painter. I refer to Kühn's study of the pigments and grounds used by Vermeer[8]. Another of Kühn's undertakings was the identification of all the pigments in a collection of over 250 nineteenth century pictures[9], the results of which form an illuminating record of the introduction and rise in popularity of some pigments of nineteenth century invention and the decline in the use of some traditional ones. One of the most important and extensive projects concerned with a group of paintings is the technical study of 'Les Primitifs Flamands', inaugurated by the late Paul Coremans as early as 1951, but which has since worked its way steadily through all the Early Netherlandish School pictures in the principal collections of the world[10].

Space does not permit listing the numerous technical reports on particular paintings which during this time have emerged from the various museum laboratories. An outstanding example is the exhaustive account of the history, condition, materials, technique and restoration of the Rubens altarpiece, *The Descent from the Cross* in the Cathedral of Antwerp[11]. An example of a slightly different but equally interesting treatment of the subject of painting technique is illustrated by Brachert's study of Leonardo[12], notable for its special emphasis on surface textures of paint. Some review articles have also been useful in assembling data and clarifying ideas, for example the series on supports

and grounds of paintings which was the outcome of periodical meetings of the ICOM Paintings Sub-committee[13]. In addition, Wehlte produced a useful reference book on painting materials and techniques[14].

Bridging the gap between literary and experimental research, a memorial exhibition for IIC's first Honorary Fellow, Edward Forbes, was held earlier in 1972. The catalogue is worth treasuring even if a visit to the exhibition was not possible[15].

X-RADIOGRAPHY AND SPECIAL PHOTOGRAPHY

These are some of the oldest methods used for trying to answer the question 'How was the picture painted?' Again, published examples of their application to individual pictures are too numerous to list, but many of the most rewarding are the work of the Louvre Laboratory, a good idea of which may be gained from a book on the subject by Hours[16]. Another useful compilation is that of X-radiographs of 61 paintings of the Dutch and Flemish Schools in the Utrecht Museum[17], while in 1969 the *Burlington Magazine* arranged an exhibition in London of X-radiographs of paintings which revealed different compositions beneath the surface[18]. During the period under consideration, improvements in methods have taken place. A means has been found to make a radiograph of a picture on a copper panel by means of electron emission[19]. A new technique is autoradiography by neutron activation[20]. Yet another is the use of infra-red luminescence[21]. Outstanding for its advantage over ordinary infra-red photography is van Asperen de Boer's method of infra-red reflectography[22]. It not only enables the underdrawing of Early Italian or Early Netherlandish pictures to be scanned, but reveals it in areas of paint not usually penetrated in ordinary infra-red photography.

IDENTIFICATION AND ANALYSIS OF MATERIALS

In this department progress can be reported. Methods for analysis of paint media have changed radically and a survey of modern developments is given by Mills in this volume. The fundamentals of the history, properties and methods of identification of pigments are gradually being laid down in a series of articles under the editorship of Gettens[23]. Microscopical, micro-chemical, X-ray diffraction and spectroscopic methods are described and a notable feature is that examples of pigments illustrated are from actual works of art, while a list is also given of occurrences in particular pictures. This project was first announced at the IIC Rome Conference in 1961 and it is hoped that, as proposed at the time, when the first ten articles have appeared, they will be republished as the first volume of a handbook of pigment identification. One or two other useful articles on pigment identification have also appeared outside this series[24].

The feeling grows with regard to pigments that the differences between particular painters, periods or

schools of painting lie not so much in the use of different ranges of pigments as in the way they were used. As a result there has been a revival of interest in what might be called the microstructure of the painting, the building-up of the paint layers within the picture and the disposition of pigment particles within the layers. A number of modern instrumental techniques, the electron microbeam probe[25], the X-ray macroprobe[26], the laser microspectrograph[27] and the infra-red microspectroscope[28] give the possibility of scanning a paint cross-section layer by layer or analysing single particles of pigment within the layers. Such methods will give much more detailed information about the way in which the painter worked. All the methods of pigment identification mentioned above are applied to detached samples of paint of microscopical size and there is always some uneasiness felt as to whether such small samples are representative of the general area from which they come. We should all like to see a really efficient 'non-destructive' method for scanning the surface of a painting to analyse the pigments. A modified form of the X-ray fluorescence analyser seems promising, but it has more problems when used on paintings than when used on metals or ceramics.

To the questions of when and where a picture was painted some comparatively new methods can give limited answers. For pigments they usually depend on detecting variations which occur in minor or trace impurities according to the age or place of origin of the pigment or the raw material from which it was made. Methods include neutron activation analysis[29], measurement of natural alpha emitters in lead white[30], and the use of isotope mass spectrometry[31]. Some of the most interesting results so far are the differences shown between lead white of the sixteenth and seventeenth century Netherlandish School and the Venetian School, and the differences between lead white produced before and after the middle of the nineteenth century. Authors concerned are careful to point out that the results must be interpreted with caution and that the ultimate success of the method will depend on making a large number of analyses from a great many paintings. It would seem that the study of impurities rather than of major components will be a prominent feature of future research on pigments. A method which differs from those already mentioned in not requiring very expensive specialized instruments is that devised by Butler[32], based on the use of the polarizing microscope, which seems to be particularly suitable for natural mineral pigments.

Leaving pigments we turn to the subject of wood. Although carbon-14 measurements have not proved so far to be applicable to paintings, tree-ring dating has recently been used on the wood of panel paintings with some success[33]. It is at present limited in this respect by the fact that reference data are so far available only for certain types of wood (e.g. oak but not poplar) and certain geographical regions (e.g. parts of the Netherlands and Germany but not Italy).

There are some aspects of painting methods and materials which seem to be unduly neglected. Few examples can be recalled in recent years of work on colour measurement, the optics of the paint film[34], the composition of the artist's palette[35], the procedure of painting[36], or the tools or instruments used by the artist[37]. The last four references quoted represent the rare exceptions.

As more and more pictures are examined in ever increasing detail, the need will be felt for a data-storage system whereby data can easily be retrieved for use and exchange. The only one known to me which is at present in use for this purpose is that at the Doerner Institute in Munich[38].

Methods of analysis are becoming more sophisticated and components analysed ever smaller. We must be careful that we do not lose sight, behind the serried ranks of grey boxes of electronics, of the work of art. In the interpretation of analytical data there is no substitute for looking long and hard at the picture itself.

References and Notes

[1] van de Graaf, J. A., *Het de Mayerne Manuscript als Bron voor de Schildertechniek van de Barok*, Utrecht (1958).
Werner, A. E., 'A "New" De Mayerne Manuscript', *Stud. Conservation*, 9 (1964), 130–134.

[2] Theophilus, *De Diversis Artibus*, translated from the Latin with introduction and notes by C. R. Dodwell, London (1961).
Theophilus, *On Divers Arts*, the treatise of Theophilus translated from the mediaeval Latin with introduction and notes by J. G. Hawthorne and C. S. Smith, Chicago (1963).

[3] Straub, R. E., 'Der Traktat De Clarea in der Burgerbibliothek, Berne. Eine Anleitung für Buchmalerei aus dem Hochmittelalter', *Schweizer. Inst. Kunstwissenschaft Jahresber.*, (1964), 89–114.

[4] *The Strasburg Manuscript. A Mediaeval Painters' Handbook*, translated from the Old German by V. and R. Borradaile, London (1966).

[5] Harley, R. D., 'Literature on Technical Aspects of the Arts. Manuscripts in the British Museum', *Stud. Conservation*, 14 (1969), 1–8.

[6] Harley, R. D., *Artists' Pigments c. 1600–1835. A Study in English Documentary Sources*, Butterworths, London (1970).

[7] See contributions by various authors in the *Burlington Magazine*, CIV (1962) and CV (1963).

[8] Kühn, H., 'A Study of the Pigments and the Grounds Used by Jan Vermeer', *Report and Studies in the History of Art*, National Gallery of Art, Washington (1968), 154–202.

[9] Kühn, H., *Die Pigmente in den Gemälden der Schack-Gallerie*, Doerner-Institut und Bayerische Staatsgemäldesammlungen, Munich (1969).

[10] The last of the series *Les Primitifs Flamands*, published by the Centre National de Recherches 'Primitifs Flamands', Brussels, fall within the period of time we are considering.

[11] Rubens, *Descent from the Cross*. Two numbers of the *Bull. Inst. R. Patrimoine Art.*, Brussels, V (1962) and VI (1963) are largely devoted to this altarpiece.

[12] Brachert, T., 'Ein Unvollendetes Madonnengemälde von Leonardo da Vinci', *Schweizer. Inst. Kunstwissenschaft Jahresbericht und Jahrbuch* (1967), 1–110.

[13] Hendy, P., Lucas, A. W. and Plesters, J., 'The Ground in Pictures', *Museum*, 21 (1968), 245–276. This is the only article of the series published during the period in question.

[14] Wehlte, K., *Werkstoffe und Techniken der Malerei*, Ravensburg (1967).

[15] Catalogue of an Exhibition of Pictures, Restoration, Books and Materials, in Memory of the Late Edward Forbes (1873—1969), Fogg Museum of Art, Harvard University, January—February 1972.

[16] Hours, M., *Les Secrets des Chefs d'Oeuvre*, Paris (1964).

[17] Houtzager, M. E., Meier-Siem, M., Stark, H. and de Smedt, H. J., *Röntgenonderzoek van de Oude Schilderijen in het Centraal Museum te Utrecht* (Catalogue), Central Museum, Utrecht (1967).

[18] Catalogue of an exhibition, *Art Detection, Painting and the X-Ray*, presented by the Burlington Magazine, London, 4—28 March 1969.

[19] Bridgman, C. F., Michaels, P. and Sherwood, H. F., 'Radiography of a Painting on Copper by Electron Emission', *Stud. Conservation*, **10** (1965), 1—7.

[20] Sayre, E. V. and Lechtman, H. N., 'Neutron Activation Autoradiography of Oil Paintings', *Stud. Conservation*, **13** (1968), 161—185.

[21] Bridgman, C. F. and Gibson, F. L., 'Infrared Luminescence in the Photographic Examination of Paintings and Other Art Objects', *Stud. Conservation*, **8** (1963), 77—83.

[22] van Asperen de Boer, J. R. J., *Infra-red Reflectography, a Contribution to the Examination of Earlier European Paintings*, doctoral thesis published by the Central Research Laboratory for Objects of Art and Science, Amsterdam (1970). See also 'Reflectography of Paintings Using an Infra-red Vidicon Television System', *Stud. Conservation*, **14** (1969), 96—118.

[23] The articles so far published in the series comprise:
Gettens, R. J. and FitzHugh, E. W., 'Azurite and Blue Verditer', *Stud. Conservation*, **11** (1966), 54—61.
Plesters, J., 'Ultramarine Blue, Natural and Artificial', *Stud. Conservation*, **11** (1966), 62—91.
Gettens, R. J., Kühn, H. and Chase, W. T., 'Lead White', *Stud. Conservation*, **12** (1967), 125—139.
Kühn, H., 'Lead-tin Yellow', *Stud. Conservation*, **13** (1968), 7—33.
Mühlethaler, B. and Thissen, J., 'Smalt', *Stud. Conservation*, **14** (1969), 47—61.
Kühn, H., 'Verdigris and Copper Resinate', *Stud. Conservation*, **15** (1970), 12—36.

[24] Kühn, H., 'Safran und Dessen Nachweis Durch Infrarotspektrographie in Malerei und Kunsthandwerk', *Leitz-Mitteilungen*, **11**, No. 1 (1961), 24—28.
Masschelein-Kleiner, L. and Heylen, J. B., 'Analysis of Ancient Red Lakes', *Stud. Conservation*, **13** (1968), 87—97.

[25] Elzinga-ter Haar, G., 'On the Use of the Electron Microprobe in Analysis of Cross-Sections of Paint Samples', *Stud. Conservation*, **16** (1971), 41—55.
Delbourgo, S., 'Note Technique sur l'Utilisation de la Microsonde Electronique dans l'Analyse des Eléments Constitutifs de la Couche Picturale', *Annales, Laboratoire de Recherche des Musées de France* (1971), 34—44.

[26] Stolow, N., Hanlan, J. F. and Boyer, R., 'Element Distribution in Cross-Sections of Paintings Studied by X-ray Macroprobe', *Stud. Conservation*, **14** (1969), 139—151.

[27] Brech, F. and Young, W. J., 'The Laser Microprobe and its Application to the Analysis of Works of Art', *Application of Science in Examination of Works of Art*, Proceedings of the Seminar conducted by the Research Laboratory, Museum of Fine Arts, Boston, Mass., (1965), 230—237.

[28] van t'Hul-Ehrnreich, E. H., 'Infra-red Microspectroscopy for the Analysis of Old Painting Material', *Stud. Conservation*, **15** (1970), 175—182.

[29] Houtman, J. P. W. and Turkstra, J., 'Neutron Activation Analysis of Trace Elements in White Lead and the Possible Application for Age Determination of Paintings', *Reactor Institute at Delft, Report No. 133—64—05*, Sept. 1964.
Lux, F. and Braunstein, L., 'Aktivierungsanalytische Gemäldeuntersuchungen Bestimmung des Spurengehaltes in Bleiweiss von Germälde der Alten Pinakothek zu München', *Z. Anal. Chem.* **221** (1966), 235—54.
Kühn, H., 'Trace Elements in White Lead and their Determination by Emission Spectrum and Neutron Activation Analysis', *Stud. Conservation*, **11** (1966), 163—169.
Lux, F., Braunstein, L. and Strauss, R., 'Investigations on the Age and Place of Origin of Paintings by Neutron Activation Analysis', *National Bureau of Standards Special Publication*, 1, No. 312 (1969), 216—225.

[30] Keisch, B., Feller, R. L., Levine, A. S. and Edwards, R. R., 'Dating and Authenticating Works of Art by Measurement of Natural Alpha Emitters', *Science*, **155** (1967), 1238—42.

[31] Keisch, B., 'On the Use of Isotope Mass Spectrometry in the Identification of Artists' Pigments', *Stud. Conservation*, **15** (1970), 1—11.

[32] Butler, M. H., 'Polarized Light Microscopy in the Conservation of Paintings', *Centennial Volume*, State Microscopical Society of Illinois (1970).

[33] Bauch, J. and Eckstein, D., 'Dendrochronological Dating of Dutch Seventeenth-Century Paintings', *Stud. Conservation*, **15** (1970), 45—50.

[34] Johnston, R. M. and Feller, R. L., 'Optics of Paint Films: Glazes and Chalking', *Application of Science in Examination of Works of Art*, Proceedings of the Seminar, Sept. 1965, published by the Museum of Fine Arts, Boston, 86—95.

[35] Rees-Jones, S., 'The History of the Artist's Palette in Terms of Chromaticity', *Application of Science in Examination of Works of Art* (1965), 71—77.

[36] Homer, W., *Seurat and the Science of Painting*, MIT Press, Boston, Mass. (1964).

[37] Schwarz, H., 'Vermeer and the Camera Obscura', *Pantheon* (1966), 170—182.

[38] Kühn, H. and Zocher, C., 'Feature Cards for Storing of Technical Data which Result from the Scientific Examination of Works of Art', *Stud. Conservation*, **15** (1970), 102—121.

2
Preliminary Observations on the Technique and Materials of Tintoretto

JOYCE PLESTERS AND LORENZO LAZZARINI

INTRODUCTION

Tintoretto is not the easiest subject for technical study. Few of his works are signed or dated, and few datable with accuracy. Paintings attributed to him must total over 300, some of immense size, and he had many assistants. Our study really began in Venice in 1968 with the restoration of the church of the Madonna dell'Orto and its contents[1], which include a number of major pictures. In 1969 an equally important restoration was started, that of the great cycle of paintings at the Scuola di San Rocco[2]. Restoration at the Scuola di San Rocco is still going on and we have been able, as at the Madonna dell'Orto, to examine the pictures and take samples from them as they are taken down in turn for treatment. Both the Madonna dell'Orto, where Tintoretto worshipped and lies buried, and the Scuola di San Rocco, of which he was a member, had great significance for the artist, and the work which he did for them he himself offered to do and for small financial reward.

Apart from these two projects, we examined a few of the Tintorettos in the Accademia Gallery, and one or two others being restored in Venice at the time. In addition, two of the Tintorettos in the National Gallery in London had been investigated some years ago, and a third very recently.

DOCUMENTARY SOURCES ON TECHNIQUE

The principal sources are Vasari[3] and Borghini[4], both writing in Tintoretto's lifetime, the biography by Ridolfi[5] published almost fifty years after his death, and the writings of Boschini[6] of an even later date. The small amount of technical data is here summarized. According to these sources (although we have few means of distinguishing how much is fact and how much legend) Jacopo Robusti (1518–94) was born in Venice, the son of a cloth dyer (hence the nickname by which he became famous). Having shown an early talent for drawing, he was placed when a young boy in Titian's studio but dismissed in a matter of days. Left without a master he returned home, fixed to the wall of his room the motto 'Il disegno di Michelangelo e il colorito di Titiano' and embarked on a programme of self-education. He practised drawing from the model and from sculpture (that of Sansovino and casts of figures by Michelangelo, we are told) and copied pictures by Titian, particularly those which established the method of colouring. He hung around wherever masons or painters were working and offered to help in order to learn their craft. By his own efforts he eventually gained commissions. It is described how, after inspecting the site, he went home and worked out the composition of the picture by arranging small wax or clay figures, draped in rags, in an open-sided box like a toy theatre. He experimented with lighting effects by shining lights through windows in the box, and even suspended some figures from the roof 'to see the effect'. This seems credible on looking at many of his pictures. Ridolfi describes how Tintoretto first painted figures nude before adding the drapery, so that the form of the limbs could be well seen beneath. The same author recounts that Tintoretto, when asked what he considered the most beautiful colours, replied

Figure 2.1 St George and the Dragon. National Gallery, London. Outline drawing to show comparative size.

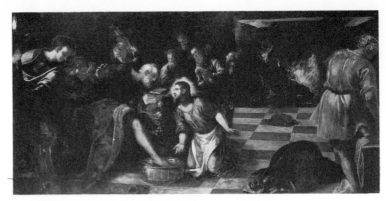

Figure 2.2 Christ Washing His Disciples' Feet, *National Gallery, London*

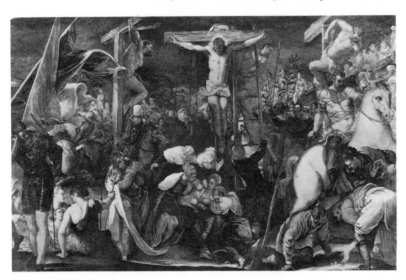

Figure 2.3 Crucifixion. *Accademia Gallery, Venice*

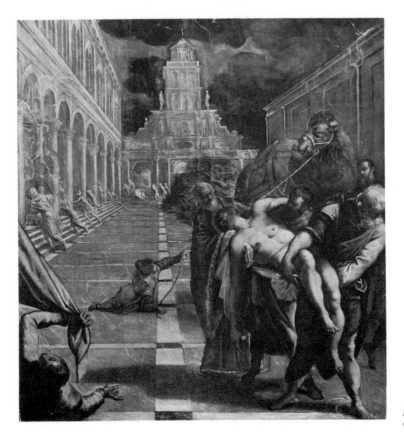

Figure 2.4 Transportation of the Body of St Mark. *Accademia Gallery, Venice*

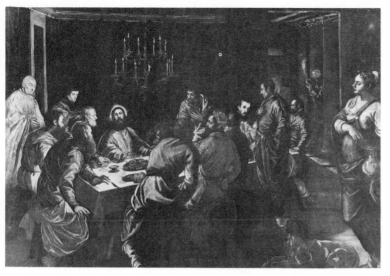

Figure 2.5 **Last Supper.** *Church of S. Simeone Grande, Venice*

Figure 2.6 Origin of the Milky Way.

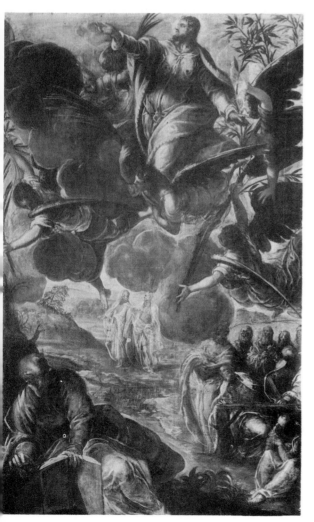

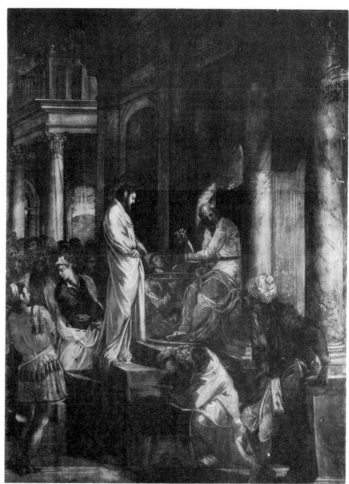

Figure 2.7 **Christ Before Pilate.** *Scuola di San Rocco (Sala dell'Albergo), Venice*

Figure 2.8 Ascension. *Scuola di San Rocco (Sala Grande), Venice*

black and white, the first because it gave strength to the figures, deepening the shadows, the second because it gave them relief. In describing his paintings the various authors remark as often on his summary manner of execution as on his remarkable powers of invention. Pietro Aretino who, in a letter of 1548, produces the first published critical appraisal of Tintoretto (the occasion being the putting on exhibition of the *Miracle of the Slave,* now in the Accademia Gallery), advises him to have more patience in the carrying out of his works[7]. Vasari, who saw the *Last Judgment* in the Madonna dell'Orto soon after it was painted, complained of its lack of proper design and finish (this reaction is not surprising in that Vasari was more accustomed to the enamel-like surfaces and meticulous detail of Florentine Mannerist paintings).

There is no record of Tintoretto's having left the environs of Venice except for one short stay in Mantua when he was aged .62. If his biographers can be believed[8], he was largely self-taught — a thing virtually unknown at the time — and what he learned, he learned within the confines of Venice.

LIST OF PAINTINGS EXAMINED

We shall concentrate on 10 paintings (though a few others will be mentioned). Their attribution (with the exception of that of the S. Simeone Grande *Last Supper*) has never been seriously challenged and their histories and provenances can be found in the literature. The eight illustrated in *Figures 2.1–8* are reproduced to show their relative size (since this proves to be a significant factor for technique), though the National Gallery's *St George and the Dragon* is so small that it has had to be shown in *Figure 2.1* merely as an outline drawing and re-illustrated not to scale in *Figure 2.9.* Conversely, the pair of pictures from the Madonna dell'Orto *Figures 2.10* and *11)* are too large to be reproduced at the same scale as *Figures 2.1–8,* but an idea of their size may be got from *Figure 2.12* which shows one of us (L.L.) standing on scaffolding in front of the *Last Judgment.* Like all but a few of Tintoretto's works[9], all ten are on canvas. The measurements are given in metres, height preceding width. In the case of pictures in the Accademia Gallery in Venice and the National Gallery in London the dates (and other information) are taken from the published catalogues[10,11]. The dates given for the remaining pictures are those which seem to receive majority, though not necessarily unanimous, support. Some pictures can be dated more closely than others. The pictures are listed below in the order in which we examined them, which happens by chance to be roughly their chronological order:

St George and the Dragon. National Gallery, London. See *Figures 2.1 and 2.9.* 1·575 x 1·003. 1560s.

Christ Washing His Disciples' Feet. National Gallery, London. *Figure 2.2.* 2·006 x 4·083. Soon after 1556.

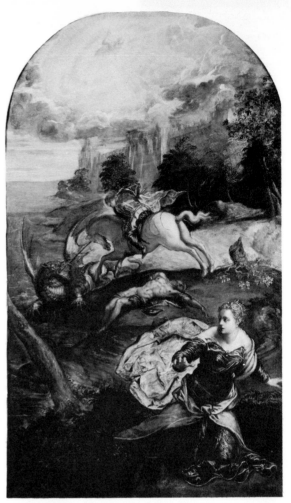

Figure 2.9 St George and the Dragon. *National Gallery, London*

Crucifixion. Accademia Gallery, Venice. *Figure 2.3.* 2·82 x 4·45. Mid 1560s.

Last Supper. Church of S. Simeone Grande, Venice. *Figure 2.5.* 2·85 x 4·15. Early 1560s?

Transportation of the Body of St Mark. Accademia Gallery, Venice, *Figure 2.4.* 3·98 x 3·15. 1562–66.

Worship of the Golden Calf. Church of the Madonna dell'Orto, Venice. *Figure 2.10.* 14·50 x 5·80. c.1560–62.

Last Judgment. Church of the Madonna dell'Orto, Venice. *Figure 2.11.* 14·50 x 5·90. c. 1560–62.

Christ Before Pilate. Scuola di San Rocco (Sala dell'Albergo), Venice. *Figure 2.7.* 5·15 x 3·80. c.1566.

Ascension. Scuola di San Rocco (Sala Grande), Venice. *Figure 2.8.* 5·28 x 3·25. c.1579–81.

Origin of the Milky Way. National Gallery, London. *Figures 2.6 and 2.16.* 1·48 x 1·65. c.1578.

METHODS OF EXAMINATION

The usual methods were employed. The surfaces of the pictures were examined with the unaided eye and with low magnification. X-radiographs and infra-red

photographs were consulted where available. Samples of canvas, ground and paint were removed for microscopical and chemical analysis. The number of samples from each picture varied (fewer than 20 from the *St George and the Dragon*, but more than 70 from the *Last Judgment*). Cross-sections were prepared from many of the samples in order to investigate the layer structure under the microscope, and photomicrographs taken at c.150x magnification, of which a selection is shown in *Figures 2.19, 20* and *21*, together with a scale to show the absolute magnification. Unfortunately these photomicrographs could not all be reproduced in colour. Identification of some pigments was made by microscopical examination of particle

characteristics and optical properties, combined with chemical tests under the microscope. Many of the problems of pigment identification will be solved only by scanning the sections layer by layer with the electron microbeam probe or the laser microspectrograph and this will eventually be done. The medium of the paint layers of seven of the pictures was examined by gas chromatography in the Scientific Department of the National Gallery, London, and the results appear in a paper contributed to this volume by John S. Mills and Raymond White. It is expected that we shall do a good deal more work on existing samples.

Instead of presenting results for each picture separately, it seems more useful to group the data

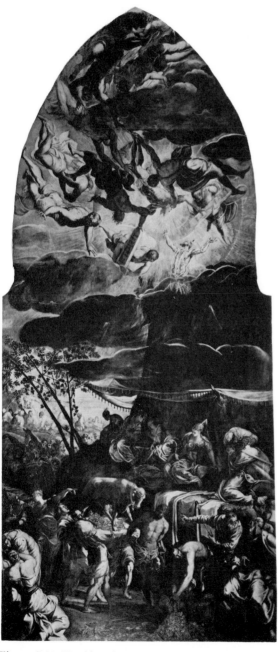

Figure 2.10 Worship of the Golden Calf. *Church of the Madonna dell'Orto, Venice*

Figure 2.11 Last Judgment. *Church of the Madonna dell'Orto, Venice*

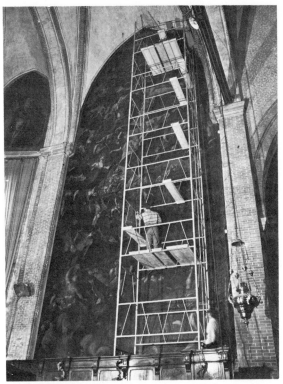

Figure 2.12 Scaffolding erected in preparation for the removal of the Last Judgment *from the wall of the choir of the church of the Madonna dell'Orto*

under feature headings. They will also be compared with findings from pictures by sixteenth century Venetian painters other than Tintoretto.

THE CANVAS SUPPORT

Five of the pictures still had remnants of the turnover of the original canvases and samples from them are shown actual size in *Figure 2.13C and 13E—H.* The others had the edges of the original canvas cut off, but for the three National Gallery pictures there exist X-radiographs which show the canvas weave actual size and small areas of these are illustrated in *Figure 2.13A, B and D.* Each of the eight canvases illustrated is different. Logically, the smallest picture, *St George and the Dragon,* has the finest canvas and the *Last Judgment,* one of the two largest, the coarsest. An unexpected finding was that the *Worship of the Golden Calf* and the *Last Judgment,* painted as a pair, have different types of canvas. The fibre of the five canvases of which actual samples are illustrated appeared from microscopical examination to be in all cases flax. The coarseness of the canvas of the *Last Judgment* led to the speculation that it might be hemp, particularly since there was a flourishing hemp industry in Northern Italy certainly before 1500. Unfortunately a distinction between flax and hemp fibres, especially when they are aged and somewhat degraded, is apparently not easy to make[12] and no positive identification could be achieved.

Like all woven textiles, artists' canvas is supplied only in certain standard widths depending on the width of the loom. A single width often suffices for a modest-sized picture, but for larger pictures several widths have to be seamed together, generally by oversewing the selvedges before the canvas is nailed to the stretcher. We have noticed that the canvas width in many large sixteenth century Venetian pictures measures a little over one metre. For example, the *Worship of the Golden Calf* is made up in the lower half of the picture of five main vertical strips of canvas, each 110 cm wide. The *Last Judgment* has a similar series but with more variation (120, 120, 115, 116, 110 cm), and the *Christ Washing His Disciples' Feet* contains an uncut width of 110 cm. In a large rectangular canvas the parallel seams usually run either vertically or horizontally with respect to the picture. This system seems to be followed to a large extent in the Scuola di San Rocco. The *Christ Before Pilate* is made up of five horizontal strips, and the *Ascension* of three main vertical strips. It was therefore surprising to find in one of the pictures in the Scuola, the *Adoration of the Shepherds* (which Ridolfi calls an 'extravagant invention' and in which the scene is divided between the upper and lower floors of the stable), that along the line of the dividing floor several small strips of canvas seem to have been inserted (see raking-light photograph in *Figure 2.15*), as though the upper and lower halves of the picture had been painted separately then joined together, the upraised hand of the shepherd being painted over the joins.

THE GROUND

In our experience wood panels of the fourteenth, fifteenth and early sixteenth century Venetian School have, in common with those of other Italian Schools of the same period, a gesso ground (i.e. a preparation of gypsum, lightly roasted so as to be partly converted into anhydrous calcium sulphate, ground to a powder, then bound with animal glue). Though practically all of Tintoretto's paintings are on canvas, many of those of Giovanni Bellini and some of Titian's are on wood panels. When Giovanni and Gentile Bellini and Titian adopted canvas supports (probably because of the problems of cost, weight and construction involved in wood panels as large as, say, Titian's *Assumption* in the church of the Frari), they appear to have gone on using gesso grounds[13]. Gesso is a brittle material more suitable for a rigid panel than for a flexible canvas support. It is also vulnerable to damp. It would also be sensitive to mechanical strains caused by bending or rolling the canvas, which had, and still has to be done in order to transport large pictures in Venice. In the *Volpato MS.,* dating from the late seventeenth century[14], we find two apprentices discussing the disadvantages of the 'old-fashioned' (i.e. sixteenth century) gesso ground on canvas compared with the 'modern' consisting of red ochre in oil. They also remark that old pictures are better-preserved if the gesso on the canvas is very thin. The gesso ground of

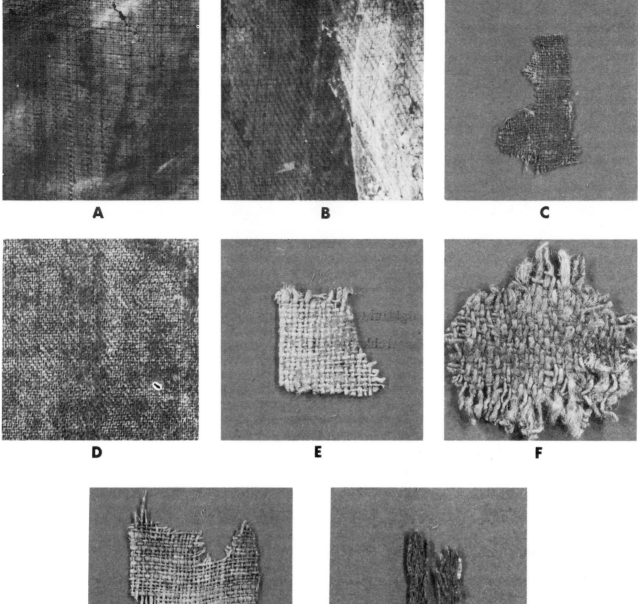

Figure 2.13 Examples of canvases from pictures by Tintoretto. The photographs in C and E–H show fragments of original canvases, actual size. Those in A, B and D are details of X-radiographs also showing the canvas weave actual size

A. St George and the Dragon
Very fine-textured, closely-woven plain canvas; occasional heavy threads at intervals in both warp and weft

B. Christ Washing His Disciples' Feet
Closely-woven twill of medium grade coarseness

C. Last Supper
Comparatively fine-textured plain weave

D. Origin of the Milky Way
Closely-woven fine twill

E. Worship of the Golden Calf
Moderately coarse plain weave, rather loosely woven

F. Last Judgment
Very coarse thick twill, loosely woven from lightly-spun thread of irregular thickness

G. Christ Before Pilate
Plain weave of medium-grade coarseness; rather loosely woven

H. Ascension
Herring-bone twill of medium coarseness, tightly spun and woven

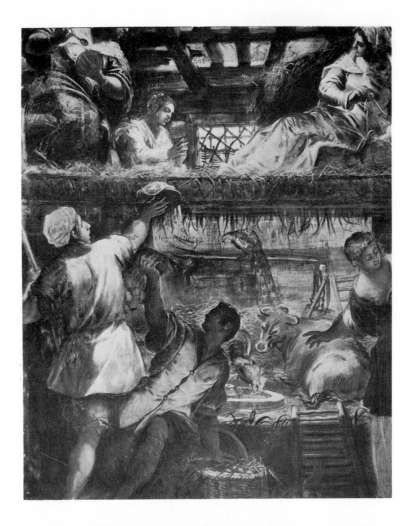

Figure 2.14 Adoration of the Shepherds *Scuola di San Rocco (Sala Grande), Venice, Infra-red photograph (detail)*

Figure 2.15 Adoration of the Shepherds. *Scuola di San Rocco (Sala Grande), Venice. Photograph in raking light to show canvas joins*

Titian's *Bacchus and Ariadne* in the National Gallery, London, was found only just to cover the grain of the fine canvas. Similar grounds were found in some of the Tintorettos examined. It will be seen from the following table that gesso grounds were identified in 8 of the 10 Tintorettos examined ('thin gesso' signifies barely covering the canvas grain).

St George and the Dragon, thin gesso.

Christ Washing His Disciples' Feet, (a) thin gesso on canvas (b) blackish upper layer of ground (charcoal black + brown ochre in oil medium).

Crucifixion, thin gesso.

Last Supper, gesso of moderate (60—100μ) thickness

Transportation of the Body of St Mark, thin gesso

Worship of the Golden Calf, gesso of variable thickness and missing in some cross-sections, possibly because of poor adhesion to paint.

Last Judgment, thin gesso.

Christ Before Pilate, (a) thin gesso on canvas, (b) dark brown upper layer of ground (charcoal black and brown ochre in oil medium).

Ascension, 'dark brown' ground directly on canvas (gesso absent in all samples); though principally charcoal black and brown ochre in oil medium, this dark ground is seen under the microscope to contain numerous multi-coloured pigment particles, among which red lake, smalt and vermilion are recognizable.

Origin of the Milky Way, 'dark brown' ground in oil medium next the canvas, and like that of the *Ascension* contains scattered multi-coloured pigment particles.

Dark-coloured grounds, usually red or brown, were introduced in the second half of the sixteenth century and not only in Venice. Their use implies a new technique, that of painting light on dark instead of dark on light (see below under *Drawing*). A dark-coloured ground has an advantage in aiding speed of execution, in that areas poorly covered by paint are less noticeable than similar areas of white ground. In fact parts are sometimes left uncovered deliberately and form part of the design. A dark-coloured ground has the disadvantage that increasing transparency of the paint layers with age may make it more apparent, as also may wearing of the paint layers, so causing an all-over darkening of the tone of the picture. This seems to have happened in the *Christ Washing His Disciples' Feet* and in some of the pictures in the Scuola di San Rocco. The only explanation we can suggest for the presence of multi-coloured particles in the 'brown' grounds of the *Ascension* and that of the *Origin of the Milky Way* is that they may consist, in part at least, of a mixture of palette scrapings, perhaps boiled up with carbon black, brown ochre and oil.

DRAWING IN GENERAL AND UNDERDRAWING IN PARTICULAR

In fourteenth, fifteenth and some early sixteenth century panel paintings an accurate and detailed black underdrawing was done on the white gesso ground. It can be seen, for example, in infra-red photographs of pictures by Giovanni Bellini. In paintings by Titian and Giorgione usually only a few sketchy lines can be seen because these two artists seem to have preferred to work out their compositions in areas of colour in the paint layers themselves. In those pictures by Tintoretto examined, the thin line of carbon black particles between gesso ground and initial paint layer, which can be interpreted as black underdrawing, were found in cross-sections of the following: *St George and the Dragon,* the *Last Supper,* the *Crucifixion* and the *Worship of the Golden Calf.* Its absence from sections of the *Last Judgment* may not be significant considering the relative area of sample (approx. 0·5 mm diameter) to picture area. Its absence from the *Transportation of the Body of St Mark* is puzzling[15].

Starting with a dark ground an obvious procedure would be to employ a white underdrawing, and this Tintoretto has done in the *Christ Washing His Disciples' Feet.* In several of the cross-sections, dots and streaks of lead white are present in and on the nearly black ground and the X-radiographs show up details, such as the drawing of a window frame, which look as if they had been done with stiff lead white paint and a coarse stiff brush. Many drawings on paper by Tintoretto survive but they are nearly all of single figures, usually nude, sometimes squared up for transfer to canvas. Ridolfi mentions that Tintoretto used a (presumably square-meshed) string net in front of his models in order to draw figures more accurately. But these preliminary drawings done, his method seems often[16] to have been to work out his compositions on the canvas itself, as did Titian, but, unlike Titian, not by building up in areas of colour, but by describing forms in terms of line. The X-radiographs of the *Origin of the Milky Way* (*Figure 2.17*) indicate that Tintoretto used a lead white underdrawing on the dark brown ground. It is interesting to compare this X-radiograph with a drawing on paper, the *Venus and Vulcan* in Berlin (*Figure 2.18*), which is rare among Tintoretto's drawings as being a study for the whole composition of a known painting, that of the same subject in the Alte Pinakothek, Munich. The spiralling lines are similar in both X-radiograph and drawing, as are the egg-shaped heads and elongated ovals of limbs, resembling those of artists' lay figures. Many *pentimenti* can be seen in the radiograph and many tentative outlines in the drawing on paper.

Tintoretto seems to use a drawing technique at all levels of the paint structure. In the *Christ Before Pilate,* what appeared, under the discoloured varnish before cleaning, to be a coarse charcoal black underdrawing of the base of the column on the right, was discovered to be a coarse charcoal black drawing, but *over*, not under, the white paint layer of the column. The characteristic ghostly figures which can be seen fleeing beneath the porticoes in the *Transportation of the Body of St Mark* or standing in the landscape in the *Ascension* are just roughly outlined in thick light-coloured paint on the darker background. Tintoretto's versatility — one might even say

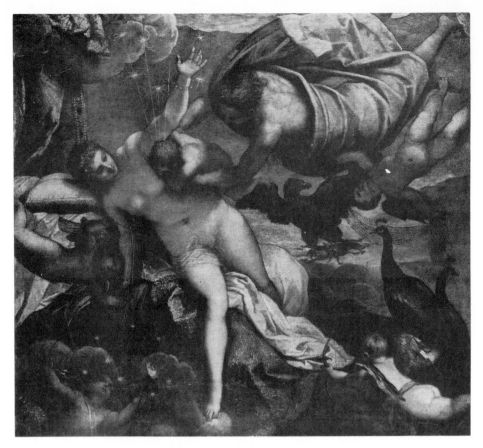

Figure 2.16 Origin of the Milky Way. *Panchromatic photograph*

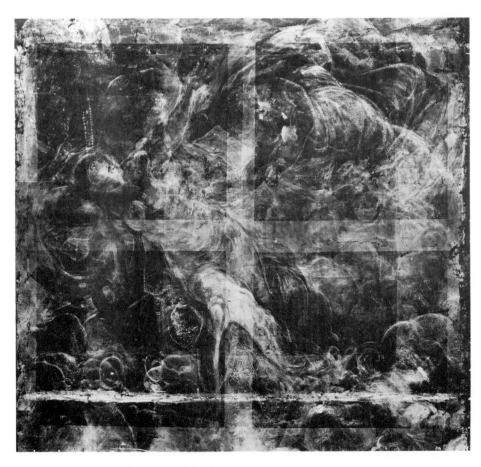

Figure 2.17 Origin of the Milky Way. *Composite X-radiograph*

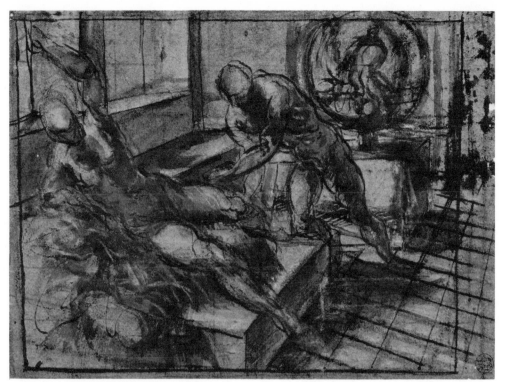

Figure 2.18 Venus, Vulcan and Mars. *Pen, wash and white highlights on blue paper, size 0·204 x 0·273 m. (Reproduced by courtesy of the Kupferstichkabinett, Staatliche Museum Preussischer Kulturbesitz, Berlin; Kdz 4193)*

perversity — in drawing reaches its extreme in the *Adoration of the Shepherds* in the Scuola di San Rocco. Judging only from visual inspection, it could be guessed to have a brown ground directly on the canvas and on this the drawing is done in carbon black which can be seen more clearly in the infra-red detail in *Figure 2.14*. The ears of corn in the foreground are left unpainted and the drawing of the cockerel and the ox just heightened here and there with touches of light paint. Here the distinction between underdrawing and drawing in general disappears.

THE PAINT LAYERS

THE PIGMENTS

Colouring is the attribute which has always been associated with sixteenth century Venetian painting. In the pictures by Tintoretto so far examined we have not come across any pigment which would not have been familiar to any artist of his period, but we may yet get surprises from more detailed analyses. The pigments identified are indicated in the captions to the photomicrographs of cross-sections (*Figures 2.19, 20* and *21*). They include (in addition to the ubiquitous lead white, charcoal black and earth colours) natural ultramarine, azurite, verdigris, 'copper resinate' type green glazes, vermilion, red lake pigments of varied hue, lead-tin yellow[17] and the yellow and orange arsenic sulphides (orpiment and realgar respectively). The identical range was found both in

Titian's *Bacchus and Ariadne* and Sebastiano del Piombo's *Raising of Lazarus* in the National Gallery, London. One reason for the colourfulness of sixteenth century Venetian painters is that often in a single picture they exploit the possibilities of the artist's palette of the time to its limit[18]. Additionally Tintoretto sometimes employs malachite, which was identified also in the Sebastiano del Piombo mentioned above, although it is not frequently found in oil paintings. We also found many occurrences of smalt (the powdered blue glass which owes its colour to cobalt)[19], but mostly in underlayers (see *Figure 2.19E*, layer 3) or mixed with ultramarine. There occurred, also as an underlayer, a blackish-blue amorphous pigment which, since it is soluble in chloroform to give a blue solution, may be indigo (see *Figure 2.20E*, layer 2). Red lake pigments of scarlet, crimson and magenta hues appear everywhere, not only mixed with white or applied as final glazes, but as thin, streaked underlayers as if used for drawing outlines. Some of the red lakes appear to have a chalk and not an aluminium hydroxide substrate. Characteristically glittering crystals of orpiment were frequently seen (see *Figure 2.19C*, layer 3), sometimes with the unusual feature of a thin glaze of crimson on top, or even below (*Figure 2.20D*, layer 3). Orpiment and realgar are not very common in other schools and periods of European easel painting. Venice was especially well-situated for pigment supplies, being both a port for European trade with the near and far East and a centre of the cloth-dyeing industry[20] of which lake pigments and indigo were by-products.

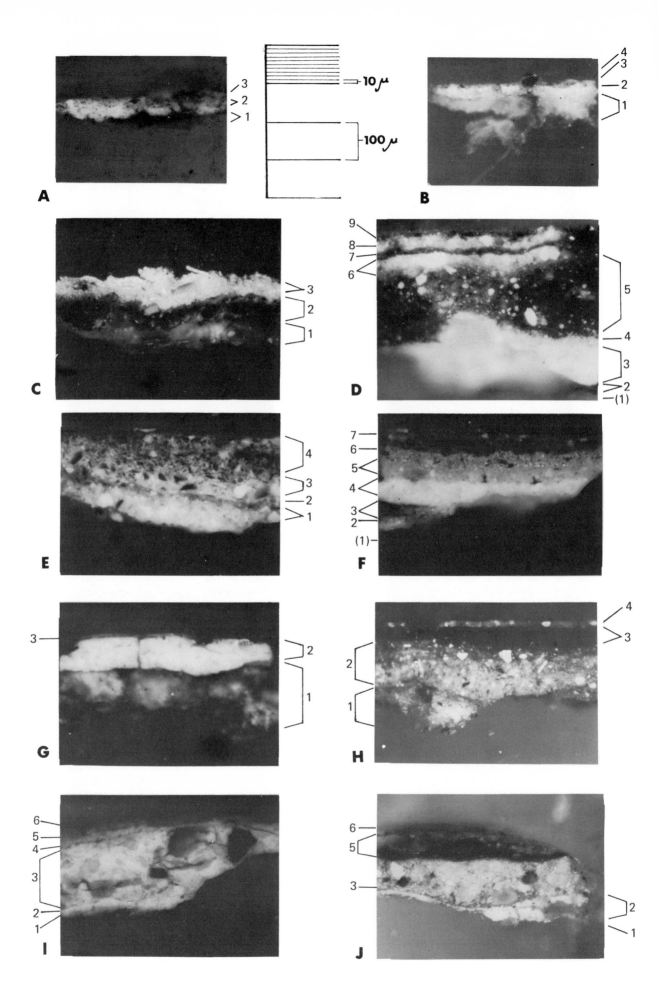

Figure 2.19 Photomicrographs of cross-sections of paint samples from pictures by Tintoretto, photographed by reflected light at approximately 150x magnification. The series is continued in Figures 2.20 and 2.21. The layers are numbered on the photographs from the bottom layer upwards and the numbers correspond to those in the captions below. See also Frontispiece

A. St George and the Dragon *Blue sky (Sample 5)*
Layer 1 *Gesso ground (brown with excess glue)*
 2 *Lead white + azurite, underpaint*
 3 *Lead white + coarse ultramarine*

B. St George and the Dragon — *Blue-green of leaves (Sample 12)*
Layer 1 *Gesso ground with canvas fibre*
 2 *Carbon black drawing, very thin*
 3 *Underpaint of lead-tin yellow + verdigris*
 4 *Brownish-green glaze with high copper ion content (has this layer discoloured?)*

C. Christ Washing His Disciples' Feet — *St Peter's orange-yellow robe (Sample 6)*
Layer 1 *Gesso ground*
 2 *Blackish upper ground layer*
 3 *Yellow orpiment + orange realgar*

D. Christ Washing His Disciples' Feet — *Blue of drapery on stool (Sample 10)*
Layer 1 *(Gesso absent)*
 2 *Fragment of black ground*
 3 *Buff coloured paint of floor tiles*
 4 *Pink glaze of terracotta tile*
 5 *Translucent dark blue-green layer of smalt + traces of lead white (underpaint for drapery)*
 6 *Pale blue highlight (lead white + ultramarine)*
 7 *Glaze of ultramarine alone*
 8 *Second pale blue highlight*
 9 *Final glaze of ultramarine*

E. Crucifixion — *Bright blue drapery (Sample 5)*
Layer 1 *Gesso ground*
 2 *Thin wash of yellow ochre + a few vermilion particles*
 3 *Lead white + large particles of smalt*
 4 *Coarse ultramarine + lead white*

F. Crucifixion — *Purples of dress (Sample 15)*
Layer 1 *(Gesso absent)*
 2 *Lead white underpaint*
 3 *Purplish-red lake*
 4 *Lead white + yellow ochre*
 5 *Yellow ochre*
 6 *Coarse crystalline vermilion*
 7 *Scumble of crimson-coloured lake + smalt + trace of lead white*

G. Last Supper — *Flesh of hand of woman (Sample 4a)*
Layer 1 *Gesso ground thick*
 2 *Pale flesh colour (lead white + vermilion)*
 3 *Thin brown glaze (perhaps shadow on hand)*

H. Last Supper — *Green tunic (Sample 6b)*
Layer 1 *Gesso ground (trace)*
 2 *Mixture of coarse crystalline particles of azurite + malachite mainly, but grains of lead white, carbon black and red and yellow pigments*
 3 *Dark greenish-brown glaze (discoloured?)*
 4 *Old repaint (before cleaning)*

I. Transportation of the Body of St Mark — *Greenish shadow on pink sleeve (Sample 2)*
Layer 1 *Gesso ground (trace)*
 2 *Lead white underpaint*
 3 *Thick lead white layer with large inclusions of deep red lake pigment*
 4 & 5 *Pale yellow-green layers (lead white + trace of copper ion)*
 6 *Discoloured varnish*

J. Transportation of the Body of St Mark — *Dark red shadow of pink sleeve (Sample 3)*
Layer 1 *Gesso ground (trace)*
 2 *Lead white underpaint*
 3 *Faint pink line*
 4 *Thick layer of lead white + vermilion + red lake*
 5 *Thick dark red glaze of lake pigment*
 6 *Discoloured varnish*

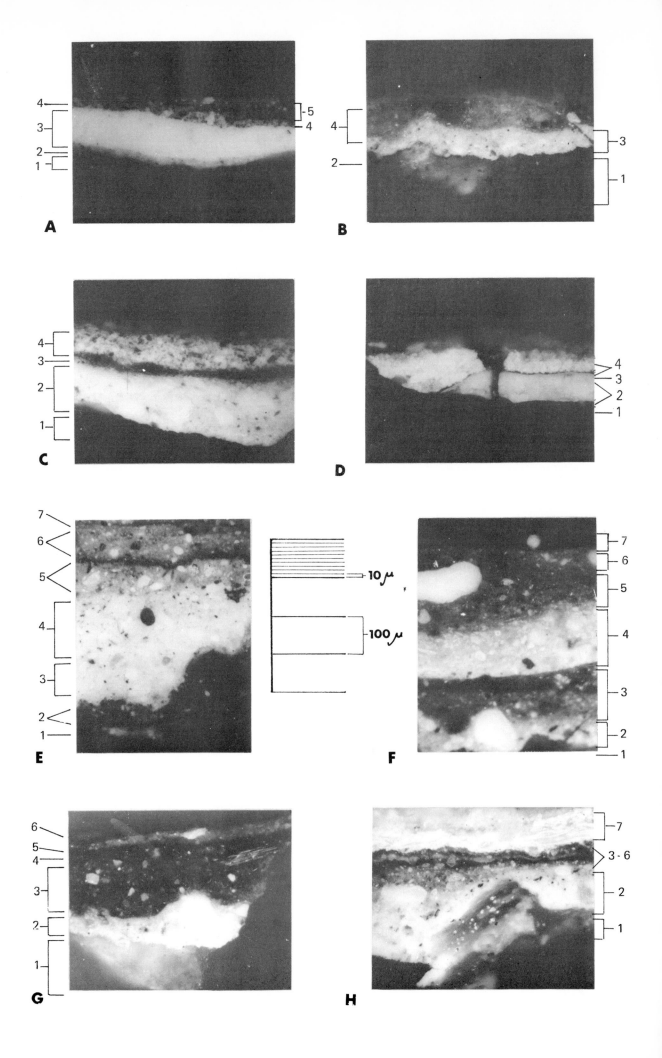

Figure 2,20 Photomicrographs of cross-sections of paint samples from pictures by Tintoretto (continued from Figure 2.19). See also Frontispiece

A–D Worship of the Golden Calf

A. *Light blue drapery near top (Sample 9, series 2)*
Layer 1 *(Gesso ground missing)*
2 *Orange-brown (lead white + ochre + vermilion)*
3 *Lead white*
4 *Thin layer of natural ultramarine + lead white*
5 *Later overpaint of lead white + Prussian blue*

C. *Blue dress of woman, lower left (Sample 22, series 2)*
Layer 1 *(Gesso missing)*
2 *Lead white underpaint*
3 *Thin line of smalt and carbon black in discoloured medium*
4 *Natural ultramarine + lead white*

E–H Last Judgment

E. *Brownish flesh of figure in foreground (Sample 7, series 3)*
Layer 1 *Fragment of gesso ground*
2 *Undulating layer of dark blue indigo-like pigment*
3 *Pale pink layer*
4 *Pale grey layer; lead white + carbon black, one particle of latter on the right showing cell structure of wood*
5 *Yellow layer containing particles looking like verdigris, malachite, vermilion etc*
6 *Buff-coloured ochre layer containing scattered green, blue and red particles*
7 *Similar to 6 (part of the thickness is outside the photograph)*

G. *Highlight on water, foreground (Sample 12, series 1)*
Layer 1 *Gesso ground*
2 *Lead white underpainting with a few red particles*
3 *Very thick grey-green layer packed with blue and green azurite and malachite particles, lead white and charcoal black (large splinter-shaped particle of latter seen upper right)*
4 *Dark brown-green glaze*
5 *Greyish-white highlight*
6 *Discoloured varnish*

B. *Dark brown flesh near top (Sample 10, series 2)*
Layer 1 *Gesso (brown from excess glue)*
2 *Carbon black drawing*
3 *Thick flesh-coloured paint (white + vermilion + red ochre)*
4 *Translucent yellow-brown layer, possibly a yellow lake*

D. *Bright yellow dress, foreground (Sample 25, series 2)*
Layer 1 *(Gesso missing)*
2 *Lead white underpaint*
3 *Thin line of deep red lake pigment*
4 *Deep yellow orpiment*

F. *Blue of drapery, woman in foreground (Sample 8, series 1)*
Layer 1 *Gesso ground (fragment)*
2 *Lead white + ochre*
3 *Yellow-brown ochre with scattered multi-coloured pigment particles*
4 *Lead-tin yellow + vermilion particles*
5 *Multi-coloured coarse granular paint with much ochre, vermilion, azurite and some lead white*
6 *Pale fawn layer with mixed ochre pigments and lead white, including a large lump on the left. This layer could be flesh paint*
7 *Deep blue (natural ultramarine + a little lead white)*

H. *Yellow-brown of drapery of angel, top centre (Sample 2, series 5)*
Layer 1 *Gesso ground with canvas fibre*
2 *Lead white + carbon black + red lead particles*
3–6 *Multiple brown and yellow-brown layers, some translucent, and with occasional multi-coloured pigment particles*
7 *Coarse, crystalline platelets of orpiment*

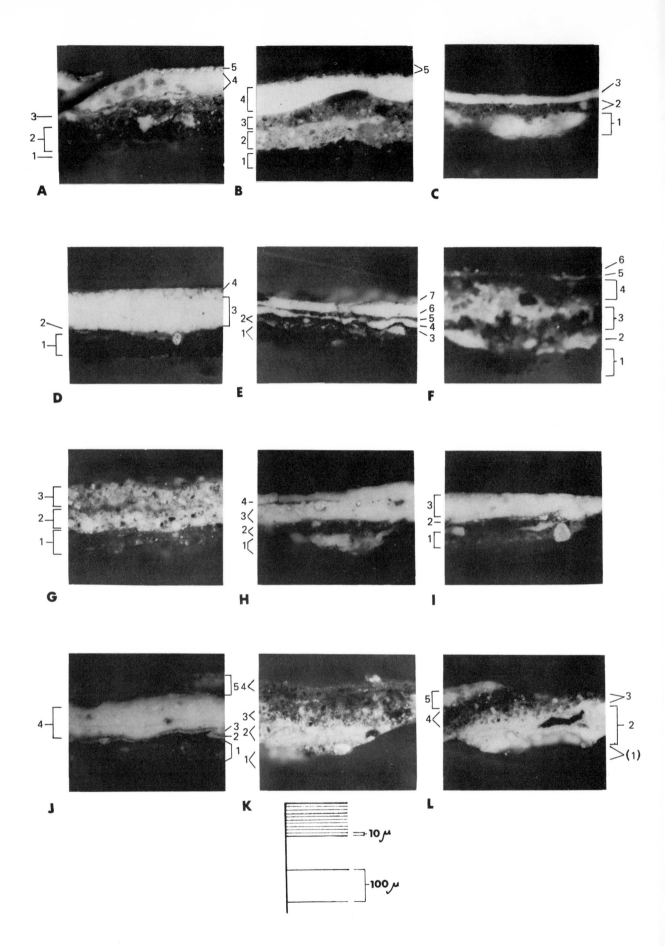

Figure 2.21 Photomicrographs of cross-section of paint samples from pictures by Tintoretto (continued from Figures 2.19 and 2.20). See also Frontispiece

A–C Christ Before Pilate

A. Red of trousers of turbaned figure, right (Sample 11)
Layer 1 Dark brown ground
2 Coarse vermilion + red lake + lead white
3 Composite layer of several streak· of crimson lake pigment
4 Lead white and few vermilion and yellow particles
5 Compact layer of coarse crystalline vermilion particles

B. Blue of scarf, turbaned figure (Sample 13)
Layer 1 Dark brown ground as in A
2 Mid pink (lead white + red lake + scattered vermilion)
3 Deeper pink layer of similar composition with large inclusions
4 Lead white
5 Very thin (almost single layer of pigment particles) of ultramarine + a few smalt fragments

C. White mantle of Christ (Sample 16)
Layer 1 Gesso ground, yellowish and canvas fibres attached
2 Dark brown ground
3 Lead white

D–F The Ascension

D. Blue-green of landscape (Sample C4)
Layer 1 'Blackish-brown' ground with scattered multi-coloured particles and streaks of colour
2 Thick red ochre paint
3 Pale pink (red ochre + lead white)
4 Pale blue (azurite + lead white)

E. White highlight on wing of angel (Sample C18)
Layer 1 'Blackish-brown' ground as in D
2 Pale green (verdigris + lead white)
3 Crimson glaze (red lake pigment)
4 Lead white
5 Crimson glaze
6 Lead white with one or two large globules of red lake
7 Discoloured varnish

F. Blackish-green leaves near Christ (Sample C20)
Layer 1 Fragment of 'blackish-brown' ground as in D and E
2 White underpaint of irregular thickness with lumps of lead white
3 Coarse granular layer (mixture of yellow and brown ochre, smalt, charcoal black)
4 Coarse granular layer (malachite, verdigris, smalt, yellow and brown ochre, charcoal black, lead white)
5 Lead white (highlight on vein of leaf?)
6 Blue-green glaze of coarse azurite, colour spoiled by sunk-in varnish

G–L Origin of the Milky Way

G. Mauve cloud, top left (Sample 1)
Layer 1 Brown ground with coloured particles
2 Pale blue-green (azurite + lead white + dark indigo-like particles)
3 Mauve (lead white + ultramarine + red lake

H. Yellow brocade pattern of crimson drapery (Sample 2)
Layer 1 Brown ground
2 Line of red lake pigment mixed with some bright orange particles
3 Pale pink (lead white + lake)
4 Bright yellow (lead-tin yellow)

I. White of bed-sheet (Sample 4)
Layer 1 Brown ground with coloured particles
2 Deep crimson glaze with a few yellow particles
3 Lead white (with no other pigments included)

J. Green of wing of putto, left (Sample 7)
Layer 1 Brown ground with coloured particles
2 Line of crimson lake glaze
3 Line of unidentified bright yellow particles
4 Lead white
5 Green glaze (high content of copper ion)

K. Darkest blue drapery on bed (Sample 13)
Layer 1 Brown ground (trace)
2 Yellow ochre
3 Line of vermilion particles
4 Natural ultramarine + trace of lead white

L. Mauve drapery shot with green (Sample 21)
Layer 1 (Brown ground missing)
2 Lead white + orange & yellow particles and large pieces of charcoal embedded
3 Granular mixture of coarse azurite + red lake + lead white
4 Vermilion + red lake
5 Greenish-white (verdigris + lead white)

In paintings before the eighteenth century it is exceptional to find complex mixtures of different coloured pigments in a single paint layer. They are usually used singly, mixed with white and/or a second colour. This has been found to be the case in pictures by Giovanni Bellini, Sebastiano del Piombo, Titian and Veronese which we have so far examined. It will be readily seen from the photomicrographs of sections that Tintoretto often mixes more than two different coloured pigments together. This is not accidental contamination for when he chooses he can paint a layer of pure lead white (as in *Figure 2.21B*). The very complicated mixtures in the underlayers of the *Last Judgment* (see *Figure 2.20E—H*) are probably a special case and will be discussed below. Pigment particle size is variable but some very large particles or aggregates (100μ or more in diameter) are seen, especially of lead white, red lakes, charcoal black and iron oxide minerals.

In looking at pictures by Tintoretto, or, indeed, at any picture of appreciable age, we have to remind ourselves that the colours may have changed in the course of time. This lesson was forcibly brought home to us when the *Ascension* at the Scuola di San Rocco was taken out of its architectural framework. Strips of paint a few centimetres wide at the top and right-hand edges of the canvas had been covered by the gilded wood moulding which surrounded them. Along these protected edges practically all the colours were brighter and more intense. Samples were taken from the various colours on the protected strips of paint and from adjacent areas on the exposed, and presumably faded, main area of the picture. The details of the changes which exist between colours in the exposed and protected areas have not yet been fully worked out, but they include fading and browning of red lake pigments and browning of green copper pigments. In the exposed area at the top of the picture the sky around Christ's head is a reddish-brown, while in the protected strip above it is mid blue. This change was so striking that it was first supposed that an organic blue dyestuff such as indigo must have faded, but microscopical and chemical examination showed that the blue pigment present in both areas was smalt and the discoloration was an extreme form of a disorder which sometimes occurs when this pigment is used in oil medium and which has been described by one of us elsewhere[21]. In fact, the only colour which showed virtually no difference between the exposed and protected areas was Christ's halo which proved to be painted in lead-tin yellow.

THE PAINT MEDIUM

Details of examination of the medium of the paint layers of seven of the pictures, using the technique of gas chromatography, are given on page 75 in this volume. The medium was in all cases identified as a drying oil and, with the exception of one sample, as linseed oil. Elementary solubility, combustion and staining tests on samples from the remaining three

pictures (*St George and the Dragon, Christ Washing His Disciples' Feet,* and the *Ascension*) also indicated a medium of drying oil. The 'Venetian Secret'[22] has long been thought to reside in the merits of a special medium, in spite of the fact that Vasari and other early writers often loosely describe sixteenth century Venetian paintings, including those of Tintoretto, as being 'in oil'. It has, however, been pointed out that the methods of analysis used for identification of oil media cannot at present reveal the mode of preparation of the oil or the presence of small amounts of additives such as resins or driers. The exception mentioned above was a sample of white paint from the *Worship of the Golden Calf* in which the fatty acids ratio was such that the medium might have been walnut oil or a mixture of walnut and linseed oils. The *Worship of the Golden Calf* appears since its recent cleaning to have a somewhat lighter general tone than the *Last Judgment* and it is interesting to recall that walnut oil is frequently recommended in early literary sources for white[23] and blue pigments in order to retain their brightness.

PAINT THICKNESS

A notable feature of the paint cross-sections as seen in the photomicrographs in *Figures 2.19—21* is the wide variation in thickness. The smallest and most delicately-painted, *St George and the Dragon*, has in some samples a total thickness of paint and ground of only $50-60\ \mu$, compared with a maximum thickness of a paint section from the *Last Judgment* (see *Figure 2.20E and 20F*) of about $800\ \mu$. These last paint sections were too large to reproduce *in toto* at the same magnification as the others. By contrast with the *Last Judgment* (maximum thickness c.$800\ \mu$ of which only a small fraction is gesso ground), the total thickness of ground and paint layers of the *Worship of the Golden Calf*, its pendant in the Madonna dell'Orto, averages only about $200\ \mu$.

THE LAYER STRUCTURE

It will be seen at once from the photomicrographs of paint cross-sections in *Figures 2.19—21* that there exist a multiplicity and complexity of paint layers in most of the pictures examined.

From the authors' experience of investigating a fair number of all sorts of paintings and their cross-sections, it is suggested that there are, in the main, two different types of circumstance which can give rise to a multi-layer structure. The first occurs when the artist desires to produce an effect, whether of colour, texture, light or shade, which cannot be achieved in a single paint layer (the techniques of glazing and scumbling fall into this category). The second circumstance arises when a feature of the design is painted over another one already completed. By this is not meant small-scale final details like the eyebrows on a face or the pattern of a brocade drapery (which must occur

in almost any type of painting) but a process involving larger areas, as for instance the superimposing of a figure on an already-painted landscape. Again, within the limits of our own experience, the first type is common in fourteenth, fifteenth, and some early sixteenth century easel paintings, the second is not. The reason lies in the method of constructing the picture. It has already been mentioned that in fourteenth and fifteenth century panel paintings the design was drawn in some detail, usually in carbon black, on the white gesso ground. Three-dimensional forms were indicated either by hatching or by subsequent washes of undermodelling. The areas were then painted in the appropriate colours, e.g. pink for flesh, blue for the Virgin's robe, green for landscape, rather like a child colouring a painting book. Since the areas were already clearly defined there was little possibility of the colours overlapping one another, except by accident or the occasional *pentimento*. When we come to painters like Titian and Giorgione, who not only freed themselves from the restrictions imposed by iconography so as to produce highly original compositions, but also chose to abandon a detailed underdrawing, this system breaks down. The result can be seen in the numerous *pentimenti* apparent in their paintings and in the X-radiographs of their paintings[24]. Often one area of paint overlaps another and the second circumstance mentioned above arises. A cross-section through the scarlet paint of Ariadne's scarf in Titian's *Bacchus and Ariadne* in the National Gallery, London, has a multilayer structure because the red scarf is painted on top of the flesh paint of Ariadne's shoulder which itself goes over the blue sky and distant landscape in some places.

Both types of multi-layer structure occur in the paintings of Tintoretto so far examined, the first type throughout. Examples of this first type are the ultramarine layer over an azurite/lead white underpaint in the *St George and the Dragon (Figure 2.19A)* and the crimson glaze over an opaque pink layer in the shadow of a pink drapery in the *Transportation of the Body of St Mark (Figure 2.19J)*. An elementary example of the second type of multi-layer structure is seen in *Figure 2.19D* in a cross-section from the *Christ Washing His Disciples' Feet*. The paint layers of a blue drapery go over the dark paint of a stool over which the drapery lies, which itself is painted on top of a tiled floor. In the *Ascension* the system of paint layers of one angel's wing seems to be superimposed on top of that of the wing of an adjacent angel *(Figure 2.21E)*, and in the *Origin of the Milky Way* there is a profusion and confusion of *pentimenti* and overlapping areas of different colour. The white of the bed linen goes over the gold-patterned crimson drapery *(Figure 2.21I)* and Jupiter's cloak over the blue of the sky.

The unusually thick and complex paint layers seen in the cross-sections of the *Last Judgment* appear to be a special case. The thick granular layers containing multi-coloured pigment particles which can be seen in *Figure 2.20E–H* can in some instances be interpreted as the grey-green or brown paint of the landscape background of the picture. On top of this seems to be painted the flesh of the figures (for an example see *Figure 2.20F*). This same cross-section also suggests that not only were the figures superimposed on the already painted landscape background, but that sometimes the drapery was added to the already painted nude figures, as described by Ridolfi. Such a system would build up a considerable total thickness of paint and a large number of layers such as we see in the cross-sections of paint from the *Last Judgment*. Like the use of a dark ground in some of his other pictures, it would speed up the covering with paint of a large canvas. Speed was important to Tintoretto, not merely because of his ever-pressing commissions (Ridolfi alleges that on account of these he often allowed pictures to go on exhibition not completely finished), but because his inspiration seems constantly to outstrip his rate of execution. It will be interesting to see if the technique of any of his other paintings resembles that of the *Last Judgment*. Within our limited experience it is not only unique for its school and period, but absolutely unique. It has often been pointed out that Tintoretto's *Last Judgment* in the Madonna dell'Orto must have been influenced both in composition and treatment of subject matter by Michelangelo's fresco of the *Last Judgment* in the Sistine Chapel. But in both colouring and technique Tintoretto's work is so far removed from Michelangelo's fresco that it might be speculated that Tintoretto was influenced only by the design, which he could have got from engravings of the fresco[25] which were circulating in Venice at the time he was executing his version of the same subject, and that he never visited Rome to see the fresco itself.

Our only general conclusion from examining such a small fraction of Tintoretto's *oeuvre* (albeit a fraction containing some key pictures) is that the pictures reveal a greater originality and versatility of technique than that of any other painter we have so far studied. The technique of Tintoretto is also seen to have some similarities to but many differences from that of either Titian or Veronese, his most eminent contemporaries and rivals.

Acknowledgements

The authors wish to express thanks to: Dr F. Valcanover, Superintendent of Fine Arts, Venice, for giving permission and facilities for the examination of the pictures in Venice, permission to reproduce photographs of them in this paper, and also for his unfailing help and encouragement; the (British) Italian Art and Archives Rescue Fund and Sir Ashley Clarke for supporting the work of both of us in the first part of our investigation and particularly in the work in the church of the Madonna dell'Orto; the Venice Committee of the International Fund for Monuments and Colonel James A. Gray, together with the Samuel H. Kress Foundation and Miss Mary Davis for continuing to support the work in Venice of one of us (J.P.); the photographic departments of the Laboratory of

S. Gregorio in Venice and of the National Gallery in London (photographs of pictures in the latter collection are reproduced here by kind permission of the Trustees of the National Gallery, London); Michael Levey, Director of the National Gallery, London, and Cecil Gould, Keeper, for reading the manuscript and making a number of helpful corrections, suggestions and additions; Miss J. Kirby of the Scientific Department of the National Gallery, London, for invaluable help in experimental work and in preparation of illustrations.

References and notes

[1] Financed by the Art and Archives Rescue Fund of Great Britain.

[2] Financed by the Venice Committee of the International Fund for Monuments, Inc., New York, and the Samuel H. Kress Foundation.

[3] Vasari, G., *Le Vite dei Eccellenti Pittori . . .*, 2nd edn. (1568).

[4] Borghini, R., *Il Riposo della Pittura e della Scultura* (1584).

[5] Ridolfi, C., *La Vita de G. Robusti detto il Tintoretto* (1642).
Ridolfi, C., *Le Meraviglie dell'Arte* (including the *Vita*), (1648).

[6] Boschini, M., *La Carta del Navegar Pitoresco* of 1660 includes biographical details whereas *Le Minere della Pittura Veneziana* (1664) and the subsequent *Ricche Minere* (1674) concentrate on the location and description of Tintoretto's works.

[7] Aretino, P., *Lettere*, Vol. IV, Paris (1608), 181–182: letter dated 'Aprile, Venezia 1548'.

[8] An assessment, from an historical viewpoint, of contemporary and early biographical sources is given by Pallucchini, R., *La Giovinezza del Tintoretto* (1950).

[9] Of a number of fresco paintings recorded as having been painted by Tintoretto, there exist some fragments of large figures removed from the façade of the Ca'Sorenzo in Venice; some small wooden cassone panels are attributed to an early collaboration with Schiavone; as well as drawings on paper, he also produced many cartoons for mosaics in the basilica of S. Marco.

[10] *Cataloghi delle Gallerie dell'Accademia di Venezia, Opere d'Arte Vol. II, Secolo XVI* (1962), compiled by S. Moschini Marconi.

[11] Gould, C., *Catalogue of the Sixteenth Century Venetian School*, National Gallery, London (1959), 83–91.

[12] A sample of the canvas from the *Last Judgment* was sent to the laboratory of the Royal Botanic Gardens, Kew, for a second opinion on the identity of the fibres but, although it was considered that the fibre was likely to be flax, there was still a lingering suspicion as to whether it might be hemp (letter from the Keeper of the Jodrell Laboratory, Royal Botanic Gardens, Kew, to one of the authors). A further opinion was that not even X-ray diffraction patterns would serve to distinguish between flax and hemp, especially when aged and in a degraded state (letter from the Shirley Institute, Didsbury, Manchester, to one of the authors).

[13] Gesso grounds have been identified on each of seven paintings on canvas by Titian so far examined, including early and very late works, and on four by Veronese.

[14] The *Volpato MS.*, transcribed and published by M. Merrifield in *Original Treatises on the Arts of Painting*, Vol.

II (1849), 821. Mrs Merrifield indicates that the manuscript derives from the town of Bassano not far from Venice.

[15] Moschini Marconi, S., 'Rivisione di Due Tintoretto', *Bolletino d'Arte* (1959), 69–81. The author describes how, when an old lining canvas was removed from the picture in 1959, there was revealed on the back of the original canvas a full-size drawing of the design on the front but in reverse and with certain differences with respect to the composition of the finished picture. Unfortunately the drawing had to be covered up during a new relining and it is not clear from existing photographs whether the drawing was executed on the back of the canvas or was originally a drawing on the front, which had in some way come through to the back.

[16] A few small oil sketches on canvas of pictures by Tintoretto exist (for example, one in the Brussels Gallery for the *Transportation of the Body of St Mark*). Some may be preliminary designs, possibly to submit for the approval of a patron, others may be by another hand, after the pictures by Tintoretto himself. Some of these oil sketches are discussed from a technical point of view by Warzée, P., 'Le Miracle de l'Esclave du Tintoret, Une Découverte Importante', *Bull. Inst. R. Patrimoine Art.*, Brussels, 6 (1963), 91–108.

[17] H. Kühn has identified lead-tin yellow in 10 pictures by Tintoretto in the Alte Pinakothek, Munich. See *Stud. Conservation*, 13 (1968), 22.

[18] The 10 pictures examined showed in general the use of a full and varied palette of pigments, with the exception of the *Transportation of the Body of St Mark*. The colour range of this last is very difficult to judge from the picture itself because of the discoloration and diminished transparency of the varnish, but from the paint cross-sections it seems to be painted in a rather restricted colour scheme of pinks, crimson reds and pale grey-greens, with the exception of a blue-green (or blue) cloak of a figure on the right and the fantastic orange hair (or fur cap) of the figure on the floor holding the rope of the camel. We have not so far had the opportunity of examining the companion picture, *The Finding of the Body of St Mark*, in the Brera Gallery, Milan, to see if this also has a similar colour range.

[19] H. Kühn has also identified smalt in five Tintorettos in the Alte Pinakothek, Munich. See *Stud. Conservation*, 14 (1969), 54.

[20] Pullan, B., *Rich and Poor in Renaissance Venice*, Oxford (1971), 96–98. The author notes that in the second half of the sixteenth century the Scuola di San Rocco had a higher proportion of representatives of the textile trades, including many dyers, in its membership than did the Scuola di San Marco. This may indicate a link between Tintoretto's family and the Scuola di San Rocco.

[21] Plesters, J., 'A Preliminary Note on the Incidence of Discoloration of Smalt in Oil Media', *Stud. Conservation*, 14 (1969), 62–74.

[22] Gage, J., 'Magilphs and Mysteries', *Apollo*, July 1964, 38–41. The author describes a brisk trade in selling bogus recipes and nostrums purporting to be the medium of Titian *et al.* to English Royal Academicians in the eighteenth century.

[23] The *Volpato MS.*, *op. cit.*, 738, advises the use of walnut oil for lead white.

[24] For example, the radiographs of Giorgione's *Tempest* in the Accademia Gallery, Venice, and those of Titian's *Noli Me Tangere* in the National Gallery in London, show fundamental changes in the composition made in the course of painting as well as numerous tentative outlines.

[25] Pallucchini, A., 'Considerazioni sui Grandi Teleri del Tintoretto della Madonna dell'Orto', *Arte Veneta*, XXIII (1969), 55, lists the engravings of the Michelangelo *Last Judgment* to which Tintoretto could have had access.

3
Application of the Electron Microprobe to the Study of Some Italian Paintings of the Fourteenth to the Sixteenth Century

SUZY DELBOURGO

INTRODUCTION

Although the last two decades have seen the successful application to the study of paintings of the metallographic technique of embedding cross-sections, we have had to wait until more recent times to see first described[1] and then applied[2] to such samples a point method of elemental analysis, namely the Castaing electron microprobe and its subsequent developments. We have recently published[3] the first results which we have obtained by the application of this method.

We are at present attempting to pursue in the Research Laboratory of the Musées de France a systematic study of the Italian Schools of the fourteenth to the sixteenth century from the Campana Collection, a study carried out in conjunction with the Paintings Department of the Musée du Louvre, and which will enable us to collect data for reference and comparison. In order to obtain as much information as possible, we have extended and expanded the usual microchemical examination by means of the application of the microprobe to samples taken from these pictures.

It must be emphasized that the chemist often has to content himself with studying a single very small sample (of the order of 2 mm) and on this he must make as many observations as possible. If several samples are available — which is rarely the case — other methods can be introduced, such as microchemical analysis, U.V. spectrography, X-ray diffraction, etc. We know that the method of cross-sections gives the stratigraphy of the painting by revealing the superposition of the constituent layers. But when we come to examining the interior of each layer, we rapidly reach the limits of the optical instrument and of micromanipulation. The problems with which we are confronted oblige us to look for a more precise method in order to achieve better separation. It now seems that the electron microprobe may fulfil these requirements in several respects.

In this report, we give a number of examples of the application of this technique to some problems which we have had to solve, and which illustrate the way in which the use of the microprobe supplements, and sometimes confirms, information gained by the usual methods applied. These examples have been chosen from the results of our study of Italian painting, now in progress, and concern either technical examinations or problems of restoration.

A frequent occurrence is that of a sample made up of very thin layers of $5-6\,\mu$ thickness, regularly superposed. Whereas microscopical observation of the section does not satisfactorily reveal the individual layers, scanning with bombardment by electrons allows their appraisal. On the X-ray image obtained with the microprobe, the layers are clearly differentiated. The segregation of the pigment in each of them, which is apparent through the variation of density on the photographic plate, leads one to suppose that the artist worked in very thin successive layers, using a fast-drying medium, and searching by means of this superposition and technique for this or that particular effect. Another case where localization and identification of elements could be achieved and irrefutably confirmed by means of the microprobe is that of the sandwiching of metal leaf (gold or silver) in the middle of the paint layers.

27

Figure 3.1 Umbria, fourteenth century

One also often encounters the superposition of layers which are either identical or only slightly different in colour (some reds and some yellows, for example). It is then difficult not to say impossible, to identify the components separately. This is the problem posed by all materials difficult to isolate for analysis, constantly bearing in mind the single sample at one's disposal, and that the grains of pigment are enveloped in medium and closely juxtaposed.

Similarly, there is the case of materials altered by physico-chemical means. Copper blue (azurite), so frequently found in the Early Italian Schools, is an example. It appears black because of the combined effect of successive layers of brown varnish, and also probably because of sulphuration of the copper by constituents of the egg medium.

Finally, there is the valuable aid which the microprobe can on occasion contribute towards restoration, of which we shall give a specific example.

IDENTIFICATION OF VERY THIN SUPERPOSED LAYERS

1. UMBRIA, BEGINNING OF THE FOURTEENTH CENTURY (VIRGIN ENTHRONED) (FIGURE 3.1)

The sample was taken from the hair of an angel and shows under the microscope the following layer structure:

a. thick gesso (250—300 μ) consisting of a single layer of gesso grosso. The elements shown on the X-ray images were: Al, Ca, Si and S, following in their distribution the coarsely-ground texture we observe in the gesso. Here the calcium sulphate contains considerable impurities of silica and clay;

b. verdaccio applied in a thin layer (30 μ) directly on the gesso. On the X-ray images are clearly seen those elements present in natural green earths (Fe, Si, K, Al, Mg);

c. very thin (6 μ) pinkish-white layer corresponding to the flesh of the angel and consisting of a mixture of lead white and a red lake pigment with alumina substrate;

d. very thin (10 μ) yellow layer corresponding to the hair, consisting of natural ochre (silica and clay). The X-ray pictures show the significant presence of Fe, Si, K, Al, Mg.

The microprobe has enabled us to differentiate between these last two extremely thin layers. We are faced with a structure frequently encountered in the quattrocento of almost linear layers, very sparsely pigmented and drawn out with a very fine brush, according to the technique described by Cennino Cennini.

2. FLORENCE, FOURTEENTH CENTURY (LORENZO DI BICCI: MALE AND FEMALE SAINTS) (FIGURE 3.2)

The red colour of the female saint's mantle appeared from the microscopic section to have been spread in a layer of exceptional thickness (50 μ) for this period and school. The microprobe revealed that, instead of

this single thick layer, there was a system of thin superposed layers which were clearly visible on the X-ray image. We are concerned here with several individual layers in which a segregation of the pigments has been effected and where the presence of phosphorus leads us to conclude that the medium is egg. This would be consistent with the hypothesis open to us that the use of a very siccative medium would permit the painter almost instantaneous superposition of the layers. The red layer so constructed (b) is composed of red lake with an aluminium substrate, covered with a layer of ochre (c).

3. SIENA, FIFTEENTH CENTURY (ANDREA DI BARTOLO: ST PETER) (FIGURE 3.3)

The yellow colour of the robe of St Peter is made up of a succession of very thin layers, yellow-orange and white. Microchemical analysis of a complete sample had revealed the presence of iron and lead, which it was impossible to localize exactly, given the thinness of the layers (10μ approximately). Analysis with the microbeam permitted the separate identification of each layer as follows:

 a. a thick gesso of gypsum (Ca, S);
 b. a red layer of red ochre (Fe);
 c. gold leaf (Au);
 d. white layer of lead white (Fe, Pb);
 e. layer of yellow ochre (Fe);
 f. layer of yellow ochre and lead white (Fe, Pb);
 g. several layers of yellow ochre (Fe).

It could also be seen on the X-ray image of the gold that it was uniformly distributed over the entire width of the paint layers as seen in the section.

Here we have, at the end of the fifteenth century, an example of a more elaborate pictorial layer. The craftsmanship continues to be diligent and careful, and faithful to the recipes, but the series of thin layers, very close to each other in tonality, shows on the part of the painter a very precise study of the colouring materials. This same spirit of research is found in the use of different mediums for each layer, alternately in oil and then in egg.

INTERPOSED LAYERS OF GOLD OR SILVER

SIENA, FIFTEENTH CENTURY (GIOVANNI DI PAOLO: ST CLEMENT) (FIGURE 3.4)

A technique current in the Sienese School is the use of a gilded or silvered patterned ground under a translucent surface coating, most often of a lake. These materials are easily recognizable in a work in good condition, but we are often confronted with a worn paint film where only traces of colour survive.

On the ground of the robe of St Clement, the traces of silvering revealed by microscopical examination under the blue colour were difficult to locate. The X-ray image of the silver appeared as a very discontinuous line, but was indisputably silver (c). This silver leaf is applied on a layer of ochre (b).

There are even more numerous examples of interposed layers of gold. Their detection is easy if several

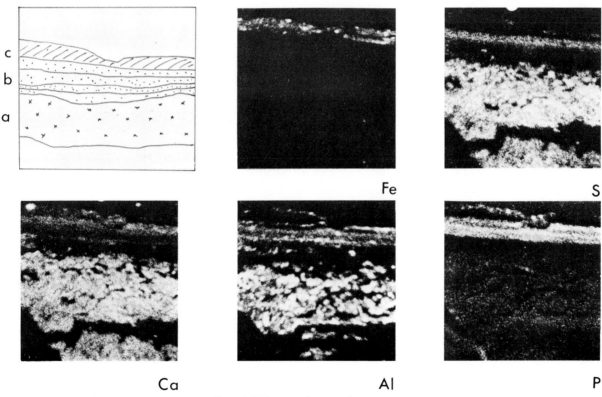

Fe

S

Ca

Al

P

Figure 3.2 Florence, fourteenth century

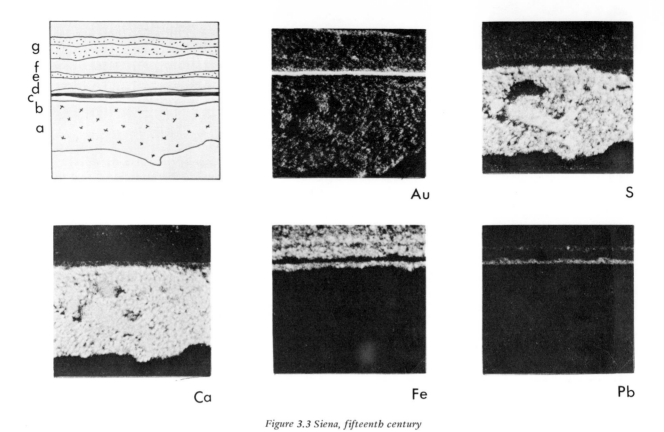

Figure 3.3 Siena, fifteenth century

Figure 3.4 Siena, fifteenth century

microscopical samples are at one's disposal, but it is necessary to resort to the microprobe if there is only a single mounted sample available.

MIXTURES OF SIMILAR COLOURS

NICE, SIXTEENTH CENTURY (BREA: THE CIRCUMCISION) (FIGURE 3.5)

The sample, of about 200 μ thickness, is from the red colour of a hat and did not include the gesso. This colour is composed of three layers of different reds, of which two are a mixture of pigments, which makes analysis for elements impossible by any other means than the microprobe. The latter showed:

a. the thick orange-red layer (80 μ) which forms the lower part of the colour contains the elements As, Pb, Fe and S. We are concerned, in fact, with a mixture of realgar As_2S_2, yellow ochre and lead white (the presence of the latter being confirmed by white granules visible in the paint under the microscope);

b. the intermediate translucent deep red layer (50μ, variable) shows on analysis only the element Al (with the addition of As from layer *a* which has diffused into the section). In all probability, therefore, this is a lake with alumina substrate;

c. the light red layer on the surface contains Hg, S, Al, Fe, and is composed of a mixture of vermilion and red ochre.

The superpositions of thick layers which we have observed here correspond to a visual approach in depth to colour sensation. The visual impressions of the artist are transcribed into the structure of the painting material. The artist of the Renaissance is already a long way from the workshop recipes of the monk Theophilus or of Cennino Cennini, which were so scrupulously put into practice by his predecessors.

DIFFICULT ELEMENTAL ANALYSIS

VITERBO, FIFTEENTH CENTURY (FRANCESCO D'ANTONIO: ST PETER) (FIGURE 3.6)

The yellow colour of the robe of St Peter is difficult to analyse for elements by microchemical methods. We are dealing, in fact, with lead-tin yellow (rapidly revealed by the microprobe) which is spread in a thick layer (b) of 50 μ on gesso (a) of considerable (350 μ) thickness.

Lead-tin yellow has often been found in pictures of the fifteenth to seventeenth century by means of emission spectrography (cf. Hermann Kühn) in a very interesting manner. However, the method involves the destruction of part of the sample. Here, the precise and regular layer of colour, applied directly on a carefully prepared gesso, bears witness to a simple, almost one-dimensional, conception of colouring material. The touch is anonymous and absolutely functional.

Figure 3.5 Nice, sixteenth century

ALTERED MATERIALS

1. FLORENCE, FOURTEENTH CENTURY (MARRIAGE OF ST CATHERINE) (FIGURE 3.7)

Practically all the blue colours of the early paintings we have studied have changed, whether by transformation of their components (which are essentially azurite), or by the addition in the nineteenth century of a dark brown varnish which has penetrated spaces between the pigment particles and masked the original colour remaining. Hence the blue of the Virgin's mantle, which in the section appears as a mass of brown resin containing blue particles, has, thanks to the microprobe, been 'rediscovered' with respect to its original stratigraphy.

a. thick layer of gesso (200 μ) showing Ca, S, Al, Si (calcium sulphate with the addition of clayey impurities);
b. thin layer (10 μ) of lead white (Pb);
c. thin layer (10 μ) of lead white with particles of carbon black (Pb, C);
d. layer of lapis lazuli (60 μ); Al, Na, Ca, Fe, S and Si present;
e. layer of copper blue (30 μ) composed of large crystals of azurite.

It is interesting to note the thin layer of grey priming which often occurs beneath blue colours, in a technique already aware of the play of colour on a dark ground.

2. ROME, END OF THE FIFTEENTH CENTURY (ANTONIAZZO ROMANO: MADONNA) (FIGURE 3.8)

The background of the picture appears to the naked eye completely black and opaque, and poses a problem for the restorer. In the microscopical section, the black background is seen to be composed of some blue particles 'swamped' by a brown medium. The X-ray images obtained with the microprobe show a considerable layer of copper blue thickly applied (approximately 100 μ). A microchemical test confirms the presence of azurite. This type of alteration of azurite, frequently encountered, provokes at the same time a browning of the pigment and of the medium which forms with the diffused copper sulphurated compounds. Furthermore, in the present case, brown varnishes coloured with iron and added at a later date have filled up gaps in the paint structure. The microprobe study has thus enabled us to rediscover the original colour of the background, providing interesting information for the history of technique, although the cleaning of the picture is made all the more difficult by the fundamental alteration of the constituents of the paint.

ASSISTANCE TO RESTORATION

FLORENCE, FOURTEENTH CENTURY (CRUCIFIXION)

The thinness of the paint layers in this work of the fourteenth century is such that the usual microchemical methods are ineffectual for determining the

Figure 3.6 Viterbo, fifteenth century

32

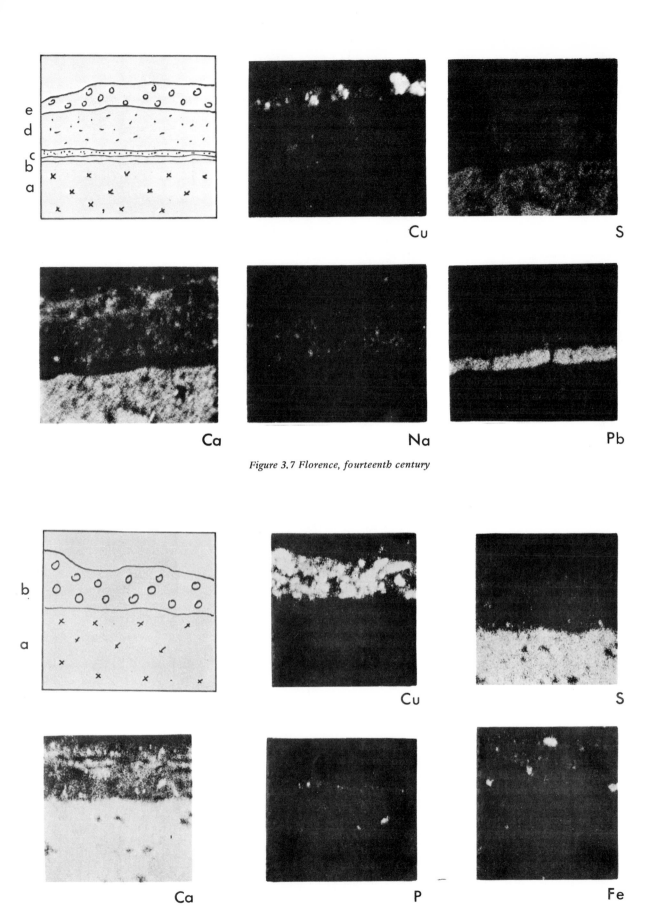

Cu

S

Ca

Na

Pb

Figure 3.7 Florence, fourteenth century

Cu

S

Ca

P

Fe

Figure 3.8 Rome, fifteenth century

Figure 3.9 Florence, fourteenth century (sound area)

Figure 3.10 Florence, fourteenth century (restored area)

constituent elements. However, it was necessary to know them, for entire areas of the picture — the arms, for example — had been completely and very competently repainted in the nineteenth century. Comparison of the X-ray images obtained on each of these areas permitted their identification.

On a well-preserved area — flesh of the forehead — the stratigraphy seemed to be normal (*Figure 3.9*):

a. thick gesso (100 μ approximately);
b. verdaccio, 20 μ thick, in which the elements present in natural green earths (Fe, K, Mg, Si) were shown, in addition to lead white;
c. pale pink layer of the flesh, very thin (6 μ), composed of ochre and carbon black.

On a restored area — the right arm — the results obtained were very different (*Figure 3.10*). The white ground did not have the composition of traditional gesso and the layer of 'verdaccio' revealed the significant presence of Al, without other elements, which suggests the presence of an organic green lake on alumina, vastly different from the verdaccio of the primitives.

CONCLUSIONS

In the field of application of scientific methods to the study of works of art and more particularly to that of the paint layer, we find ourselves, as distinct

34

from other realms of science, in a phase where the accumulation of data must be the primary task and aim of the physical chemist. It is with this in mind that we consider it would be interesting to collect as much information as possible about the Italian painters of the fourteenth to sixteenth century. It is as a result of comparison of a large number of results, by the rational application of the most appropriate methods of study, that we have the chance of obtaining the most complete information.

On samples of less importance than those at our disposal, which were rare or even unique, it would not be feasible to apply, solely and without discrimination, this most sensitive and most recent method. But, on the other hand, knowing what confirmatory evidence it can give to the art historian and the restorer, it would be extremely interesting to take advantage of the ultimate perfection of analysis which the microprobe constitutes.

In our present attempts to study one school, although it may seem premature to draw any conclusions of a general character it seems to us that there can be extracted some remarks pertinent to the history of art. Indeed, in penetrating the paint layers and entering into the secrets of their nature and of their superposition, a link, tentative as yet, tends to become established between the aesthetic of the work of art and its material composition.

When more data becomes available, it will be established that the physico-chemical structure of a primitive painting in the Byzantine two-dimensional tradition is made up of thin regular layers, applied with the discipline of an exact and well-learnt craft by an artist who is still only an artisan. Later, with the linear perspective of the fourteenth century, for this idea of clarity and logic is substituted the sense of arabesques and shapes. The translation of reality requires a new rendering of the material. The pictorial technique remains laboured and faithful to recipes; but, in order the better to suggest the new space in three dimensions, the painter begins to explore other processes: the use of layers in oil and in egg, of opaque and translucent materials, applied alternately and as evenly as possible.

Step by step, with the approach of the Renaissance, art becomes dependent on thought and obliges the artist to take account of his own personality and to question his mission. The painter then ceases to be an executant in order that he may formulate his own precepts. He seeks, by means of superpositions of colours, a more profound vision which will give his painting a new dimension. He paints in freer layers, using impasto and fluid paint in turn, with more elaborate colours, profiting by the resources of the paint itself and so transcribing more freely his own emotion. And it is the tell-tale microprobe, among other methods of investigation, which arrives several centuries later to bring to light the intimate bonds between form and technology, between perception and creative activity. It seems evident that the aesthetic of the work of art, and with it all our sensuous and visual impressions, will henceforth find their concrete equivalent deep within the paint.

Acknowledgement

The analyses with the microprobe were done at the Bureau des Recherches Géologiques et Minières (B.R.G.M.) with the financial support of the Centre National de la Recherche Scientifique (C.N.R.S.).

References

[1] Young, W. J., 'Application of the Electron Microbeam Probe and Micro X-Rays in Non-Destructive Analysis', *Recent Advances in Conservation,* Butterworths, London (1963), 33—38.

[2] Elzinga-ter Haar, G., 'On the Use of the Electron Microprobe in Analysis of Paint Samples', *Stud. Conservation,* **16** (1971), 41—55.

[3] Delbourgo, S., 'Note Technique sur l'Utilisation de la Microsonde Electronique dans l'Etude des Eléments Constitutifs de la Couche Picturale', *Annales du Laboratoire de Recherche des Musees de France* (1971), 34—44.

4
The Technique of a Group of Norwegian Gothic Oil Paintings

LEIF EINAR PLAHTER AND UNN PLAHTER

INTRODUCTION

About 30 Norwegian mediaeval panel paintings have come down to us. Almost all of these paintings are altar frontals, that is, they used to cover the front of the altars in the churches. Today most of these paintings belong to the Universitetets Oldsaksamling, Oslo, and the Historisk Museum, Bergen.

None of the frontals is signed or dated, and written sources concerning their origin are not known. The paintings are dated, on stylistic criteria, to the period 1250—1350. Both in style and motif, the frontals reflect the international Gothic style. Some of them are closely related to English manuscript illumination; however, no doubt as to the Norwegian origin of the frontals seems ever to have been put forward[1].

PREVIOUS EXAMINATIONS

Until now, only two fairly thorough technical examinations of Norwegian Gothic panel paintings have been published. In 1962, Kaland and Michelsen published the results of the examination and restoration of the painting from the church of Fet (*Figure 4.1*), dated 1260—80[2]. The support was found to be of pine wood, the ground consisted of chalk and glue. The gilding was done with silver leaf covered with a yellow glaze (imitation gold). The pigments were reported to be azurite, malachite, massicot or litharge, yellow and red lake, a brown iron oxide, lead white and a black carbon pigment. The binding medium of the paint layers was found to be based on a drying oil.

In 1969, Kaland published the results of the examination and restoration of the frontal from the church of Tresfjord (*Figure 4.2*), dated to the first half of the fourteenth century[3]. The support was pine; the ground, chalk and glue. The 'gilding' consisted of silver leaf glazed with yellow. The pigments were reported to be azurite, verdigris, orpiment, yellow iron oxide, yellow lake, vermilion, red lead, red lake, red iron oxide, lead white and black. The binding medium of the paint layers was based on a drying oil.

TECHNICAL EXAMINATION OF THREE FRONTALS FROM THE CHURCH OF TINGELSTAD

Below we present some of the results of an examination of three altar frontals, dated 1260—1300, from the twelfth century church of Tingelstad[4]. The frontals now belong to the Universitetets Oldsaksamling, Oslo. This presentation is a summary of a book on the subject[5].

DESCRIPTION OF THE PAINTINGS

'TINGELSTAD I' (COLOUR PLATE 4.1)

Madonna and Child and Scenes from the Life of Mary
Dimensions: 98·5 x 160 cm

The surface is divided vertically into three main sections. The middle section is occupied by the

Plate 4.1 Altar frontal from the church of Tingelstad (Tingelstad I), 1260–1300, Universitetets Oldsaksamling, Oslo

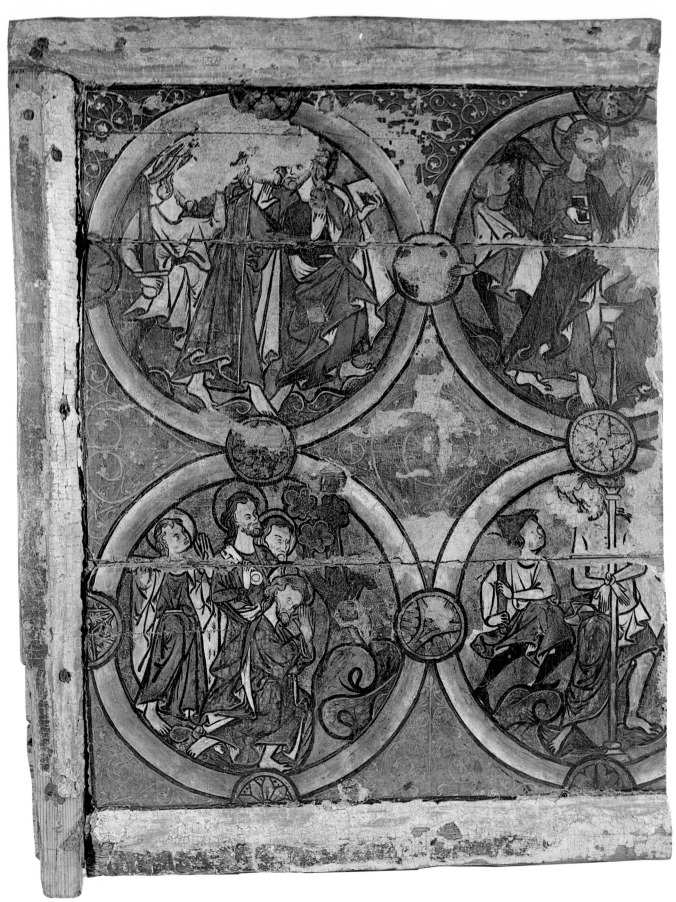

Plate 4.2 Altar frontal from the church of Tingelstad (Tingelstad II), 1260–1300, Universitetets Oldsaksamling, Oslo

enthroned Virgin and Child. The sections on each side are subdivided into four smaller compartments arranged in two tiers – here, the following scenes from the life of Mary are portrayed: the Annunciation, the Visitation, the Annunciation to the Shepherds, the Adoration of the Magi, the Presentation in the Temple. Each of the four last-mentioned scenes is divided into two compartments. The division of the surface is in the form of arcades, i.e., each scene is framed by columns spanned by arches.

'TINGELSTAD II' (COLOUR PLATE 4.2)

The Passion of Christ
Dimensions: 98·8 x 75·5 cm

The panel is a fragment, cut off on the right hand side. The preserved part is divided into four circular medallions in two tiers depicting stories from the Passion of Christ. The chronology of the scenes seems to be arranged in circular order, from the Agony in the Garden bottom left, the Capture top left, the Trial top right, to the Flagellation bottom right.

'TINGELSTAD III' (FIGURE 4.3)

The Legend of St Egidius
Dimensions: 99·5 x 75 cm

The panel is a fragment, cut off on the left hand side. The preserved part has remains of four compartments in two tiers depicting scenes from the life of the saint. Each compartment, which is framed by undulating bands, is basically circular, with four pointed tongues protruding in the diagonal directions.

Figure 4.1 Fragment from the church of Fet, 1260–1280, Historisk Museum, Bergen

Figure 4.2 Altar frontal from the church of Tresfjord, first half of the fourteenth century

37

Figure 4.3 *Altar frontal from the church of Tingelstad (Tingelstad III), 1260–1300, Universitetets Oldsaksamling, Oslo*

MATERIALS AND TECHNIQUE

The *panels* are made up of three or four horizontal planks of pine wood. The wood in Tingelstad I and II is of poor quality, containing big knots and other irregularities, and the carpentry work is roughly and carelessly executed. The quality of the wood in Tingelstad III is better, and the carpentry work shows a higher standard of craftsmanship. All three panels have fixed *frames*. The frames lie on the surface of the panels with the edges flush with the edges of the panels, i.e., the panels and the frames have the same external dimensions.

The panels are held together by the fixed frames; in Tingelstad I and II also by cross bars on the back. In Tingelstad III the planks have been glued together edge to edge; the joints are also strengthened with vertical wooden dowels. The planks of Tingelstad I and II have never been glued together; the planks were attached to the cross bars and the frame in such a way as to leave the joints slightly open (3–4 mm). To prevent the planks from dislocation, they were secured in place with vertical wooden dowels drilled into the edges of the planks. The open joints have been plugged from the front by wooden wedges. Most of the joints in the panels, the corners of the frames, and weaknesses, cracks, etc., in the wood have been strengthened with strips of *canvas*.

The *ground* is composed of chalk in an aqueous medium. The thickness varies considerably on each panel, estimated at between 1–5 mm. The main lines in the architecture and the figures, as well as all boundaries between painted and gilded areas, are *incised* into the ground (*Figure 4.4*). No underdrawing on the ground has been found.

Excepting Tingelstad II, fine *ornamental motifs* have been incised into the gilded backgrounds. In the central scene of Tingelstad I there is a foliate motif set against a cross-hatched background (*Figure 4.5*). The minor scenes have double diagonal straight lines constituting a square-shaped pattern. In Tingelstad III it has not been possible to identify the motifs completely.

The surfaces of the grounds seem to have been impregnated with tempera (egg white?). The layer of tempera probably served as an *insulation layer* making the ground non-absorbent, as well as *mordant* for the silver leaf in the gilded areas. The *gilding* is done with silver leaf glazed with a yellowish transparent layer (imitation gold). Before the actual painting began, those areas of the ground which had not been gilded seem to have been coated with a layer of unpigmented oil.

Table 4.1 shows the pigments which have been identified in the three paintings[6].

Those pigments which have been derived from natural minerals (lapis lazuli, azurite, orpiment, cinnabar, haematite) must almost certainly be imported, as these minerals occur very rarely or not at all in Norway. The chalk of the grounds has been examined as to its content of coccoliths (minute sea organisms)[7], and the frequencies of some species of coccoliths indicate that the chalk has originated from countries outside Scandinavia.

Natural ultramarine blue, which has been used in

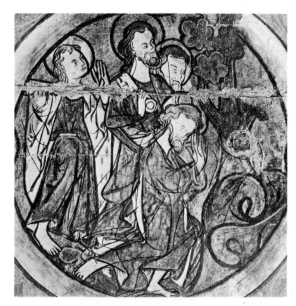

Figure 4.4 Tingelstad II, *detail of the Agony. The black lines indicate the incised lines of composition. Observe the deviations between the incised and painted lines*

the blue garments in Tingelstad III, appears to have been used to a rather limited extent in Norwegian mediaeval works of art. The draperies painted with this pigment are quite pale in colour — the tint is more grey than blue. The cross-sections show the blue layer to contain numerous colourless crystalline impurities, which might indicate that the mineral has simply been crushed and used as pigment without being purified. Another reason might be that the blue paint layer is made up of so-called ultramarine ash, i.e. the poor (and cheap) quality which was obtained when the blue ultramarine particles were separated from the colourless elements of the mineral[8].

The *binding media* in the comparatively minor areas of azurite and ultramarine blue and orpiment yellow seem to be on a base of egg tempera containing some oil. The media of all other colours are based on a (vegetable) drying oil containing some egg protein (see 'Analyses of the binding media' below).

The pictures have been painted according to a comparatively simple scheme. Most of the essential areas have been built up in two main layers, although a few one-layer and three-layer structures are found. To a very great extent the underpaint consists of a very thin (10 μ) layer of lead white (60 μ in Tingelstad III). The lead white underpaint constitutes a powerful reflecting layer, the purpose of which would be to increase the colour intensity of the final paint layers. It should be noted that the painters of these frontals knew how to take full advantage of the transparency of the oil colours: to a great extent they worked with glazes on white or very light underpaints. For instance, the biggest and most conspicuous areas in Tingelstad I (the Virgin's tunic and mantle in the central scene) are underpainted with lead white and glazed with verdigris and red lake respectively, a technique which brings out the maximum tinting strength of the green and red pigments. The transparency of these colours is demonstrated by a peculiar detail in the technique: the black lines which indicate the folds of the draperies, the main formations of the landscapes, etc., were painted directly on the white underpaint, whereupon the whole areas were glazed with verdigris or red lake, the black lines being clearly visible through the glazes.

Table 4.1

	Tingelstad		
	I	II	III
Azurite	x	x	x
Ultramarine			x
Verdigris(?)	x	x	x
Orpiment	x	x	x
Yellow organic colouring material	x	x	x
Red lead	x	x	x
Vermilion	x	x	x
Red iron oxide		x	x
Red organic colouring material	x	x	x
Lead white	x	x	x
Chalk	x	x	x
Carbon black	x	x	x

Figure 4.5 Tingelstad I, *the central scene. Calque of the incised foliate pattern of the background*

The garments and the landscapes are painted in a single layer with unmixed pigments on top of the white underpaint. There is no modelling in light and shade; the folds of drapery as well as the landscape formations are marked only with the powerful black linear design. These lines do not follow the incisions accurately; in Tingelstad I and II they have been drawn rather freely and deviate in places quite considerably from the incised lines (*Figure 4.4*). The flesh colour is mainly greyish-white. In some of the faces a slight modelling of the eye sockets, chin, etc., can be observed, painted wet on wet with darker grey.

The use of chalk as a constituent in the paint layers is worthy of notice. In European paintings, chalk seems primarily to have been used as the main constituent in the grounds with animal glue as binding medium. The chalk/glue combination produces a whitish mass with considerable hiding power, while, mixed with oil, the chalk becomes yellowish and translucent. In Tingelstad I a transparent blueish paint has been used which is a mixture of chalk and minor quantities of azurite, carbon black and lead white.

PAINTING METHODS AND MATERIALS

The high chalk content makes this paint so transparent that it could be used in the same way as the green and red colours mentioned above, i.e. as a final glaze on top of the black linear design. Chalk has been identified as a constituent in different colours in all three paintings; possibly there are smaller or greater amounts of chalk in all paint layers. One reason for the admixture of chalk in the paint could be to give 'body' to the slow drying oil colours and to counteract the tendency of the paint to flow during drying.

DEFORMATIONS IN THE PAINT LAYERS

It falls beyond the scope of this article to give a description of the state of conservation of the three frontals or an account of the actual restoration work; these subjects are dealt with in the main publication[5]. Here we will only draw attention to one phenomenon which is frequently found in Norwegian mediaeval paintings and polychrome sculptures: the tendency of the paint to form so-called premature cracks. Premature cracks are found most frequently in the painted parts bordering on the gilded areas (*Figure 4.6*), i.e. in areas where the yellow glaze of the gilding underlies the surface paint. In these areas the paint has cracked, and each 'island' of paint has shrunk considerably, increased in thickness and wrinkled (*Figures 4.7, 4.8* and *4.9*). These deformations are characteristic of oil paint which has been applied on an insufficiently matured oily substratum.

Figure 4.7 Tingelstad I, *detail of the Annunciation to the Shepherds, Gabriel's face. Macro, raking light. The area in the rectangle is shown enlarged in* Figure 4.8

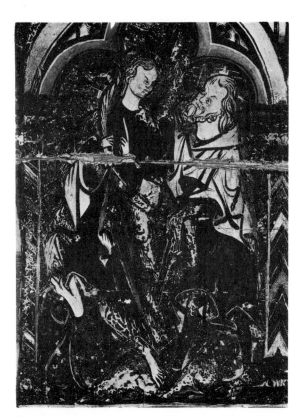

Figure 4.6 Tingelstad I, *detail of the Annunciation of the Shepherds. Premature paint deformations in areas bordering on the gilded background*

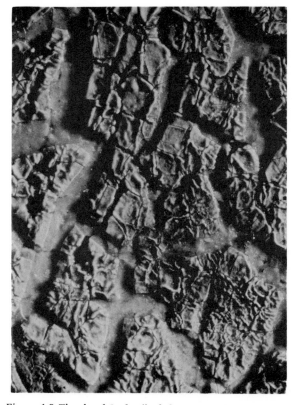

Figure 4.8 Tingelstad I, *detail of the area marked in* Figure 4.7. *Macro, raking light. Premature paint deformations*

40

ANALYSES OF THE BINDING MEDIA

The binding media have been examined by means of solubility tests, gas chromatography, infrared spectrophotometry and thin layer chromatography.

The solubility tests were carried out on samples of all colours from all three paintings, showing solubility properties resembling those of oil which in some cases could be mixed with egg tempera. Gas chromatography was carried out on samples from Tingelstad I only. The high content of azelate indicated that the oil is a vegetable drying oil (*Figure 4.10*). Infrared spectrophotometry was carried out on samples from all three paintings and indicated the presence of a protein apart from the oil content. Thin layer chromatography was carried out on samples from Tingelstad I and II. These gave an amino acid pattern which strongly resembled that of egg protein.

Examination of the surfaces of the paintings show that glazes have been used extensively, and that the modelling has been done wet on wet with visible brush strokes — all characteristics of oil technique. The premature deformations in Tingelstad I and II with cracked, shrunken and wrinkled paint also indicate that a slow drying oil was the main constituent of the binding media in the main parts of these paintings.

No analyses determining the proportion of oil and egg have been made. The above mentioned analyses, however, as well as surface examination of the different colours, have led to the conclusion that two main types of media were used:

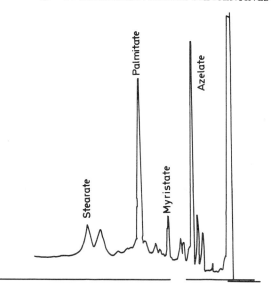

Figure 4.10 Gas chromatogram of the methylated fatty acids of the medium in Tingelstad I

1. The comparatively minor areas of azurite and ultramarine blue, as well as the orpiment yellow areas, seem to have a medium on a base of egg tempera containing some oil.
2. All other colours have a medium based on a vegetable drying oil containing some egg tempera.

CONCLUDING REMARKS

The Norwegian frontals represent the only sizeable number of Gothic easel paintings in existence in northern Europe. As regards materials and technique, it would seem improbable that the frontals belong to a circumscribed native tradition. Most likely the frontals reflect, not only stylistically but also technically, a school of painting that must have flourished in the countries bordering on the North Sea, a school of paintings of which the Norwegian frontals are almost the only surviving examples. The study of the materials and technique of this group of paintings may thus contribute to the knowledge of a chapter in the history of European painting technique, that is, oil painting from a period prior to that of the van Eycks, which until now has been rather obscure.

References and Notes

[1] Recently it has been proved that the frontals from the church of Årdal (*Årdal II*, Historisk Museum, Bergen) and from the church of Tresfjord must have been painted in Norway. During restoration work on the paintings, the conservator Bjorn Kaland discovered strips of parchment over the joints of the panels. The parchment was fragments of manuscripts with Norwegian texts, datable to 1280–1300. See Holm-Olsen, L., 'Pergamentfragmenter i Antemensaler fra Bergen', *Bergens Historiske Forenings Skrifter*, **69/70** (1970), 27–44.

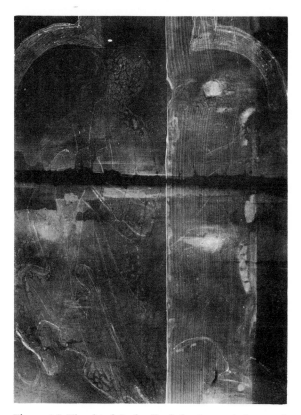

Figure 4.9 Tingelstad I, *detail of the Annunciation to the Shepherds. X-ray photograph*

[2] Kaland, B. and Michelsen, K., 'A Mediaeval Panel Painting at the University of Bergen. Preliminary Report', *Bull. Inst. R. Patrimoine Art.,* **V** (1962), 195–205.

[3] Kaland, B., 'Das Antependium von Tresfjord', *Maltechnik,* **75** (1969), 6–17.

[4] The study of the materials and technique, as well as the actual work of conserving the paintings from Tingelstad, have been carried out in part at the Institut Royal du Patrimoine Artistique, Brussels, during stays at the institute made by Norwegian chemists and restorers in 1961, 1963 and 1965–66.

[5] Plahter, L. E., Skaug, E. and Plahter, U., *Gothic Painted Altar Frontals from the Church of Tingelstad – Materials, Technique, Restoration,* Universitetsforlaget, Oslo (1974).

[6] The techniques used for the examination of the pigments included cross-sections, microscopic and microchemical analyses. In some cases, X-ray diffraction powder patterns were also used.

[7] The analyses of the chalk grounds were carried out by Dr Katharina Perch-Nielsen, Universitetets Institutet for Historisk Geologi og Palaeontologi, Copenhagen. See also Perch-Nielsen, K., 'Fossil Coccoliths as Indicators of the Origin of Late Cretaceous Chalk Used in Mediaeval Norwegian Art', *Universitetets Oldsaksamlings Årbok, 1970–71* (1973), 161–169

[8] Plesters, J., 'Ultramarine Blue, Natural and Artificial', *Stud. Conservation,* **11** (1966), 63–64.

5
Development of Oil Paint and the Use of Metal Plates as a Support

J. A. van de GRAAF

The fact that copper and other metal plates were rather frequently used as a support for oil paintings from the middle of the sixteenth until the middle of the seventeenth century is generally known. As far as I know, however, an explanation for this use has never been given and it has remained a mysterious phenomenon.

Firstly we may state that the use of copper, as a support for oil paintings, emerges in the middle of the sixteenth century.

Vasari mentions in the *Life* of Sebastiano del Piombo (1485−1547) that the latter was painting on silver, copper, lead and other metals[2], but it is Carel van Mander (1548−1606) who gives in his *Schilder-boeck* (1604) more details about the matter. Van Mander mentions in the *Life* of Bartholomeus Spranger (1546−1625) that that painter executed at Rome a *Last Judgment* on copper[3]. This is now in the collection of the Regia Pinacoteca at Turin and is dated about 1570[4]. In the *Life* of Pieter Vlerick (1539−81), van Mander states that there was a painter named Michel Gioncquoy who came from Rome and had painted many pictures on copper[5]. In his *Life* of Hans Rottenhammer (1564−1623) van Mander observes that when the latter came to Rome he started painting on copper 'as is the working method of the Netherlandish painters'[6].

From these sources, we know that the method of painting on copper and other metal plates was in use in the second half of the sixteenth century, which is confirmed by the surviving pictures from that time. On the other hand, this information does not allow us to determine where the use originated, whether

perhaps at Rome (the early use at Rome mentioned by Vasari in the *Life* of Sebastiano del Piombo) or in the Netherlands (the statement of van Mander in the *Life* of Rottenhammer that it was a Dutch working method). Perhaps the surviving works give us a clue to the solution because they indicate that metal supports were mostly used in the North, especially by Netherlandish and German painters[7].

Similarly we do not learn anything from the literary sources which would give an explanation for the use of metal as a support in the first place, why it was used instead of wood and canvas, and why in the course of the seventeenth century it practically disappeared as a support. Certainly these are important questions and worth further inquiries. Then we must investigate the history of art techniques, which might give an explanation of these questions (see *Table 5.1*).

OIL PAINT ON METAL LEAF

In this connection we have to go back to the eighth century. In the so-called *Lucca Manuscript*, dating from the eighth century[8], there is mentioned a method of colouring tin leaf with an oil varnish mixed with saffron and orpiment to get an imitation of gold leaf. The same recipe is found, for example, in the eleventh century manuscript of Theophilus[9], Book I, Chapter 26, and in the thirteenth century manuscript of Eraclius[10], Book III, Chapter 13. In the seventeenth century, the same recipe is mentioned by De Mayerne[11], f.67r. and very extensively on f.73v. and 74r[12], from which it seems clear that this method

43

Table 5.1. THE DEVELOPMENT OF OIL PAINTING ON METAL PLATES

Date	Easel Painting	Miniatures	Glass-painting	Enamelling	Picture Construction
				Email cloisonné	Since 800, oil paint over tin leaf for imitation of gold leaf.
				Email champlevé	Since 1100, with pigments for decorative work.
1300	Wood with glue distemper (or egg tempera) with protective coat of varnish		Coloured glass with grisaille	Email translucide	
	Mixed technique (underpaint in glue distemper or egg tempera with glazes in oil paint)		With transparent colours in varnish medium		
		Minute details	Stained glass		
1400	Pure oil paint on a white priming (Van Eyck) in glazing technique on wood panel				
	Canvas as a support for easel painting in oil paint (Venice)			Painted enamels on copper	
1500	Opaque and transparent oil painting				
1550	Copper as a support for oil paint				

still had its value in the seventeenth century, while De Mayerne himself also experimented with this coloured varnish on metal leaf.

It seems clear that the following description given by Theophilus was developed from the above-mentioned 'coloured varnish' for gold leaf imitation:

'*Transparent painting*
there is also done on wood a type of painting called "transparent", called by some "glorious painting", which is done in this way: Take some tin leaf, neither varnished nor coloured with saffron [as had been done in the previous recipes for the imitation of gold leaf] but plain and carefully polished, and with it cover the place you wish to paint thus. Then very carefully grind the pigments, which are to be applied with linseed oil, and when they are very finely ground draw them on with a brush, then let them dry.'[13]

Cennino Cennini, at the beginning of the fifteenth century, describes the same technique in Chapters 97 and 98. It is De Mayerne[14] in the seventeenth century who points out that this same technique was used by Hans Holbein the Younger (1497–1541):

'A nice rendering of crimson-red satin, which I have seen on old paintings of Henry VIII, his son Edward and his daughter Mary, kings of England. A layer of silver leaf, well smoothed and very even, as if burnished, glazed with a very nice madder lake, and on this, when it has dried, the folds have been made with madder lake and darkened with the same and a little black. I think the same could be done with transparent verdigris on silver or gold. It is a very beautiful work [later addition of De Mayerne] by Hans Holbein.'[15]

Some works in the technique described are known; for example, the Coronation Chair in Westminster Abbey in London is painted in this way.[16] This chair was ordered in 1299 by Edward I and is painted in a transparent red paint on tin leaf. The painting described by De Mayerne is most likely the painting by Hans Holbein the Younger at Hampton Court near London (No. 510), representing Henry VIII, his wife, his son Edward and his daughters Mary and Elizabeth. Although the painting was very dirty when I saw it, the technique described is seen in the dresses of Henry and his wife and daughters.

What was the intention of painters working in this way? It seems quite clear. From the *Lucca Manuscript* up to De Mayerne, it is always prescribed that the work should be carried out with oil or varnish and only transparent pigments are mentioned, such as saffron, crimson madder and the transparent green verdigris. Using such colours in an oil medium, the paint remains transparent and permits the light to go through the paint layer and be reflected by the metal leaf back again through the paint layer, by which means the light is very intensely 'coloured' and becomes a most brilliant hue, very much suited to the imitation of gold, satin and silk, materials which are glossy in themselves, and which are specified in the recipes.

Though the method described above of oil paint on metal leaf seems at first sight to have been the precursor of painting on copper plates, there are many reasons to reject this supposition, in the first place because the former invention was clearly intended to give a 'metallic' appearance to the colours. We have therefore to consider some other techniques besides transparent painting on metal leaf (see *Figures 5.1* and *5.2*).

GLASS PAINTING

It is quite remarkable that the authors of the different handbooks on glass painting and stained glass, even when they write about purely technical matters, only mention the use of coloured glass, painting with grisaille, and painting with enamels for the flourishing period of monumental glass painting. It is inexplicable that authors who give clear evidence of their knowledge of old treatises[17] do not mention that, in the fourteenth century, oil paint was already being used on monumental glass paintings.

Antonio da Pisa, as early as the end of the fourteenth century, gives a full description of glass painting with oil paint:

'I will describe to you how to paint and how to make certain colours with which you can paint on glass without staining [i.e. colouring with metal oxides and re-firing] it again; this is the best method. If you want to paint on glass with verdigris and other colours, then grind the verdigris or other colours with varnish on a stone and, when it is ground very finely, then paint whatever you wish upon the glass and let it dry in the sun, and it will be like stained glass. Or else grind the colour with boiled linseed oil and grind with each of them whatever you wish.'[18]

In what way and for what purposes oil paint on glass was used, before and during the lifetime of Jan van Eyck, is clearly explained in a recipe by Cennino Cennini, never quoted in connection with the evolution of oil paint technique:

' . . . when you wish to make small figures or coats of arms or devices, so small that it will be impossible to cut them in glass: After you have done the shadows with the aforesaid colour [Schwarzlot] you can colour some of the hangings and do the outlines with colours with oil. And these colours do not have to be stained [i.e. re-fired] and you cannot do so, because nothing would remain. Just let the colours dry in the sun.'[19]

The explanation for this application of oil paint on glass is given by the fact that enamel painting on glass

starts in Venice round about the middle of the fif-
teenth century, that is, not until about 100 years later.

It would be very difficult to discover any trace of
oil paint on surviving windows of that time, because
the oil paint must very soon have weathered. Unfor-
tunately I could not even find any literary source to
confirm the hypothesis mentioned above — that
Van Eyck had worked as a glass painter before he
began his easel paintings in oil paint — apart from the
following passage in the *Life of Hugo van der Goes*
by Carel van Mander, which seems to point in this
direction:

> 'In the same church [Saint Jacobskerk at Ghent]
> there was a window-glass representing a very
> beautiful Descent from the Cross, but I am in
> doubt whether the painting was done by him
> [Hugo van der Goes] or by his master Johannes
> [van Eyck].'[20]

Notwithstanding the lack of extant originals and
literary sources, we believe on the grounds of purely
technical data that Jan van Eyck must at least have
been familiar with the technique of oil painting on
glass which existed in his time, or he himself must
have worked as a glass painter before he started to
apply oil paint to easel paintings in the particular
way he has, that is, in very thin, transparent layers.

In the first place there is the 'mysterious' bright
green colour, used by Van Eyck and other Flemish
Primitives, the so-called copper resinate. Laurie[21]
was the first person to reconstruct this colour by a
solution of verdigris (copper salt) in Venice turpen-
tine. This green colour is fully transparent and gives a
green-stained, pellicular paint. It can be applied merely
by dilution with oil of turpentine, without any other
addition, which makes it very suitable for glass
painting. It is a remarkable fact that this colour, in
general use by fifteenth century easel-painters, was,
until recently, mentioned only once in any literary
source on easel painting.[22] A second reference has
just been discovered by Joyce Plesters in the *Secreti*
of G. B. Birelli (Florence, 1601)[23], which pre-dates
by some decades the recipe of Bouffault in the seven-
teenth century manuscript of De Mayerne, already
known to us[24]. Neither the recipe of Bouffault nor
that of Birelli, however, mentions this colour for
easel painting. The Bouffault recipe mentions it
especially for colouring gold or silver leaf.

The solution to this problem may be found in
another manuscript of De Mayerne[25]. On folio 85r.vv
are given a number of recipes for painting on glass.
Under these we find the following description:

> 'Green [is made] with distilled verdigris, as
> people call it in Germany (see above with
> respect to grinding). Make a wooden box with a
> rim and put into it a glass, which does not
> touch the bottom. Put into it the green with
> sufficient Venice turpentine to stir it to the
> consistency of a paste. Put it over a stove or
> furnace and when it feels the heat the turpentine

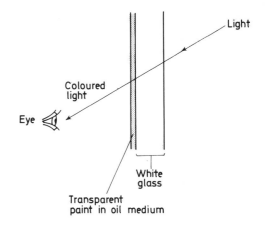

Figure 5.1 Painted glass technique (i)

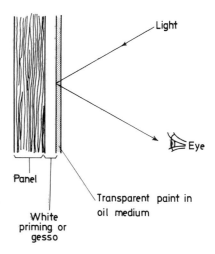

Figure 5.2 Fifteenth century easel painting

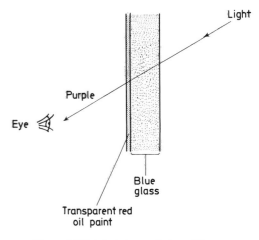

Figure 5.3 Painted glass technique (ii)

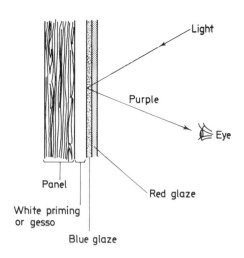

Figure 5.4 Oil painting technique

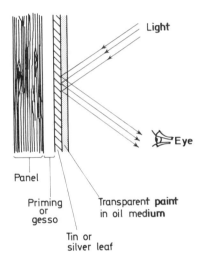

Figure 5.5 Painting on metal leaf in oil medium

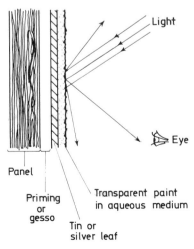

Figure 5.6 Painting on metal leaf in aqueous medium

will penetrate the box and you will have your green in the glass, to be used as described above.'[26]

It seems clear from the seventeenth century recipes that the so-called copper resinate, in agreement with earlier recipes, was first used for colouring silver or gold leaf, then for glass painting, as is stated by the recipe from the end of the fourteenth century in the treatise of Antonio da Pisa, quoted above. Copper resinate is very well suited for painting on glass on account of its non-crystalline and sticky character. At the end of the sixteenth century, colours dissolved in the same sticky medium were still in use for glass painting, as is evident from the so-called *Paduan Manuscript*:

> 'The clear gloss of ground bright colours on glass is made with equal parts of oil of turpentine and turpentine [i.e. turpentine resin] placed over a moderate fire until the turpentine is melted.'[27]

Secondly, copper resinate is not the only pigment from which we conclude that Van Eyck and his followers were acquainted with glass painting. There is yet another pigment which again and again is identified by the laboratory in paintings[28] of Van Eyck and later: the so-called 'jaune canarie' or 'lead-tin yellow', which has never been mentioned in any treatise for easel painting. Such a colour, however, was known in the fourteenth and fifteenth centuries for painting and is identical with the 'giallorino' mentioned *inter alia* by Cennino Cennini in Chapter 46. Until recently, this giallorino was usually interpreted as Naples yellow (lead antimonate), but most authors are cautious of this interpretation[29] and it has also been interpreted as massicot (yellow lead oxide)[30].

From the fifteenth century *Bolognese Manuscript* we get clear evidence that giallorino means a lead-tin oxide yellow:

> 'To make yellow glass for paternosters or beads: Take one pound of lead and two pounds of tin and calcine them and make glass for paternosters.
> 'To make giallorino for paintings: Take two pounds of this calcined tin and lead and two pounds of that glass for paternosters and two and a half pounds of red lead and half a pound of sand from the Val d'Arno, very finely pounded, and put it into the furnace and let it refine and it will be a perfect colour.'[31]

This description is in agreement with the statement of Cennino Cennini that the giallorino is as hard as stone and very difficult to grind[32]. According to Borghini, in the sixteenth century, there were two sorts of giallorino, a 'giallorino fine' which came from Flanders and another one which came from Venice, identical with the one described in the *Bolognese Manuscript*, and both were used for oil painting[33].

47

We may conclude from these recipes that the jaune canarie or lead-tin yellow was in use by glass painters at the end of the fourteenth century and came into use by easel painters round about the same time. By means of laboratory analyses, Dr Hermann Kühn came to about the same conclusions[34], although he goes much further by supposing that the Northern 'massicot', often mentioned in sixteenth and seventeenth century sources and generally accepted as a lead oxide, has to be identified as the lead-tin yellow[35]. From the point of view of the literary sources, I believe that there is no reason at all to doubt the hypothesis of Dr Kühn. The literary sources only strengthen his hypothesis. At the same time, his researches strengthen our own hypothesis that the jaune canarie or lead-tin yellow used by early easel painters from the fourteenth century is derived from glass-makers and glass painters, which pigment then to a large extent took the place of orpiment in easel painting[36].

In the third place, and last but not least, both the aesthetic and the purely working technique of the fifteenth century easel painters in general bear a great resemblance to the window-glasses of that time. The fifteenth century easel painting with its clear, transparent and bright colours and all representations seen in full light, is nearly an imitation, though with many more details, of the coloured glass windows. From the above-mentioned sources we know that the application of oil paint on glass was put into practice long before the application of oil paint on easel paintings by Van Eyck. The physiological effect of the colours is nearly identical: for glass paintings they are seen by transmitted light, for easel paintings by light reflected from beneath the surface and hence also by transmitted light (see *Figures 5.3* and *5.4*).

The paint structure of the easel paintings of Van Eyck and his followers is very complex and based on the transparency of the colours, which are applied in very thin layers one over another by means of the glazing technique and not by the physical mixture of separate, differently coloured pigments in the paint. From an historical point of view, this is an inexplicable technical phenomenon for easel paintings but it becomes clear if one accepts that Van Eyck was familiar with the technique of oil paint on glass. For in the technique of oil paint on glass it was an absolute necessity to paint with very thin glazes. It was also, for instance, necessary to glaze a very thin red oil paint over a blue glass to achieve a purple colour. The same technique was followed in the fifteenth century Flemish easel paintings, without any technical necessity (see *Figures 5.5* and *5.6*).

Another technical similarity between oil painting on glass and easel painting is to be found in a description of the beginning of the sixteenth century, which seems to have been derived from an older Northern source:

'If you wish to paint with other colours, which are beautiful but do not penetrate into the glass and remain on the surface, use in the first place verdigris, madder, stone black or charcoal black and generally all the colours which have no body, and the blue ones, etc. Give with the brush a coat of nut-oil (or linseed oil is better) on the glass, according to the painting you wish to execute. Let the coat dry well in the shade, then grind the colour with the same oil and paint upon the said coat of oil and let it dry; it will be beautiful, and even though the colour does not penetrate into the glass, it will remain beautiful for a long time and you may even varnish it, in the way you know.'[37]

Here we have a description of the same working technique as has been used by Van Eyck, who applied a layer of pure linseed oil over his priming — the so-called 'couche d'imperméabilisation'[38] — and over this coat his very thin paint glazes.

To sum up, it seems very plausible, from an historical-technical point of view, that Van Eyck worked as a glass painter, before he started with his easel painting. Not only the use of the above-mentioned colours but also his painting technique points in this direction: the glass-like aspect of his colours, achieved by the addition of resin or varnish, the miraculously thin, transparent paint layers, the effect of the light reflected from the depths by means of a white priming, which physically is closely related to the effect of the transmitted light from glass paintings or the transparent oil paint with varnish on metal leaf.

ENAMELLING

After the *émail cloisonné* and the *émail champlevé* there appears at the end of the thirteenth century the *émail translucide*. The technique of the *émail translucide* is quite in agreement with the spirit of the thirteenth and fourteenth centuries. The technique of this process is described by Vasari[39] and treated at length by Cellini[40]. The main points of this technique are that gold or silver plates were carved like a picture in low relief. Copper plates could not be used for this kind of enamelling, because the transparency of the colours would be affected unfavourably by the copper oxides, especially when, as often happened, the alloy contained some tin. The carved picture was embedded with a layer of transparent enamel in different colours, with a level surface. So each figure was not only given its appropriate colours but the varying thicknesses of the transparent enamels, caused by the engraving beneath the enamels, afforded a splendid gradation of tones in each colour, forming the shadows and thus the spatial relations.

The time was ripe at the end of the thirteenth century, as is proved by the work of the Pisani and Giotto, for this type of volume and spatial effect, and so the information of Vasari, that Giovanni Pisano, in the year 1286, had executed *émaux translucides* for an altar in the Cathedral of Arezzo, is credible, although the altar itself has vanished. There exists,

however, a chalice in the treasury of the monastery of the Franciscans at Assisi, decorated with *émaux translucides* on the foot, which was executed by the goldsmith Guccio Manuaia of Siena by order of Pope Nicholas IV in the year 1290, as is inscribed on the chalice. The lack of further dated enamels and sources, and the fact that many enamels are copies from miniatures[41], makes it very difficult to say much about the origin and the first period of the *émaux translucides,* but the flourishing period of this process fell mainly in the second part of the fourteenth and in the fifteenth centuries though the process remained in use during the sixteenth, and the beginning of the seventeenth century.

Round about the time that painting was more or less liberated from exclusively religious requirements, at the time when the art of enamelling on glass and windows was discovered, and the glossy and beautifully transparent appearance of oil paint for easel paintings became known throughout Europe, the process of the *émail translucide,* which was tied to engraving, no longer satisfied the desires of the time. In all these processes of enamelling, the enamel was used rather in the way of inlaid stones, opaque or transparent, but suddenly, towards the middle of the fifteenth century, real painting with enamels, executed with a brush, was born. The earliest examples were probably done by Jean Fouquet[42]. They are executed in gold paint in cameo on a very thick copper plate on a black ground with counter-enamel. From about the same time there exist two enamels in the Museum at Poitiers, of a man and a woman[43].

From the second part of the fifteenth century until the end of the seventeenth century it was the school of Limoges which produced most of the painted enamels, a school of enamellers already famous in the thirteenth and fourteenth centuries for the *émaux champlevés.* The somewhat mysterious studio of the so-called *prétendu* Monvaerni[44] seems to have been the starting point of the painted enamels at Limoges, and the works attributed to him are executed on rather thin *copper plates.*

The rapid development of the painted enamels at Limoges may evolve on the one hand from the long tradition of working with enamels, but on the other hand surely from the familiarity with glass painting of the early enamel painters at Limoges[45]. We were lucky to have found some recipes of the famous school of Limoges; up till now, no recipe concerning the technique of enamelling there was believed to exist[46]. One of these recipes, which is very interesting in connection with the copper support, we shall publish here for the first time:

'*To enamel on copper or brass, as is done at Limoges.* One must have mineral water[47], as they have in the said place, and in which is boiled the copper or brass on which you want to enamel. Note, however, that neither transparent nor white enamels are suitable and that those which are applied must only be soaked in vinegar, and take care not to re-heat it nor use borax on it, but only clean it with urine and lye. To enamel on brass. The normal way is to engrave it fairly deeply and then to boil it three or four times in water with alum, then clean it well and brush it with a goldsmith's brush, load it with enamel and put it in the fire, and when it is withdrawn from the fire it must be covered promptly with a crucible or something else appropriate lest it break into pieces.'[48]

This recipe fits with the facts: nearly all the enamels of Limoges are applied on copper instead of gold[49] and in these cases it is necessary to give the copper an etching, to wash it with water and to apply the enamels as soon as possible to avoid oxidation[50].

After the flourishing period of painted enamels at Limoges, at the beginning of the sixteenth century — by such enamellers as Nardon Penicaud (born between 1470—80 and still alive in 1539) and Leonard Limosin (1505—77) — there was, at the end of the sixteenth century, a decay of this art. At the same time, the production of such enamels started all over Europe, and they sank lower and lower in artistic merit and became a purely industrial production, of the quality of the products of our modern souvenir shops. We may conclude, however, that the method of painting on copper plates was known throughout Europe by the middle of the sixteenth century.

In this light it is not surprising that easel painters in the second part of the sixteenth century started to experiment with painting in oil paint on copper plates. In the first place, the copper plate was generally known as a support from enamel painting, and was very much in use by easel painters for making engravings. In the second place, the white priming of the Flemish Primitives in the fifteenth and the beginning of the sixteenth century was, in the course of the sixteenth century, replaced by the imprimatura. As early as 1464, Filarete[51] states:

'White lead is very good, but it does not matter if you take any other colour [for the imprimatura]'.

Vasari[52] and Armenini (1587)[53] give a clear description of this imprimatura and Armenini says the best one is a flesh colour, but often a red-brown, a blue or a grey imprimatura was used. Not only was the most commonly used colour of the imprimatura a flesh colour closely similar to the colour of copper, but the imprimatura also shone like copper, because it was applied with a high proportion of varnish, as is emphatically stated by Armenini[54].

The use of a copper plate as a support for easel paintings did not produce much difference in appearance from the use of the imprimatura on panels, but it had some advantages over wood panels and canvases. In the first place, there was no need to prepare the wood and canvases with a white ground, which then had to be further prepared with an imprimatura. By using a copper plate, everything was ready at once for painting, with the advantage of the absence of the imprimatura, which was often blamed for spoiling the

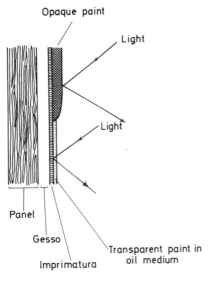

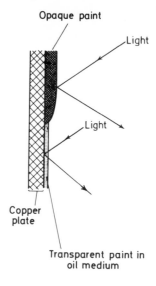

Figure 5.7 Painting of gessoed panel

Figure 5.8 Painting on copper plate

Figure 5.9 Guercino (Bolognese School 1591–1666) Angels Weeping over the Dead
Christ. Oil paint on copper panel, 0.368 x 0.444m
(Reproduced by courtesy of the Trustees, National Gallery, London)

colours applied over it, on account of the amount of oil and varnish it contained (*Figures 5.7* and *5.8*). The corrosion of the copper plate, which was the problem of the enamellers and spoiled their colours, did no harm to the oil paint, because the paint isolated the copper from the air. Moreover, if there was corrosion through any chemical reaction, it seems not to harm the paint.

The disadvantage of the copper support for oil painting, that the paint has a poor attachment to the

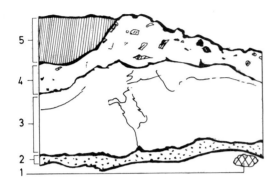

Figure 5.10 Diagram of cross-section through the blue paint of the drapery of GUERCINO'S Angels Weeping over the Dead Christ. *(Magnification c. 350x)*
1 *Fragment of copper from panel*
2 *Line of green corrosion product (copper oleate?) between copper panel and ground.*
3 *Cream-coloured ground layer (lead white + red lead in oil medium).*
4 *Pale blue underpaint.*
5 *Ultramarine glaze.*

support, is generally known. Sometimes this defect seems to be overcome by the coincidence of a corrosion of the surface of the support, perhaps caused by the reaction of the medium with the copper by forming a layer of copper oleate or copper resinate, as Joyce Plesters found on a painting of Guercino (*Angels Weeping over the Dead Christ*, National Gallery, London, No. 22). This layer, probably accidental, had the useful effect of attaching the paint firmly to the surface of the copper plate (*Figures 5.9* and *5.10*).

For painters who worked in a rather traditional way, that is, with glazes, or painters who worked in the then more modern way of the 'mixed technique', which means with opaque colours in the foreground and very transparent glazes for the background, as for example Rubens did, the use of copper plates was preferable to working on a prepared panel or canvas, when the size of the painting was not too large. The spatial relations were nearly mechanical and so acquired in a rather easy way. When the technique of glazing in oil paint became less prevalent around the middle of the seventeenth century, there was no longer any purpose to be served by using copper plates as a support and, concurrently, the copper support tended to disappear[55].

OIL PAINT AND USE OF METAL PLATES AS SUPPORT

References and Notes

[1] I am indebted to Miss Joyce Plesters of the National Gallery, London, for additional information.

[2] There are paintings painted not only on copper but also on silver and other metals. For instance, Adam Elsheimer sometimes painted on silver. Gonzales Coques (National Gallery, London, No. 1011) did the same. Scipione Pulzone (National Gallery, London, No. 1048) painted on tinned copper. Supports of this kind are, however, quite rare.

[3] van Mander, C., *Het Schilderboeck . . .*, Harlem (1603–1604), f.270: '. . . alwaer hy een stuck maeckte can het Oordeel/ses voeten hoogh/op een *coper plaet*/vol werk/ datter viif hondert tronien in quamen/. . .'.

[4] Dietz, E., 'Der Hofmaler Bartholomäus Spranger', *Jahrb. der Kunsthistorischen Sammlungen des Allerhöchsten Kaiserhauses*, **XXVIII**, 103 *et seq.*

[5] van Mander, C., *op. cit.* f., 249v: '. . . eenen Schilder Michiel Gioncquoy, die corts van Room ghecomen was: desen was van Doornijck en hadde te Room seer veel *coperkens* geschildert/meest wesende cleen Crucifixkens/. . .'.

[6] van Mander, C., *op. cit.*: '. . . Te Room ghecomen wesende/ begaf hem op *coperen platen* te schilderen/gelijk de wijze der Nederlanders is . . .'.

[7] Joyce Plesters has compiled a list of paintings on metal supports in the collection of the National Gallery, London. From the end of the sixteenth and the first half of the seventeenth century, there are thirteen Netherlandish, four German, seven Italian and one French paintings on metal plates. From the second half of the seventeenth century there are only four Netherlandish and one Spanish paintings on metal supports. In the eighteenth century, the method is only exceptionally applied, especially in France. See further: van de Graaf, J. A., *Het De Mayerne Manuscript als Bron voor de Schildertechniek van de Barok*, (1958), 17.

[8] *Compositiones ad Tingenda*, Bibl. Capitolare di Lucca, MS.490 (Published by Muratori, L. A., *Antiquitates Italica*, II, 364–387: Dissertatio XXIV).

[9] Theophilus Presbyter, *Schedula Diversarum Artium*, editions by Lessing (1781, etc.), Hendrie (1847), Ilg (1874) and Theobald (1933). The manuscript is dated by Ilg round about the year 1100; by Degering (1928) and Theobald, the tenth century is accepted as its origin, while Dodwell (1961) and Hawthorne and Smith (1963) have dated its origin between 1110 and 1140.

[10] Heraclius, *De Coloribus et Artibus Romanorum*, edited *inter alia* by Ilg in *Quellenschriften für Kunstgeschichte* (1849). Books 1 and 2 seem to have been written in the tenth century, while Book 3 seems to have been added by French compilers in the thirteenth and fourteenth centuries (see Loumyer, G., *Les Traditions Techniques de la Peinture Médiévale* (1920)).

[11] van de Graaf, J. A., *Het De Mayerne Manuscript als Bron voor de Schildertechniek van de Barok*, (1958), no. 2a.

[12] Van de Graaf, J. A., *op. cit.*, no. 2b, 2c.

[13] Theophilus, *Schedula Diversarum Artium*, Lib. I, Cap. 29: '*De pictura translucida*. Fit etiam pictura in ligno, quae dicitur translucida, et apud quosdam vocatur aureola, quam hoc modo compones. Tolle petulam stagni non linitam glutine nec coloratam croco, sed ita simplicem et diligenter politam, et inde cooperies locum, quem ita pingere volueris. Deinde tere colores imponendos diligentissime oleo lini, ac valde tenues trahe eos cum pincello, sicque permitte siccari.'

[14] van de Graaf, J. A., *Het De Mayerne Manuscript als Bron voor de Schildertechniek van de Barok*, (1958), no. 3.

[15] 'Belle facon de satin cramoysi que j'ay veue au tableaux anciens de Henry VIII, Edouard son fils, & Marie sa fille Rois d'Angleterre. Couche argent en feuille, sur lequel bien applany & fort equal, comme bruny, glace auec tresbelle Lacque, & sur icelle seichée fay les plis auec Lacque, & enfonce auec le mesme & vn peu de noir, Je coy que le mesme se fera auec verd le gris distillé, sur argent ou sur or. C'est vn trebeau labeur de Hans Holbein.'

[16] Rees Jones, S., 'The Coronation Chair', *Stud. Conservation*, I (1954), 103–114.

[17] See, for example, Fischer, J. L., *Handbuch der Glasmalerei*, Leipzig (1937).

[18] da Pisa, A., *Secreti per Lavorare li Vetri, Secondo la Dottrina di Maestro Antonio da Pisa Singolare in Tal Arte*, Archivo della Communale, Assisi, MS 692, (published by Bruck, R., *Rep. für Kunstwissenschaft*, XXV (1902), 240 *et seq.*): 'Io te voglio dare el modo del dipenzare e del modo da fare certi colori; che se fanno pose nel vetro senza ricuocere, in che maniere se puo fare per lo meglio modo. Si tu voi depenzare suso in un vetro del verderame e altri colori senza ricuocere el vetro, macina el verderame o altri colori con vernice liquida sopra de un porfiro e quando hai ben macinato sotilmente, diplinge quelle che tu vuoi sopra del vetro, e poi lassale seccare al sole e parra ricotto. O veramente macina el colore con l'olio del seme del lino che sia cocto e macina con ciascheduno de questo quelle che tu vuoi.'

[19] Cennini, C., *Il Libro dell'Arte o Trattato della Pittura*, Chap. 171: '. . . E se t'avvenisse avere a fare figurette piccole, o arme o divise si piccole, che i vetri non se potesser tagliare; aombrato che hai col predette colore, tu tu puoi colorire alcuni vestimenti, e tratteggiare di *colore ad olio*: e questo non fa luogo ricuocere, ne non si vuoi fare, perchè non faresti nienti. Lascialo poi seccare al sole, come a lui piace.'

[20] 'In dezelfde kerk bevond zich ook een glasvenster, voorstellende een heel mooie Kruisafneming, maar ik verkeer in twijfel of de teekening van hem dan wel van zijn meester Johannes was.'

[21] Laurie, A. P., *The Pigments and Mediums of the Old Masters*, 35–38.

[22] van de Graaf, J. A., *Het de Mayerne Manuscript als Bron voor de Schildertechniek van de Barok*, (1958), no. 68.

[23] Joyce Plesters gives the following very interesting explanation of the 'copper resinate' recipes, and the Birelli one in particular: 'Verdigris or any copper compound will dissolve in oils (e.g. linseed or walnut oil) to some extent to produce a green solution because the copper ions react with the fatty acids of which the oils are composed but, because fatty acids are weak acids, not much reaction takes place and not much copper is dissolved; hence the green colour, although looking quite strongly coloured when in the bottle, is a very weak green when painted out as a thin film. However, the Birelli recipe then goes on to say that if you add a little resin, the green colour will be much more beautiful. This is because the organic acids which are contained in natural resins react quite readily with the copper ion to form a bright green solution. Oddly enough, Venice turpentine (the balsam), which is specified in the De Mayerne recipe, is one of the least reactive from this point of view because it has a lower acids content and more esters. The latter do not react with copper. An excellent copper resinate can be made from rosin, and a great deal of either verdigris or copper carbonate or black copper oxide will dissolve in the resin and give an intensely green clear varnish-like solution.' Some years ago, in collaboration with A. D. Baynes-Cope at the British Museum Research Laboratory, we came to about the same conclusion as Miss Plesters: the harder the resin, the better the copper resinate. Some sorts are very hard after drying and do not dissolve in the solvents commonly used for picture cleaning. This observation may remove the fear of some people that the copper resinate glazes are dissolved by cleaning a painting.

[24] 'Pour fare le vert transparent que s'applique sur vn fond d'or ou d'argent'.

[25] British Museum, Sloane 1990.

[26] '*Vert.* auec vert de gris distillé, qu'on appelle en Allemagne, fs vt supra pour le regard de broyer. Fay vne liste de bois cum limbo mets la en vn verre ne atingat fundum. Mets y ton vert auec terebentine de Venise s.q. ad consistentiam pastae agita. Mets le au poisle ou fourneau, & quand il sentira la chaleur la terebentine penetrera la boite & auras ton vert dans le verre que vtere vt supra.'

[27] *Paduan Manuscript*, Chap. 105: 'Il lustro di rasa si fa per macinar colori vivi in vetro con parti uguali d'acqua di raggia, e pece greca sopra foco moderato fine si liquefacci la pecce greca.' (Merrifield, M. P., *Original Treatises on the Arts of Painting*, Vol. II (1849), 697).

[28] Identified for the first time by Jacobi, R., 'Uber den in der Malerei Verwendeten Gelben Farbstoff der Alten Meister', *Angewandte Chemie*, **54** (1941), 28–29.

[29] Thompson, D. V., *The Materials of Mediaeval Painting*, 179–180; de Wild, A. D., *Het Natuurwetenschappelijk Onderzoek van Schilderijen*, (1928), 87; Gettens, R. J. and Stout, G. L., *Painting Materials*, (1943), 24.

[30] Thompson, D. V., *op. cit.*, 180. The interpretation of the 'Giallorino' of Cennini as 'Naples yellow' seems to have been derived from the name 'Zalolino', a fifteenth century ceramic enamel which is, in fact, a lead antimonate, but Naples yellow as a painting pigment is described for the first time by Passeri in 1758, and has never been found before that time in any easel painting, as is stated, for example, by de Wild, *op. cit.*, 87 *et seq.*

[31] *Bolognese Manuscript*, Chap. 272: 'A fare vetrio giallo per patre nostro o ambre. Tolli piombo lb.j.stagno lb.doj, et fundi et calcina et fa vetrio per patrenostro.'; *idem*, Chap. 273: 'A fare Zallolino per dipengiare. Havve lb. doi de questo stagno e piombo calcinato et doi lb.de questo vetrio da patrenostrj et doi lb.et $\frac{1}{2}$ de minio et meza lb.di rena de valdarno sotilmente pista et metti in fornace et fa affinare et sera perfecto.' (Merrifield, M. P., *Original Treatises on the Arts of Painting*, Vol. II, 529).

[32] Cennini, C., *Il Libro dell'Arte o Trattato della Pittura*, Chap. 46: 'E grieve come prieta, è dura da spezzare.'

[33] Borghini, R., *Il Riposo*, Florence (1584), 209: 'Di Fiandra viene vn giallo detto giallorino fine, che ha in se materia de piombo, e s'adopera a colorire a olio; vn altro giallorino viene ancora di Vinegia composto di giallo di vetro e giallorino fine, che etiando serue per olio.'

[34] Kühn, H., 'Lead-tin Yellow', *Stud. Conservation*, **13** (1968), 7 *et seq.*

[35] Kühn, H., *op. cit.*, 8–9.

[36] Kühn, H., *op. cit.*, 20 *et seq.* A list of 158 paintings with notable occurrences of the 'jaune canarie' in paintings dated from 1300 until 1750.

[37] *Marciana Manuscript* 'Library of S. Marco, Venice (between 1513 and 1527), Chap. 325: ' . . . Se vuoi colorire d'altri colori i quali saranno begli ma non penetrano nel vetro, ma stanno in superficio: et maxime verderame, laccha fine, nero di noccioli di pesce arsi, o di carbone et universalmente tutti i colori che non hanno corpo et azzuro fine di cenere, etc. Da col pennello una mano di olio di noce, o di lino é meglio in sul ventro secondo la dipintura che vuoi fare, poi lascialo bene secare a l'ombra, poi macina il colore con detto olio, et dipingi sopra quello, et lascia seccare: et sarà bello, et benche non penetri durera assai tempo bello, puoi etiam poi invernicalo ut scis.' (Merrifield, M. P., *Original Treatises on the Arts of Painting*, Vol. II, 616).

[38] Coremans, P. *et al. L'Agneau Mystique au Laboratoire*, Antwerp (1953), 75.

[39] Vasari, *Introduzione*, Chap. 33: '. . . e come s'intagliano gli argenti, per fare gli smalti di bassorilievo . . .'.

[40] Cellini, B., *Trattati dell'Oreficerice e della Scultura*, Florence, (1568), Chap. III.

[41] For an attempt at identifying the '*émaux translucides*', see: Guth-Dreyfus, K., *Translucides Email in der Ersten Hälfte des 14. Jahrhunderts am Ober-, Mittel- und Niederrhein*, Basle (1954), 12 *et seq.*

[42] Marquet de Vasselot, *Les Emaux*, 15 *et seq.*

[43] Molinier, E., *L'Emaillerie*, Paris (1891), 242 *et seq.*, with illustrations.

[44] Marquet de Vasselot, *Les Emaux*, 11 *et seq.*

[45] Molinier, E., *L'Emaillerie*, Paris (1891), 238: ' . . . nous trouvons, à l'origine de l'émail peint, les verriers: en Italie, les verriers de Murano, en France, les peintres de vitraux de Limoges; ce sont des artistes limousins qui ont exécuté les verrières de Solignac, d'Eymoutiers et de l'église Saint Pierre du Queyroux, à Limoges. Les Pénicaud, qui figurent en tête de la liste des peintres émailleurs limousins, étaient

des verriers.'

[46] Gauthier, M. M., *Emaux Limousines*, Paris (1950), 11: 'L'absence totale des documents écrits interdit toute description authentique des procédés employés par les anciens artisans limousins.'

[47] What exactly may have been the contents of the mineral water which was used at Limoges, we do not know. Perhaps it was the water of the fountain of the church of St Martial at Limoges, which was used for preference by the enamellers on account of its good qualities, as is said by the seventeenth century chemist Bonaventura de Saint-Amable (see Rupin, E., *L'Oeuvre de Limoges*, Paris (1890), 184).

[48] *'Pour esmailles sur le cuiure ou loton, comme l'on fait à Limoges.* Il faut auoir de l'eau minerale telle qu'ils ont au dit lieu, & dans icelle faire bouillir le cuiure ou loton sur lequel vous voulès esmailler. Remarquent pourtant que les esmaux clairs ny le blanc n'y sont pas propres, & que ceux qui s'y appliquent ne se doibuent destremper qu'au vinaigre, n'y la besoigne ne se recuire, ny passer auec le borax, mais seulement la nettoyer auec vrine & lexive. Pour emailler sur le loton. La facon ordinaire est de le tailler assess creux & puis le faire bouillir trois ou quatre fois dans l'eau auec de l'alum, puis le bien nettoyer & sayeter, le charger d'esmail & le mettre au feu, & lors que l'a tire du feu il le faut estouffer promptement auec un creuset ou autre chose propre, de peur qu'il ne s'esclatte.'

[49] Gauthier, M. M., *Emaux Limousines*, Paris (1950), 14: 'Le métal de soutien utilisé par les émailleurs de Limoges est, non pas l'or, mais un cuivre rouge d'une faible dureté, il est extrêmement malléable et ductile.'

[50] Hasenohr, C., *Email*, Dresden (1955), 82.

[51] Averlino, A. (Filarete, 1400–69), *Trattato dell'Architettura* (1463), published by von Oettingen, W., *Quellenschriften für Kunstgeschichte*, Vienna (1890), 641: 'Prima il legnio ingessato e ben pulito; e che tu gli dia una mano di colla e poi una mano di colore macinato a olio. S'ella è biancha, e buona; et anche fusse altro colore, non monta niente, che colore che sia.'

[52] Vasari, *Introduzione*, Chap. VII and IX.

[53] Armenini, G. B., *De Veri Precetti della Pittura*, Ravenna (1587), 122 *et seq.*

[54] '. . . e poi la imprimatura sotilmente, ma tra l'altre di queste si tiene essere molte buona quella che tira al color di carne chiarissima con vn non sò che di fiammegiante mediante la vernice che ui entra vn poco più che nell'altre, percioche con gli effetti si vede che tutti i colori che ui si pongono sopra, e in specie gli azzuri, e i rossi ui compariscono molto bene, e senza mutarsi, cinciosia che l'oglio come si fa tuttauia pallidi, onde tanto più rozzi si fanno quanto più essi trouano le lor imprimatura sotto esser più scure.'

[55] See *Note 7.*

6
On the Punched Decoration in Mediaeval Panel Painting and Manuscript Illumination

MOJMIR S. FRINTA

The decoration of certain specific areas, covered with gold leaf, on late mediaeval panel paintings is an expression of the high level of sophistication achieved in the early fourteenth century. The saints' haloes are the main vehicle of this refined decorative tendency, and to some extent their garments, crowns and jewels, as well as the adorned borders of the panels and, exceptionally, the entire golden background. Basically, two types may be distinguished: engraved and punched decoration, which represent two more or less consecutive stages in the techniques of embellishment of the paintings. The engraved decoration was superseded by the punched one in the early fourteenth century in the prominent centres of painting such as Siena and Florence while in others the use of the former persisted a generation or two longer. That is not to say, however, that the practice of punching patterns was not used earlier. Haloes on some Italian duecento panels were occasionally adorned with simple patterns of iterative punching, crudely done with small pointed punches. More commonly, however, if decoration was carried out at all, the halo was first delineated by a single or double engraved circle and then a pattern was painted on it, usually in red.

By the second part of the thirteenth century, the haloes began to be provided with pointed punch marks or small circular ones. Similarly, the engraved pattern within the haloes was sometimes accentuated by punch-dotted lines which may have formed the design itself, e.g. Cimabue's Santa Trinita *Madonna* and his *Crucifixion* from Santa Croce in Florence[1].

The study of the punched decoration shows that it was very much part of the artist's personal style; it was an integral part of his design of the panel, revealing his aesthetic attitudes. Cennino Cennini says in his *Craftsman's Handbook*[2] that the stamping is one of the most delightful branches of the painter's craft, thus indicating that it was by no means considered an inferior occupation to be carried out by an assistant. Generally there is a close correlation between the quality of the punchwork and the quality of the painting itself. The process began with an outlining of the figures and their haloes — usually by engraved lines — and then the gold was laid on the bolus. It can be proved that the stamping by the punches followed next, before the actual painting, by the occasional partial or even complete covering up of a punch impression stamped at the border line of the halo and the figures with paint from the adjacent area. To facilitate the work of stamping, the panel had to be kept for a certain time in a damp cellar so that the gesso would absorb enough moisture.

The investigation of these punched decorations does not merely yield information on changing practices and techniques, but can be extremely useful in other objectives including the dating of the paintings, problems of attribution, and the establishment of a sequence in the artist's production. This investigation can trace the influence of one studio upon another, and yield insights into the delicate problems of authenticity[3].

A special type of punched decoration deserves our attention because of its potential in providing solutions to such problems as dating, attribution, and authenticity. The punch in this type was not a simple tool (i.e. pointed, blunt or hollow, which would produce a

54

small circle) but its tip was variously shaped, ranging from stars and rosettes to complex floral shapes. I came across several instances of animal forms which, however, remain exceptions (*Figures 6.7, 6.8 and 6.15*). These complex types of punches may conveniently be called 'motif punches'. An identity or merely a similarity of two impressions can be readily established, with far-reaching implications. My experience shows that individual masters owned a number of distinctive motif punches of their own that were used only by the master or his collaborators in the studio. I am building a file of negatives of life-size details, with a centimetre scale recorded alongside the impressions whenever possible. My collection now comprises some 10 000 negatives.

As a special study, I am trying to obtain details of punch work on restored portions of genuine paintings, as well as those on recognized forgeries, paintings of doubtful authenticity, and honestly produced copies. It seems to me that the margin between the activities of forging and copying may occasionally have become dangerously narrow. Allow me to illustrate. In some cases the restorer was content to suggest the missing portions of the punched pattern by a simple free-hand imitation of the shapes. In other situations the restorer used a simpler punch than the original one to fill in the interrupted continuity of a damaged pattern (*Figure 6.1*). The restorer might also have used a punch that he happened to own that was more or less similar to the original one[4]. A more delicate situation arises with the discovery of such a punch impression on a painting that does not show any evidence of restoration, because one cannot presume that the restorer would have owned an original punch. This could be an indication of a forgery yet such an indictment must be carefully deliberated before being voiced: there may have been important restorations when an exacting restorer might have made an exact replica of the authentic punch by casting it from an undamaged

Figure 6.2 Detail of the angel in the copy of Martini's Annunciation *by Nicholas Lochoff at the Helen C. Frick Art Center of the University of Pittsburgh, Pa. (Photo courtesy of the University of Pittsburgh)*

impression in the panel itself or another one by the same painter. He would have used it later in other restorations as well. The separate identity of such a replica may be difficult to establish.

What kind of material was used to make the original punches? Unfortunately, I know of no punch tools of the late Gothic period which have survived, so that any speculation as to the material used remains hypothetical. I received information on the tools of one of the great copyists of our time, the Russian Nicholas Lochoff, who was in close contact with Italian restorers and the 'antiquarian' Federico Ioni. It is possible to assume that some continuity of practice and technology could have lingered on in the restorers' profession and could have been used by the copyist. Lochoff used a set of punches for his copy of Simone Martini's *Annunciation* of 1333, closely copied in ivory from the impressions on the original[5] (*Figures 6.2–4*). However, a close scrutiny of many distinct impressions made me feel that ivory was not the sole material and that metal was also used. The conformation of some impressions, consisting of wiry forms which in the punch must be in relief in order to stamp, led me to reconstruct the fashioning of such tools as by a process of casting rather than carving (*Figure 6.5*). The desired crisp protrusion was simply engraved into a matrix (clay, soft stone?) from which a cast was conveniently made. The same might be true for the tiny star-rosettes whose components widen, then taper to a point, a design that would be easy to accomplish through engraving, as the tapering is natural to an engraved stroke. It is difficult to reach this effect

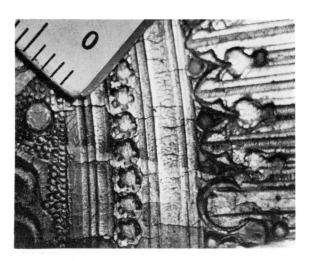

Figure 6.1 Detail of the halo of S. Ansano in the Annunciation of 1333 by Simone Martini and Lippo Memmi (Florence, Uffizi). The restoration is visible in the lower right corner: a simple curved punch was used instead of a Gothic cusped arch and a circle instead of a leaf

using the opposite approach of removing material from around the intended ridge-like design (*Figure 6.6*).

The early paintings of Simone Martini present supporting evidence, as do the miniatures of the Prague illuminators' studios, under the Bohemian king Wenceslaus IV, later in the century. Simone's minute fleur-de-lys and heart-shaped leaf must have been exquisite little tools, and so were the Bohemian lion and imperial eagle, and various foliage and rosette punches in the Wenceslavian Bible (*Figures 6.7–8*). Their very goldsmith's character seems to suggest that they were cast in a precious metal such as silver. A harder metal, such as bronze or brass, was not necessary as the resistance of the gilded gesso is minimal. More support for the premise that some punches may have been made of metal, rather than some material such as ivory, can be found in a comparison with book-binders' tools. Similar shapes of punches appear

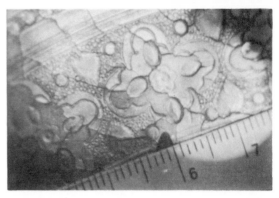

Figure 6.4 Detail of the angel's halo in the Annunciation *by Martini (Uffizi)*

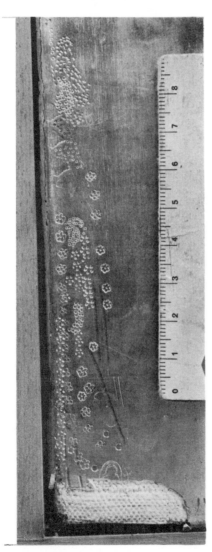

Figure 6.3 Detail of the gilded back of the Lochoff panel on which Lochoff tested his punches: a double-contoured arch, a Gothic cusped arch, a serrated leaf, a hexa-rosette, a penta-rosette, two types of penta-dot rosette, and tiny circles to work the background of the halo

Figure 6.5 Detail of the border of a Crucifixion *by an associate of Pietro Lorenzetti (Florence, Museo Stibbert)*

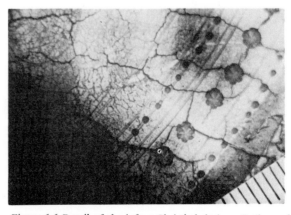

Figure 6.6 Detail of the infant Christ's halo in an Enthroned Madonna *by Maestro di S. Cecilia (Pescia, Museo Civico)*

Figure 6.7 Detail of the background of a miniature (folio 301r) in the Bible of King Wenceslaus, c.1390 (Vienna, National Library, Cod.2760)

in leather work, although later. However, in view of the toughness of leather, these punches had to be made of metal[6].

Florence appears to have been the first to use the technique of motif punch decoration. There are also duecento examples from Pisa, Siena, Umbria and Marche[7]. The earliest motif punches were small, and variations of stars and star-rosettes were featured in a modest way. Duccio favoured engraved decoration, as can be seen in his *Maestà*. Strangely enough, however, in his earlier Ruccellai *Madonna,* a number of decorative procedures are juxtaposed — the engraved line, the punch-dotted line and rosette, and the rosette punches in the circumference of the angels' haloes[8]. There is a startlingly classical air about the engraved foliage pattern which is set off against a background of cross-hatching[9].

This was an early stage in the development of punched decoration. A background consisting of dot- and minute circle-punched marks was to replace the hatching during the first third of the fourteenth century, still in conjunction with the free-hand pattern. After that, the motif punches came into use[10]

The motif punches were, however, not an invention of the late duecento. I found their earliest appearance in Byzantine painting of the sixth century[11]. The technique seems to have gone out of use in post-iconoclastic icon painting. No instance of punched decoration is known to me until the examples from the post-Byzantine period, when its use in Yugoslav and Greek icons may possibly be the result of Italian

influences. In contrast, early thirteenth century Italian panels such as the Tivoli and Sutri panels do show Byzantine influence[12]. The fact that they do not have motif punches supports the assumption that middle Byzantine painting did not rely on this decorative mode.

Much stranger and less explicable is the occurrence of motif punches in the West, at the turn of the thirteenth century. Two perfectly formed punch-marks were used to decorate the golden background of the miniatures in the Psalter of Queen Ingeborg[13]. A special clay padding was necessary before the application of the gold leaf, in order to make the stamping feasible. Through a stylistic comparison, some contact with Byzantine tradition can be ascertained to have existed, but more immediate precedents than the early Byzantine icons bearing this type of decoration have yet to be discovered. Nor is there a precedent for the Ingeborg punch-work in Western illumination, and the English examples of less exacting punch-work seem to have followed the Ingeborg model or perhaps paralleled it, stemming from a common imported tradition. It was not until the end of the fourteenth century that a revival of this splendid motif punch technqiue took place in Bohemian manuscript illumination and in the circle of Lorenzo Monaco in Florence.

Conservative small stars continued to be a staple of the modest decorative systems in the work of such early trecento painters in Florence as Maestro di S. Cecilia, Pacino di Bonaguida, Jacopo del Casentino, early Bernardo Daddi and Taddeo Gaddi, as well as painters in Umbria, Marche, Emilia (Bologna, Modena), and Venice (*Figure 6.6*). Paolo Veneziano persisted in combining punched stars with simple engraved scrolls in his haloes, and some Riminese painters continued to decorate the gold backgrounds with engraved foliate patterns.

North Italian punch forms were imitated by trans-Alpine artists, the earliest examples being the Klosterneuburg altarpiece and several paintings in Cologne. The great impact of these rather simple North Italian motif punches may be observed in fourteenth century

Figure 6.8 Detail of a miniature in the Wenceslavian Bible in Vienna

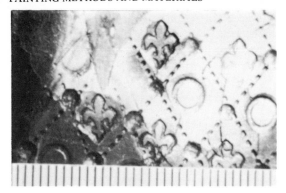

Figure 6.9 Detail of a drapery in the Stories of St Lucy by Jacobello del Fiore (?), (Fermo)

Figure 6.11 Detail of the Virgin's halo in an altarpiece by Ugolino di Nerio (Barone Ricasoli, Castello di Brolio)

Figure 6.10 Detail of the halo of St John the Evangelist in Simone Martini's altarpiece of 1319 (Pisa, Museo S. Matteo)

Figure 6.12 Detail of the Virgin's halo in the Madonna from S. Francesco in Pistoia of 1340 by Pietro Lorenzetti (Florence, Uffizi)

Bohemian painting[14]. Another technological device uniting Central European painting with that of Northern Italy was the use of the running wheel to produce dotted lines (*Figure 6.9*).

In Siena, one of the followers of Duccio, Maestro di Città di Castello, added to the Ducciesque engraved floral patterns small rosette punches which he grouped in triads around the haloes.

In view of the situation still prevailing in Siena, the innovations of Simone Martini must be understood as truly revolutionary. He started at the stage of the engraved and dot-punched pattern which was embellished at strategic spots with miniscule punch impressions, as illustrated in his large *St Louis of Toulouse* (datable as shortly after 1317). From this he moved swiftly and decisively to a fully developed style, imaginatively combining numerous motif punches, as found in his Pisa altarpiece of 1319. Floral and other motif punches, which were larger than Martini's early punches, were stamped, formally clustered in fours, sixes or eights, to form large composite rosettes (*Figure 6.10*). The border of the paintings was adorned by an arcade consisting of a rounded arch punch with a tiny pendant. Most of this repertory appears consistently in Simone's subsequent work. His brother-in-law Lippo Memmi apparently shared the punches with him and he also adopted Simone's imaginative combinations of punches into luxurious clusters.

There is a quite beautiful foliage punch that appears in a number of Martini's paintings (*Figure 6.10*). Interestingly, a larger yet very similar punch imprint appears in two paintings attributed to Ugolino di Nerio[15] (*Figure 6.11*). Which of the two artists was the first to conceive this floral shape? Ugolino was probably older than Martini as he is mentioned only in the years 1317—27 and his style was more archaic. From this, one would be tempted to conclude that Ugolino devised this particular punch and that Simone copied his smaller punch from Ugolino's[16]. Yet in view of the fact that Ugolino, a close follower of Duccio, was a traditionalist by nature, it is more likely that he was influenced by Simone in this respect, and was less likely to be an innovator of such a punchmark. In any case, Ugolino was the only painter of the Ducciesque school who fully embraced the new decorative system, as demonstrated in his large, almost sculptured motif punches on the dismembered altarpiece from S. Croce in Florence, datable around 1325[17].

Martini's new concept of decoration, shared by Lippo Memmi, became highly influential in Siena as well as in other centres, of which Pisa must be principally cited (Francesco Traini, Giovanni di Nicola). An initial inspiration from Martini's innovation may well account for the distinctive decorative schemes of the Lorenzetti brothers. The transition from engraved to

punched decoration can be followed in the signed works of Pietro Lorenzetti. His altarpiece in Arezzo (dated 1320) still shows the style of engraved patterns, while there is a complete conversion to punch work in the large dismembered altarpiece of 1328 from the Carmine Church in Siena. His repertoire of punched decoration is distinguished by several naturalistic floral punches (*Figure 6.12*).

It is possible to isolate paintings attributed to Pietro on which punch-marks do not agree with those on his authenticated works. Several coherent groups of paintings out of the voluminous body of attributions to Pietro can be assigned to anonymous collaborators and followers, and in one case even to a known painter[18].

On the basis of similarities in punched decoration, the Sienese influence — and even training in Siena — of a number of outside painters can be postulated. One of them is a Marchigian painter, Allegretto Nuzi, who must have received his initial training in the Lorenzetti studio before moving to Florence, where

Figure 6.14 Detail of the halo of St Venantius in a panel with two saints by Allegretto Nuzi (Fabriano, Museo Civico, No. 2)

Figure 6.13 Detail of the border of the altarpiece of 1361 by Jaume Serra (Zaragoza, Museo Provincial)

his style underwent Florentine influences. He imitated several of Pietro Lorenzetti's distinctive punches (*Figures 6.12* and *6.14*).

The motif punches never became as popular in Florence as they were in Siena. Their introduction in the second quarter of the century presupposes a knowledge of Sienese decoration. Bernardo Daddi's border arcade with pendants was inspired by Martini. But in general, Daddi's punch-work was more rudimentary than that of the Sienese, as he arranged his punch-marks in rows rather than in clusters[19]. Exceptional in his ambit, and indeed anywhere, are fancy forms such as the monster punch (*Figure 6.15*).

The migration of the punch tools is an interesting study in itself. There was the obvious sharing and then passing on of tools from father to son. This can account for the identity of certain punch-marks in the paintings of Bartolo di Fredi and Andrea di Bartolo, Taddeo di Bartolo and Gregorio di Cecco (his adopted son), of Taddeo and Agnolo Gaddi, of Benvenuto di Giovanni and Girolamo di Benvenuto. More problematic is the reappearance of identical punch impressions in unrelated works, such as those of Ugolino Lorenzetti (Maestro d'Ovile) of Siena and

the works of the Florentine Cione brothers. The tools were probably passed on through the intermediary of Giovanni da Milano, who also used them[20].

Truly baffling is the appearance in Catalonia of a series of punches that had earlier belonged to a collaborator of Pietro Lorenzetti, whom I propose calling the Master of Beata Umiltà, and who seems to have been active in the 30s and 40s in Siena. Three of the punches can be authenticated as being once Pietro's (*Figures 6.12* and *6.13*). Four of these punches were used in an altarpiece by the Catalonian painter Jaume Serra, painted in 1361[21]. Two figurative punches noted in Ambrogio Lorenzetti's Massa Marittima *Maestà* appear later in the Tortosa altarpiece by Pere Serra[22]. How did these punches get to Catalonia? Stylistic ties are evident between the earliest of the Serra works, such as the altarpiece in Zaragoza of 1361, and those attributed to the Master of St Mark (Ramon Destorrents?) who was possibly Serra's teacher. The faces with dark beards recall those of Ugolino di Nerio's altarpiece of c.1325 and also those painted by Pietro Lorenzetti. In view of this stylistic dependence, matched by the importation to Catalonia of Italian iconographic novelties such as the *Nursing Madonna of Humility*, it becomes plausible to suggest that Jaume Serra journeyed to Siena as, at a previous date, did another Catalan painter, Ferrer Bassa. It is likely that the Lorenzetti brothers perished in that

Figure 6.15 Detail of the halo of St Lawrence in a Coronation altarpiece by a follower of Bernardo Daddi (Florence, Accademia, No. 3449)

terrible year 1348 when a large part of the Sienese population was wiped out by the Black Death. A hypothesis may be formulated that Jaume Serra acquired some of their punches during his visit to Siena some time after 1348. The contacts of the Serra studio must have persisted, because in the later works of Pere (a retable of 1395) we find large arch punches similar to those of Taddeo di Bartolo and the attributions to Andrea Vanni. Correspondingly, a shift from the Lorenzettian typology to the heavier forms of Taddeo di Bartolo may be recognized. Serra's studio was the only one in Spain consistently using motif punches derived from Siena. Sporadic use of motif punches may be seen in paintings originating from Valencia (Maestro di Marti Torres). Spanish painters were basically conservative, and well into the fifteenth century they used modest forms of small stars and crosses running in rows within the haloes. European production in general showed a move away from motif punched decoration.

Florentine painters who, before the mid-fourteenth century, fell under the spell of the Sienese decorative convention, gradually abandoned the use of motif punches in favour of simpler decoration. Then the final blow to punched decoration came with the introduction of a realistic background with landscape and architectural settings, eliminating the traditional golden background.

Of all Italian schools, that of Siena testifies to the duration and immense popularity of the technique of punched decoration. That its artists conserved the golden background and haloes adorned with this technique well into the late quattrocento can be shown by the productions of Matteo di Giovanni, Neroccio di Bartolommeo Landi, Benvenuto di Giovanni, and Francesco di Giorgio Martini. Before the middle of the fifteenth century, retrospective tendencies appeared in Sienese painting, reflecting a certain revival of the forms of the first part of the trecento. This nostalgic evocation of the past may be illustrated by several copies of Memmi's *Madonnas* by Pellegrino di Mariano. Hand in hand with these evocations of the glories of the trecento goes a conscious imitation of the trecento manner of decoration and of the punches themselves. Sassetta and Giovanni di Paolo may be mentioned in this connection[23].

A comprehensive study of punched decoration can give valuable factual information and stimuli to the art historian, museum curator, restorer and private collector alike.

References and Notes

[1] Oertel, R., *Early Italian Painting to 1400*, Praeger, New York (1968), plates 39, 42b, 45.

[2] Cennini, C., *Il Libro dell'Arte*, edited by Daniel V. Thompson, Yale University Press (1932), Chapter CXL: 'Questo granare che io ti dico e de'belli membri che habbiamo'.

[3] Frinta, M., 'An Investigation of the Punched Decoration on Mediaeval Italian and Non-Italian Panel Paintings', *The Art Bulletin*, June 1965, 261–5. My research was supported by Fellowships from the Research Foundation of the State University of New York and Grants from the American Philosophical Society and the Kress Foundation.

[4] Such as an arch punch on a portion of the border of a Florentine *Crucifixion* in the Acton Collection in Florence, a punch which also appears on the restored edge of a *Madonna* attributed to Cenni di Francesco (Kress Collection K 268, now University of Kansas), thus establishing that these two paintings must have passed through the same Florentine restoration workshop.

[5] From a written communication from his daughter. Lochoff was originally commissioned by the Russian Tsar to make copies of early Italian masterpieces.

[6] There exist collections of Renaissance and later bookbinders' metal punches, e.g. in the Pierpont Morgan Library in New York and in the workshops in Santa Croce in Florence.

[7] As outstanding examples may be mentioned: Coppo di Marcovaldo's *Madonna* in Siena, dated 1261; Cimabue's *Crucifix* in Arezzo Migliore Toscano's panel of 1271 in the Uffizi; *dossali* by Guido da Siena; Vigoroso da Siena's *dossale* in Perugia (1280?); Deodato Orlandi's *Crucifix* in Lucca (1288). In Umbria, star punches appear in the paintings of Maestro di Cesi and Maestro di San Francesco.

[8] Oertel, R., *op. cit.*, plate 43.

[9] Oertel, R., *op. cit.*, plate 76.

[10] The term 'motif punch' was introduced by Erling Skaug, 'Contributions to Giotto's Workshop', *Mitteilungen des Kunsthistorischen Instituts in Florenz* (1971), 141–60.

[11] Septua-rosette alternates with a cross in the halo of Christ in an icon on Mount Sinai. (Chatzidakis, M. and Grabar, A., *Byzantine and Early Mediaeval Painting*, The Viking Press (1965), plate 47.) Furthermore, this technique may be observed in the seventh century panels from Mount Sinai, now in Kiev.

[12] Oertel, R., *op. cit.*, plates 12, 13.

[13] Frinta, M., 'Punchmarks in the Ingeborg Psalter', *The Year 1200: A Symposium*, (1975), 251–60. Metropolitan Museum of Art, New York.

[14] Frinta, M., 'New Evidence of the Relationship of Central European and Italian Painting During the Fourteenth Century', *Acta of the XXII International Congress of History of Art*, Budapest (1972), 647–52.

[15] Altarpiece in Castello di Brolio and a *Madonna* in San Casciano.

[16] Because this large foliage punch appears in only two paintings, one may perhaps go even further and tentatively explore the possibility of whether this could be taken as a sign that these two paintings were painted rather by one of the two brothers of Ugolino, Guido di Nerio and Minuccio di Nerio, who were also painters.

[17] Frinta, M., 'Note on the Punched Decoration of Two Early Painted Panels at the Fogg Art Museum: *St Dominic* and the *Crucifixion*', *The Art Bulletin*, Sept. 1971, 306–9.

[18] Frinta, M., 'Chipping Away at the Presumed Oeuvre of Pietro Lorenzetti and Related Works: Maestro di Beata Umiltà, Mino Pareis and Jacopo di Mino del Pellicciaio', *Mitteilungen des Kunsthistorischen Instituts in Florenz* (1976).

[19] This also applies to the production of Giotto's studio (Skaug, E., *op. cit.*).

[20] Frinta, M., *op. cit.* reference 18.

[21] They are: disjoint hexa-rosette, fleur-de-lys, two sizes of palmette.

[22] Yet another distinctive punch of Pietro, namely a tulip-like shape, emigrated to Catalonia and the studio of the Serra, because it appears in the *Madonna* in the church in Moyá. There were punches in the collection of this studio pointing to the production of Ugolino Lorenzetti, such as two varieties of complex tetra-rosette.

[23] Sassetta shows a predilection for extremely small punches, such as dot-rosettes of the Martini-Memmi type, tiny arches resembling those of Niccolò di Bonaccorso, trefoils similar to those of Pietro Lorenzetti; he also imitated the larger shapes such as Ugolino Lorenzetti's complex tetra-rosette and simplified fleur-de-lys which was also used by Paolo di Giovanni Fei. Giovanni di Paolo, too, liked the tiny punches but also imitated some larger punches of Simone Martini.

7
Artists' Brushes—Historical Evidence from the Sixteenth to the Nineteenth Century

ROSAMOND D. HARLEY

In the sixteenth century Boltz wrote that with good tools a job is half completed at the start. He and other painters describe brushes, the most important tools of the painter, with reference to the materials from which they are made, method of manufacture, various types and their uses in painting. However, some of the English documents present difficulty in interpretation.

There is generally no problem in knowing when reference is made to bristle brushes but it is sometimes difficult to establish exactly what raw material is indicated in connection with soft hair brushes (*Figure 7.1.*). English writers of the sixteenth and seventeenth centuries generally mention either miniver or calaber tails for brush-making; the tails only are used for they bear longer guard hairs than the rest of the pelt. The *Oxford English Dictionary* suggests that both *miniver* and *calaber* were names for the fur from some type of squirrel, yet, as any painter knows, hair from the squirrel, *sciurus vulgaris*, lacks the resilience of some other types of soft hair and brushes made from this hair offer less control in fine work. It seems unlikely that artists would use squirrel hair exclusively and this doubt is supported by evidence in a sixteenth-century English manuscript.

> 'Take a pensyll made of a Calabers tayle or a Squirrells tayle and lay on thy syse substan cyally.'[1]

Clearly calaber and squirrel were not the same and this is confirmed by the seventeenth-century painter, Henry Gyles, who states that *caliver* is a finer fur than that of English squirrel.[2]

Miniver is mentioned more frequently than calaber in sixteenth and early seventeenth-century sources. For example, Gyles writing in 1664 mentions the latter whereas Norgate's treatise written *circa* 1620, parts of which Gyles had copied, contains a reference only to miniver.[3] The *Oxford English Dictionary* contains a suggestion, which is apparently not supported on etymological grounds, that miniver might have been a name used for ermine, the winter fur of the stoat, or for a mixture of ermine and weasel. Either explanation is readily acceptable to an artists' brush-maker, for hair from weasel, a general term for *mustela,* and ermine, *mustela erminea,* are good for brush-making. A standard work of reference on fur definitely links the old name *miniver* with ermine.[4] From works on painting it seems that the name went out of use during the seventeenth century and it is perhaps significant that in 1692 Marshall Smith wrote that ermine was the hair used for the best fitches.[5]

Richard Symonds' Italian/English list[6] written c.1652–54 gives an indication of other raw materials used at that time.

'varo — miniver
puzzola — pole catt
tasso — gray badger
setola — hogs bristle'

It is interesting that polecat, *mustela putorius,* the ferret in its wild state, is not mentioned in native English sources although it appears in Symonds' notebook, which was written in Italy, and it is mentioned as *Iltis* by the sixteenth-century German writer, Boltz. The European species of badger, *meles*

Figure 7.1 Tails used in brush-making, left to right, two varieties of squirrel, ermine, red sable

taxus, has a grey tinge to its fur, and hair for brush-making is taken from the back of the animal instead of the tail. However, it is not mentioned with any frequency in English sources until one comes to eighteenth-century books. For that period the interpretation of *calaber* still presents a problem, for it appears in documents dating from the first half of the century, listed as *calve* in the English Customs records for 1720 and *callaber* in 1750, whereas camel hair is listed in 1760.[7] Camel hair pencils were first mentioned at about the same time, in the *Artist's Repository* (1784—86) and in John Payne's *Art of Painting in Miniature.*[8] In books on painting there is no overlap between the use of the terms *calaber* and *camel,* thus suggesting that the latter, which was in fact applied to squirrel hair, was merely a corruption of an old term which was no longer understood.

One of the most puzzling features of early written evidence on brushes is the absence of any mention of sable, *mustela sibirica,* even though references to it in sources unconnected with painting suggest that the fur was available. Nevertheless, sable pencils were on sale by the late eighteenth century and were mentioned by John Payne[9], who states that there are two kinds of hair pencils, dark brown (squirrel) and yellowish red, the latter being

> 'for what reason I know not, called Sabel Pencils, and are of a stiffer nature than the others and bear more than double the price. They certainly are a useful kind of Pencil, as long as the fine flue at the end of the hair remains, on account of their elasticity; but the instant the flue is worn off, they, from their harshness, become useless.'

Ackermann was selling both sable and so-called camel hair pencils in London in 1801, and, throughout the nineteenth and twentieth centuries, sable hair has remained as the most valued soft hair for artists' brushes because of its fine taper and resilience.

Early accounts of actual brush-making offer few problems of interpretation to anyone familiar with the process. Most writers knew that the end of the tail

should be broken off at the last joint and set aside, not because the hair is too long as Cennino says but, as Gyles[10] correctly states,

> 'the tip end of the tayle is not for makeing pensills on because the haires are crooked bending towards the poynts, but all the other haire above that joynt is usefull'.

The tips can be used for making brushes in which control is not required. Scissors are used to cut the hair from the rest of the tail and the wool is removed from the guard hairs, usually by means of a comb. Boltz suggests knocking it out with a stick, but it seems likely that he would also have lost a quantity of guard hairs by that method. Gyles is the only writer to describe the method of placing groups of hairs in a cylinder and tapping it repeatedly until all the hair lies level; he suggests knocking forward to the tips and then trimming the roots level, whereas the modern method is to knock the hair back to the roots and then sort the hair into groups of uniform length by 'dragging to length'. Gyles' insistence, stating more than once

> 'besure to keep the small ends of the haires all one way',

suggests that he was not familiar with 'picking', the modern method of removing a few reversed hairs from a group, nor with 'turning', a method by which a

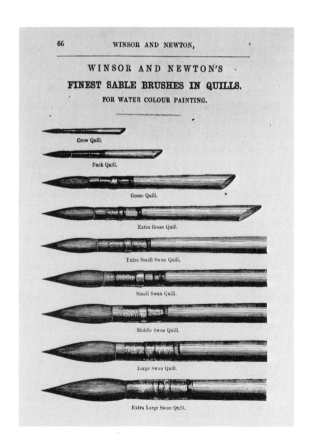

Figure 7.2 Nineteenth-century illustration of sable pencils in quills showing traditional sizes

completely mixed group may be sorted out. Early accounts of brush-making do not provide a description of the method of shaping a pointed pencil, although Gyles refers to the fact that a double loop should be tied round the hair loosely at first, the hair rolled round and the knot tightened up, which suggests that he had an idea of the method.

Soft hair pencils were generally inserted in quills, only those of water fowl being really ideal on account of their suitable wall thickness and resistance to water. Seventeenth-century English references are to the quills of duck, goose or swan; later references to non-aquatic birds such as lark or crow are merely an indication of the size of the brush not the origin of the quill (*Figure 7.2*). Boltz describes how quills must be trimmed and soaked in lukewarm water before the hair is inserted; this prevents splitting as the hair is placed into the quill, tip end first, and is guided through with a stick. Gyles emphasizes the care with which this must be undertaken to avoid spoiling the shape of the brush and finally he suggests inserting a handle made of ivory, brasil wood or ebony. He recommends handles the length of an ordinary pen for miniature painting but specifies no length when he comes to mention bristle brushes for oil painting. However, other authors recommended that these brushes may be anything from nine inches up to sixteen inches or more for large landscapes.[11]

It must not be supposed that artists commonly made their own brushes, for far more writers on painting provided information on sources of supply than described the process of brush-making. Many indicated different types of brushes that were available, and, once again, care is necessary in the interpretation of various English terms. Today an artists' pencil is a round, pointed brush made from soft hair, whereas it is clear from written sources that the word *pencil* was during the seventeenth century applied to any relatively small brush, soft hair or bristle, flat or round. Only the largest examples, such as those used for priming or painting frames were called brushes.

Another problem of interpretation occurs with the word *fitch*. In English, fitch hair means polecat fur, and, by association, it may be used for an artists' brush made from polecat. More usual throughout the seventeenth century was the use of the word *fitch* to mean a square-ended brush, for a number of writers referred to pencils 'fitched or pointed' and a complete list of different sizes and types of brushes is given in *The Excellency of the Pen and Pencil*.[12]

'Ducks Quill fitched Goose Quill fitched
Ducks Quill pointed Goose Quill pointed
 " " Bristle " " Bristle
Swans Quill fitched Bristle Pencils; some in
Swans Quill pointed Quills, others in Tinn-cases
 " " Bristle bigger than Quills, and others
Hairing or Jewelling in Sticks.'
 Pencils

The same anonymous author continues to describe in some detail the method of painting a portrait in oil,

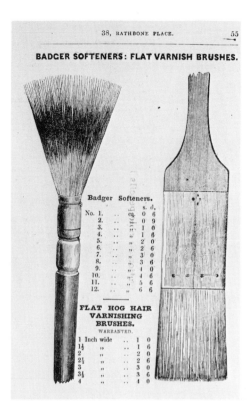

Figure 7.3 A badger hair softener for oil painting and a hog bristle varnish brush

including the purposes for which the various brushes are to be used. Swans-quill pointed pencils are for blocking in the face, whereas either goose-quill pointed pencils or duck-quill fitched may be used for outlining the features with lake.

'Having thus put in all your Colours both light and dark, take the great Fitch-pencil, either that in the plate, or that in the stick, and sweeten the Colours therewith; by sweetening, is meant the going over these several Shadows thus laid with a clean soft Pencil, which with orderly handling will drive and intermix the Colours one into another, that they will appear as if they were all laid on at once and not at several times. If this great fitch'd Pencil be too big, you may use a lesser; but note, that the bigger Pencils you use, the sweeter and better your work will lie, and it is as easie to handle a great Pencil as a little one, if you use your self to it.'[13]

At a later period, brushes used for this technique of blending were called sweeteners. In the eighteenth and nineteenth centuries, badger hair, which tends to be stiff and bristle-like, was used for these brushes; they were more costly than bristle brushes, for in the *Artist's Repository* badger tools are listed at a price of eightpence to two shillings each as opposed to hog tools at twopence to one shilling each (*Figure 7.3*). Riggers are also described in the same book[14] as

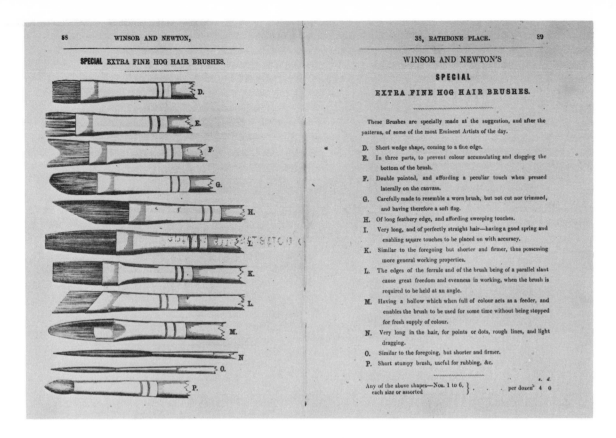

Figure 7.4 A variety of special shape bristle brushes made in the nineteenth century

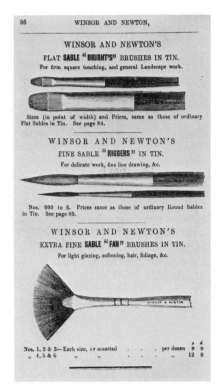

Figure 7.5 Nineteenth-century illustration of brights, riggers and fan brush

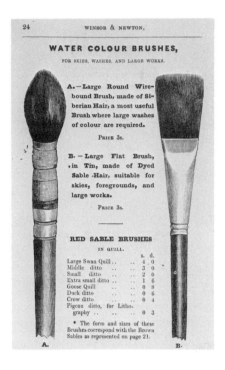

Figure 7.6 Alternative methods of securing hair with binding or ferrule

Figure 7.7 British Museum MS. Harley 6376, page 88, showing a brush-washer

Figure 7.8 British Museum MS. Harley 6376, page 89, showing a brush-washer

'those for shipping painters, very long in the hairs, and slender; useful to insert the ropes, &c.'

Throughout the nineteenth century specialized brushes such as sweeteners and riggers were still available but, with the growing use of tin ferrules which superseded the cord binding that had previously secured hog bristle to the brush handle, a greater number of shapes were introduced for oil painting. Use of tin ferrules, which may be flattened with pliers, meant that flat brushes could be made to replace fitched or square-ended round brushes. In England the word *fitch* came to be applied to the short and square, flat brushes that are called *brights* in America. Special shaping of tin ferrules allowed brushmakers to produce unusual patterns, although, with the exception of the fan shape, none had any lasting popularity (*Figures 7.4 and 7.5*). Silver or tin ferrules were also used for watercolour pencils though these did not supersede pencils in quills during the nineteenth century (*Figure 7.6*).

Many writers on painting included comments on the selection and care of brushes. Tests for a water-colour pencil were summarized by Gyles[15]:

'you must Choose such as are fast in the quills, cleane sharpe and even pointed, which you may try by moistening them in your mouth and squesing them flatt betwixt the thumb and forefinger of your left hand, which if it be fast in the Quill, and all the haires even of a length and levill, after you have so squesed it that pencill is good, otherwise no, . . . likewise if they be not devided into two parts as many times they doe but full and thick next the quill, and soe discending into a round and sharpe point.'

There was great insistence that the hair should be firmly tied, for a brush that shed hairs during painting was useless. Virtually without exception painters suggested putting a soft hair pencil in one's mouth to test the point; not until the nineteenth century did a writer point out

'this is the way to make a good point to a bad pencil; the point should be made by the pencil maker not by the purchaser'.[16]

They were familiar with the methods of eliminating odd stray hairs by picking them off with a knife and by quickly passing the brush through a flame, and hops were the recommended moth deterrent for seventeenth-century soft hair brushes. Miniature painters recommended that certain brushes should be reserved for use with gold, but this was to save the gold for future use by washing it out so that it would settle and could then be reclaimed. A similar idea was employed by some oil painters who washed out their brushes in linseed oil and then used the colour that sank to the bottom for priming canvases.[17] Those who did not paint every day were recommended to wash oil brushes with soap and water whereas others would leave their brushes immersed in oil. A brush

Studio Brush Cleanser, with Steel Clips, Washer and Cleaner, &c., complete.

RETAIL, £1 5s. WHOLESALE, 16s. 8d.

Figure 7.9 A nineteenth-century brush-washer

washer of this type was described by Gyles (*Figures 7.7* and *7.8*) in the seventeenth century and somewhat similar washers were available during the nineteenth century (*Figure 7.9.*).

Since the sixteenth century relatively little has changed in the tradition of brushes and brush-making. Red sable has emerged as the most favoured soft hair and this has meant that certain other types of hair, such as ermine and badger, are hardly ever used. Because of its 'flag' or divided tip, bristle is still the most favoured material for oil painting brushes. Early accounts of brush-making omit certain techniques that can be employed but as all the documentary material examined was written by painters and not by brush-makers there can be no certainty that craftsmen did not employ most of the methods that are used today. Probably the greatest advance that has taken place is in the widespread adoption of metal ferrules during

the nineteenth century even though cases of tin (which does not suffer from any reaction with pigments) were used for large brushes two hundred years earlier. Doubtless machinery for the manufacture of seamless ferrules that are comfortable to hold led to universal acceptance of metal ferrules for brushes of small size with the result that during the nineteenth century artists' brushes acquired the form and appearance that they still retain today.

References

[1] Victoria and Albert Museum MS. 86. EE.69, f. 2, (formerly MS.86. L.65).
[2] British Museum MS. Harley 6376, 13.
[3] British Museum MS. Harley 6000, f. 4.
[4] Bachrach, M., *Fur. A Practical Treatise*, New York (1953), 316.
[5] Smith, M., *The Art of Painting According to the Theory and Practise of the Best Italian, French and Germane Masters*, London (1692), 74.
[6] British Museum MS. Egerton 1636, f. 18v.
[7] Public Record Office, Customs 3/22 (1720), 3/50 (1750) and 3/60 (1760).
[8] Anon., *The Artist's Repository and Drawing Magazine*, London (1784—86), 62.
 Payne, J., *The Art of Painting in Miniature on Ivory*, 2nd ed., London (1798), 18.
[9] Payne, J., *op. cit.*
[10] British Museum MS. Harley 6376, 13.
[11] Amongst descriptions of brush-making at various periods are:
 Cennini, C., *The Craftsman's Handbook*, translated by D. V. Thompson, New York (1933), 40—42 (late fourteenth century).
 Boltz von Rufach, V., *Illuminirbuch, Künstlich alle Farben Zumachen und Bereyten* (1566), 53v—54v.
 British Museum MS. Harley 6376, 12—16 and 87—89 (Henry Gyles, seventeenth century).
 Ure, A., *A Dictionary of Arts, Manufactures and Mines*, London (1839), 633.
[12] Anon., *The Excellency of the Pen and Pencil*, London (1688), 95.
[13] Anon., *The Excellency of the Pen and Pencil*, London (1688), 101—102.
[14] Anon., *The Artist's Repository and Drawing Magazine*, London (1784—86), 63.
[15] British Museum MS. Harley 6376, 12.
[16] Clark, J. H., *A Practical Essay on the Art of Colouring and Painting Landscapes in Water Colours*, London (1807), 16.
[17] Bate, J., *The Mysteryes of Nature and Art*, 2nd ed., London (1635), 219—220.

IDENTIFICATION OF PAINT MEDIA

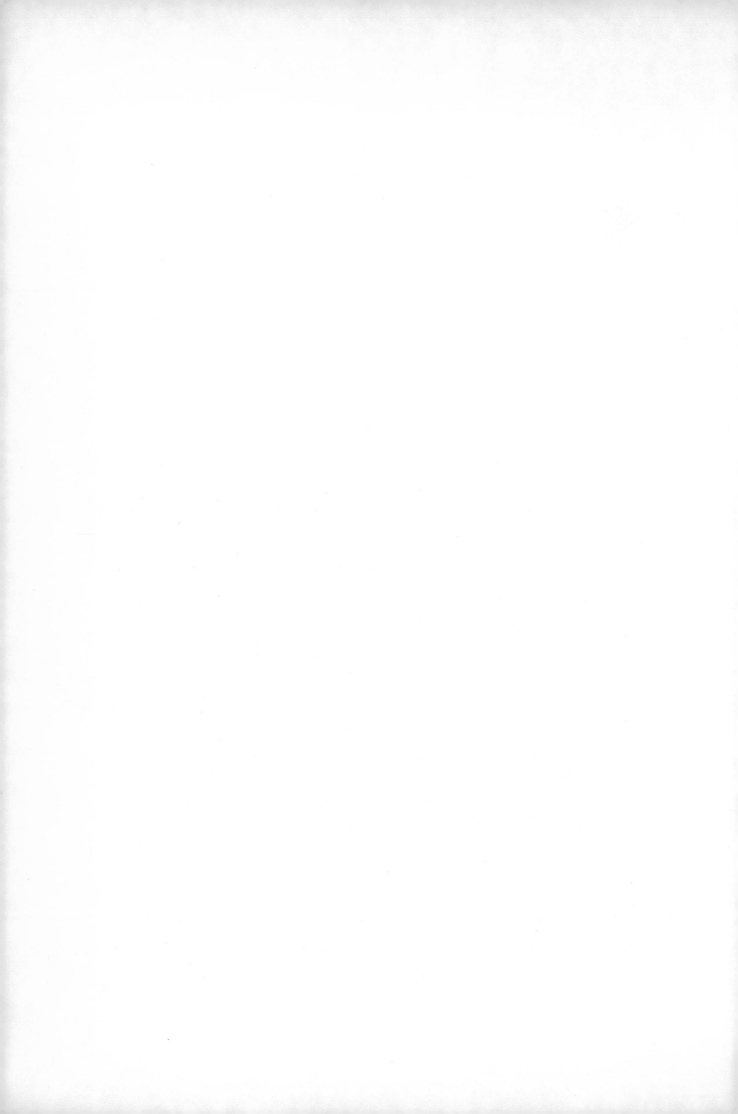

8
The Identification of Paint Media—An Introduction

JOHN S. MILLS

The identification of media is an aim that has always taken second place to the study of the layer structure and the pigments of paintings. This is a natural result of the fact that varying the medium does not necessarily have an obvious visual consequence. Further, identification can rarely be made with the satisfying assurance possible with pigments, even though the range of likely media is quite small. This means also that knowledge of the medium has seemed of less significance — it carries relatively little distinctive information. This remains true, yet knowledge of the medium *is* important in our total understanding of a painting's technique, and moreover it is beginning to seem that variability of medium through the layers and colour areas of a given painting may be much greater than has been previously supposed.

When easel pictures are under consideration, as now, possible media are confined essentially to egg and glue tempera, drying oils and possibly natural resins. Plant gums are unlikely to be encountered by chance and need not be taken into account when devising a scheme of analysis. They are more likely to be sought for deliberately when examining, say, watercolours or miniatures. The possible presence of other materials such as waxes has also always to be borne in mind, even if only as possible later accretions.

The sort of analytical approach which will be adopted by a conservation centre, museum laboratory or other institution will probably be determined in the first instance largely by the scientific bent of the staff concerned, as well as the instrumentation available or funds for purchasing it. This in turn will depend on the size and scope of the laboratory. If this is large and a wide range of types of object is under investigation then it may well be that a chemist will be available specializing in organic materials with the instrumentation required to cope adequately with the problem of their identification. If the laboratory is small and concerned only with a single class of object such as easel pictures then it will be only rarely that this degree of specialization will be feasible or that money will be forthcoming for expensive instruments. Even if it is, it is still unrealistic to suppose that a small staff can concern itself with these as well as the identification of pigments and other analytical tasks. The possession of an instrument such as a gas-chromatograph is not a key to the automatic revealing of secrets. On the contrary it usually reveals whole new fields which need detailed and careful investigation, and the individual finds himself getting more deeply involved than he bargained for. At least this remains so at present when to be working on chromatographic analysis is still to be concerned more with methods than the application of standardized procedures to the study of artists' techniques. Thus it is hopeless to suppose that instruments should be acquired so that they may be on hand to solve problems as they come up on an *ad hoc* basis. Not that there are *no* routine procedures; there are some. Fatty acid analysis for example comes almost into this category, but even here unfamiliar components are liable to appear on the gas-chromatogram which are not explainable on existing knowledge.

Perhaps the time will come when these techniques are sufficiently worked out for them to be carried out by non-specialists according to a given scheme. In the

mean while what are the approaches open to a small laboratory of limited means? In the last year or two there has been a resurgence of interest in the use of staining techniques to differentiate between proteins and oils on mounted cross-sections of paint fragments[1,2]. Very considerable refinement is claimed in that oils, egg yolk or whole egg, and egg white and glue may be distinguished as groups, as well as possibly emulsions made with some combinations of these. Clearly such a technique is not just a 'poor relation' of chromatographic methods for use *faute de mieux*. Indeed it may achieve analysis of media in layered structures where this is beyond the scope of methods which would need separate samples from each layer. Nevertheless, as the authors have emphasized, considerable care is needed in interpreting results, and any laboratory embarking on the method has to set up its own carefully standardized conditions. Examples of studies involving these techniques are the theme of the paper in this volume by M. C. Gay.

Important though it may be when layered structures are being examined, the staining method cannot distinguish between types of oil or types of protein. The latter will perhaps be distinguishable eventually by the fluorescent antibody technique[2] but this is still very much in the development stage. The distinguishing of egg from oils, and of oils from one another, by gas-chromatographic analysis of their fatty acids has been a particular study at the National Gallery laboratory and some results of this method are given here in a separate paper. Another way of making these distinctions is by detecting another group of components of oils and fats, namely the sterols or triterpenes. In the case of egg yolk these comprise quite a high percentage of the solid components and consist largely of one compound, cholesterol. With the oils, however, they are quite minor components and their detection in small samples does not *a priori* seem very hopeful. Nonetheless it has been reported[2,3] that oils and egg yolk may indeed be successfully distinguished by thin-layer chromatography of their neutral unsaponifiable components, supposedly the sterols, and that the method still works for old samples from pictures. The detection of cholesterol is a feature of a technique new to the field of medium analysis and reported on in the paper in this volume by Weiss and Biemann, namely the application of mass-spectrometry. In this case the whole sample was introduced into the inlet system and gradually heated, a series of mass-spectra being obtained, and that of cholesterol appearing at a certain temperature. The use of mass-spectrometry is also very important in another way, that is for identifying peaks obtained during gas-chromatography, especially unknown ones which, as mentioned earlier, sometimes turn up. Unfortunately the very high cost of the instrumentation will put it beyond the reach of all but a few laboratories. The protein-containing media – glue, egg, and possibly casein – are probably best differentiated at present by analysis of their component amino acids. This has been in use for some time but it does require larger samples than are normally available from easel pictures.

The analysis must be effected by some form of chromatography, and in fact paper chromatography itself was first developed for precisely this application. The protein-containing sample has first to be subjected to a rather prolonged acid hydrolysis to break it down into amino acids. This process normally also dissolves the inorganic pigments present and removal of the resulting soluble salts is necessary and sometimes troublesome. Paper chromatography is carried out on the free amino acids themselves and they are shown up on the chromatogram by means of a colour reaction. Egg protein and glue are distinguished simply by the presence in the latter only of the component hydroxyproline, all the other amino acids being common to both. Unfortunately the colour reaction for this compound is rather weak and transitory; nevertheless, many successful identifications have been made in this way[4,5,6]. Thin-layer chromatography may be used in the same way and is quicker and less troublesome[7,8]. Recently[9] these analyses have been effected using the amino acid analyser, a commercially available instrument which utilises a form of column chromatography over ion-exchange resins with automatic detection of the eluted acids and their recording on a strip chart recorder. This has the great advantage that a quantitative analysis is obtained, giving far greater assurance to the identification. Unfortunately the sample size required is still rather larger than that usually available from pictures.

Gas chromatography is an approach which has many attractions but also, in practice, some drawbacks. Although there is an extensive literature on methods there is rather little on actual applications. The main point here is that, just as fatty acids must first be converted to their more volatile methyl esters to render them suitable for gas-chromatography, so must the amino acids be converted to suitable derivatives, only here with the added complication that these have *two* functional groups – the acid group and the amino group – which have to be derivatized. One simplifying approach to this problem is to derivatize both functional groups simultaneously using NO-bistrimethylsilyl-acetamide, a reagent which forms derivatives with many classes of compound. This is the method described in an accompanying paper by Dr Masschelein-Kleiner. Another approach which we have favoured, and which has been described in various forms in the literature[10,11] is to use the ester-trifluoroacetates. Very good chromatograms are obtainable with these derivatives; the real problem remains the removal of the inorganic contaminants.

Paint medium analysis has least to show in the field of natural resins. There have been rather few reports of definite detection of resin in paint layers and the resin is not usually specifically identified. Analysis is usually based on comparison of thin-layer chromatograms with those of standards, supported by infra-red spectroscopy. However, carefully controlled experiments to check the reliability of such identifications by studies on aged standards have yet to be reported. We have carried out a good deal of work on the gas-chromatography of natural resins and find

that the composition of aged samples is often very remote from that of fresh material. Nonetheless several successful identifications have been made of resins many centuries old when these have been used in applications favourable to their preservation, as in adhesive compositions for example, but we have had less success with films. Others, however, have reported the use of resin as a paint medium. Thus a red translucent glaze on the polychrome sculpture of the Herlin altarpiece of 1466 is said to be madder in resinous medium, possibly dammar or mastic, sometimes without oil[8]. Such a finding raises questions, however, as to how such paint was formulated and applied.

The subject of resins is a large one, made difficult for the non-specialist by the absence of any reliable book and the dispersal through the literature of the considerable amount of new knowledge.

References

[1] Gay, M. C., 'Essais d'Identification et de Localisation des Liants Picturaux par des Colorations Specifiques sur Coupe Mince', *Annales du Laboratoire de Recherche des Musées de France* (1970), 8.

[2] Johnson, M. and Packard, E., 'Methods Used for the Identification of Binding Media in Italian Paintings of the Fifteenth and Sixteenth Centuries', *Stud. Conservation*, 16 (1971), 145.

[3] Johnson, M., Rosenberg, H. E. and Skowronski, R. P., 'Thin-Layer Chromatography of Sterols on Magnesium Trisilicate', *Stud. Conservation*, 16 (1971), 165.

[4] Macek, K. and Hamsik, M., 'Paper Chromatography — A New Method for the Characterization of Binding Media', *Umeni* (Prague), 2 (1954), 58.

[5] Hey, M., 'The Analysis of Paint Media by Paper Chromatography', *Stud. Conservation*, 3 (1958), 183.

[6] 'Essai d'Identification d'une Colle Animale Utilisée par Rubens', *Bull. Inst. R. Patrimoine Art.*, 6 (1963), 57.

[7] Masschelein-Kleiner, L., Heylen, J. amd Tricot-Marckx, F., 'Contribution à l'Analyse des Liants, Adhesifs et Vernis Anciens', *Stud. Conservation*, 13 (1968), 105.

[8] Broekman-Bokstijn, M., van Asperen de Boer, J. R. J., van't Hul-Ehrnreich, E. H. and Verduyn-Groen, C. M., 'The Scientific Examination of the Polychromed Sculpture in the Herlin Altarpiece', *Stud. Conservation*, 15 (1970), 370.

[9] Keck, S. and Peters, T., Jr, 'Identification of Protein-Containing Paint Media by Quantitative Amino Acid Analysis', *Stud. Conservation*, 14 (1969), 75.

[10] Darbre, A. and Islam, A., 'Gas-Liquid Chromatography of Trifluoroacetylated Amino Acid Methyl Esters', *Biochem. J.*, 106 (1968), 923.

[11] Zumwalt, R. W., Kuo, K. and Gehrke, C. W., 'A Nanogram and Picogram Method for Amino Acid Analysis by G.L.C.', *J. Chromatog.*, 57 (1971), 192; 57 (1971), 209.

9
The Gas Chromatographic Examination of Paint Media. Some Examples of Medium Identification in Paintings by Fatty Acid Analysis

JOHN S. MILLS AND RAYMOND WHITE

Since the publication of the initial study[1] of the feasibility of distinguishing between egg tempera and the three principal drying oils when used as paint media, we have examined a fair number of paint samples from pictures and propose to present the results here. Hindsight permits us to see that we should have taken many more samples than we actually did when opportunities arose, and that fewer questions would have been left unanswered by employing a more systematic approach. However, in the early days we were far from assured that the method would yield reliable results on pictures, given their long history of relinings, application and removal of surface coatings, etc., or indeed that the results themselves would be of sufficient interest or value to justify a routine removal of samples from all pictures undergoing restoration. Thus samples were usually only taken for chromatographic analysis when it was thought that this might provide answers to specific problems such as distinguishing between original paint and later additions, or when knowledge of the medium would be of distinct art historical interest. Furthermore the number of samples taken from any one picture was usually not more than two or three and perhaps only one. The object of taking more than one was more that of obtaining thereby an average result of greater statistical significance, than stemming from the thought that different media might be employed in different areas. This latter possibility and that of mixed media were added complications which we were perhaps unwilling to dwell upon overmuch since they seemed just too demanding of the method. The further complication, highlighted in recent papers[2,3] and in the paper by

M. C. Gay in this volume, of the possibility of the use of different media in the different layers of the painting's structure, could also hardly be coped with in the absence of supplementary techniques. We chose, or were compelled to start from a simplistic view of the problem and modify this if results required.

The following results are obtained solely by the gas-chromatographic analysis (GLC) of the fatty acids present, supplemented occasionally by a few simple tests or observations on solubility, results of pyrolysis, etc. We will first briefly summarize previous findings and the assumptions which have to be made in deducing the nature of the medium from such analysis.

It was found that for dried paint films incorporating drying oil or dried egg fats, only the two saturated fatty acids, palmitic and stearic acid, with a lesser amount of the mono-unsaturated oleic acid, could be detected in sizeable amount by GLC after suitable processing of the sample. In the case of drying oils another major component — present in amounts usually as large as, or larger than, palmitic acid — is azelaic acid, a degradation product of the doubly or triply unsaturated acids, linoleic and linolenic acid, which are responsible for the drying properties of the oils. Because of the low proportion of these acids in the triglyceride make-up of egg fats, correspondingly small amounts of azelaic acid are formed on ageing and it is present in quantities of the order of $0 \cdot 1 - 0 \cdot 2$ of the amount of palmitic acid. The finding of the former pattern — palmitate, stearate, large amount of azelate — is taken as proof of the presence of drying oil, while the latter — palmitate, stearate, small amount of azelate — is evidence of fats other than

drying oil and thus, in the context of easel painting, of egg tempera medium. This latter inference is, of course, not entirely free of objections. Fats and fatty acids themselves are ubiquitous contaminants which could have become incorporated in various ways into the paint film. Conversely, since egg fats are non-drying, they never become insoluble and are likely to have been largely removed from films which have been often cleaned with solvents. We have, indeed, had paint samples in which essentially no fatty acids could be detected. This is reasonable evidence of the absence of oil and, in an easel picture, suggestive of egg, but of course such negative findings are very unsatisfactory. Obviously a positive detection of egg protein or egg sterols is called for. Fats and fatty acids are also contaminants of solvents and glassware and may thus be introduced in the course of the analysis. Due regard must therefore be paid, when interpreting results, to sample size, instrument sensitivity setting, etc. We will elaborate on this below.

Generally we have not found too much difficulty in making the decision between 'oil' and 'not oil/probably egg', and any sort of quantitative value of the azelate/palmitate ratio to mark the dividing line has not been adopted. Nonetheless there are cases in which the azelate peak is too large for egg alone but not big enough for pure oil. One is forced to think that both media must be present here, either mixed or as constituents of separate layers.

If it is decided that the medium is drying oil alone, the palmitate/stearate ratio is measured. We still measure peak areas by cutting and weighing, though now this is done on photocopies rather than the original chromatogram. Although there is no proof that the palmitate/stearate ratios always fall within the ranges we reported previously it does seem, even from the small number of paint samples so far analysed, that two main groups emerge corresponding to the ratios for walnut and linseed oils. The former appears to have been the preferred vehicle in the earlier Italian Schools while the use of linseed oil seems to become more general from the early sixteenth century.

The only examples of the apparent use of poppy-seed oil have been in French pictures, and notably in Seurat and Monet. It would be interesting to find if its use was common in paints made up by nineteenth century French colourmen.

EXPERIMENTAL

SAMPLING

Nearly all samples examined have been from pictures undergoing conservation treatment, and they are normally taken after the removal of varnish and old retouchings. They have usually been taken from the margins of damaged areas and as far as possible only material from the topmost paint layer is taken, by careful chipping or scraping with a fine scalpel. The sample is transferred directly to a small centrifuge tube for saponification, etc. There is not normally any problem in obtaining adequately sized samples from most pictures but occasionally with small, very thinly painted pictures we have felt that samples would inevitably be too small and we have preferred not to take them at all.

SAMPLE TREATMENT

In general this follows the lines previously described and we continue to prefer the use of diazomethane for methylation since it is quick and involves the minimum of manipulation of the sample. Indeed we do not think that any other method would be practicable with the small sample sizes we usually handle. We find, though, that the presence of methanol is critical to the success of this method when methylating very small samples of fatty acids, a fact which eventually dawned on us after a period of obtaining very weak peaks when it was being omitted. We cannot explain why this should be so.

As mentioned earlier, fats and fatty acids are common contaminants of glassware and solvents (as well as being always present on the skin). We now use AnalaR grade solvents (ether and methanol) and further purify these by passing them through a column of alumina. Notwithstanding these precautions we still find that carrying through a complete saponification and methylation procedure without any sample and concentrating the final solution to the point where the whole of it is injected ($1 \mu l$) we still get a palmitate peak of about 1/10 full scale at an instrument attenuation of $\times 1000$ (10^{-9}A full scale). We try, therefore, not to use higher sensitivities than this when using the whole of very small samples, and we also take this background into account. Usually, however, our sample size is such that, especially with oil films, we get large peaks with only 1/3 or so of the sample, and perhaps lower sensitivities, and here the background is not significant.

Our earlier results were obtained using the Pye Panchromatograph but since 1970 we have used a Pye 104 instrument. This has given very superior results in the way of resolution, peak shape, detector sensitivity, noise level, etc. The column used is now a 5' glass one of 3% OV-1 silicone programmed from 110° to 190° at 5°/min. With these conditions some lower-boiling resin and wax components may also show up if present.

Results are given in the *Table 9.1*. Comment, if called for, is made in the following notes. Not all the results are of equal reliability and we naturally have more faith in those run more recently. In all cases, conclusions are only based on probabilities, not certainties. These will be stronger in time, when or if patterns emerge, particularly if incorporating the results of other and independent workers.

Table 9.1.

Artist and Picture	Gallery and No.	Date	Area Sampled	Medium	P/S	Oil Type	Note
ITALIAN SCHOOLS							
GIOVANNI da ORIOLO *Portrait of Lionello d'Este*	N.G. 770	Mid 15th C.	Black robe Blue background White inscription Red garment Flesh	Egg Egg Egg Egg Egg			
PIERO della FRANCESCA *Baptism of Christ*	N.G. 665	c.1440	Blue sky White area Green leaves	Egg Egg Egg			
St Michael	N.G. 769	c.1460	Blue sky White wing Unpigmented brown layer over ground	Oil Oil Oil	3·1 3·2 2·4	Walnut Walnut Walnut	1.
AMBROGIO BERGOGNONE *Virgin and Child with SS.*	N.G. 298	c.1490	White dress Blue dress	Oil Oil	2·9 3·0	Walnut Walnut	
GIOVANNI SANTI *Virgin and Child*	N.G. 751	Last quarter 15th C.	Blue sky White parapet Green of headdress Brown drapery in top corners Green edge of foregoing	Egg Oil Oil Egg Mostly egg	 3·0 2·8	 Walnut Walnut	2.
CARLO CRIVELLI	N.G. 807	c.1490	White of textile, LHS Blue, Virgin's robe Green of robe	Egg Oil Oil + egg	 2·4	 Walnut	3.
MICHELANGELO *Entombment of Christ*	N.G. 790	c.1500	Flesh of St John's arm Scarlet drapery of seated figure, left White under- modelling of figure	Oil Oil Egg	1·35 1·65	Linseed Linseed	 4.
RAPHAEL *Crucifixion*	N.G. 3943	c.1503	Brown earth Green robe Blue sky	Oil Oil Oil	1·8 1·8 3·0	Linseed Linseed Walnut	 5.
Julius II	N.G. 27	c.1511	Green background	Oil	3·0	Walnut	
LORENZO COSTA Altarpiece, *Madonna and Child with SS.* Central panel	N.G. 629	1505	Red swags on canopy Green of canopy Browned foliage Blue sky Virgin's red robe	Oil Oil Oil Oil Oil	2·3 2·8 2·75 unreli- able unreli- able	Walnut Walnut Walnut	
Side panel, *St Peter*			Sky, blue upper Sky, white lower Blue robe	Oil Oil Egg/Oil	unreli- able 3·25	 Walnut	 6.
Side panel, *St John Baptist*			Sky, blue upper	Oil	2·6	Walnut	
FRANCESCO FRANCIA *Virgin and Child with SS.*	N.G. 638	c.1500	Flesh, Virgin's neck Blue sky	Oil Oil	2·55 unreli- able	Walnut	
Virgin and Child with two SS.	N.G. 179	c.1517	Saint's white robe, RHS Blue sky	Oil Oil	1·5 1·9	Linseed Linseed	 7.
Lunette to the above	N.G. 180	c.1517	Ground Red paint Greenish paint	Oil Oil Oil	1·85 1·7 1·8	Linseed Linseed Linseed	

Table 9.1 (*cont.*)

Artist and Picture	Gallery and No.	Date	Area Sampled	Medium	P/S	Oil Type	Note
			Blue overpaint on Virgin's robe	Oil	2·55	Walnut	
			Green overpaint on Virgin's robe	Oil	2·9	Walnut	
			Grey of added spandrel	Oil	2·3	Walnut ?	
GAROFALO *Holy Family with SS.*	N.G. 170	Early 16th C.	White floor	Oil	2·8	Walnut	
			Orange sky	Oil	3·4	Walnut	
Madonna and Child with SS.	N.G. 671	Early 16th C.	Green	Oil	2·35	Walnut	8.
			Saint's hand, LHS	Oil	2·6	Walnut	
			Saint's armour, LHS	Oil	2·5	Walnut	
			White highlight of Saint's armour, LHS	Oil	3·3	Walnut	
			Brown between hands of Saint, RHS	Oil	2·45	Walnut	
			Green from added top	Egg +			
			Grey from added top	Egg +			
CORREGGIO *School of Love*	N.G. 10	Early 16th C.	Venus's flesh	Oil	2·6	Walnut	
			Green foliage	Oil	2·05	?	
Christ Taking Leave of his Parents	N.G. 4255	c.1510	Christ's white robe	Oil	2·75	Walnut	
			Blue sky	Oil	2·7	Walnut	
TITIAN *Bacchus and Ariadne*	N.G. 35	1522–3	White	Oil	1·95	Linseed	
SEBASTIANO del PIOMBO *Raising of Lazarus*	N.G. 1	c.1518	Blue and white	Oil	2·0	Linseed	
TINTORETTO *Origin of the Milky Way*	N.G. 1313	c.1577	White paint	Oil	1·65	Linseed	
			Brown paint	Oil	1·7	Linseed	
Last Supper	San Simeone Grande, Venice	1562–3	Dark paint on turn-over of canvas	Oil	1·1	Linseed	
			White paint of tablecloth	Oil	1·2	Linseed	
Transportation of the Body of St Mark	Accademia Gallery, Venice	1562–6	Greenish-grey shadow of flesh	Oil	2·0	Linseed	
			Pink of sleeve	Oil	1·8	Linseed	
			Red shadow of sleeve	Oil	1·65	Linseed	
Crucifixion	Accademia Gallery, Venice	1554 ?	Flesh	Oil	2·0	Linseed	
			Green of tunic	Oil	1·5	Linseed	
Last Judgment	Madonna dell'Orto, Venice	1562–4	Dark green of river	Oil	2·0	Linseed	9.
			Flesh	Oil	1·7	Linseed	
The Golden Calf	Madonna dell'Orto, Venice	1562–4	Dark green-brown background	Oil	1·7	Linseed	
			White highlight on pink drapery	Oil	2·45	Walnut ?	
Christ Before Pilate	Scuola di San Rocco, Venice	1566–7	White highlight, base of column	Oil	1·45	Linseed	
G. B. TIEPOLO *Venus Entrusting Cupid to Time*	N.G. 6387	c.1755	White of Venus's robe	Oil	1·55	Linseed	
			Brown of Time's garment	Oil	1·25	Linseed	
The Plague of Serpents	Accademia Gallery, Venice	1734–6	Grey paint	Oil	1·65	Linseed	

Table 9.1 (*cont.*)

Artist and Picture	Gallery and No.	Date	Area Sampled	Medium	P/S	Oil Type	Note
SPANISH SCHOOL							
MASTER OF RIGLOS *Crucifixion*	N.G. 6360	Mid 15th C.	Blue paint over gold Brown background	Egg Egg			
Attrib. MARZAL de SAS Altarpiece of St. George from Valencia	Victoria and Albert Museum	1410–20					
Central Virgin and Child			White paint Blue paint	Egg Egg			
Dustboard			Brown paint	Egg			
VELAZQUEZ *The Toilet of Venus*	N.G. 2057	c.1650	Dark red glaze Dark red glaze Dark red glaze + vermilion Dark red glaze + vermilion Dark red glaze + iron oxide	Oil Oil Oil Oil Oil	1·35 1·3 1·35 1·45 1·45	Linseed Linseed Linseed Linseed Linseed	10.
NORTHERN EUROPE							
G. DAVID *Christ Nailed to the Cross*	N.G. 3060	1480s	Blue sky Green sleeve Christ's flesh	Oil Oil Oil	2·7 2·4 3·4	Walnut Walnut Walnut	
QUINTEN MASSYS *Crucifixion*	N.G. 715	Early 16th C.	Green foliage Blue	Oil Oil	unreliable unreliable		
RUBENS *Peace and War*	N.G. 46	c.1629	White impasto Other white area	Oil Oil	1·8 2·05	Linseed Linseed	
RUYSDAEL *Landscape*	N.G. 990	1660s	Grey cloud	Oil	1·4	Linseed	
FRENCH							
P. de CHAMPAIGNE *Cardinal Richelieu*	N.G. 1449	After 1640	White ermine	Oil	4·5	Poppy ?	11.
J.B.S. CHARDIN *The House of Cards*	N.G. 4078	1741 ?	Grey coat	Oil	1·85	Linseed	
The Young Schoolmistress	N.G. 4077	1740 ?	White paint	Oil	2·1	Linseed	
MONET *Waterlilies*	N.G. 6343	c.1918	Yellow Green Mixed, mainly green	Oil Oil Oil	5·3 5·2 4·3	Poppy Poppy Poppy	
SEURAT *Une Baignade, Asnières*	N.G. 3908	c. 1884	Green trees White garment	Oil Oil	3·4 4·0	Poppy ? Poppy	

NOTES TO THE TABLE

1. These were some of the earliest samples that we examined; nevertheless the results seem quite clear cut. There is possibly a little oil in the green foliage of the *Baptism,* perhaps from copper resinate paint. The brown layer over the gesso of the *St Michael* appeared to be an unpigmented oil or oil-resin film, possibly of the type reported by Stout as occurring in some predominantly egg-tempera paintings[4].

2. There is some uncertainty with this picture as to whether some areas are later additions. Undoubtedly original blue paint of the sky showed almost no fatty content and was therefore probably in egg. Probably original paints of the white parapet and green of the virgin's head-dress were both in walnut oil. Brown paint from drapery in the top corners, of questionable originality, clearly contained egg fats and no oil, while a green band along the edge of this drapery, similar in appearance to the above green, appeared to be predominantly egg with some oil.

3. The medium of the white of the textile was unambiguously egg. The blue seemed to be mostly oil while the green had a rather low azelate peak and possibly contained both media. It had three layers and the lower may have been egg, the top oil.

4. The unfinished state of this picture allowed the sampling of the under-modelling layer.

5. The ratios here are sufficiently different for one to have some confidence that two different oils were used. The use of the less-yellowing walnut oil for the light coloured sky would be rational.

6. This picture seems to be largely painted in a medium of walnut oil. The blue robe of St Peter showed a rather low azelate peak, however, (only about 1/4 the intensity of palmitate) and probably contained some egg.

7. No. 638 was examined using the old instrument and only one of the samples gave a reliable result. It seemed to be walnut oil. The later painting appeared to be painted with linseed oil, both in the main panel and the arch-shaped lunette. This latter was extensively repainted, presumably in the nineteenth century, and spandrels in grisaille added. Unexpectedly the results for this repaint were more consistent with walnut oil.

8. Both of these paintings by Garofalo appear to be in walnut oil. No. 671 had a shaped top representing a baldachino or canopy over the Virgin, which was suspected on several grounds of being a nineteenth century addition. The medium of this was found to be quite different from that of the main body of the painting. It was rather vulnerable to cleaning solvents and contained extractable material of a resinous nature. GLC showed egg fats but no drying oil. Probably the medium was a quick drying egg-varnish emulsion. The probable story of this addition has been described in a National Gallery Report[5].

9. All these Tintoretto samples seem to be essentially linseed oil with the possible exception of one sample from the *Golden Calf.* The range of P/S ratios is, however, surprisingly wide. It must be considered possible that oils were mixed through accident or indifference. Also the addition of egg to linseed oil would raise the P/S ratio, but there is no reason to suppose this to be the case here. All the samples showed large azelate peaks. The addition of sufficient egg to increase materially the P/S ratio would also result in a significant reduction in the proportion of azelate. There is no significant change in this, however, from the low P/S samples of the *Last Supper* to the relatively high ones of the *Last Judgment.*

10. Unfortunately only these red glaze samples were taken, the object at the time being to see if some later repaints could be distinguished by this means. They could not.

11. It is now tantalizing that no other samples were taken. One would like to know if this apparent use of poppy oil was general or confined to the white areas.

Acknowledgement

Dr F. Valcanover, Soprintendente delle Belle Arti, Venice, for permitting Miss J. Plesters of this department to take samples from paintings in public collections in Venice.

References

[1] Mills, J. S., 'The Gas-Chromatographic Examination of Paint Media. Part I. Fatty Acid Composition and Identification of Dried Oil Films', *Stud. Conservation,* **11** (1966), 92.

[2] Gay, M-C., 'Essais d'Identification et de Localisation des Liants Picturaux par des Colorations Specifiques sur Coupe Mince', *Annales du Laboratoire de Recherche des Musées de France,* (1970), 8.

[3] Johnson, M. and Packard, E., 'Methods Used for the Identification of Binding Media in Italian Paintings of the Fifteenth and Sixteenth Centuries', *Stud. Conservation,* **16** (1971), 145.

[4] Stout, G. L., 'One Aspect of the So-Called Mixed Technique', *Tech. Stud. Fine Arts,* **7** (1938), 59.

[5] *The National Gallery, January 1969–December 1970,* (1971), 50.

10

Application of the Staining Method to Cross-sections in the Study of the Media of Various Italian Paintings of the Fourteenth and Fifteenth Centuries

MARIE CHRISTINE GAY

On the occasion of a recent programme of restoration undertaken by the Department of Paintings of the Musée du Louvre, on Italian paintings of the fourteenth and fifteenth centuries from the Campana Collection, we were able to take a series of microscopic samples which allowed us to study their pictorial technique and to try to answer questions posed by the Restoration Service.

Certain of these samples were used to make cross-sections on which staining tests made possible the identification of the media. The technique of making the cross-sections, and the identification reactions have been described in detail in a previous article.[1] We only describe here the method of working.

MICROSCOPIC EXAMINATION

A cross-section is mounted in Depex* and examined in reflected light; this allows us to observe the stratification, the thickness of the layers and their colour. The examination of the cross-section in transmitted light, between crossed polarizer and analyser, gives supplementary information on the various layers. One observes, where present, the successive varnishes — varnishes containing pigments, thick varnishes in which the stresses are shown up by birefringence, and, sometimes, a varnish separating the original paint layers from a repaint.

The paint layers are often opaque, especially if

*A mounting medium provided by Gurr's and which has the advantage over Canada balsam of not yellowing.

the pigment is finely ground; sometimes large coloured crystals can be seen to be surrounded by medium. At other times, the medium appears to have gone and the paint layer is then very fragile (*Figure 10.1*).

Gesso and chalk grounds look very different in transmitted light. Observed between crossed polarizer and analyser, the gesso appears to be formed of large bright crystals; the preferential orientation of the crystals makes it possible to distinguish the different layers (*Figure 10.2*). Chalk, which is more opaque, appears in the form of small, round, bright crystals.

It is thus possible to observe the nature of the ground, its glue content and, possibly, the purity of the gesso used.

PRELIMINARY TESTS FOR DISTINGUISHING BETWEEN OILS AND PROTEINS

Fuchsine S in water permits localization of the proteins and starch paste. Dry-heating a cross-section identifies:

wax, which melts from $60°C$
resins, which melt from $120°C$
dried oils, which melt from $160°C$
egg-yolk, which melts from $200°C$.

Melting is shown by the appearance of fine bright droplets.

Lugol (I_2 + KI) colours starch blue, dextrines red and shows up lead pigments in the form of yellow lead iodide.

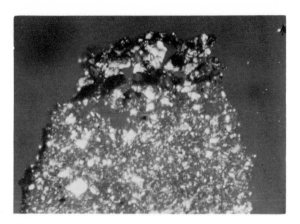

Figure 10.1 Blue of the Virgin's mantle (Painting no. 5)

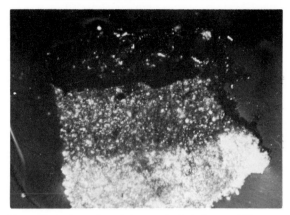

Figure 10.2 Blue: edge of the mantle (Painting no. 10)

Solubility in water, solvents and caustic soda complete these preliminary tests.

CONFIRMATION REACTIONS

These are then selected taking account of the nature and colour of the pigments.

For the proteins: Light Green
 Ninhydrine collidine reagent
 Biuret reagent (alkaline: the oily layers disintegrate)
 Millon reagent (acidic: effervescence of the carbonates)
For the lipids: Sudan Black B
 Oil Red O

In contrast to Johnson and Packard[2], we decided against staining thick sections because the results could be misleading. In fact, certain porous layers can absorb the stain and washings are insufficient to eliminate the excess; one thus risks a falsely positive test. The stain could also infiltrate the cracks and discontinuities between the layers. This phenomenon, although not giving rise to an erroneous interpretation, leads to a less clear stained image.

Sudan Black B only gives good results on liquid fatty materials, which necessitates heating the cross-section. We also prefer to effect successive stainings on different sections to avoid 'interference' (for example, two blue stains not giving the same indications: blue toluidine and Sudan Black) and the chemical reactions between stains (acid and basic stains, for example). Finally, this allows us to make as many tests as necessary to obtain a definite identification.

We can thus, thanks to single stains on thin cross-sections, identify and localize oil, egg, gelatin glue and starch. Identification of oil-resin mixtures and albumen remains more tricky. The nature of the drying oil must be determined by gas chromatography of the methyl esters[3] or by thin layer chromatography of the sterols[4]. Only the use of fluorescent antibodies on the sections would allow us to identify individually the proteins of egg yolk, casein and albumen.[2]

For this study, we have only dealt with samples revealing the original paint layer, possibly beneath repaints. The study which we are presenting here relates to eight paintings of the fourteenth century and ten paintings of the fifteenth century, chosen from the principal schools of painting. We give below a summary of the analysis results and observations carried out on the sections. The paintings have been numbered arbitrarily from 1 to 8 for the fourteenth century and from 9 to 18 for the fifteenth century.

1. SIENESE SCHOOL, BARTOLO DI FREDI, ADORATION OF THE SHEPHERDS

Face of the shepherd on the left
1. gesso of calcium sulphate and gelatin glue (120 μ)
2. imprimatura
3. terre verte with egg (10 μ)
4. very thin pink layer with egg (6 μ)

2. UMBRIAN SCHOOL, MASTER OF 1310, MAESTÀ

Blue robe of the Virgin
1. gesso of calcium sulphate and gelatin glue (240 μ)
2. very thin layer of lead white with oil (5 μ)
3. large blue crystals in an oily medium (30 μ)
4. oil-resin varnish
Hair of the donor
1. gesso as above
2. thin red layer with little medium (10 μ)
3. brown varnish of uneven thickness
4. red and lead-white layer with oil (40 μ)
5. lead white with oil, very thin
6. varnish
Hand of the angel
1. gesso as above
2. lead white with oil (in two 40 μ layers)
3. proteinaceous medium (less than 20 μ)
4. varnish

3. SCHOOL OF ROMAGNA, CRUCIFIXION

Face of Saint John
1. gesso: two thick layers of calcium sulphate and gelatin glue (200 μ) one very thin layer of calcium sulphate and gelatin glue (20 μ)
2. verdaccio: terre verte and lead white with egg (20 μ)
3. pink layer: lead white and ochre with egg (40 μ)
4. several very homogeneous yellow layers with egg (40 μ) with cracks penetrating to the gesso
5. varnish
6. layers of repaint, without cracks, with oil-resin medium

4. SCHOOL OF RIMINI, CHRIST IN THE TOMB

Flesh
1. gesso applied in two layers (350 μ), with gelatin glue and gypsum mixed with chalk
2. green-yellow paint layer with egg (10 μ)
3. green-yellow paint layer with egg (15 μ)
4. varnish
Gold
1. gesso as above
2. very thin irregular red layer (3 to 10 μ)
3. gold

5. FLORENTINE SCHOOL, ALLEGRETTO NUZI, MAESTÀ

Blue of the Virgin's mantle (*Figure 10.1*)
1. heterogeneous gesso: gypsum with gelatin glue (180 μ)
2. oil impregnation
3. thin layer of lead white with oil (10 μ)
4. layer of copper blue and egg (80 μ)
5. thick oil-resin varnish
Pink of the shoulder of the angel at the bottom on the left
1. gesso as above
2. layer of lead white with red pigment particles, with egg (20 μ)
3. varnish

6. FLORENTINE SCHOOL, MADONNA AND SAINTS

Blue of the Virgin's mantle
1. coarse gesso: calcium sulphate and gelatin glue (300 μ)
2. imprimatura
3. light blue layer (10 μ)
4. large blue pigment particles with egg (60 μ)
5. varnish
White on gold
1. coarse gesso as above
2. irregular red layer (about 10 μ), probably with egg-white
3. gold leaf

4. layer of white with oil
5. brown varnish

7. FLORENTINE SCHOOL, MARRIAGE OF SAINT CATHERINE

Blue of the Virgin's mantle
1. homogeneous gesso: gypsum and gelatin glue (300 μ)
2. thin layer of lead white with oil (10 μ)
3. very thin grey layer (6 μ)
4. dark blue layer with egg (30 μ)
5. light blue layer with egg (30 μ)
6. successive varnishes

8. FLORENTINE SCHOOL, CHRIST ON THE CROSS

Hair
1. gesso of calcium sulphate and gelatin in two layers (200 μ)
2. very thin translucent layer (less than 10 μ) with oil-resin, coloured with red and black pigment particles
Flesh of the body and face
1. gesso in two layers (200 μ) as above
2. black imprimatura (5 μ)
3. green layer with egg (10 μ)
4. translucent oil-resin yellow layer (15 μ)
Flesh of the arm (repaint)
1. gesso as above
2. light green layer on a base of lead white and oil (10 μ)
3. yellow oil-resin layer
Fabric
1. gesso as above
2. imprimatura
3. light green layer with egg (25 μ)

9. FLORENTINE SCHOOL, NERI DI BICCI, CORONATION OF THE VIRGIN

Gold of the background (*Figure 10.3*)
1. gesso of calcium sulphate and gelatin glue (200 μ) applied in two layers, the upper layer being richer in glue
2. layer of ochre with egg-white (15 μ)
3. gold leaf
Blue of Christ's mantle
1. gesso in two layers as above
2. azurite layer with egg (100 μ)
3. varnish
Green of the bishop's robe (*Figure 10.4*)
1. gesso as above — with egg
2. light green (60 μ) — The yellow layers which
3. yellower green (30 μ) — have a less fatty medium
4. green (40 μ) — may be whole egg (yolk and white) while the
5. yellow (30 μ) — green layers would be
6. varnish — with egg yolk.

80

Figure 10.3 Gold leaf (Painting no. 9)

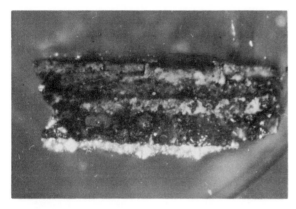

Figure 10.4 Green of the bishop's mantle (Painting no. 9)

Hair of the angel
1. gesso as above
2. lead white with egg (10 μ)
3. three yellow layers with egg (35 μ)
4. varnish
Yellow robe of the angel
1. gesso as above
2. yellow layer with egg (40 μ)

10. FLORENTINE SCHOOL, MACHIAVELLI, MADONNA

Face of the Virgin
1. gesso: gypsum and gelatin glue (180 μ)
2. verdaccio: terre verte and lead white with egg (30 μ)
3. very thin layer of lead white with red pigment particles, with egg (10 μ)
4. oil-resin varnish (two layers)
Blue (*Figure 10.2*)
1. gesso as above
2. pink layer: lead white with red pigment particles, with egg (25 μ)
3. blue layer with very little medium (10 μ)
4. blue layer (lead white and copper blue with oil = 80 μ)
5. varnish

11. SIENESE SCHOOL, ANDREA DI BARTOLO, SAINT PETER

Yellow of vestment
1. gesso: gypsum with gelatin glue (140 μ)
2. imprimatura
3. layer of red ochre diluted with albumen (10 μ)
4. gold leaf
5. lead white with oil (6 μ)
6. yellow ochre with egg (20 μ)
7. lead white with oil (10 μ)
8. several thin layers of yellow ochre with egg (25 μ)
9. varnish

12. SIENESE SCHOOL, TADDEO DI BARTOLO, MADONNA

Brown colour of the reverse of the Virgin's mantle
1. gesso of calcium sulphate and gelatin glue, applied in two layers, the second layer being richer in glue (60 μ)
2. very even layer of red ochre with albumen (10 μ)
3. gold leaf
4. green layer of copper resinate with oil (12 μ)
5. oil-resin varnish

13. SIENESE SCHOOL, TADDEO DI BARTOLO, MADONNA

1. gesso: gypsum with gelatin glue (400 μ)
2. red ochre layer with white of egg (10 μ)
3. gold leaf

14. SIENESE SCHOOL, GIROLAMO DI BENVENUTO, SAINT JEROME

Brown, right cheek of lion
1. ground of restoration: zinc white with oil
2. layer of thick glue
3. thin orange layer with egg (20 μ)
Red cushion
1. ground as above
2. glue
3. grey layer with egg
4. malachite green (10 μ)
5. ochre (15 μ) } with oil
6. malachite green (25 μ)
7. red (50 μ)
8. oil-resin varnish
Grey rock
1. ground as above
2. glue
3. grey layer with egg
4. varnish
Edge of the grotto
1. ground as above
2. glue

 3. grey layer with egg (20 μ)
 4. ochre with egg (30 μ)
 5. varnish
White of the book
 1. ground as above
 2. glue
 3. lead white with oil (25 μ)
 4. varnish
Robe of the saint
 1. ground as above
 2. glue
 3. grey layer with egg (20 μ)
 4. varnish
Flesh of the left arm
 1. ground as above
 2. glue
 3. yellow ochre and lead white with egg (80 μ)
 4. varnish

15. MARCHIGIAN SCHOOL, CENTRAL PANEL OF TRIPTYCH, VIRGIN AND CHILD

Pink of the Virgin's brow
 1. gesso of calcium sulphate and gelatin glue (150 μ)
 2. terre verte with egg (40 μ)
 3. very thin pink layer (10 μ)
 4. varnish
 5. layer of repaint: lead white and red with oil
Other samples taken from the cheeks and chin of the Virgin and the face of the Child show layers of pink repaint with oil, applied directly on the surface or on a thick layer of gum-resin.
Blue of the Virgin's mantle
 1. gesso as above
 2. thin grey layer of lead white and carbon black with oil
 3. light blue layer of finely ground azurite with egg (30 μ)
 4. a few crystals of lapis lazuli (sometimes absent) with very little or no medium
 5. repaint: copper blue with oil (80 μ)
 6. very thin grey layer with oil (5 μ)
 7. varnish (wax, resin and oil)

16. MARCHIGIAN SCHOOL, VIRGIN AND CHILD WITH SAINTS

Blue of the background
 1. gesso of calcium sulphate and gelatin glue
 2. thin layer of lead white with oil (10 μ)
 3. original blue layer with egg (25 μ)
 4. starch glue
 5. dark blue (Prussian blue) with oil (15 μ)
 6. light blue (Prussian blue and lead white) with oil (25 μ)
 7. varnish
Wing of the angel on the left
 1–6. same sequence of layers
 7. lead white with oil
 8. varnish

17. MARCHIGIAN SCHOOL, PAOLO DI GIOVANNI DA VISSO, VIRGIN AND CHILD

Hand of the Virgin (*Figure 10.5*)
 1. gesso in two layers: gypsum with gelatin glue
 2. verdaccio: terre verte with egg (40 μ)
 3. very thin pink layer (5 μ) with egg
 4. varnish
Robe of the Virgin
 1. gesso as above
 2. lapis lazuli with egg (50 μ)
 3. varnish

18. CAPRIOLI (END OF THE FIFTEENTH CENTURY), VIRGIN AND CHILD

Wing of the angel
 1. gesso of calcium sulphate mixed with chalk and gelatin glue (400 μ)
 2. pink (30 μ)
 3. varnish
 4. heterogeneous white layer with glue (30 μ)
 5. layer of glue
 6. gold leaf
Red of the background (*Figure 10.6*)
 1. gesso as above
 2. pink with egg (12 μ)

Figure 10.5 Flesh: hand of the Virgin (Painting no. 17)

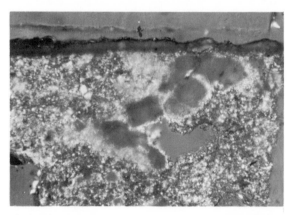

Figure 10.6 Red of the background: gesso mixed with chalk (Painting no. 18)

CONCLUSION

Taking all the results which we have presented, the following observations emerge:

The ground is always calcium sulphate, sometimes very pure (paintings 3, 7 and 12), sometimes mixed with chalk (paintings 4, 5, 6 and 18, *Figure 10.6*), always bound with gelatin glue. This gesso, very variable in thickness (120–400 μ), can be applied in one or two layers; the second layer, richer in glue, is generally prepared with very finely ground plaster. In painting no. 3 a third layer of gesso, very smooth and very thin, indicates a particularly careful preparation. The nature of the gesso (purity of the gypsum and glue content) and the number of layers do not seem to be linked to a given period or a particular school.

Over the gesso is found an impregnation either with oil (for example, no. 5) or with glue (no. 10) which ensures the impermeability of the surface.

The first paint layer may consist of a thin layer (10–20 μ) of lead white with oil (paintings 2, 7 and 16) or a grey or black imprimatura which does not cover all the gesso since it is not found on all the cross-sections (paintings 1, 6, 8, 11 and 15). One or the other of these layers is generally applied under the blues, the other colours usually being applied directly on the gesso.

The gold leaf is laid on a layer of red ochre, bound with white of egg. This layer may be thin and irregular (paintings 4 and 6), sometimes thicker (10–15 μ) and regular (paintings 9 and 13). The gold leaf is applied directly on the layer without glueing, the egg white acting simultaneously as a binder for the ochre and a glue for the gold leaf.

The flesh colour is obtained by a larger or smaller sequence of layers, generally including one of verdaccio and one or several layers of pink or green-yellow. The terre verte constituting the 'verdaccio' is either alone and bound with egg (paintings 1, 4, 8, 15 and 17) or mixed with lead white and similarly bound with egg (paintings 3 and 10). In certain paintings (2, 5 and 14) the layer of 'verdaccio' is absent. Over the 'verdaccio' we observe one or several pink or green-yellow layers, sometimes very thin (less than 10 μ) and generally bound with egg.

The blues (generally taken from the mantles of the Virgin) have often become so brown that the original colour is hidden. Numerous tests have enabled us to show that there may be two reasons for this browning, either that the proteinaceous medium has been oxidized and partially transformed into copper 'proteinate' (in the case of azurite crystals) or that the medium has disappeared, leaving lacunae between the blue crystals (*Figure 10.1*) which have been partially filled by the varnish. The successive cleanings and removals of varnish have not been able to eliminate this resinous brown mass which has penetrated too deeply between the pigments. This explains why one finds, associated with the blues, either egg-based media or oil-resin media, which are in fact residues of more recent varnishes. The layers of blue colour are applied either on a lead white or on a lighter blue layer of which the basis is lead white. We have found only two exceptions, in paintings 9 and 17, where the blue paint layer is applied directly on the gesso.

We have studied only one sample comprising a copper resinate in an oily medium.

For the other colours we have observed, on the cross-sections, two principal techniques:

1. a sequence of thin regular layers (20–40 μ), either bound with egg (paintings 3 and 9, hair of the angel), or bound with egg but with alternate layers richer in protein: the medium in this case might possibly be egg yolk and whole egg (painting 9, green of the bishop's robe, *Figure 10.4*); or, again, bound alternately with oil or with egg, in the works of the fifteenth century (paintings 11 and 14).
2. sometimes one finds only one or two layers, with the same medium, usually egg (paintings 8, 17 and 18).

Sometimes these two techniques may be found in the same painting; this is the case with the *Coronation of the Virgin* of Neri di Bicci, where we have been able to observe:

a single layer with egg for the mantle of Christ
one or two layers with egg for the robe of the angels
three layers with egg for the hair
four layers with egg for the green robe of the bishop.

The artist has opted for an application in one or several layers, according to the colour which he wished to obtain. Various techniques could thus be used simultaneously, at the same period and in the same studio.

Thus it seems likely that oil was only used in the fourteenth century for the impregnation of the gesso or in a layer of lead white applied on this gesso, the paint layers being specifically always with egg. In the fifteenth century certain layers (e.g. copper resinate, layers rich in lead white) may sometimes be in oil, but egg is still the favourite medium. Thus the recipes used seem to be thoroughly in agreement with those recommended and described by the master of the *Libro dell'Arte*, Cennino Cennini[5].

References

[1] Gay, M. C., 'Essais d'Identification et de Localisation des Liants Picturaux par des Colorations Spécifiques sur Coupes Minches', *Annales 1970 – Laboratoire de Recherche des Musées de France*, 8–24.

[2] Johnson, M. and Packard, E., 'Methods Used for the Identification of Binding Media in Italian Paintings of the Fifteenth and Sixteenth Centuries', *Stud. Conservation,* **16** (1971), 145–164.

[3] Mills, J. S., 'The Gas Chromatographic Examination of Paint Media', *Stud. Conservation,* 11 (1966), 92–106.

[4] Johnson, M., Rosenberg, H. E. and Skowronski, R. P., 'Thin-layer Chromatography of Sterols on Magnesium Trisilicate', *Stud. Conservation,* **16** (1971), 165–167.

[5] Brunello, F., *Il Libro dell'Arte di Cennino Cennini*, Neri Pozza, Vincenza (1971).

I I
Contribution to the Study of Aged Proteinaceous Media

LILIANE MASSCHELEIN-KLEINER

INTRODUCTION

Since one can only take a very little material from a work of art, analysis of the proteins formerly used as paint media is often very difficult. Numerous studies in this field have already been published. A detailed bibliography will be found in the recent article by Keck and Peters[1].

We have tried to improve the identification of the four principal proteinaceous media: animal gelatin, casein emulsion, the white and the yolk of egg. A very sensitive method at our disposal for this purpose is gas chromatography. One should first check, by a nitrogen test, that the medium does indeed contain protein[4].

PREPARATION OF VOLATILE DERIVATIVES

We chose N-trimethylsilyl derivatives because of their simplicity of preparation. The process was carried out in a glass test tube (length about 60 mm, internal diameter 2·5 mm).

1. PURE AMINO ACIDS

0·1 to 1 mg of amino acid was admixed with 40 μl of *bis*-(trimethylsilyl)-acetamide (Schuchardt BL 157, München) B.S.A. The tube was sealed, then placed in an oven at 110°C for three hours. The end of the reaction was characterized by the dissolving of the amino acid and the yellowing of the solution.

2. PROTEINS

1 to 10 mg of sample were introduced into a Pyrex tube (3 mm internal diameter, 10 cm long). 0·2 ml of 4% H_2SO_4 was added and the tube was sealed. Hydrolysis was carried out in an oven for 72 hours at 110°C. The product of hydrolysis was transferred by means of a pipette into a 10 ml beaker and neutralized with barium carbonate. The precipitate was eliminated by centrifuging followed by filtration. Most of the impurities were thus extracted at the same time as the barium sulphate. The filtrates were reduced on a hot-plate to about 0·5 ml, then introduced into a new Pyrex tube. To concentrate them, small quantities of acetone were added and the azeotropic mixture thus formed was evaporated. The last traces of moisture were eliminated by adding methylene chloride. 40 μl of B.S.A. were then added. If the tube was still damp, the reagent formed a white vapour and it was necessary to recommence drying. Silylation was carried out at 110°C for five hours.

The results thus obtained are better than with hydrochloric acid hydrolysis. In this case, it is difficult to eliminate certain hygroscopic salts such as chlorides, which is unfavourable for silylation.

GAS CHROMATOGRAPHY

1. EXPERIMENTAL CONDITIONS

Apparatus: Hewlett-Packard 5750 with flame ionization detector

84

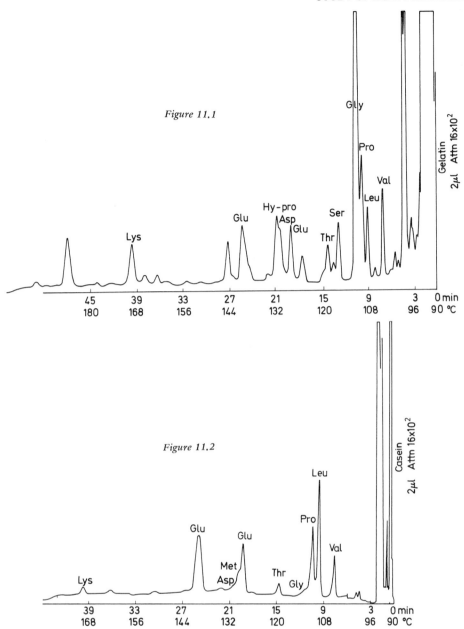

Figure 11.1

Figure 11.2

columns: 6 ft x 1/8 in. stainless steel containing
 10% UCC W982 on silanized chromo-
 sorb W.
injector: 195°C
detector: 400°C
temperature programme: 90°C to 220°C at
 2°C/min.
carrier gas: Helium, 30 ml/min.

2. SEQUENCE OF AMINO ACIDS

The reagent gives a high peak at the start of the analysis;
we shall take it as a reference point, for the following
relative retention times:

Reagent	1·00
Valine	1·67
Leucine	2·12
Proline	2·29
Glycine	2·43
Serine	2·98
Threonine	3·31
Glutamic acid	4·40
Methionine	4·57
Aspartic acid	4·72
Hydroxyproline	4·81
Glutamic acid	5·83
?	6·26
Lysine	9·10

Gehrke and Leimer[3] have shown that the silylation
of certain amino acids may lead to the formation of
more than one amino acid derivative. Thus glycine
gives di-trimethylsilyl and tri-trimethylsilyl derivatives.
Glutamic acid and lysine similarly form two. Our

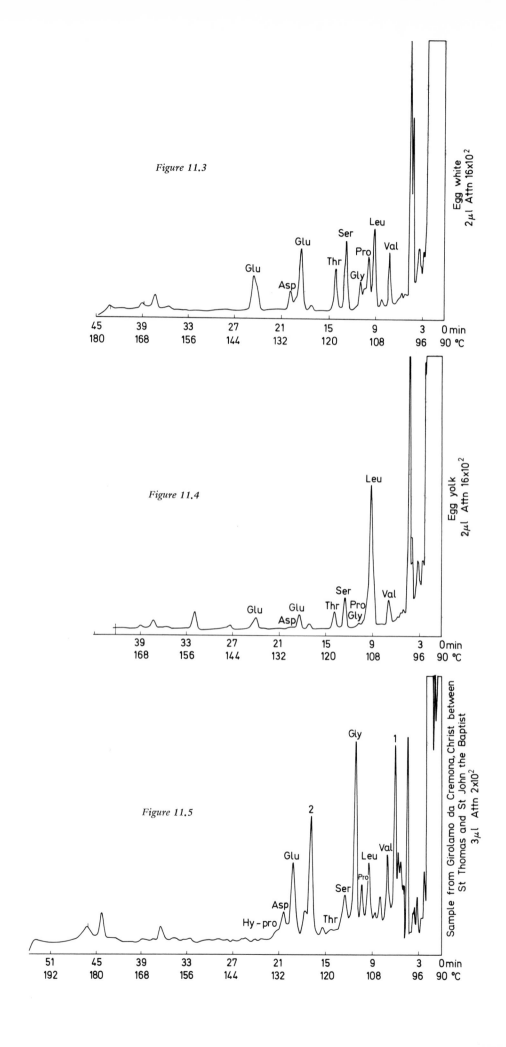

Figure 11.3

Figure 11.4

Figure 11.5

silylation conditions favour the formation of tri-trimethylsilylglycine which is advantageous because the di-trimethylsilyl derivative is masked by the reagent.

3. PROTEIN ANALYSIS

Hydrolized animal glue (rabbit glue, Angouleme, Rousselot S. A., Tournai) contains a lot of glycine (*Figure 11.1*). In addition, hydroxyproline is identified, although this acid is difficult to separate from aspartic acid.

Hydrolized casein (casein emulsion, F. R. Paris, Ets Meier-Garin, Brussels) contains hardly any glycine (*Figure 11.2*). It contains nearly equal quantities of leucine and proline. Keck and Peters[1] found the same result for casein dating from 1967, by means of ion-exchange chromatography.

We also observe a serine deficiency. Gehrke and Leimer[3] suggest in this connection the possibility of decomposition on the heated metal of the injector.

Hydrolized egg white, dating from 1933 (*Figure 11.3*) shows well-separated peaks of leucine, proline and glycine. Aspartic acid is well represented.

Hydrolized egg yolk dating from 1937 (the latter two samples were provided by Mr R. J. Gettens) (*Figure 11.4*) contains a lot of leucine, which masks even the proline. We should remember that not even Keck and Peters[1] identified proline in the sample of egg yolk dating from 1941.

4. APPLICATIONS

Girolamo da Cremona, *Christ between St Thomas and St John the Baptist*, fifteenth century, Musées Royaux des Beaux-Arts.

Panel painting, sample removed from the blue of the sky. *Figure 11.5* shows glycine as the principal constituent, as in animal gelatin. Two fractions, *1* and *2*, do not correspond to any amino acid. They indicate the presence of a substance which is not a protein.

Dirk Bouts, *Hell,* fifteenth century, Musée de Lille.

Panel painting; sample taken from the back. The separated fractions are the same as in the previous case. The medium is animal glue. An analysis carried out under other conditions[2] showed in addition traces of oil.

CONCLUSIONS

It is possible to characterize aged proteinaceous media by gas chromatography. We have tried, in fact, to distinguish mixtures of proteins with each other or with other kinds of media such as oil.

References

[1] Keck, S. and Peters, T., 'Identification of Protein-Containing Paint Media by Quantitative Amino Acid Analysis', *Stud. Conservation,* **14** (1969), 75–82.

[2] Masschelein-Kleiner, L., Heylen, J. and Tricot-Marckx, F., 'Contribution à l'Analyse des Liants, Adhésifs et Vernis Anciens', *Stud. Conservation,* **13** (1968), 105–121.

[3] Gehrke, C. W., and Leimer, K., 'Trimethylsilylation of Amino Acids', *J. Chromatog.* **53** (1970), 201–208.
Zumwalt, R. W., Roach, D. and Gehrke, C. W., 'Gas-Liquid Chromatography of Amino Acids in Biological Substances', *J. Chromatog.* **53** (1970), 171–194.

[4] Kühn, H., 'A Study of the Pigments and the Grounds Used by Vermeer', *Reports and Studies in the History of Art,* National Gallery of Art, Washington (1968).

12

Application of Mass Spectrometric Techniques to the Differentiation of Paint Media

NORMAN R. WEISS AND K. BIEMANN

The analysis of media has long presented many serious problems to the conservation chemist. Organic compounds of the types commonly encountered in any such study, lipids, proteins, carbohydrates, etc. are hardly easy to characterize in a precise way. Moreover, natural media, in contrast to synthetic ones, are invariably complex mixtures of these compounds, altered, often drastically, by age. An additional challenge is posed by the obvious limitations of sample size when dealing with the study of works of art. Some of these problems have been discussed by de Silva[1].

Earlier studies[2-6] have utilized such instrumental techniques as gas chromatography, infra-red spectrophotometry, and automated amino acid analysis in the attempt to characterize media. It is the intention of this paper to summarize briefly the studies which have been undertaken in this laboratory with yet another means of analysis, mass spectrometry.

THEORY

The basic principles of mass spectrometry were well established in the early years of this century. (Thomson[7], Dempster[8], and Aston[9] were among the pioneers in the field.) A charged particle, linearly accelerated by an electric field, is directed into a magnetic field that lies perpendicular to its line of flight. The particle is deflected by the force of the magnetic field into a curved path. The radius of curvature of this path is proportional to the ratio of the particle's mass to the charge that it carries. (For singly-charged ions, the deflection thus varies with mass.)

In the past decade, these principles have been successfully applied to the determination of the structures of organic compounds. A substance is vaporized at extremely low pressures (about 10^{-7} mm Hg), and molecules ionized in the gas phase by an electron beam. Many of the resulting 'molecular ions' (M^+) rapidly break up, yielding fragment ions of lower mass. This 'fragmentation pattern' is predictably determined by the structure of the molecule under study. The ions produced are then 'sorted' by their deflection in the mass spectrometer. The resulting plot of intensity (that is, the number of ions detected) versus mass-to-charge ratio (m/e) is a 'mass spectrum'. The position of ions in the spectrum thus provides a measure of molecular weight, and of the masses of sub-units of the molecule. Determination of structure is a process of logically re-assembling these units.

A number of excellent monographs dealing with the mass spectra of organic compounds have been published[10-12]. The existing body of periodical literature is already enormous, and its growth continues to be rapid. Much of this material deals with bio-medical applications and with the chemistry of natural products.

APPLICATION

The experiments which we have performed thus far have been carried out on three instruments of differing design, and illustrate four of the most useful mass spectrometric techniques currently available. The first, and most basic, experiments have involved the direct

insertion into the mass spectrometer (Du Pont Instruments 21–491) of small samples, typically about 0·1 mg, of various dried media films.

Early in this work, it was noted that the appearance of the spectra varied considerably with temperature. This was taken to be the result of thermal fractionation of the various components present in the samples. In such a case, it is useful to record a number of spectra while gradually increasing the temperature of the sample over as wide a range as possible. For these experiments, we use a mass spectrometer (Hitachi RMU-6L) which scans rapidly (about 4 seconds/spectrum) and repetitively, and is connected to an IBM 1800 computer to accumulate the data. As many as 400 spectra can be recorded in a single run.

Information of a more detailed nature can be provided by high resolution mass spectrometry (HRMS). A high resolution instrument (in this case, Du Pont Instruments 21–110) is able to measure the m/e of ions with a much higher accuracy, and thus makes possible the determination of their elemental compositions. For example, one can distinguish the presence of a methylene group, $-CH_2$, with a mass of 14·0156, from that of nitrogen, which has a mass of 14·0031.

We are also exploring the application to media analysis of combined gas chromatography-mass spectrometry (GC-MS). Gas chromatographic techniques have (as mentioned above) already been proved useful in this field by several researchers[2-4]. GC-MS allows for the mass spectrometric analysis of separated components of mixtures. A gas chromatograph is connected to the inlet system of the mass spectrometer (Hitachi RMU-6L). Rapid scanning allows for continuous monitoring of the gas chromatographic effluent.

In this way, several spectra are taken of each of the compounds present. Peak identification is thus possible from the structural information available in the mass spectra, and need not rely solely upon retention-time data. The selection of relevant spectra for detailed examination is made with the assistance of a 'total ionization' plot. This is a plot of intensities of the consecutive spectra versus spectrum number, and is analogous to an ordinary gas chromatogram. So-called 'mass chromatograms', plots of the intensity of a specified m/e versus spectrum number, can also be useful in interpreting the data.

EXAMPLES

The nature and scope of our experiments can be more precisely understood with the help of some specific examples. *Figure 12.1* shows a spectrum obtained when a sample from a dried egg yolk film (prepared a few months earlier) was heated to above 400°C. This spectrum, plotted above m/e 120, shows many of the characteristics of that of a triglyceride mixture[13]. The data indicate the presence of palmitic, stearic, oleic, and linoleic side chains. Indeed, the similarity to a dried oil film is a reflection of the difficulty often encountered in differentiating these materials by conventional means.

The presence of triglycerides is certainly not unexpected in the spectrum of an egg yolk film. More than 60% of the dry weight of the yolk is generally lipid material; more than 40% of the dry weight is reported to consist of triglycerides[14]. Thus the possibility of clearly distinguishing egg yolk (or whole egg) from oil must lie in the ability to analyse for minor components. An eight year old egg yolk film was examined with the MS-computer system described above. A total of 400 spectra was recorded in this particular run. *Figure 12.2* illustrates spectrum number 160, taken at 230°C. An interesting feature of the high mass end of the spectrum is the grouping of ions at m/e 353, m/e 368, m/e 371, and m/e 386. This series of ions is a familar aspect of the mass spectrum of cholesterol, a substance long recognized as a constituent of egg yolk[14]. A mass spectrum obtained with an authentic sample of cholesterol is shown for comparison in *Figure 12.3.*

Figure 12.1 Egg yolk film, 18 weeks old, 400⁺ degrees

Figure 12.2 Conservation Center Number 6, Spectrum Number 160

Figure 12.3 Cholesterol

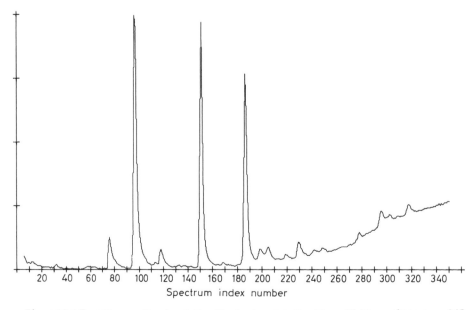

Spectrum index number

Figure 12.4 Fogg Museum Number 1, Total ionization plot, Run No. = 47, Num. of Spectra = 345

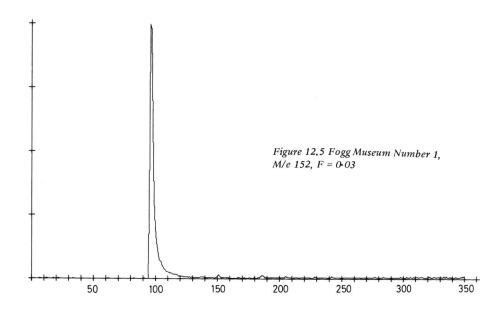

Figure 12.5 Fogg Museum Number 1,
M/e 152, F = 0·03

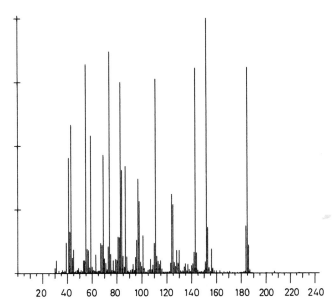

Figure 12.6 Fogg Museum Number 1, Spectrum Number 96

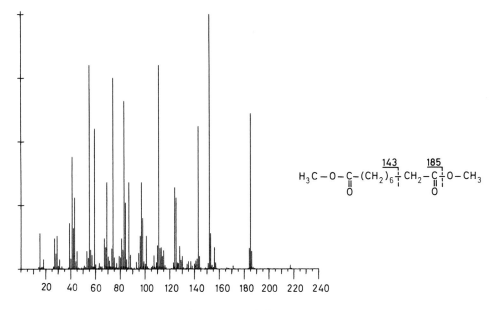

$$H_3C-O-\underset{\underset{O}{\|}}{C}-(CH_2)_6 \overset{143}{\vdots} CH_2-\underset{\underset{O}{\|}}{C} \overset{185}{\vdots} O-CH_3$$

Figure 12.7 Methyl azelate

This identification was further confirmed by high resolution mass spectrometry. The actual mass of the largest of these four ions was found to be 386·3551, which fits well the sum of 27 carbon atoms (at. wt. 12·0000), 46 hydrogen atoms (at. wt. 1·0078), and one oxygen atom (at. wt. 15·9949), i.e. $C_{27}H_{46}O$, the empirical formula of cholesterol. The data are summarized in *Table 12.1.*

Table 12.1.

Measured m/e	Ion Composition	Calculated m/e	Interpretation
353·3198	$C_{26}H_{41}$	353·3208	Loss of water and methyl group
368·3437	$C_{27}H_{44}$	368·3443	Loss of water
371·3324	$C_{26}H_{43}O$	371·3314	Loss of methyl group
386·3551	$C_{27}H_{46}O$	386·3549	Molecular ion

The presence of cholesterol has not been observed in any of the dried oil films that we have examined, and may, in fact, be the key to the distinguishing of egg yolk from other types of media. We are also currently testing samples of glair (egg white), and anticipate that the absence of lipid material in egg white will greatly simplify the task of recognizing it when it appears as a medium.

Figures 12.4—7 illustrate the format of our GC-MS data. The first of these is a 'total ionization' plot for a sample of methyl esters prepared from a 37 year old dried oil film. About 0·4 mg of the film was saponified with 0·5 N methanolic NaOH, and the methyl esters prepared with BF_3-methanol. This is a modification of the method of Metcalfe et al.[15]. Separation was done on a 6' column of OV-17, programmed from 90° to 300°C at 10°/minute. The three major peaks (at about spectrum numbers 100, 150, and 190) represent the methyl esters of azelaic, palmitic, and stearic acids.

Proof of the identification of methyl azelate is made with the use of the 'mass chromatogram' of m/e 152 shown in *Figure 12.5.* M/e 152 is the base peak (that is, the most intense peak) of the mass spectrum of methyl azelate, but is not commonly noted in the spectra of other methyl esters. The single, sharp peak in the 'mass chromatogram' is the result of this fact. Examination of spectrum number 96 (*Figure 12.6*), and comparison with the reference spectrum known to be that of methyl azelate (*Figure 12.7*), confirms the structure. Some of the interpretation of the 'fragmentation pattern' of methyl azelate

is presented in *Figure 12.7.* A more detailed discussion has been published by Ryhage and Stenhagen[16].

Acknowledgements

This work was supported in part by a Training Grant from the National Institutes of Health (GMO 1523). The authors wish to thank Miss Elizabeth Jones, Fogg Museum, Harvard University, and Professor Lawrence J. Majewski, Conservation Center, Institute of Fine Arts, New York University, for providing several of the samples used in these experiments.

References

[1] de Silva, R. H., 'The Problem of the Binding Medium Particularly in Wall Painting', *Archaeometry,* **6** (1963), 56.

[2] Stolow, N., 'The Application of Gas Chromatography in the Investigation of Works of Art', *Application of Science in Examination of Works of Art,* Museum of Fine Arts, Boston (1965), 172.

[3] Mills, J. S., 'The Gas Chromatographic Examination of Paint Media. Part I. Fatty Acid Composition and Identification of Dried Oil Films', *Stud. Conservation,* **11** (1966), 92.

[4] Masschelein-Kleiner, L., et al., 'Contribution à l'Analyse des Liants, Adhésifs et Vernis Anciens', *Stud. Conservation,* **13** (1968), 105.

[5] Lord, R. C., 'Application of Infrared Spectroscopy to Art Problems', *Application of Science in Examination of Works of Art,* Museum of Fine Arts, Boston (1965), 222.

[6] Keck, S. and Peters, T., 'Identification of Protein-Containing Paint Media by Quantitative Amino Acid Analysis', *Stud. Conservation,* **14** (1969), 75.

[7] Thomson, J. J., *Phil. Mag.* **21** (1911), 225.

[8] Dempster, A. J., *Phys. Rev.* **11** (1918), 316.

[9] Aston, F. W., *Phil. Mag.* **38** (1919), 707.

[10] Biemann, K., *Mass Spectrometry: Organic Chemical Applications,* McGraw-Hill, New York (1962).

[11] McLafferty, F. W., *Interpretation of Mass Spectra,* Benjamin, New York (1966).

[12] Budzikiewicz, H., Djerassi, C. and Williams, D. H., *Mass Spectrometry of Organic Compounds,* Holden-Day, San Francisco (1967).

[13] Barber, M., et al., 'The Mass Spectrometry of Large Molecules. I. The Triglycerides of Straight Chain Fatty Acids', *Tetrahedron Letters,* No. 18 (1964), 1063.

[14] Marion, W. W., 'Eggs' in *Kirk-Othmer Encyclopaedia of Chemical Technology,* 2nd ed., **7** (1965), 661.

[15] Metcalfe, L. D., et al., 'Rapid Preparation of Fatty Acid Esters from Lipids for Gas Chromatographic Analysis', *Anal. Chem.,* **38** (1966), 514.

[16] Ryhage, R. and Stenhagen, E., 'Mass Spectrometric Studies. III. Esters of Saturated Dibasic Acids', *Archiv. Kemi,* **14** (1959), 497.

13
An Improved Pyrolytic Technique for the Quantitative Characterization of the Media of Works of Art

GEORGE deWITT ROGERS

INTRODUCTION

Initial studies carried out in this laboratory demonstrated that the technique of pyrolysis gas chromatography (PGC) could be used to characterize and differentiate the various media found in works of art[1]. Those studies were done with a Perkin-Elmer pyrolysis accessory and a Perkin-Elmer 800 gas chromatograph and the results, while significant and encouraging, contained some undesirable features due to the nature of the instrumentation. One of the difficulties was the maintenance and detection of the actual pyrolysis temperature due to the great mass of the sample boat which acted as a heat sink; the large volume of the furnace; and the placement of the measuring thermocouple outside the furnace. Another difficulty lay in the 'dead space' between the pyrolysis outlet and the gas chromatographic inlet which allowed some of the pyrolysis vapours to condense out before reaching the column and others to bleed slowly into the column with deleterious effects on the resolution and separation. These technical difficulties, the unwieldy operation of the accessory and the moderately large sample size (approximately 0·5−1 mg) combined to reduce the efficiency and reproducibility of the PGC analyses, introducing variations of 10% in the retention times of the pyrogram. Thus, while the pyrograms could be qualitatively differentiated in regard to the different media, exact quantitative analysis was difficult.

The problem of irreproducible PGC analysis has plagued most workers in the field − not just this laboratory − particularly in their attempts to pyrolyse complex solids, and has occasioned a number of papers on its theoretical and practical connotations[2,3,4]. It now appears that a major source of this irreproducibility lies in the failure of the instrumentation to control the rate of temperature rise in the sample during pyrolysis as this, more than the final equilibrium temperature, determines the nature and extent of the polymer decomposition[4].

Recently, this concept of rate control has been combined with other concepts of heat production and sensing in a new pyrolysis instrument − the 'Pyroprobe 100 Solids Pyrolyzer'[5]−which offers the researcher a controlled temperature rise to a constant final temperature (which can be confidently set from 300 to 1000°C), rapid cool-down, and simplicity of operation, regardless of sample phase. This laboratory has purchased one of these units and it is the purpose of this paper to present an evaluation of its application to the characterization and possible identification of artistic media.

EXPERIMENTAL APPARATUS

The 'Pyroprobe 100' pyrolysis system consists of a sample probe, a gas chromatographic interface and a control module. Two different probes are provided with the instrument (*Figure 13.1*). One is a ribbon probe (R98) for samples that can be coated on the surface, and the other is a coil probe (C88) for solid samples which can be placed inside a quartz tube (25·4 mm by 2 mm internal diameter) and inserted in the coil. The probe is inserted into the interface which

93

Figure 13.1 The ribbon and coil probes for the 'Pyroprobe 100'. In the foreground is the quartz insert for solid samples

Figure 13.4 The total pyrolysis system. The 'Pyroprobe 100 Solids Pyrolyzer' connected to the gas chromatograph along with the electronic digital integrator

Figure 13.2 The front of the control module for the 'Pyroprobe'. Note the controls for: 1. 'INTERFACE' temperature, 2. 'RAMP' or rate of temperature increase, 3. 'INTERVAL' of pyrolysis, 4. 'FINAL TEMPERATURE', and also 5. 'CURRENT' meter, 6. 'RUN' button, 7. 'PROBE' connection

is directly connected to the injection port of the gas chromatograph, and the pyrolysis parameters are set by switches on the control module (*Figure 13.2*) (some gas chromatographs will have inlets that can accept the probe directly, obviating the interface). The large quantity of heat necessary for pyrolysis is produced from an electric current passing through a metal filament (the ribbon or the coil). Accurate control of both the rate of temperature increase and the final temperature of pyrolysis is achieved through control circuitry that employs the filament as both heater and sensor. With this design, the ribbon probe can achieve a temperature of $1000°C$ in 17 msec and cool down to $500°C$ in 290 msec while the coil probe can achieve a temperature of $1000°C$ in 1200 msec and cool down to $500°C$ in 2900 msec. The final temperature is set on the instrument with the aid of a calibration graph (*Figure 13.3*) and is reproducible to within $4°C$[6].

The rise in temperature can be controlled at rates at 20, 10, 5, 2, 1, 0·5, 0·2 and 0·1°C/msec and can be maintained for intervals of 20, 50, 100, 200 and 500 msec or 1, 2, 5, 10, 20 sec. In addition to these pyrolysis parameters the control module can heat the interface up to $500°C$ to prevent condensation of the pyrolysis vapours before they reach the column. The control box also contains a meter that indicates when current is being applied to the probe instrument.

The gas chromatograph (GC) used to analyse the pyrolysis vapours for this work was a Hewlett-Packard model 5750 with flame ionization detection. The detector output was fed to a Hewlett-Packard 3370A electronic integrator wherein the peaks were sensed, analysed and then displayed on an HP 17503A one-millivolt recorder. With this experimental arrangement (*Figure 13.4*) it was possible to measure, without attenuation of the detector signal, the retention times of the pyrolysis products to 0·01 min and the areas to 1 μV-second.

Figure 13.3 Calibration graph of coil probe C88 from data supplied by manufacturer

PROCEDURE

In operation, a solid sample is placed inside the quartz tube and the tube inserted into the probe coil. Then

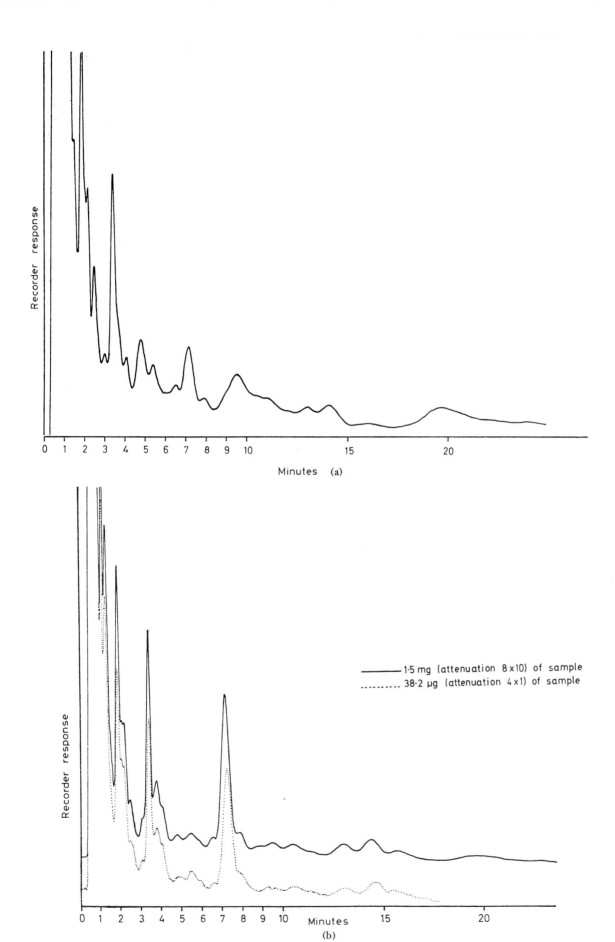

Figure 13.5 (a) Gas chromatographic analysis of the pyrolysis products (pyrogram) of a 7 year old, unpigmented linseed oil film. (attenuation 8 × 10). (b) Pyrograms of a 7 year old linseed oil/white lead film.

Figure 13.6 Representational pyrograms of pigmented and unpigmented oil films. A. Alkali refined linseed oil film, 7 years old. B. Linseed stand oil film. 11 years old. C. Linseed oil/white lead film. 7 years old. D. Linseed oil/iron oxide film, 7 years old. E. Linseed oil/barium sulphate film, 7 years old

the septum and its retainer are removed from the interface and the probe inserted and fastened by tightening the large knurled disc. The GC trace can be monitored for any products that will be evaporated from the sample at the interface temperature or until a stable baseline is obtained. With the conditions set on the control module the 'RUN' button is depressed (and the 'START' button of the integrator also, if area and time data are to be obtained) and the sample is pyrolysed automatically. At the end of the GC analysis the probe is unscrewed and removed from the interface and the septum replaced. The quartz insert is then cleaned of organic residue by a 20 sec pyrolysis at 1000°C in air. Naturally, inorganic residues, i.e. pigment, will remain on the insert but inserts are cheap and disposable. The GC trace and integrator tape are often available for interpretation.

In this report, paint samples were pyrolysed in the coil probe at 600°C for 20 sec, with a temperature rise of 20°C/msec. The interface was held at 200°C, and the pyrolysis vapours were analysed on 6 ft x 1/8 in

O.D. stainless steel column containing 10% UC-W98 on Chromosorb W (80/100 mesh) at 78°C. The injector and detector temperatures were 205° and 225°C respectively, and the nitrogen carrier gas flow was 57 cc/min. The detector output at 8 x 10 attenuation was fed to the digital integrator, and thence to the 1 mv full scale recorder, running at 0·5 in/min.

EXPERIMENTAL RESULTS

FIGURE 13.5.

(*a*) This is an example of the PGC analysis of a 7 year old, alkali-refined linseed oil film (unpigmented), and demonstrates completion of analysis in approximately 20 min from pyrolysis.

(*b*) These are the pyrolysis patterns of two different sample weights of a 7 year old white lead/linseed oil and demonstrate that as little as 38 *micrograms* of pigmented paint (equivalent to ∿7 *micrograms* of

Figure 13.7 Representational pyrograms of unpigmented media. A. Alkali refined linseed oil film, 7 years old. B. Egg white film, 2 years old. C. Gelatin. D. Mastic gum. E. Singapore dammar, lumps*

**Analyses done at attenuation of 4 x 10, instead of at 8 x 10.*

organic material) can give a distinctive pyrogram reproducible with that of a 1·5 mg sample, and still not exhaust the sensitivity of this instrumentation. It is also noted that the pigmented film and the unpigmented film give comparable pyrograms, and that this represents at least a tenfold decrease in sample size from that used in the previous report[1].

The rest of the pyrograms in this paper are presented in a reduced form wherein the area of each peak, as found by the digital integrator, is taken as a percentage of the area of the strongest peak and then plotted as a function of retention time. This representation is similar to that used in the field of mass spectroscopy and has been employed by others[7].

FIGURE 13.6.

This is a survey of three pigmented, and two unpigmented oil films, to show the effect of pigment on the pyrolysis pattern. In general, the unpigmented oil films and the white lead/barium sulphate films are very similar, with the major effect of the pigment being the doubling or tripling of the peak around 7·2 min. However, the iron oxide pigment seems to increase greatly the size of many of the common peaks, e.g. around 0·5, 1·1, 1·9, 3·4 and 7·2 min, and produce a new peak of 0·55 min. While the effect of pigment on the pyrolysis patterns of paints has been reported before as of little qualitative significance[1,8] it is known that iron compounds do affect the ageing reactions of oil paints — leading to greater depolymerization[1] — and have been shown to catalyse cyclization and isomerization of the pyrolysis products of tristearin[9]. Thus, the great increase in certain pyrolysis products would be expected with iron-rich samples, along with the appearance of new compounds which, if they were simple isomers, might not be resolved from the compounds usually found in oil pyrolyses. At the same time any slight differences due to pigments will be magnified on this instrumentation because of its increased efficiency and sensitivity.

FIGURE 13.7. FIGURE 13.8

A comparison of unpigmented linseed oil and other media shows definite differences in the individual cases and some group similarities. For example, the peaks at 0·9, 1·7, 2·3 and 3·6 show up in egg white but not in linseed oil. Mastic resin has more peaks than linseed oil in the regions 0–1 min, plus two significant peaks at 7 and 9 min. Dammar exhibits very few peaks and thus is easily differentiated from the other media. From the representations, mastic and dammar seem to be differentiable on the basis of quantities of peak while gelatin and egg white – both proteins – show many correspondences with a major difference being the peak ratios, especially the peak at 1·5 min in gelatin and the peak around 7·2 min in egg white.

To give some idea of the validity of these characterizations for media of greater age, linseed oil/white lead, egg yolk/white lead, and egg white/white lead samples were pyrolysed and compared with white lead samples taken from a Rembrandt painting and from a seventeenth century Dutch painting. As far as the young pigmented media go, egg yolk has a number of peaks similar to linseed oil although differing widely in relative area, e.g. 7·2, 3·4, 3·7, 1·75, 1·25, 1·08 and 0·6 min, but also contains significantly more peaks that would differentiate it, e.g., 1·5, 3·1, 8·9 and four peaks at less than 1 min. Egg white hardly matches linseed oil at all, especially with major peaks at 6·1, 2·3, 1·6 and three early peaks at less than 1 min. Egg white

Figure 13.8 Representational Pyrograms of white lead pigmented media. A. Linseed oil/white lead film, 7 years old. B. Egg yolk/white lead film, 2 years old. C. Egg white/white lead film, 2 years old*. D. Sample from Rembrandt painting dated 1650, white lead pigment. E. Sample from a seventeenth century Dutch painting, white lead pigment
*analyses done at attenuation of 4 x 10, instead of at 8 x 10

Table 13.1 COMPARISON OF RETENTION TIMES (MINUTES) FOR MAJOR PEAKS OF PIGMENTED AND UNPIGMENTED EGG WHITE FILMS.

Unpigmented (2 years old, egg white, averages of 3 PGC analyses)	White Lead Pigmented (2 years old, averages of 3 PGC analyses)	Iron Oxide Pigmented (2 years old, averages of 3 PGC analyses)
0·47 ± 0·02	0·47 ± 0·01	0·46 ± 0·01
0·63 ± 0·03	0·65 ± 0·01	0·65 ± 0·01
—	0·81 ± 0·01	*
0·96 ± 0·03	0·96 ± 0·01	0·97 ± 0·01
1·25 ± 0·03	1·28 ± 0·01	1·27 ± 0·01
1·55 ± 0·03	1·59 ± 0·01	1·59 ± 0·01
1·76 ± 0·03	*	1·78 ± 0·01
2·35 ± 0·03	2·37 ± 0·01	2·38 ± 0·00
3·63 ± 0·03	3·67 ± 0·01	3·68 ± 0·00
—	6·11 ± 0·01	*
7·20 ± 0·10	7·41	7·47 ± 0·00

*present but not detected by integrator due to surrounding peaks.

Table 13.2. COMPARISON OF RETENTION TIMES (MINUTES) OF MAJOR PEAKS FOR LINSEED OIL, STAND OIL, AND WHITE LEAD/LINSEED OIL FILMS.

Alkali Refined Linseed Oil (7 year old, naturally aged unpigmented film; averages of 4 PGC analyses)	Alkali Refined Linseed Oil/White Lead (7 year old, naturally aged pigmented film; averages of 3 PGC analyses)	Linseed Stand Oil (11 year old, naturally aged unpigmented film; averages of 3 PGC analyses)
0·50	0·57 ± 0·01	—
0·61 ± 0·02	—	0·64 ± 0·02
1·06 ± 0·02	1·04 ± 0·02	1·09 ± 0·01
1·26 ± 0·01	1·23 ± 0·02	1·30 ± 0·02
1·53 ± 0·02	—	—
1·89 ± 0·02	1·82 ± 0·02	1·94 ± 0·01
2·16 ± 0·03	2·16 ± 0·02	2·23 ± 0·02
2·57 ± 0·03	2·55 ± 0·06	2·67 ± 0·01
3·47 ± 0·04	3·37 ± 0·02	3·51 ± 0·03
—	3·78 ± 0·02	—
4·7 ± 0·1	—	4·63 ± 0·01
5·4 ± 0·1	5·47 ± 0·03	5·54 ± 0·01
7·1 ± 0·1	7·17 ± 0·01	7·30 ± 0·04

Table 13.3. COMPARISON OF RELATIVE AREAS OF SOME MAJOR PEAKS IN PYROGRAMS OF LINSEED OIL FILMS.

Average Retention Time (minutes)	Peak Area as Percentage of Area of Largest Peak	
	Alkali Refined Linseed Oil	White Lead/Linseed Oil
1·26	17, 37, 21	23, 25
1·89	14, 17, 15	16, 20
3·47	12, 15, 13	16, 16
7·2	7, 9, 8	20, 27

and egg yolk have similarities in the region 0—1·5 min but the major peaks at 1·75, 2·1, 3·4 and 3·7 in egg yolk are missing in egg white. Both the seventeenth century samples (which were found to have linseed oil as their medium before[1]) are comparable with the 7 year old white lead/linseed oil reference, and with the unpigmented oil — more so than with any other medium studied.

The reproducibility of the PGC analyses of any particular sample of media is within 1% overall. Usually the retention times of repetitive runs will vary by only plus or minus 0·02 min. (In the egg white series, (*Table 13.1*) both pigmented films yield pyrograms that have major peaks that agree in retention time to 0·01 min). In the oil series, however, there are greater variations both within pyrolyses of the same sample and between linseed oil, stand oil and the pigmented oils (*Table 13.2*). At the moment, the resolution of the peaks and the small number of samples tested preclude any thorough statistical analysis of significance, but it appears from an inspection of the

99

pyrograms *in toto* that these variations reflect more on variations in pyrolysis efficiency than on variations in the thermal products. The physical nature of the medium and its matrix will determine to a certain extent the rate of heat transfer from the coil to the organic material, and this will determine the rate of evolution of the chemical compounds that make up the pyrolysis vapours. Most likely these factors affect the injection volume of particular compounds and hamper their separation and resolution on the gas chromatographic column. Some evidence for this lies in the 'shifted' appearance of replicate pyrograms, wherein the peaks differ between runs by a roughly constant factor. Further evidence is found in *Table 13.3,* where the relative areas for major peaks of linseed oil and white lead/linseed oil films show variations within analyses of the same sample, and yet exhibit an overall trend i.e., roughly equal areas for the first three peaks noted and a tripling of the peak at 7·2 for the white lead film.

CONCLUSIONS

The quantitative results in regard to retention time and area measurement demonstrate simultaneously the power and limitation of the total technique. The integrator can sense the retention times to 0·01 min and areas to 1 μV-second as previously stated. However, its accuracy and reproducibility are directly related to the resolution and reproducibility of the analytical column, and it is obvious from the three pyrograms presented in full in this paper that all the components of the pyrolysis vapour are not being resolved and separated completely, and that this represents the major source of error in the present quantitative data. Even so, these results represent an increase in both reproducibility and sensitivity of a factor of 10 over the Perkin-Elmer system used before.

The minor effect of pigments — particularly iron oxides — can be dealt with quite easily by the quantitative aspects of the instrumentation and can be used to strengthen the identification of a medium. Finally, the installation of the pyroprobe unit ensures that all of the vapours are produced no more than 25 cm from the analytical column and their transit is through a heated line that ensures the analysis of all compounds produced.

Thus it has been demonstrated that the 'Pyroprobe 100' pyrolysis system coupled to a good analytical gas chromatograph and an electronic digital integrator can produce qualitative and quantitative characterization of media of works of art. Since qualitative differences were already described in a previous paper[1], the emphasis of this research has been on improving the PGC analytical system to the point where reproducible quantitative results can be obtained on very small samples which will serve to characterize not only single component media of works of art, but multi-component media. With the utility of the pyrolysis instrument established, and the efficiency of the integrator known, further work will concentrate on the last factor, i.e., the analytical column. In this area the open tubular column[10] which offers the benefits of reduced sample size and increased resolution over conventionally packed columns, will probably be the optimum choice.

It is also evident from this work that a good statistical base must be built up for each medium. In this way effective differences in peak area and retention times can be utilized in identifying the media of works of art and artifacts.

Acknowledgements

The author would like to thank Dr Nathan Stolow, Director of the Canadian Conservation Institute, for his continued support during this project; Mr. Raymond Lafontaine for the many PGC analyses that he performed and for his helpful suggestions; and Dr J. F. Hanlan for his interest and comments.

References

[1] Stolow, N. and Rogers, G. de W., 'Further Studies by Gas Chromatography and Pyrolysis Techniques to Establish Ageing Characteristics of Works of Art' in International Seminar on *Scientific Examination of Works of Art,* Museum of Fine Arts, Boston, 15—19 June 1970.

[2] Juvet, R. S., Smith, J. L. S. and Li, K. P., *Advances in Chromatography 1971* (edited by A. Zlatkis), University of Houston Publishers, Houston (1971), 166.

[3] Levy, R. L., Fanter, D. L. and Wolf, C. J., *Advances in Chromatography 1971* (edited by A. Zlatkis), University of Houston Publishers, Houston (1971), 155—59.

[4] Guiochon, G. and Farré-Rius, F., 'On the Conditions of Flash Pyrolysis of Polymers as Used in Pyrolysis — Gas Chromatography', *Anal. Chem.* **40** (1968), 998—1000.

[5] The Pyroprobe 100 Solids Pyrolyzer, manufactured by Chemical Data Systems Inc., Oxford, Pa., U.S.A.

[6] Martin, A. J., Sarner, S. F., Averitt, O. R., Pruder, G. D. and Levy, E. J., 'Controlled Heating Rate Pyrolysis — A New Concept in Solids Pyrolysis', *Bulletin CDS100—371A,* Chemical Data Systems Inc., Oxford, Pa., U.S.A.

[7] Walker, J. Q. and Wolf, C. J., 'Complete Identification of Chromatographic Effluents Using Interrupted Elution and Pyrolysis—Gas Chromatography', *Anal. Chem.,* **40** (1968), 711—714.

[8] Jain, N. C., Fontan, C. R. and Kirk, P. L., 'Identification of Paints by Pyrolysis—Gas Chromatography', *J. Forensic Soc.,* **5** (1965), 102—109.

[9] Shulman, G. P. and Evans, E. L., 'Thermal Decomposition of Tristearin', 61st Annual Meeting, *Amer. Oil Chem. Soc.,* New Orleans, 26—30 April 1970.

[10] Ettre, L. S., *Open Tubular Columns in Gas Chromatography,* Plenum Press, New York (1965).

PRACTICAL PAINTING RESTORATION

14
The Use of Dimethylformamide Vapour in Reforming Blanched Oil Paintings

HERBERT LANK AND VIOLA PEMBERTON-PIGOTT

Figure 14.1 shows a detail of an eighteenth century Venetian oil painting on canvas, which had been accidentally left in a leaking case during several days of heavy rain. It was established that the paint below the varnish had completely blanched (see right side of *Figure 14.1*).

Gas chromatography analysis[1] showed the medium of the painting to be essentially linseed oil. Microscopical examination and chemical analysis of paint samples revealed that no blanching of the pigments had taken place (see report below on examination of paint samples). The breakdown was therefore of the medium and not of the pigments. The mechanism leading to the blanched effect has not been precisely established but may be due, at least in part, to the leaching out of water-miscible components of the drying oil film.

After removal of the perished varnish, solvents, both as liquid and as vapour, were found to be ineffective in removing the blanching when applied to the surface of the paint. These solvents included acetone, alcohol, diacetone alcohol, morpholine and triethanolamine. A drastic method described in the nineteenth century by Secco-Suardo[2], tried experimentally on a small area, was found to be partially successful. It consists in pouring alcohol on the picture and lighting it. The considerable risk to the areas of dark glazes ruled out this method. Further trials showed that exposing the blanched paint to dimethyl formamide vapour completely reformed the oil medium of the paint (see report on examination of paint samples and *Figures 14.2, 14.3* and *Colour Plates 14.1, 14.2*).

Since the first trials in 1970, this method has been used successfully on a considerable number of pictures in which the visual unity had been distorted by areas of blanched paint; for instance, the blanched areas, consisting mainly of green glazes often found in seventeenth century pictures, can be reformed.

Another application, which is sometimes successful, consists in softening hard repaint, thus allowing it to be safely removed by mild solvents or scalpel.

APPARATUS

The improved apparatus[3] used to effect the treatment described below is illustrated in *Figures 14.4 and 5*. It consists of a bottomless box, 66 cm x 55 cm, with a sliding lid. The sides are made of 65 cm-wide extruded aluminium strips, supporting a wire mesh (1000 μ) tray, 2·3 cm from the underside of the box. A felt pad, 9·5 mm thick, is placed on top of the wire mesh.

The vapour box is held rigidly by an overhead grid on runners, allowing it to be moved above the picture surface (see *Figure 14.5*). Further mobility is obtained by castors attached to the legs of the table supporting the picture. Vertical control is achieved by retracting the box support uprights into those overhead, by means of a pulley system with a ratchet lock.

As the picture surface is rarely parallel to its back, fine adjustment is provided on the four sides of the box by wing nuts on spring washers (see *Figure 14.4*). A fan extractor is fitted to a hood, hinged centrally in two sections above the box.

103

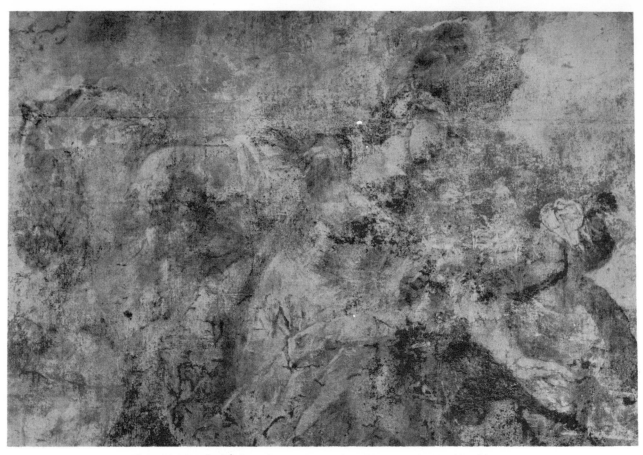

Figure 14.1 Detail of eighteenth century Venetian oil painting showing blanching

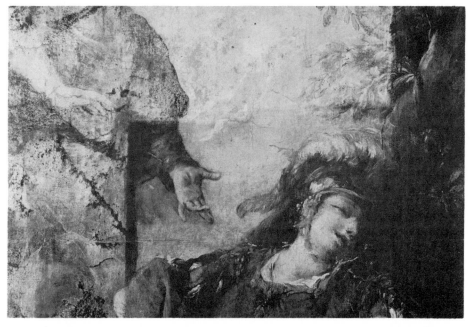

Figure 14.2 (a) Detail showing the re-forming process partially completed

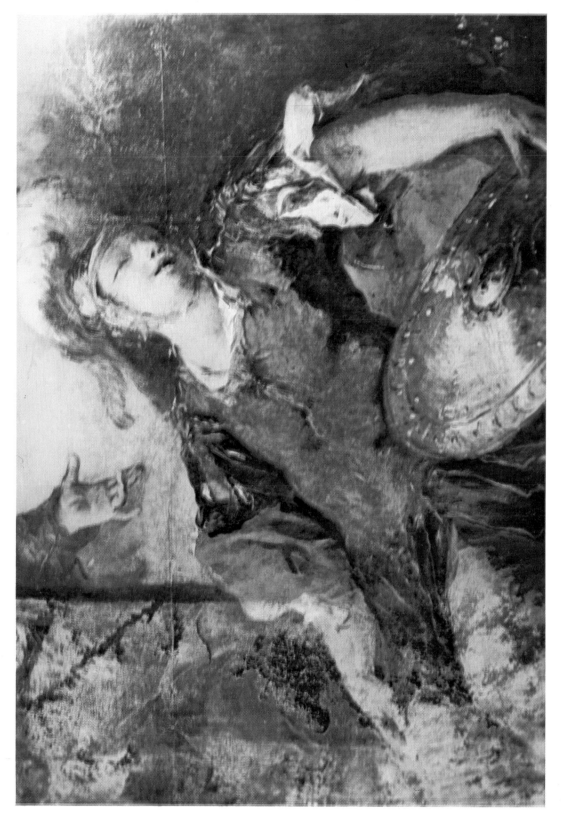

Plate 14.1 Detail of blanched oil painting showing treatment partially completed

Plate 14.2 Detail of blanched oil painting showing treatment partially completed

Figure 14.2 (b) Detail showing the re-forming process partially completed

Figure 14.3 Detail showing the result of the re-forming treatment

Figure 14.4 Detail of apparatus, showing tray and felt pad

TREATMENT

The felt pad is saturated from the top with dimethyl formamide (DMF)[4]. Complete penetration of the pad is not required, nor is it advisable, as care must be taken to avoid surplus solvent dripping from the wire mesh onto the picture. The lid of the box is closed.

The box is then raised by the pulley to a height above the work-table and the picture is placed in position, face upwards. Adjustments are made to bring that portion of the paint requiring treatment directly beneath the box. The box is then lowered slowly and fine adjustments are made to allow it to 'float' minimally above the picture. The sides of the box should not touch the paint surface. Slight fan-extraction is now sufficient to contain any escaping fumes.

The length of treatment varies between 2–20 hours. The painting should be examined hourly. Once saturated, the felt pad will retain adequate solvent strength for several weeks. No further cleaning should be undertaken on a treated picture for at least ten days.

Small containers for local treatment are easily devised.

Regeneration of paint with DMF vapour is usually effective, even through recently applied varnishes. These appear generally unchanged. It is, however, advisable to replace these some time after treatment,

whenever possible, because their eventual breakdown may have been accelerated.

REPORT ON EXAMINATION OF PAINT SAMPLES
by Joyce Plesters, National Gallery, London.

At an early stage in the investigation of the picture's condition and possible treatment, a number of paint samples was taken with the object of discovering whether the blanching involved change in the medium or pigments or both. It will be seen below that it was established that the blanching was due to changes in the medium only. Subsequently a further series of samples was taken in order to compare the effectiveness of different methods which were tried out for regenerating the medium, and to compare original unblanched paint (from the undamaged corners and edges of the picture) with paint affected by different degrees of blanching, and with paint of which the medium had been treated in order to try to regenerate the medium and restore the original appearance.

THE PAINT MEDIUM

Although blanching of this type (which appears to be associated with changes in medium rather than pigment) is always difficult to reverse, there are a few

Figure 14.5 The apparatus in use

methods which have been used to 're-form' the paint film when the latter is oil paint. It was therefore considered important to establish that the medium of the painting was in fact drying oil. In an analysis carried out a few years ago of samples from the series of paintings by Giannantonio Guardi, *The Story of Tobias and the Angel* in the church of Sant' Angelo Raffaelo in Venice, the results of the gas chromatographs were rather ambiguous and could have been interpreted as indicating a mixture or emulsion of protein and oil. The *Tobias and the Angel* series shows the same pale colours and impasto highlights as this picture. Samples of the paint layers were taken from several areas of the picture, the medium extracted and subjected to analysis by Dr J. S. Mills using the method of gas chromatography. Results showed fatty acids and their breakdown products characteristic of drying oils in general and of linseed oil in particular. There was no indication of the presence of egg or any other

protein. It may be concluded that the picture is painted in a medium which is essentially linseed oil; consequently methods suitable for regenerating oil paint may be considered for the blanched areas.

Almost the entire area of the large picture was affected by blanching. The only unaffected parts were at the corners and narrow strips along each of the four edges, presumably where the picture had been protected by the struts of the packing case. A series of samples was taken from pale blue paint on the unaffected strips on the left and right edges, and from adjacent blanched areas. Samples were also examined from areas of pale blue paint treated with dimethyl formamide vapour which were close to the areas from which were taken the two series of samples of unaffected and blanched paint described above. A fourth set of samples was also taken from a small area of the picture on which the method of Secco-Suardo (described above) had been tried.

107

PRACTICAL PAINTING RESTORATION

MICROSCOPICAL EXAMINATION

The top surface of a paint fragment from each of the samples was examined and photographed under the microscope at 65x. The same fragment in each case was then mounted in a block of transparent synthetic resin and one face of the latter ground and polished in the usual way to expose a cross-section of the edge of the paint fragment so that the layers could be studied under the microscope. Colour photo-micrographs of the cross-sections so prepared were taken at 110x magnification. Microchemical tests were made to identify the pigments present which proved to be, in the uppermost blue paint layers of all the samples examined, lead white mixed with Prussian blue.

OBSERVATIONS ON MICROSCOPICAL EXAMINATION AND PHOTOMICROGRAPHS OF THE SAMPLES

The first conclusion to be drawn from the microscopical examination of the samples is that the blanching is essentially a surface phenomenon, its effect probably not extending into the top paint layer for much more than $10-20 \mu$. 10μ is approximately the thickness of a single coat of mastic varnish. The remainder of the thickness of the uppermost paint layer (its total thickness may vary between, say, $30-80 \mu$ from sample to sample) seems unaffected, as do the layers of underpaint and the red-brown ground. It is fortunate that, as with most eighteenth century Venetian pictures, the red-brown ground has an oil medium. Had the ground been gesso, having a water-soluble glue medium, as is often the case with Venetian sixteenth century pictures on canvas, the painting might not have survived its ordeal by water at all. It need not occasion surprise that a phenomenon affecting so little of the thickness of the paint film (which itself is of considerable thickness in many parts) should cause such a devastating alteration to the surface appearance of the picture. It may be recalled that the 'bloom' which occurs on mastic varnish is a layer of ammonium sulphate crystals or their dissolved droplets of a thickness considerably less than that of the varnish layer itself, yet is capable of effectively obscuring the surface of a picture. It was therefore not unexpected that microscopical examination of the paint surface and of cross-sections of the samples did not show dramatic differences between the unaffected, the blanched and the regenerated parts. Nevertheless there were small and significant differences. Under the microscope the affected paint appears almost white on the top surface and with a rough 'lumpy' appearance compared with the surface of the unaffected paint. Discoloured varnish could still be seen in a crack in the surface of the paint. In the paint sections the topmost part of the blue layer looked a paler colour than in the unaffected samples and had small white inclusions. The paint surface beneath the varnish was no longer a smooth, straight line as in the unaffected samples, and small particles of whitish paint or pigment seemed to have pushed themselves up into

the varnish layer. They may well be partly responsible for the general whitish appearance of the paint surface.

In samples and sections from areas of paint treated with dimethyl formamide vapour it could be seen under the microscope that the paint surface had become deeper blue in colour and smoother in surface than samples from the affected areas and, in fact, closely resembled in appearance the samples from the unaffected areas.

The samples from the areas treated by igniting alcohol on the picture surface showed that this method had also been successful to some extent in regenerating the blue colour and dispelling blanching. However, a cross-section through the paint when viewed under the microscope at a higher (c.200x) magnification still shows some irregularity on the surface, the presence of white nodules, and, in addition, a few carbon black particles lodged on the surface which do not appear in any of the other three series of samples.

POSSIBLE MECHANISMS OF BLANCHING AND REGENERATION

The oil medium of oil paint can in general be assumed, when dry, to form a comparatively clear and transparent solid film in which the particles of pigment are suspended. Although brief contact with water has no noticeable effect on oil paint, prolonged soaking may cause water to be absorbed by the film and, since it is immiscible with oil, will produce a white turbid effect like an emulsion. With even more prolonged contact with water, the oil paint film may soften and ultimately disrupt. In cases where blanching is only slight, as for example that caused by steam from moisture in the materials during a relining operation, gentle dry heat, such as that provided by a heated spatula or relining iron, may suffice to dispel the moisture and cause the turbidity to disappear. In more severe cases, stronger measures have to be taken which generally involve the use of a solvent or chemical reagent which will partly dissolve or react with the oil medium so as to soften the paint itself. On re-solidifying, the paint film often regains its original appearance, presumably with loss of porosity or dispersion of enclosed moisture. Solvents or reagents sometimes used for this purpose include diacetone alcohol (a neutral organic solvent which will swell oil paint), and more or less alkaline reagents such as ammonia, triethanolamine, morpholine and dimethyl formamide.

None of the above methods, including the application of liquid dimethyl formamide, was successful in regenerating the surface of this picture. The difficulty in this case was partly the high degree of blanching and partly the presence of a comparatively intact varnish film which could not be removed before carrying out any operation to regenerate the paint film, because of the latter's deteriorated condition as a result of the damage by water. The success of the method was probably due to the fact that the dimethyl formamide vapour (unlike the liquid form) was

capable of penetrating the varnish film and entering the paint layer beneath. Dimethyl formamide has no effect on the pigments themselves, either on lead white or Prussian blue.

Acknowledgement

The invaluable advice and assistance of Miss Joyce Plesters and Dr J. S. Mills of the Scientific Department, National Gallery, London, is gratefully acknowledged.

References and Notes

1 Gas chromatography analysis of the medium of the paint was carried out by Dr J. S. Mills, Scientific Department, National Gallery, London.

2 Secco-Suardo, G., *Il Restauratore dei Dipinti*, Part II, Chapter I describes 'Il Metodo Guizzardi per Amollire col Fuoco le Croste e le Vernici Dure' and comments 'questo terribile mezzo, che constituisce il punto culminante di quanti se ne ponno adoperare sopra i dipinti'. Part I of the work was published in 1866; Part II was completed in 1873 and published posthumously in 1894.

3 The apparatus was constructed by John Money Designs Ltd, 109 Queen's Road, London SW19, England.

4 DMF is hazardous to health, particularly by skin absorption. The following precautions should be taken by all operatives handling DMF:

1. Contact with skin and contamination of personal clothing should be avoided. Protective overalls, eye protection and disposable gloves should be worn.

2. Splashes on the skin should be washed off immediately with soap and water.

3. The box should preferably be loaded in a fume cupboard, or in the open, before attaching it to the rest of the apparatus. Extractor fans must be full on.

4. Reports indicate that women operatives considering pregnancy are strongly advised to be punctilious in avoiding contact with DMF and related solvents.

15
Treatment of Cupped and Cracked Paint Films Using Organic Solvents and Water

MARGARET WATHERSTON

INTRODUCTION

Initially most paintings are two-dimensional — the artist applies paint to a flat surface, usually canvas; with time, deterioration and accidents may occur which change the flat surface into a three-dimensional one. Expansion and contraction of the threads in a canvas due to fluctuations in humidity will gradually cause an oil paint layer and ground to develop a pattern of cracks, as they become less flexible with age. The cracks are frequently accompanied by gradual cupping of the paint layer so that there is surface distortion of the painting into ridges and hollows. An accidental blow to the back of the canvas, or lack of adhesion between the surface paint and the layer beneath it, can produce lifting and flaking of the paint layer. All such changes in the surface alter the reflections of light from it and therefore change the image presented to the viewer. This destroys the aesthetic intentions of the artist.

These changes in the paint layer and ground have been treated in various ways over the years. For example, during the lining process, damp paper has been introduced between the original canvas and the lining canvas, to correct cupping of the paint layer; and to correct flaking, adhesives have been used from the front or back of the painting.

This report is a revision, with additional material, of a report given in 1969[1] in which I suggested that certain organic solvents, mixed with water, appeared to be effective in treating cupped paint layers, flaking, and interlayer cleavage, when used in conjunction with the controlled heat and pressure provided by the

vacuum table. The treatment described in this article is a *separate procedure* to be completed on the vacuum table prior to lining of the painting.

The action of the organic solvent and water vapours gradually rising through the painting from underneath, going into the facing layers and then being removed by the vacuum pump — accompanied by controlled heat and pressure — is completely different from the action of the same solvents when applied to the surface of the painting as in cleaning. The idea of using solvent vapours (mainly to improve deteriorated varnish layers) was tried in the past without lasting success, in the 'Pettenkofer method'. This, however, was many years before the invention of the vacuum table which provides the controlled heat and pressure essential for the treatment outlined in this report.

We hope that the procedure outlined here — which combines solvent and water vapours with controlled heat and vacuum pressure — may bring about improvement of a more lasting nature. The results over the past several years have been very encouraging, but it is impossible to say whether they will continue to be successful over a longer period.

A painting should always be examined with a low-power binocular microscope to determine the successive layers of paint that may be present in areas where the surface has cracked or flaked. Only then is it possible to decide what mixture of water and organic solvents should be used and what length of time on the vacuum table is necessary.

This report is in three sections. The first deals with the procedure usually followed for the treatment of paintings where a simple paint structure is involved —

110

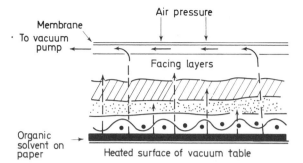

Figure 15.1 Arrangement of painting on vacuum table for water/organic solvent treatment

i.e., the artist has applied his paint, thinned with linseed oil and turpentine, directly onto a canvas prepared with a linseed oil ground; there is no particularly noticeable brushwork or impasto. The second section deals with more complex paint layers and other special cases. The third section gives tests done to arrive at this approach and lists sources of materials.

Figure 15.1 is a schematic representation of a painting on the vacuum table, with the various materials used above and below it during the water/organic solvent treatment.

MATERIALS – PHYSICAL MODALITIES AND THEIR FUNCTIONS

ORGANIC SOLVENTS

The organic solvents used must have specific properties:
1. a softening effect on oxidized linseed oil films;
2. miscibility with water, so that the concentration of the solvent can be changed;
3. a slow rate of evaporation.

Cellosolve acetate, dimethyl formamide and occasionally pyridine are the organic solvents used.

DISTILLED WATER

Water is used to change the concentration of the solvent or solvents; it also softens the glue sizing in the canvas threads and assists in flattening the canvas since, in extremely cupped paintings, the fabric tends to follow the contours of the paint layer.

FACING LAYERS

Facing materials used during treatment are as follows:
1. Layer of varnish in contact with the surface of the painting.
2. Layers of varnish or cellulose gum applied to 1.
3. Layer of facing paper.
4. A sheet of porous material impregnated with silicone.
5. Blotting paper.

More detailed descriptions and reasons for their use are given in the following pages.

TREATMENT OF CUPPED AND CRACKED PAINT FILMS

HEAT

The heat source is provided by the vacuum table. Heat gradually vaporizes the mixture of organic solvents and water which rises through the canvas, ground and paint layer. The combination of heat and solvent vapours temporarily softens the paint layer and it gradually flattens.

VACUUM PRESSURE

The painting is kept under light pressure on the vacuum table while the heat and solvent mixture soften the paint layer. As the paint layer becomes more plastic, the light uniform pressure from above causes raised paint to flatten and return to its original plane. Solvent and water vapours are drawn off by the vacuum pump. Brushwork and impasto, when present, are not affected (see Figures 15.2 and 3).

STUDIO PROCEDURES

It is absolutely essential that anyone interested in working with the treatment suggested read this article very carefully and determine in advance the type of paint structure involved. Everything suggested is essential if problems are to be avoided, and no short-cuts, such as eliminating 'cushion' layers or shortening the treatment time on the vacuum table, should be contemplated.

PREPARATION OF THE PAINTING FOR FACING

Surface grime is removed from the painting, as it could become embedded in the softened paint layer during treatment and be difficult to remove later. Old varnish is also removed along with any trace of surface grime left from previous cleanings which may be found beneath it. For cleaning, cotton-tipped applicators are used, one or more at a time, with suitable solvents, depending on the condition of the surface. If the paint layer is too fragile to permit cleaning the painting is first lined on the vacuum table with wax-resin adhesive, then cleaned prior to treatment.

APPLICATION OF 'CUSHION' LAYERS OF ACRYLIC RESIN OR CELLULOSE GUM

A heavy glossy layer of facing material (either acrylic resin or cellulose gum) is built up on the surface of the painting by brush coats or spraying. Generally five brush coats of the mixture described in the following paragraph are sufficient to form an adequate protective layer to which facing paper will be attached. The 'cushion' layer is extremely important because, without it, the facing paper could become struck to the paint, when the latter is temporarily softened during treatment.

Figure 15.2 Detail (slightly enlarged) of flaking on early twentieth century American painting, before treatment

Figure 15.3 The area shown in Figure 15.2, after treatment

Figure 15.4 Klucel facing being removed without solvents after water/organic solvent treatment of the paint layer: A. Klucel, B. silicone-treated Pellon

Acrylic resin (Elvacite 2044) is used for the 'cushion' layer when an old lining and aqueous adhesive have to be removed from the back of the painting. Cellulose gum (Klucel Type E) is used when there is no lining or adhesive to be removed. Klucel does not adhere to the surface of the painting as well as Elvacite 2044 and is unsuitable when extensive work has to be done on the back prior to treatment. Klucel has the important advantage of being easily detachable from the surface of the painting after treatment (see *Figure 15.4*). This saves time and there is no need to use solvents to dissolve a heavy resin layer.

Elvacite 2044 comes in granular form and is made into a stock solution, which is used for brushing, of one part resin to four parts solvent (petroleum benzine) by weight. The stock solution is diluted with four parts by volume of petroleum benzine if spraying is necessary.

Klucel Type E also comes in powder form and is soluble in a variety of organic solvents and in cold water. A stock solution which is used for brushing is made up of one part Klucel added gradually to four parts of methyl alcohol by weight. Methyl alcohol was selected because it can be used safely with older paint layers and also with acrylic paint in contemporary works where one may have to treat pressure cracks. A painting in oil is first given two thin layers of Elvacite 2044, as a foundation for the Klucel. Elvacite resin is not affected by methyl alcohol in which Klucel is dissolved.

FACING THE PAINTING

After the cushion layers of either Elvacite 2044 or Klucel Type E have been applied, the painting is faced with a sheet of wet-strength paper applied with Elvacite emulsion.[2]

When the surface of the painting is only slightly cupped, facing paper is applied in one sheet. Where cupping or flaking are more serious or where impasto is pronounced, 4in squares of wet-strength paper are used, each overlapping about $\frac{1}{2}$in. This method is useful as one or two squares of facing paper can be removed later at different points on the surface to check the effectiveness of the treatment before the painting is lined. After facing paper is attached, the painting is removed from its stretcher and any work on the back is done, such as removal of an old lining and adhesive or of any knots and protruding threads on the reverse of the original canvas.

SILICONE-TREATED LAYER OF COTTON SHEETING AND BLOTTING PAPER

Two additional layers of material are required between the faced painting and the vacuum table membrane. The first, directly above the painting, is finely woven cotton sheeting, brushed with three coats of silicone solution, which is diluted with four parts petroleum benzine by volume. The second, on top of

the cotton sheeting, is blotting paper, which is directly below the vacuum table membrane. The silicone-treated sheeting, which is porous, permits the solvent and water vapours rising from the painting to enter the blotting paper, but keeps the blotting paper from adhering to the softened facing layers. Blotting paper is also porous and helps to maintain a vacuum over the entire painting, and in addition absorbs solvent and water vapours, which are then drawn off by the vacuum pump.

ORGANIC SOLVENT/WATER MIXTURES

The most frequently used mixtures prepared by volume are the following:
1. One part cellosolve acetate: two parts water.
2. One part of a mixture of equal amounts of cellosolve acetate/dimethyl formamide: two parts water.

QUANTITY OF WATER/ORGANIC SOLVENT MIXTURE USED

A relatively small amount of the water/organic solvent mixture is needed under the painting. It is easiest to control the amount used if it is brushed onto wet-strength paper, and then blotted. Prussian blue aniline dye is added to the mixture to make it more visible. Brushing smooths expansion wrinkles in the paper caused by the moisture. The paper is then blotted with cotton sheeting to remove excess moisture. The paper should be *slightly damp* but not excessively wet (in the sense of being shiny or slippery to the touch). *Uniform dampness* is necessary — there must be no dry spots or wet spots.

PREPARATION OF THE VACUUM TABLE (SEE FIGURE 15.1)

A sheet of Mylar is taped to the metal surface of the vacuum table, extending well beyond the area to be occupied by the painting.

The wet-strength paper for use under the painting is cut 2in smaller than the surface size of the painting to be treated. This is to prevent the mixture of organic solvents and water which will be brushed onto the paper from escaping at the edges of the painting instead of rising through it.

The silicone-treated sheeting and the blotting paper which will be used on top of the painting are cut 4in larger than the painting. If there are tacking edges, these are trimmed to a width of 1in and the crease caused by the edge of the stretcher is flattened. The silicone-treated layer will not adhere to the paint under it or to the blotting paper above it, but it is porous and permits the escape of the water and solvent vapours from the painting into the blotting paper, where they are drawn off by the vacuum pump. For this treatment, the vacuum table should be equipped

with a water trap so that water vapour is not carried into the pump. A simple solution is to have a flask with a double-holed stopper inserted into the line leading from the table to the pump.

TEMPERATURE AND TIMING ON THE VACUUM TABLE

The faced painting is placed face up on the damp wet-strength paper. The silicone-treated sheeting and blotting paper are placed on top of the painting, and should extend at least 2in beyond it in each direction.

A vacuum is created with a Mylar or rubber membrane: pressure is kept under 5in of mercury (127 mm) until a maximum temperature of 65°C is reached and is never permitted to go beyond 7in of mercury during the hours of treatment. This prevents the paint film, temporarily softened during treatment, from being pressed too strongly against the canvas.

A surface temperature of 65°C on top of the membrane, where it covers the blotting paper, was selected, as it was not too far removed from the temperature at which a painting is usually wax-lined on the vacuum table. This temperature is reached in approximately one hour; this will probably vary from table to table and should be checked in each case. The vacuum table is kept at this temperature (65°C) for a period of six hours. Thermometers on top of the Mylar membrane and the vacuum gauge are checked frequently.

After six hours, the temperature controls are turned off, and the painting is allowed to cool to room temperature under vacuum.

The six hour period at 65°C was selected for general use. At this temperature, blotting paper on top of the painting should feel dry after the vacuum is released and the membrane removed. This indicates that the solvent and water mixture has passed through the painting into the blotting paper, and has been drawn off by the vacuum pump.

Certain precautions are necessary: if the painting were removed too soon, the blotting paper would feel slightly damp indicating that there could still be some of the solvent mixture left in it and the paint layer. This would tend to make the paint layer soluble in petroleum benzine or xylene when these are used later to remove the facing layers. *Thorough drying under vacuum is absolutely essential.* If the blotting paper still feels damp after the painting has cooled to room temperature and the vacuum has been released, the painting should be returned to the vacuum table for an additional three hours under vacuum at 65°C and then cooled as before to room temperature.

CHECKING PAINT LAYER PRIOR TO LINING AFTER TREATMENT

The condition of the paint layer should be checked before the canvas is lined, to see the extent of the improvement in the cupping or flaking. Blotting paper and siliconed sheeting will lift away from the surface of the painting very easily. Where acrylic facing layers have been used, one or two small sections of facing paper and varnish can be removed with petroleum benzine to expose the paint surface. A Klucel facing can be lifted or rolled back, starting at one corner, to uncover a small area. Both types of facing are left in place during the lining.

LINING AFTER WATER/ORGANIC SOLVENT TREATMENT

The painting should be lined immediately. If time does not permit both treatment and lining in one day, the painting is left under vacuum overnight, at room temperature, and lined at once the next day. Immediate lining is necessary because, while cupping or flaking will have flattened, the cracks are still present as breaks in the paint layer and ground and are a source of weakness in the structure. Lining is always done on the vacuum table, as this permits a gradual increase and decrease in temperature with the painting held under pressure.

Wet-strength paper used under the painting during treatment should be left in place during lining. The blotting paper and silicone-treated sheeting are left on top of the painting during the lining. There are two advantages in doing this:

1. The presence of the blotting-paper layer over the painting assists in creating a vacuum.
2. The blotting paper serves as a surface buffer if the surface of the painting is rolled during lining to extrude any excess lining adhesive.

The lining canvas, whether of linen or fibreglass, should be of heavier weight per square yard than the canvas on which the painting was originally executed. If necessary, an interlayer of finely woven fabric, such as cotton sheeting, can be used so that a clash between the texture of the original canvas and the lining canvas is avoided. However, if the pressure on the painting during lining is kept no higher than 7in the problem of the canvas texture does not seem to occur.

REMOVAL OF FACING LAYERS

After the painting has been lined and cooled to room temperature on the vacuum table, facing paper and 'cushion' layers of either Elvacite 2044 or Klucel are always removed.

Elvacite 2044 facings are removed by brushing a section of the faced surface, approximately 9in square, with petroleum benzine and then covering the section with a piece of Mylar. The Mylar is smoothed out so that it is closely in contact with the surface and keeps the solvent from evaporating. We leave this for one minute and prepare a second section in the same way during this period. After one minute, the first area is tested and it is normally found that the facing paper and Elvacite resin have become easy to remove. Xylene

can be used in place of petroleum benzine on older paintings where there is no danger of solvent action on the paint layer.

Klucel facing is loosened at one corner of the painting with a spatula and the facing layer is gradually lifted and rolled back. The layer of wet-strength paper which was added over the Klucel layers, prior to treatment, serves to hold the Klucel together while it is being removed – Klucel alone cannot be removed so easily.

The painting is not mounted on its permanent stretcher until the facing layers have been removed and any additional cleaning finished which the conservator may consider necessary.

SPECIAL CASES

It is rather difficult to write about such things as complex paint layers and other special cases in connection with the use of organic solvents and water on the vacuum table. The suggestions I have to make are based purely on observations gathered over the past several years in working with different paintings and testing as many different paint samples as possible.

I feel that two potentially difficult types of paint structure should be mentioned at once. The first is the one containing an excessive amount of linseed oil, particularly if the painting is of the last 100 years. There is always a danger of the oil film expanding and then wrinkling, giving the appearance of a painting that has been overheated during the application of a glue lining. By lowering the temperature at which the treatment is done and at the same time prolonging the 'drying time' on the vacuum table to balance the lowered temperature, this problem can be avoided. A list of suggested temperatures and related drying times is given in the section dealing with tests.

The second potential difficulty lies in a painting where the artist has used an oil-chalk ground containing very little binding medium. These grounds are brittle and crumble easily. We feel that a fraction of the binding medium is probably removed by the action of the organic solvent vapours rising through the painting. Where the ground contains very little oil binding medium to begin with, it would be further weakened by such treatment. These grounds are frequently quite resistant to penetration by wax-resin adhesive but possibly there might be a way of strengthening them – and thus making treatment possible – by the introduction of an adhesive such as Beva* in a very dilute form and then heating the painting on the vacuum table to activate the adhesive.

I might also point out that any inscriptions on the back of the canvas with modern marking pen inks should be removed, as certain types of ink can bleed through to the surface of a painting. It is satisfactory if all the ink that can be removed by cotton-tipped applicators and solvents such as petroleum benzine is taken off. There is always a faint residue that has

*See Chapter 24.

penetrated so far into the threads that it cannot be dissolved out but we have found that this does no harm. This 'bleeding through' phenomenon does not always occur but the possibility should be avoided.

REMOVAL OF OLD LINING AND ADHESIVE FROM AN EXTREMELY CUPPED PAINT LAYER AND SUBSEQUENT TREATMENT ON VACUUM TABLE

The surface of the painting is protected with a heavy cushion layer of Elvacite 2044 resin solution. If the cupped condition of the surface is extremely severe, the resin solution should be applied by spraying repeatedly until a heavy glossy layer is obtained. Petroleum benzine is used as a thinner for the resin, since it evaporates very quickly. The surface of the painting is then faced with two layers of wet-strength paper and Elvacite 2044 emulsion. The second layer of facing paper, when dry, is coated with Elvacite 2044 resin applied with a brush.

The next step is further protection of the surface while work is being done to remove the old lining and adhesive. This can be done in two ways: with wax or with silicone rubber.
1. Protection with wax or
2. Protection with silicone rubber

PROTECTION WITH WAX

The painting is removed from its stretcher and the tacking edges are flattened. The painting is then placed face up on cardboard or masonite covered with glassine paper, and the tacking edges held with masking tape. Melted wax-resin adhesive is brushed onto the surface, a warm iron is passed lightly over the surface of the wax to smooth it and a wax-impregnated piece of blotting paper is attached to the wax-coated surface in the same way.

The painting is next turned face down on glassine-covered cardboard, and the old lining and adhesive removed. It is possible to scrape the back of the canvas, because the wax forms a protective cast for the paint layer. The painting is then placed face up on the vacuum table over a sheet of wet-strength paper brushed with the selected water/organic solvent mixture.

When the vacuum table has reached a surface temperature of 65°C on top of the painting, the wax facing layer will have melted through the blotting paper. The vacuum pump is now turned off for a few minutes and the Mylar or rubber membrane is removed. The blotting paper, which is soaked with wax, will peel off easily, and paper towels are used to absorb the remaining wax. Silicone-treated sheeting and new blotting paper are then placed on top of the painting to take up the organic solvent and water vapours as they rise through the painting and facing paper. The vacuum is again created. The treatment is then continued as previously described.

PROTECTION WITH SILICONE RUBBER CAST

Instead of the protective layer of wax just described, which involves interrupting the vacuum table procedure, a silicone rubber cast of the surface of the painting can be made. I much prefer this but if the painting is large it can be rather expensive.

The painting is removed from its stretcher and the edges of the canvas are flattened. The edges are then taped to a cardboard or masonite sheet covered with glassine paper, with the painting face up. We now create a slight raised edge around the painting by cutting strips of cardboard which are taped about $\frac{1}{2}$ in out from the face of the painting over the tacking edge. Masking tape is put over the cardboard and onto the surface of the tacking edge next to the painting (this will prevent silicone rubber mixture from seeping under the cardboard strips). The cardboard strips should be a trifle above the surface of the painting and one can determine this by laying the edge of a ruler over the painting to determine the highest point of the surface. Sometimes two or three thicknesses of cardboard have to be built up, if there is brushwork or impasto. Properly placed cardboard strips create a slight wall or margin around the outside of the painting about $\frac{1}{2}$ in away from the painted surface.

The silicone rubber mixture is poured over the surface of the painting and up to the cardboard strips until it is level with the top of the latter. Then a smooth piece of cotton sheeting or canvas is placed on top of the silicone rubber, and a sheet of masonite, cut to approximately the size of the outer dimensions of the cardboard strips, is placed on top with weights. This will ensure complete contact between fabric and silicone, as the former is to give handling strength to the rubber.

We usually add a small amount of rapid-acting catalyst to the normal silicone rubber mixture, to speed setting of the cast, but this is entirely a matter of preference. When the cast has set (one corner can be tested first by lifting gently), it is peeled back from the surface of the painting, and a perfect impression of the surface should result. If the entire painting/cast combination is not too heavy, the masking tape holding the edges of the canvas to the bottom layer of masonite can be removed and the painting-with-cast turned over so that the back of the painting is exposed. If this is awkward because of the size of the painting, the cast can be removed and placed fabric side down on a flat surface. The fabric edges can be stapled to keep the cast from moving. The masking tape is then removed to loosen the edges of the painting from the masonite support, and the painting is fitted face down into the cast. The back of the painting is now exposed for the removal of the old lining and adhesive.

PREVIOUSLY WAX-LINED PAINTINGS

A badly cupped painting which has been wax-lined during a past restoration can be improved by treatment without removal of the old lining. However, there is one drawback to be noted about treating a painting already on a lining, and that is that the texture of both the original canvas and the lining canvas may tend to become more prominent after the organic solvent/water treatment, as the old lining was probably done some years ago with the painting face down, with the result that the problem of the clash between the texture of the original canvas and that of the lining did not arise at that time. I feel that it is in every way preferable to face the painting for treatment, and to remove an old lining and as much of the wax adhesive as possible.

Because the presence of wax-resin lining adhesive in the original canvas will present a temporary barrier to the penetration of the organic solvent and water vapours, additional 'drying time' on the vacuum table has to be allowed. An extra three hours is added to the basic period of six hours at 65°C.

INSUFFICIENT IMPROVEMENT IN CUPPING OF THE PAINT LAYER

Occasionally, when a test area of the facing is removed and the surface of the painting checked prior to lining, it will be found that the appearance of the cupping has not sufficiently improved. This usually indicates that the solvent mixture selected was not strong enough to soften the paint layer, and the vacuum table treatment will be repeated, using the next strongest solvent mixture. For example, an eighteenth century French painting (detail shown in *Figures 15.5 and 6*) had to be treated three times before the concentric circles of cupping, which apparently had existed for a very long time, disappeared. The first treatment was with equal parts of cellosolve acetate and water; the second was with the addition of dimethyl formamide, and the third was with the introduction of pyridine. Each time, the proportion of solvent mixture to water was one to one because of the age of the painting.

DIFFERENCE IN DIMENSION BETWEEN CANVAS AND PAINT LAYER

Occasionally, cupping will be found to be very much improved but there will still be a slight ridge in the paint layer where the two edges of a crack meet. I do not know whether this is caused by slight expansion of the paint layer, because both the upper and inner surfaces have been exposed over a period of time, or whether the canvas, free of the paint layer where the latter has cracked and curved away from the fabric support, has become smaller because of shrinkage. (*Figures 15.7 and 15.8*).

We treat this condition by replacing facing layers and placing the painting, face down, around a cardboard roller. The roller has been covered with thin linoleum, blotting paper and a layer of silicone-treated sheeting to provide a seamless, non-stick surface in contact with the faced painting (*Figure 15.9*).

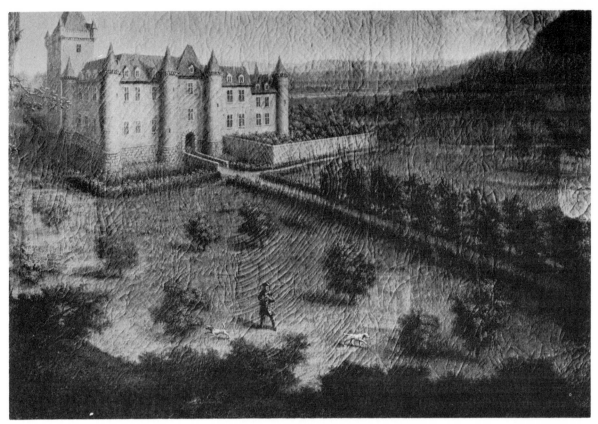

Figure 15.5 Detail of surface of an eighteenth century French painting, before treatment to improve cracked and cupped paint layer

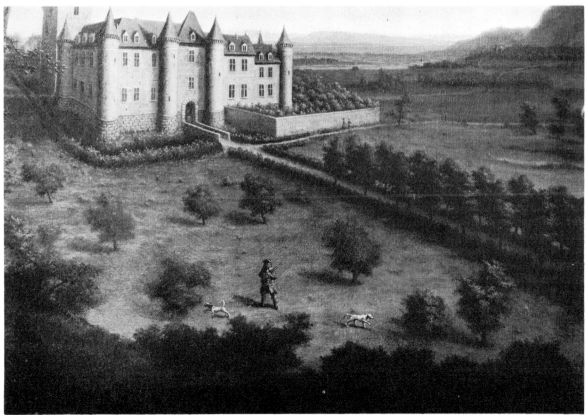

Figure 15.6 The painting shown in Figure 15.5, after the third treatment with water and organic solvents

Figure 15.7 Detail of surface of mid-nineteenth century American painting before treatment to improve cracked and cupped paint layer

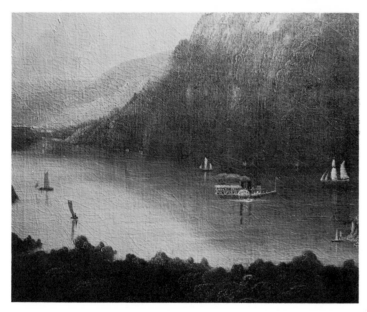

Figure 15.8 The painting shown in Figure 15.7, after initial treatment with water and organic solvents, showing the 'ridges' still remaining

Figure 15.9 The faced painting rolled in reverse over a 12in diameter cardboard cylinder, in preparation for treatment to relax and stretch the canvas threads. Wax-resin adhesive has been ironed into the back of the canvas

Work is done over the individual cracks, working in the direction of the threads of the canvas, with a heated spatula and cellosolve acetate. We keep the spatula at a medium temperature − i.e. about the temperature required to melt wax-resin adhesive − so that there can be no danger to the paint layer. An area about 2in square is brushed with cellosolve acetate and covered with Mylar. The warm spatula is applied over the Mylar, back and forth with the curve of the roller, to stretch the threads running in the direction of the curve of the roller. The painting has to be rolled in the reverse direction on the roller, in order to treat the canvas threads running in the opposite direction. By covering the canvas with squares of Mylar, the threads are protected from abrasion, and the cellosolve acetate is forced into the fabric and cannot be lost through evaporation. Treatment with organic solvents and water is then repeated on the vacuum table.

The procedure outlined can be quite time consuming if the entire surface of the painting has to be treated. However, quite frequently, only a few of the cracks will present the problem of ridges. In the latter case, their location is traced on a sheet of Mylar placed on the surface of the painting, which is then used as a guide to locate the areas to be treated when the painting is turned face down over the roller.

I should mention here a 'pre-stretching' method developed by the Restoration Department of the National Maritime Museum, Greenwich, which may be simpler and more effective than the above approach.

INTERLAYER CLEAVAGE AND FLAKING

Although the treatment of paintings with organic solvents and moisture was developed as an approach to the correction of cupped paint layers, we discovered, really by accident, that interlayer cleavage and surface flaking also appear to be corrected. In the case of interlayer cleavage, the internal softening of the binding medium in the paint layers, along with the gentle vacuum pressure, apparently presses the layers in contact with each other. Because the binding medium has temporarily become sticky or plastic, it would appear that the layers adhere to each other after treatment.

In the case of flaking, it may be that the facing varnish which has run beneath the flaking paint layer acts as an adhesive and this, along with the relaxation of the paint layer due to solvent action during treatment, causes the correction of flaking.

EXTREME IMPASTO

As noted previously, the silicone-coated fabric layer and layer of blotting paper are necessary on top of the faced painting. If there is extremely pronounced impasto, the above-mentioned layers might tend to press down too heavily on the peaks of the impasto when the paint is softened, even though the vacuum pressure is kept very low. We therefore cut slits to

TREATMENT OF CUPPED AND CRACKED PAINT FILMS

break the surface of the fabric and blotting paper, wherever necessary, to allow lessening of pressure on the high points. Undercuts in the impasto are filled with silicone rubber. These areas must be kept at a minimum because the rubber is not porous and the organic solvent mixture must have a means of escape from the paint layer. Gesso can also be used. Both these materials are applied after the facing layers are in place. This type of surface problem occurs very rarely.

UNUSUALLY HEAVY PAINT LAYER

If the paint layer is unusually heavy because of impasto or a multi-layer structure, the original canvas and lining may still not be adequate support for the paint layer. The painting will therefore be mounted on a honeycomb panel after the water/organic solvent treatment and lining. Wax-resin adhesive is used and the vacuum table set to reach a surface temperature on top of the painting and Mylar or rubber membrane of 65°C. We mount the lined painting on a piece of 0·1in masonite, with wax-resin adhesive, and mount the primed canvas on a second piece of masonite, which will be used as the back of the honeycomb panel. After the painting and masonite have cooled to room temperature under vacuum, a Lebron strainer with kraft paper honeycomb is attached to the back of the painting-on-masonite and the second piece of masonite is attached to the strainer to close off the back. By assembling the panel after the painting is secured to the masonite, a lower temperature can be used in mounting, less time on the vacuum table is required and there is no danger of the panel warping due to heat.

The above method was developed a few years ago, when it seemed to be the practice of some conservators to have a honeycomb panel made up in advance and then to mount the painting on its surface by means of wax-resin adhesive. This sometimes resulted in various problems of uneven temperature and warping. It may be that the method of mounting the lined painting first, and then making up the panel, is now more commonly used.

RESINOUS PAINT FILMS

Oil paint to which the artist has added a natural resin varnish (to quicken drying time or to produce a transparent glaze) can present special problems:

1. it is affected by heat to a greater degree than an oxidized linseed oil paint film;
2. it is more easily affected by solvent action than an oxidized linseed oil film;
3. facing paper can leave an imprint on it if insufficient 'cushion' layers of varnish are used before facing paper is applied.

We have tried to avoid the above problems in the following ways. Areas of this type are given more than

Figure 15.11 The painting shown in Figure 15.10, after treatment with water and organic solvents

Figure 15.10 Detail of surface of eighteenth century Italian flower study, before treatment to improve the cracked and cupped paint layer

the customary four coats of Elvacite or Klucel facing material, and the quantity of the organic solvent/water mixture used can be kept as low as possible. It is also possible to use an organic solvent/water mixture of lesser strength on the resinous areas, or to treat the painting at one of the lower temperatures indicated, with prolonged drying-time on the vacuum table.

One can also avoid treating these areas entirely, if they are covered on the reverse of the painting with Mylar cut about 1in larger in each direction than the area which one wishes to mask off.

EXPERIMENTAL WORK

The experiments with organic solvent mixtures and water were first done on paintings by the writer and, more recently, on old student paintings obtained from the Art Students League, New York. These were canvases up to 30 years old, which had been left in storage.

After approximately two years of experiments on samples, we began to use the treatment on paintings. Where possible, the paintings that have remained in the New York area are checked twice a year for evidence of a return of the cupped condition. So far, no change has been noted. I do not know whether this will be true for all types of paintings or whether, after a longer period, the cupping will tend to reappear. At present, however, it seems worthwhile to write about this approach, so that further tests can be carried out on a wider scale.

When these experiments were begun, I was not aware of any published material on the use of organic solvents with heat and vacuum, so the entire approach had to be worked out on a trial and error basis. A summary of tests done in developing this work, and a list of sources of materials used, are given in this section.

Test material mentioned in the following pages has been kept, except where it seemed repetitious. Initial tests were done on a purely trial and error basis, as we were working with several variables — temperature, time on the vacuum table, pressure, solvent mixture and the amount of solvent mixture to be used.

Numerous student paintings of the writer, and old student paintings from the Art Students League, New York, were cut into pieces approximately 2in x 5in, in concurrent studies. Different tests were done on samples from the same painting, so that age, colour and brushwork would be as uniform as possible for each group. The approach described previously was gradually developed.

AMOUNT OF ORGANIC SOLVENT TO BE ADDED IN WATER

When these experiments were begun, we started with one part by volume of cellosolve acetate to nine parts of water, because the action of the solvent under heat and vacuum was unknown and we were concerned

about the possibility of the paint layer being left in a weakened, soluble condition. However, we found that, as long as sufficient drying time was allowed for the solvent to evaporate from the paint layer, an increase in the proportion of solvent appeared to bring improved visual results without weakening of the paint layer. Therefore, the amount of cellosolve acetate was gradually increased and other solvents were introduced, so that the most usual mixture now is one part by volume of solvents to two parts by volume of water.

Experiments have also been done using organic solvents alone. These were found to be effective in softening the paint film but, because they did not have the softening effect of water on the canvas and its glue size, water has been retained. The proportions of one solvent to another will vary from painting to painting, but the combinations we now use most frequently are the following:

By volume:
1. One part cellosolve acetate to two parts water.
2. One part cellosolve acetate and one part dimethyl formamide to four parts water.
3. One part cellosolve acetate, one part dimethyl formamide and one part pyridine to six parts water.
4. One part dimethyl formamide and one part pyridine to four parts water.

Tests have been done by the writer on paintings less than 15 years old, using 2, 3 and 4, with no apparent increase in the solubility of the paint film after thorough drying. However, it should not be necessary to use these solvents on paintings of the last 150 years.

AMOUNT OF ORGANIC SOLVENT MIXTURE TO BE USED

The amount of organic solvent mixture will depend on the thickness of the paint layer. When tests on paint samples were begun, we tended to use far more organic solvent/water mixture than necessary. An excessive amount of solvent will obviously take longer to pass through the paint layer. We found that, even though the blotting paper on top of the paint sample felt dry, the paint would be more easily soluble than before the test in solvents such as acetone or toluene, indicating that solvent still remained in the paint layer. We therefore reduced the amount of solvent mixture to just enough to make the wet-strength paper under the painting damp — the solvent mixture is brushed on to wet the paper evenly and is then blotted off until a uniform dampness is reached.

If we are treating an extremely thick paint layer, we use two pieces of wet-strength paper under the painting instead of one, so that more of the solvent mixture can be introduced; the treatment time at maximum temperature of 65°C is then doubled. This will usually mean that treatment has to be extended over two days; we turn the heat off after, for example, six hours at maximum temperature the first day, but keep the vacuum on. The vacuum is kept on overnight,

and the remaining hours of heat treatment completed the following day.

It is very rarely necessary to use the double sheet of paper described above. We always begin with the normal treatment outlined in the first section of this paper and then change the approach if a second treatment is necessary.

A sheet of non-woven fibreglass or Pellon can be placed between the wet-strength paper and the painting to delay action of the mixture of solvent and water on the back of the painting. If more than one painting is to be on the vacuum table, wet-strength paper for the first painting is covered with polyethylene plastic film, to prevent evaporation of the water/organic

Figure 15.13 A detail of the surface of the painting in Figure 15.12, before treatment

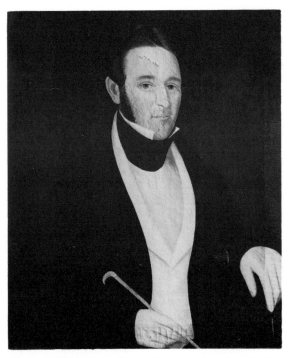

Figure 15.12 An early nineteenth century American painting by Ammi Phillips, showing the cracked and cupped paint layer

solvent mixture while the paper for the next painting is being prepared.

The water/organic solvent mixture could be sprayed directly onto the back of the painting, but it is preferable to brush it onto wet-strength paper, as this delays the effect of the moisture on the canvas.

PRESSURE ON THE SURFACE OF THE PAINTING DURING TREATMENT

Pressure is kept under 5in (127 mm) until maximum temperature is reached and is never permitted to go above 7in. This is to prevent the paint film, temporarily softened during treatment, from being pressed against the canvas, which would result in the texture of the canvas showing through the paint layer more strongly than before. Light vacuum pressure also

prevents the heavy imprint of the texture of the facing material, on the rare occasions when an unattached facing is employed.

At first, we used a much higher pressure and also applied pressure with a roller on top of the vacuum-table membrane. This was found to be unnecessary, as the essence of this treatment is that the solvent action with heat causes the paint layer to soften and relax of its own accord. Pressure is always kept at the lowest reading consistent with the painting and other layers of material being held in place under the membrane.

FACING MATERIALS

When tests on paint samples were begun, we wanted to have a facing material that could be peeled back immediately from the paint surface, without the use of solvents, so that immediate comparison of the samples could be made. In order to keep the blotting paper from sticking to the paint layer, a layer of silicone-treated porous material was introduced. Dow

Figure 15.14 The detail shown in Figure 15.13, after treatment with water and organic solvents

Corning water repellent C-20-563 mixed with an equal part by volume of petroleum benzine was brushed onto various fabrics and papers. We found that the facing material may leave a slight, uniform imprint of its texture on the softened paint film (particularly on areas of brushwork or impasto) which is clearly visible at 7x magnification. To avoid this, it was decided that 'cushion' layers of a varnish or other material should be placed on top of the paint layer, and the use of layers of Elvacite 2044 and of Klucel Type E was developed.

The idea of using a facing directly in contact with the paint layer may still prove to be useful under certain circumstances, i.e. with a contemporary painting where one does not want to have to brush or spray any protective layers onto the surface, because of the newness of the paint layer. We have experimented with Pellon, photographers' background paper, finely woven sheeting, parachute nylon, spun-bonded polyethylene and spun-bonded polyester, and a heavier grade of wet-strength paper. Of these, the parachute nylon and heavier wet-strength paper leave least imprint, but come in limited sizes; the sheeting comes in widths up to 120in and if washed repeatedly until it is very limp and soft, and then treated with silicone, it can be quite satisfactory. We are continuing to work on this idea.

TEMPERATURE

The first factor to be decided was temperature. We selected 65°C because it was close to the temperature at which paintings are often lined, and we felt that we could work upwards or downwards from the 65°C starting point. As it happened, the 65°C temperature was retained as the most frequently used treatment temperature. Tests were run at 80°C and 93°C with no visible alteration of the paint layer, but it seemed safer to work with the lower temperature.

Under certain circumstances, i.e. when the paint layer is of recent date, or where there is an excessive amount of binding medium in the paint layer, and for resinous paint films, work is done at a lower temperature, and a longer drying-time allowed, to compensate for the lowering of the temperature.

1. A surface temperature of 55°C on top of the faced painting requires that the drying period be extended to 9 hours.
2. A surface temperature of 50°C on top of the faced painting requires that the drying period be extended to 12 hours.
3. A surface temperature of 43°C on top of the faced painting requires that the drying period be extended to 18 hours. We have used this experimentally, but have never found such a low temperature necessary.

DEGREE OF SOFTNESS REACHED BY PAINT FILM

To record, visually, the degree of softness reached by the paint film during treatment, paint samples were

tested with wire netting, of the kind used in window screens, directly in contact with the paint layer.

This type of wire netting consists of straight vertical wires, 1/16in apart, through which horizontal wires are woven at 1/16in intervals, the points where the wires cross forming thick spots in the netting construction. Pieces were cut to the same size as the paint samples to be tested and brushed twice with the Dow-Corning silicone mixture diluted with an equal part by volume of petroleum benzine, so that the wire would leave an imprint in the paint film but not stick to it.

Each sample was prepared for testing on the vacuum table as follows (the different layers were stapled together at one end):
1. Wet-strength paper
2. Coated canvas sample on top of *1*
3. Silicone-treated wire netting on top of *2*
4. Silicone-treated Pellon on top of *3*
5. Blotting paper on top of *4*

Tests were first done at the 65°C surface temperature, allowing six hours' drying time at this temperature, and then at the other temperatures and times suggested above. Heat only and water only were used, in addition to the various water/organic solvent mixtures.

In each group tested on the vacuum table, the samples were treated as follows:
1. One sample was kept as a control.
2. One sample was treated only with heat.
3. One sample was treated with water and heat.
4. One sample was treated with *Mixture 1* and heat.

And so on through *Mixtures 2, 3* and *4*. For each test, seven uniform samples were necessary.

The imprint left by the wire netting on the various samples is shown in diagrammatic form in *Figure 15.15*. The imprint varied from light marks as in *1*, where heat alone was used, to a complete pattern of the wire netting as in *6*, depending on the degree to which the samples temporarily softened during test

Figure 15.15

treatment. We also found that imprint *6* could vary from shallow to deep; this was particularly true with recent oil paint films and Liquitex films. Liquitex was tested because it is so frequently used by contemporary artists, and their paintings tend to develop clusters of pressure cracks with cupping of the paint layer.

Since many different types of oil paint samples were tested, and they varied in age, oil content of the paint, and thickness of the paint layer, imprints varied somewhat from test to test. However, there appeared to be a definite progression from the light (or non-existent) impression when heat alone was used to the deep impression resulting from stronger solvent/water mixtures. This may seem a rather clumsy way of testing the softening effect of various solvents when used as outlined in the article, but it is useful because it gives a permanent visual record of what has occurred.

SILICONE RUBBER MOULDS OF CRACKS AND BRUSHWORK

When the surface condition of the painting was particularly interesting, silicone rubber moulds of the paint surface before and after treatment were made. Extra catalyst is added to the rubber, to permit setting and removal from the paint surface within half an hour. Silicone rubber moulds will last indefinitely, and plaster casts can be made from them at any time, to compare the brushwork, etc., before and after treatment.

DIFFUSION OF WATER/ORGANIC SOLVENT MIXTURE

There are sometimes occasions when one section of a painting requires treatment with a stronger water/organic solvent mixture than the rest of the painting. The lateral diffusion of a water/organic solvent mixture was tested by adding aniline dye to the mixture and placing wet-strength paper, brushed with the mixture, under the paint sample. The back of the paint sample was half covered with Mylar, held in place with Mylar tape, so that the wet-strength paper was in direct contact with only half of the canvas. After removal from the vacuum table, the tinted water/organic solvent mixture had spread under the Mylar to a depth of $\frac{3}{4}$in along the threads of the canvas. This was only done once as a test, and it is possible that, with a canvas of different weight, the result would vary slightly. However, it indicated that the strong solution should be kept well within the boundaries of the area of paint to be treated.

SOURCES OF MATERIALS

1. *Aerosol*: Cat. No. SO-A-292, OT Solution, 10%
 Fisher Scientific Company, Domestic Order Department, 52 Fadem Road, Springfield, New Jersey, U.S.A.

2. *Blotting paper*: Maximum width 57in, 50 lb rolls
 W. D. Harper Inc., 225 Park Avenue, New York, N.Y. 10003, U.S.A.

3. *Chemicals*
 Ethylene glycol monoethyl ether acetate: Cat. No. E-181
 Dimethyl formamide: Cat. No. D-119
 Pyridine: Cat. No. P-369
 Fisher Scientific Co., see *1* above

4. *Cotton applicators*: 6in stems, available in lots of 50 boxes, 1000 to a box
 The Torrent Corp., P.O. Box 166, 211 Green Bay Road, Thiensville Wisconsin 53092, U.S.A.

5. *Cotton sheeting*: 200 threads per square inch, 108in wide
 West Point Pepperell, 111 West 40 Street, New York, N.Y. 10018, U.S.A.

6. *Elvacite resin*: 50 lb drums (Elvacite 2044) (formerly called Lucite 44 or normal butyl methacrylate)
 E. I. Du Pont de Nemours and Company, 350 Fifth Avenue, New York, N.Y., U.S.A.

7. *Mylar*: Type 50A, $\frac{1}{2}$ mm thick, 72in wide, 200 lb rolls
 E. I. Du Pont de Nemours and Company, see *6* above. Also in smaller quantities from N. Teitelbaum Sons Inc., 261 Grand Concourse, Bronx, N.Y. 10451, U.S.A.

8. *Parachute nylon*: No. E1 4141, thread count 93 x 93, 95 oz per square yard (minimum order 250 yards)
 George Harris Corp., 1440 Broadway, New York, N.Y., U.S.A.

9. *Pellon*: Type KL 1350 W, rolls 49in wide
 Pellon Corp., Industrial Division, Jackson Street, Lowell, Mass. 01852, U.S.A.

10. *Polyvinyl emulsion*: Schweitzer No. 5714 (chemically inert)
 Technical Library Service, 104 Fifth Avenue, New York, N.Y. 10011, U.S.A.

11. *Reemay*: spun-bonded polyester, Type 2440
 Spunbonded Products Marketing Division, Centre Road Building, E. I. Du Pont de Nemours and Company, Wilmington, Delaware 19898, U.S.A.

12. *Rhoplex AC-34*: acrylic emulsion
 Rohm and Haas Co., Independence Mall West, Sixth and Market Streets, Philadelphia, Pa. 19105, U.S.A.

13. *Silicone*: C-2-0563, water-repellant
 Dow-Corning Corp, P.O. Box 549, Englewood Cliffs, New Jersey, U.S.A.

14. *Silicone rubber*: Dow-Corning Silastic 'A' RTV Mold-Making Rubber, No. 1 and No. 4 tubes of catalyst
 Industrial Plastic Supply Co., 309 and 324 Canal Street, New York, N. Y. 10013, U.S.A.

15. *Tyvek*: spun-bonded polyethylene, Types 1443 and 1458, with perforations
 see *11* above

16. *Wet-strength paper*: Aldex No. 13, available in 500 sheet lots, 24in x 36in; also by special order in 100 lb rolls, 78in wide
The Aldine Paper Co. (Division of Gould Paper Corp.), 145 East 32 Street, New York, N.Y. 10001, U.S.A.

It should be noted that these are the materials used in the work described in the text. Similar materials are available in other countries, sometimes under different brand names.

References and Notes

[1] Watherston, M., 'A Vacuum Table Treatment for Cupped Paint Films on Canvas Using Chemicals and Water', IIC-Amer. Group, *Technical Papers From 1968 Through 1970*, New York (1970), 121–143.

[2] Elvacite emulsion: an adhesive made with one part by volume of the stock solution of Elvacite resin in petroleum benzine and one part of water with the addition of an emulsifying agent aerosol.

16
Removing Successive Layers of Painting: Further Work

TASSO MARGARITOFF

In 1967, I published[1] my original method for separating the different layers of icon paintings while keeping intact all layers of paint. This method consisted in covering the painting with muslin adhered with animal glue; applying a compress of flannel or blotting paper well damped with dimethyl formamide; wrapping this assembly in polythene sheet, and exposing it to controlled heating by infra-red lamps. After removal of the polythene sheet and compress, and application of a new layer of glue, the upper paint layer with its muslin facing could be slowly and carefully detached.

I still use this method, with some modification, when no ground exists between the paint layers.

Figure 16.1 The apparatus for producing water vapour

However, because there very often is a thin intermediate ground, at least in Greek paintings, and because dimethyl formamide is highly toxic and difficult to use safely, I have developed another method.

WATER VAPOUR METHOD

The apparatus (*Figure 16.1*) consists of an ordinary laboratory wash-bottle, covered with protective wire netting, with two rubber pipes A_1 and B_1 fitted to the inlet and outlet tubes A and B. At the end of A_1 there is a regulator for the flow of the water vapour, which also acts as a safety valve. At the end of B_1 there is a wooden handle, with a regulator and a socket for the needle jet. The bottle stands on an electric hot-plate with heat-control.

The apparatus is used as follows:

1. The wash-bottle is three-quarters filled with distilled water and brought to the boil on the electric hot-plate, the regulator on pipe A_1 being fully open.
2. The flow of water vapour is directed towards the outlet pipe B_1 by decreasing or completely stopping the flow from A_1, using the regulator.
3. By changing the size of the needles at the end of pipe B_1, the density of the vapour can be increased or decreased; and
4. By manipulating the regulator B_1, the quantity of vapour required can be controlled, while the pressure of the jet is controlled with the regulator A_1.

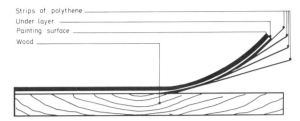

Strips of polythene
Under layer
Painting surface
Wood

Figure 16.2 A cross section of the painting, the panel and the insertion of the polythene strips

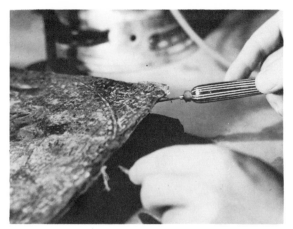

Figure 16.5 Detail of the start of removal

Figure 16.3 The painting at the beginning of the cleaning process before the removal

Figure 16.6 Detail during the removal process

Figure 16.4 Starting the removal

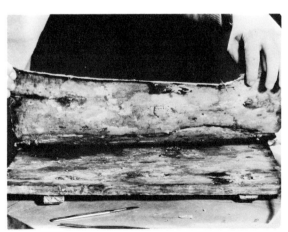

Figure 16.7 In the middle of the removal process

PREPARATION FOR TRANSFER

1. Coloured and black-and-white photographs are taken, both general and detailed.
2. The condition of the original paint layer, hidden under the later painting, is determined by X-radiography.
3. The colours of the upper layer are tested for solubility in acetone.
4. The properties of the ground of the upper layer are examined (e.g. its hygroscopicity).
5. Wax, smoke and dust are cleaned from the upper layer and especially the edges of damaged areas, where there is contact with the original painting.
6. Cracks or damaged areas are covered with bees-wax, taking care that the wax does not cover any part of the upper layer which is going to be removed.
7. Any gold or silver areas must be covered with a thick layer of dammar varnish.
8. After the dammer varnish has completely dried, a soft medium-sized brush is used to apply a very thin coat of Uhu universal glue[2] thinned with acetone in the proportion 1:4 glue:acetone.
9. Next, a sheet of Klinex paper is applied to the surface and adhered with the same Uhu/acetone mixture (1:4). This must be done very carefully, so that the Klinex adheres over the entire surface.

The preliminary phase is now complete and, after 24 hours, the main phase of the removal can begin.

MAIN PHASE

1. The apparatus described above is activated, using a small needle at first and a larger one as the removal progresses.
2. We take a thin surgical knife, a series of spatulas, and strips of polythene in various widths, from 10 cm up to 10 cm greater than the width of the picture, and
3. With two trained assistants, the removal is begun, starting from the easiest point, if there is one, or from any edge of the painting. The left hand directs the water vapour, while the right hand uses a spatula or the knife to assist the removal of the upper layer. Wider strips of polythene are placed between the layers as the upper layer is progressively raised (*Figure 16.2*). With correct placing of the strips, the detached upper layer will be protected against crushing; it will be supported across its whole width; it will not re-adhere to the original painting; and,

Figure 16.8 The reverse side of the removed painting and its panel

Figure 16.9 The panel and the removed painting

with the last and widest strip of polythene, it is easily transferred to a flat surface, to be prepared for mounting on a new ground. (*Figures 16.3—9*).

With this method we can also re-lay blistered paint on hygroscopic grounds, on wood, or wall paintings; and glue can be added to the distilled water, depending on the result required. I am having constructed a complete (and completely safe) water-vapour jet system which will have a steel kettle, instead of the dangerous fragile glass wash-bottle, a compressor, a pressure-meter, an electrically-heated pipe for the vapour gun, and other improved features.

References and Notes

[1] Margaritoff, T., 'A New Method for Removing Successive Layers of Painting', *Stud. Conservation*, **12** (1967), 140—146.
[2] Uhu: a commercially available clear rubbery adhesive.

17
The Restoration of Portrait Miniatures

JIM MURRELL

Although outside the regular experience of the picture restorer, the specialized techniques of miniature restoration are of some interest because very few restorers are not at some time faced with the problem of restoring a portrait miniature. Miniatures have been painted in many different techniques including water-colour on ivory, vellum and paper, oil on copper, and in vitreous enamels. Of these techniques, the ones which present special problems are miniatures painted in water-colour on vellum and ivory. These are also the predominant portrait miniature painting techniques. The methods involved in the restoration of those painted in water-colour on paper are related to normal water-colour restoration methods; those in oil on copper, to oil restoration procedures; and the restoration of enamelled miniatures is not unlike ceramic restoration. My comments on the restoration of miniatures are concerned almost entirely with the English School, because by far the greater proportion of my experience has been in that field, but the techniques employed in other schools differ only slightly and the restoration methods are therefore closely related.

Miniature painting methods changed immensely during their 300 years of development and a good knowledge of the history of miniature technique is essential to the restorer. The few paragraphs which follow are only a brief survey of the subject.

Portrait miniature painting derived from the techniques of manuscript illumination during the sixteenth century. In the first half of the century there was a school of portrait miniaturists working at the court of Henry VIII, who had been trained as illuminators and

who practised both arts concurrently. Hans Holbein the Younger was the first important non-illuminator miniaturist. He was followed in the late sixteenth and early seventeenth century by the great English miniaturists, Hilliard and Oliver. The techniques of this period were very close to those of the illuminators, with a few notable exceptions. The support was almost invariably vellum mounted on card, although it has frequently been erroneously stated that the majority of miniatures of this period were painted on playing cards. This misinterpretation was the result of too superficial an examination of the supports. The vellum was attached with starch paste to a playing card which was subsequently burnished from the back, causing an intimate union of vellum and card. On a cursory examination it is difficult to detect the separate layer of vellum, and it is this, in conjunction with the playing card cypher showing at the back, which has given rise to this myth. The pigments were ground with minimal amounts of gum arabic with the addition of sugar candy, as a plasticizer, to those colours, such as the lakes, which tend to crack.

One of the features of English miniature painting in this period, which only existed in a rudimentary form in manuscript illumination and which was not employed to any great extent on the continent, was the use of an opaque underpainting for the flesh. This consisted of a heavy wash of lead white mixed with red lead, vermilion and ochre to form a light flesh tone. The features were modelled over this ground by hatching or stippling semi-transparent colour. The ground, which was called the 'carnation', was left for the highlights. After the features had been delineated,

129

any excess 'carnation' was removed with a damp brush before carrying out the background and costume. Techniques in early miniatures were simulatory rather than illusionary, in that the surface textures of objects were rendered in materials which had similar surface qualities, rather than with colour and varied handling of the brush. Different grades of white and black pigments were used to render varying textures of drapery. Metallic objects were represented with gold and silver powders in gum arabic which were burnished and were also used as underlays for depicting jewels, which were applied with pigments ground in Venice turpentine and applied in a molten state.

In the seventeenth century the Elizabethan methods were modified to some extent. Vellum mounted on card was still used as the support but as the size of miniatures had increased, both sides of the card were usually given a thin coat of glue/chalk to counter the pull of the vellum. A 'carnation' flesh ground was still used but the modelling of the features was increasingly carried out in opaque colour leaving little of the ground visible. The use of metal powders and special techniques for simulating the tactile qualities of cloth, jewellery, etc., gave way to illusionary rendering with colour and brush.

In the early eighteenth century ivory almost entirely replaced vellum as the painting support. At first the luminous quality of ivory was not exploited and it was almost half a century before a suitable technique was evolved. Rosalba Carriera, who is credited with being the first artist to paint on ivory, frequently used a very thin opaque wash under the flesh and modelled over it as if working on a 'carnation' ground, and although the Lens family, who were the first English miniaturists to use ivory, began to use transparent modelling on the flesh, the backgrounds and costumes of their works were carried out in opaque matt colour in the manner of the vellum painters. The ivories were at first very thick, often as much as 1/8 in, and were prepared by grinding the surface with wet pumice powder and bleaching in the sun.

After these early attempts the paintings became more and more transparent and the colours were ground with increasing amounts of gum. By the middle of the century ivories were much thinner and were usually attached to a piece of paper or card. Their translucency was often exploited by carrying out some of the painting on the reverse side of the ivory or by inserting pieces of reflective metal foil between the ivory and its card support. By the first quarter of the nineteenth century the use of gum had become excessive, and exaggerated amounts of hygroscopic plasticizers such as honey, and later glycerine, were added to prevent the over-gummed colours from cracking. In about 1830 a new method of cutting to obtain large sheets of ivory was invented. The sheets were cut by peeling the outer layers from the circumference of the tusk with a special lathe, in the way that veneers are made. Very large miniatures were painted on supports made by joining several sheets of 'veneer' cut ivory together, sometimes with the grains of the sheets running in different directions.

PROBLEMS OF MINIATURES PAINTED ON VELLUM

SUPPORTS

The vellum supports of early miniatures are usually quite stable and rarely cause any real problems. Occasionally the vellum begins to separate from the card which forms the secondary support and in a few cases the card itself begins to warp. In both these instances it is desirable that the vellum should be firmly attached to a new support before the movement causes paint losses. In both cases the old card should be carefully removed by cutting it away. The vellum can then be relaxed by treating the back with a 5% solution of water in ethanol before attaching it to a new support made of laminations of hot-pressed rag paper using a mixture of animal glue and starch. The miniature is then covered with siliconized paper and pads and put under pressure until dry.

THE PAINT LAYER

1. *Cleaning.* Surface cleaning of miniatures can usually be carried out using eraser ground to a powder. I favour the soft vinyl erasers for this purpose as they can be ground to a fluffy material that can be rolled over the surface of the paint without causing abrasion. If the paint is too friable for the dry method to be used or if there are oil or grease stains, solvents such as acetone, white spirit, benzine and alcohol can be used. Spirit soap can also be employed in conjunction with a volatile solvent. Sometimes miniatures were varnished during early restorations thereby completely altering their surface and tonal qualities. It is impossible to lay down any general rules for the removal of such varnishes, but one method which I have found to be effective is to roll the miniature with swabs containing a balanced mixture of acetone and cellosolve. When the varnish in the lower paint layer has softened it can be rolled away with acetone.

2. *Old retouches.* Many early miniatures have been retouched to some extent. Usually it is only slight, being a reinforcement in transparent water-colour of areas which have faded. Unless early retouches cause serious disfiguration, it is advisable not to attempt to remove them. If they are on the flesh areas of the miniature they will have been absorbed into the top layer of the 'carnation' ground, and to remove them inevitably means loss of a certain amount of original pigment. In other areas, old retouches can be removed relatively easily. The method is to lift them off by using the scalpel and small spatulas in conjunction with ultra-fine abrasives. It *is* possible, using these methods, to remove a retouch from the 'carnation' and repolish the ground to its original lustre. This is important because differences in the surface textures of a miniature can be more disturbing than poor colour matches.

3. *Flaking.* Paint loss is rare on early miniatures and when it does occur it is usually due to flexing of the

support, either through warping or because it has been badly handled. Flaking can be treated by introducing poly(butyl methacrylate) resin (Bedacryl 122X) behind the flakes using a fine brush. The flakes are then pressed down after being covered with siliconized paper. Any traces of resin on the surface must be removed with a solvent. I use Bedacryl in preference to other flake-laying adhesives because of its effectiveness in very low percentage solutions and the consequent ease with which it can be manipulated on such a small scale.

4. *Blackening of lead whites.* Although other whites were available, lead white was used extensively throughout the early period. It was regarded as the best white for painting the flesh and many artists used it exclusively. As they were ground with the absolute minimum of binder, the lead whites in vellum miniatures are particularly susceptible to the action of hydrogen sulphide. Such cases should normally be treated in a sealed cabinet with hydrogen peroxide vapour, but on some occasions it is necessary to apply the peroxide (100 vols) with a brush, after mixing it with ether. This method is particularly useful in cases where early restorers, unable to oxidize the sulphide have put a wash of colour over the area.

5. *Mildew and fungus.* In common with painting in all water-colour techniques, miniatures are susceptible to mould growths, which occur when the RH is high. In the early stages of infection, miniatures can be treated for mould by brushing the spores away and then exposing them in a thymol chamber for several days. In certain cases, hard incrustations are left on the surface of the miniature and these have to be removed with a scalpel.

6. *Retouching.* The ethics of retouching miniatures are sensitive and each case has to be assessed individually. To be effective at all, retouches have to be deceptive. On the miniature scale, any difference in technique or texture between the original and the retouch could be more disturbing than the damage itself. For the same reason there are few miniatures where one can either use a barrier between the original and the retouch or carry out the retouch in a non-aqueous medium. There is an advantage to be gained from the use of non-aqueous media because the retouches can be removed with a solvent which would not affect the original, but this is not possible with the great majority of early miniatures because of the absorbency of the paint.

PROBLEMS OF MINIATURES PAINTED ON IVORY

SUPPORTS

Ivory presents many more conservation problems than vellum. Early ivories, being thick and cut across the grain of the tusk, are less susceptible to warping and splitting than the later, thinner ones, in particular those peeled in sheets from the circumference of the tusk. Old ivory, particularly if it has been kept in a dry atmosphere, tends to become embrittled from the surface inwards. Warping occurs in different forms and for a number of reasons and, apart from the danger of the ivory splitting along the grain during warping, there is also a danger that paint loss will follow movement in the ivory. Three of the more common types of distortion are:

1. Simple concave curvature at right-angles to the grain, which is usually caused by a drop in the RH. As thinner sheets of ivory were used, they were invariably stuck to a secondary support of card. Often it is the card which is causing the warp, not the ivory. Cracking does not usually occur in such cases but when it does, it is due to the frame permitting a certain amount of warp and then restricting further movement. Sometimes a miniature is saved from cracking by the force of its warp which bursts the frame apart, releasing the ivory.

2. Some ivories were only attached to their support cards in a few places and this creates uneven tensions in the ivory when it warps, causing corrugated buckling and, in many cases, splitting.

3. The movement of ivories which have been 'veneer cut' seems to be an inevitable process and cannot be entirely obviated with the very best climate control. The problem is always exacerbated when two sheets of ivory have been joined at the edges with the grain running in contrary directions. The stress caused by the uneven shrinkage invariably causes buckling and splitting.

The treatment of supports varies according to the type of warping or splitting which has occurred. In cases of simple warping, where the secondary support is causing the movement, it is often only necessary to cut away the card. Given a few days to relax, the ivory will become quite flat of its own accord. In other cases it is necessary, after removing the card, to subject the ivory to gradually increasing pressure to flatten it. If an ivory has been warped for a long time, and has become embrittled and set in that position, any immediate attempt to flatten it by using pressure will result in cracking. An effective method for dealing with such ivories is to remove a thin layer or shaving from the back, when the ivory will become relatively supple again. If an ivory continues to return to its warped position, it can be treated by placing it face up, with silicone protection and pressure on the surface over a grid aperture, slightly smaller than the dimensions of the miniature, in a sealed box containing wet silica gel. The box is so constructed that the wet gel can be removed and replaced with dry gel after the ivory has relaxed, without disturbing the miniature. With some miniatures it is possible to treat the backs with a 5—10% solution of water in alcohol before putting them under pressure. Another method which I have developed recently and which has proved very successful is to apply to the back of the ivory a mixture of 5 parts almond oil, 10 parts acetic acid and 85 parts industrial methylated spirits. A very thin

application is made and the treatment is repeated every two or three hours for two to three days. Not only does this treatment restore the suppleness to the most brittle ivories, but it also restores their translucency.

Many ivories have to be relaid on a new support, either because they are cracked or because they cannot be relied upon to remain flat. The ivories are flattened and any cracks joined from the back, using fine mulberry tissue and animal glue, before they are attached with animal glue to a support specially prepared by laminating hot-pressed rag paper. Large nineteenth century ivories often require supports of up to twenty laminations. Other supports have been used experimentally including perspex, which makes a firm, thin support and is very useful for relaying vellum miniatures with drawings or inscriptions on the reverse. It can also be used for ivories, and an intermediate layer of mulberry paper is used, as it is difficult to find a suitable adhesive with which to stick ivory directly to perspex. The great advantage of paper laminations, however, is that they can always be removed easily by peeling or cutting them away, layer by layer. When the ivory has been attached to the support, it is immediately put under pressure in a bookbinder's press. When re-laying cracked miniatures I normally apply a very thin film of methacrylate resin to the paint surface around the cracked area to prevent any possible damage to the painting due to moisture or adhesive being forced through the crack under pressure. After re-laying, this film can be easily removed with acetone. Any gaps which remain in split miniatures, due to uneven shrinkage, can then be filled with a wax filler before inpainting. The filler is composed of beeswax mixed with pigments and inerts to match the colour of the ivory, and is applied with a heated spatula. After levelling with a warm spatula, it can be smoothed using chloroform. I generally add a small amount of ox-gall to the first layer of inpainting.

THE PAINT LAYER

1. *Cleaning.* The cleaning of miniatures on ivory can be carried out in the same way as for vellum miniatures. In the later, gummy miniatures, the surfaces are far less friable and better adapted to dry cleaning methods. Miniatures on ivory which have been incorrectly varnished during early restorations often suffer severe paint loss because the paint is better attached to the varnish than to the ivory. It is essential, therefore, that such varnishes should be removed, and fortunately the process is usually easier than with vellum miniatures, often requiring no more than a gentle rolling with acetone.

2. *Old retouches.* Because of the thinner, transparent techniques it is easier to remove retouches from ivory miniatures. If the retouches were carried out in water-colour they have to be removed by the same techniques as for vellum, but frequently on gummy miniatures they are in oil paint and can be taken off with solvents. An ultra-violet light box is invaluable as a check on progress when removing retouches.

3. *Flaking.* Flaking on ivory miniatures generally takes the form of long curled flakes, in contrast to the crumbling which occurs on vellum. Stronger solutions of methacrylate are necessary to fix them, and flattening is best carried out under great pressure.

4. *Blackening of lead whites.* With the increase in transparency, many artists no longer used whites, even for highlights, the tone of the ivory standing for the lightest tone in the painting. In the late eighteenth and early nineteenth centuries, alternative whites such as zinc oxide and barium sulphate were introduced as water-colour pigments. It is not surprising, therefore, that the incidence of blackening of lead pigments is far less on miniatures painted after the introduction of ivory. Because of the higher proportion of hygroscopic binding materials it is dangerous to treat the surface directly with ethereal peroxide, and the chamber should be used in most instances.

5. *Mildew and fungus.* Because of their hygroscopic nature, miniatures on ivory are far more susceptible to moulds than those on vellum. The methods of removal and treatment are the same as for vellum, but often on removal of the spores the ivory is found to be stained. These marks can generally be removed by spot-bleaching with hydrogen peroxide. Miniatures which have been exposed to damp and mould growths for long periods often become severely blanched, and the paint dry and powdery. This can be treated by painting on a very thin solution of gum arabic with a small amount of ox-gall added to it. The treatment is carried out in short hatching strokes which are allowed to dry thoroughly before applying another layer, with the strokes at a slightly different angle. As many as ten or twelve applications may be necessary, depending on the condition of the miniature. This treatment not only consolidates the paint, but also restores it to its original tones.

6. *Retouching.* When retouching ivory miniatures, an absolutely correct match of the surface texture and gloss is very important. Unlike vellum miniatures, the retouch generally has to be matched to one very thin, transparent or semi-transparent layer of paint. This makes it easier to record the exact areas of inpainting for future reference. Most retouches are carried out in water-colour, but it is possible with some later, very glossy miniatures to retouch in resins such as MS2A or Paraloid B72. It is also possible with these very gummy miniatures to apply a film of microcrystalline wax as a surface protection. Naturally this is not possible on earlier miniatures where the refractive indices of the matt colours would be altered.

The lockets and frames of miniatures are a problem to the potential restorer because they were often constructed so that they would be difficult to open without specialist knowledge. The complexities cannot be explained in a short article and instruction should be obtained from a practising goldsmith. Ideally the restorer of miniatures should be well acquainted with the metalwork techniques involved.

It cannot be too strongly emphasized that when a

miniature is removed from the protection of its locket it is one of the most vulnerable of art objects and should be handled with the greatest care and delicacy.

Control of atmosphere is essential in miniature collections as ivory tends to warp if the RH is below 50% and the paint to grow moulds at an RH of over 68%. Miniatures are particularly prone to fading and the accepted rules for lighting vulnerable objects should be strictly observed. These are, firstly, elimination of the ultra-violet component, and secondly, restriction of light level to a maximum of 50 lux (5 lumens per square foot). A restriction on the hours of viewing should be borne in mind as a possible further reduction in the amount of light.

VARNISHES

18
Problems in the Investigation of Picture Varnishes

ROBERT L. FELLER

INTRODUCTION

Modern organic chemistry has provided us with an almost overwhelming variety of colourless resins, many of which are considerably more durable than materials available to the conservator just a generation ago. The chemist's task is to select from this vast array those that are best suited for a particular need in conservation.

Modern 'high polymers' exhibit significantly different properties from those of the traditional natural resins used as protective coatings. To help the conservator learn how to use these new substances, the National Gallery of Art Research Project set out to describe the characteristics of just one class of material having broad utility: synthetic thermoplastic resins. It was the purpose of the Oberlin Seminar on Resinous Surface Coatings of 1957, and the subsequent two editions of the book *On Picture Varnishes and Their Solvents,* to describe how to classify and select thermoplastic resins, how to apply, and how to remove them.[1] To the degree that these objectives may have been achieved there is little need to add more on this occasion, except to offer our continued assistance in the application of the principles expressed in those 230-odd pages (the revised edition will hereafter be referred to as *FSJ*).

Rather than review the information in the new edition, I shall use this opportunity instead to introduce data that do not appear in the book and to point out some unfinished business. My title employs the word 'problems', not because those remaining on the subject of solvent-type varnishes are so very great, but because it is the duty of the conservation scientist to anticipate and to examine all possible problems associated with the long-range objectives of preservation and conservation.

Most of my research has concerned polymers having degrees of polymerization of about 100 or more. However, we have no cause to neglect the properties of low molecular weight polymers such as Resins AW2, MS2A and Ketone Resin N. For this reason other papers in this volume discuss the use of these materials in picture and retouching varnishes.

RANGE OF PROPERTIES OF THERMOPLASTIC RESINS

KEY PROPERTIES

The physical properties of thermoplastic resins may be conveniently defined in terms of three parameters:

1. a measure of the modulus of elasticity or rigidity,
2. the intrinsic viscosity or a related indicator of average molecular weight, and
3. the 'strength' of solvent required to dissolve the resin.

As shown in *FSJ Figure 5-3* (p. 132) *Sward Hardness, viscosity grade* (defined as the viscosity in centipoises at 20% solids by weight in toluene at 21°C), and the *solubility grade* (defined as the percentage of toluene in n-dodecane necessary to produce a clear

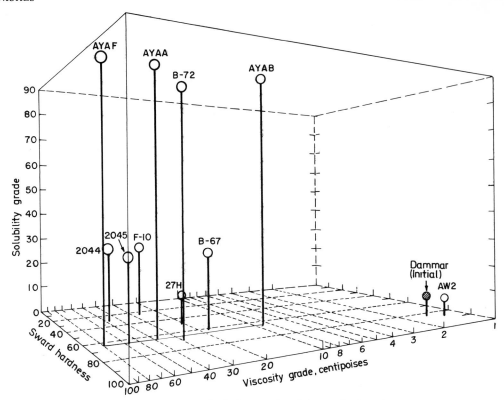

Figure 18.1 Key physical properties of thermoplastic resins

solution at 25°C) serve as convenient indicators of these properties. One may look upon these three properties or 'parameters' as defining the characteristics of resins in a three-dimensional space. (*Figure 18.1*).

LIMITATIONS IN THE MEASURE OF SOLUBILITY GRADE

The scale of solubility grade is one of the principal weaknesses of this scheme because not all resins produce a convenient 'cloud point' when their toluene/dodecane solutions are chilled. Moreover, the data in *Figure 18.1* relate only to the characteristics of the resins in their initial condition; with age, solubility may change markedly. For example, when thoroughly aged, dammar and mastic will fall outside the present borders of the diagram because, in that condition, they will no longer be completely soluble in toluene.

Solubility parameters might replace the present scale, perhaps those of a series of solvents such as the cyclohexane-toluene-acetone mixtures that we have described elsewhere.[2]

LOWER LIMIT TO HARDNESS

Poly(n-butyl methacrylate) has largely been rejected as a final surface coating because it is technically in the liquid state at room temperature, that is, it is above its 'second-order-transition temperature'. As such, the coating tends to imbibe the dirt that falls upon it. A simple practical test for this behaviour is to coat films

onto a white surface, leave them for a time in a dirty area under normal conditions of temperature, and then attempt to clean them off with detergent, water, and a soft cloth. Polymers that are much above their second-order-transition temperature will remain dark grey with the collected dirt (*Figure 18.2*).

The importance of the three-dimensional concept in *Figure 18.1* is that it permits us to compare readily the essential physical properties of any new resin offered for consideration. Moreover, should we find qualities that we do not care for in the polymers presently available, we can judge, by means of the diagram, the extent to which we may wish to change one or the other. In this manner, the properties of an experimental poly(isoamyl methacrylate) resin, 27H, were selected to be close to the upper limit of viscosity grade, and the lower limit of hardness and of solubility grade, considered appropriate for protective coatings for use on easel paintings. The results in *Figure 18.2* indicate that the hardness of 27H may still have been a bit too low (more precisely, its second-order-transition temperature, about 26°C, may have been too low).

BRITTLENESS TO BE TOLERATED

The question of how much brittleness may be tolerated is a problem that remains unsettled. In the molecular-weight range of thermoplastic resins of interest to us in the picture varnish problem, brittleness is closely dependent upon viscosity grade (*Figure 18.3*).[3] The steady trend in America has been towards polymers

DIRT PICK-UP ON
17 YEAR OLD PROTECTIVE COATINGS

Poly (n-butyl methacrylate) Viscosity Grade 27 Poly (isoamyl methacrylate) Viscosity Grade 21 Poly (isobutyl methacrylate) Viscosity Grade 55 Dammar Mastic

Figure 18.2 Dirt pick-up on 17 year old protective coatings

of lower viscosity grade than the two most popular ones in the 1940–55 period: Lucite (now Elvacite) 2044 and poly(vinyl acetate) AYAF. We have taken advantage of new products, and believe today that 27H and Paraloids B-72 and B-67 (viscosity grades 22, 29, and 18, respectively; see *FSJ Tables 5-2* and *5-3*) are close to the upper limit of viscosity grade (and hence, greatest toughness) that one may require in a protective coating for easel paintings.

Of course, one may choose films more brittle than these, but just what the lower limit of viscosity grade should be, I am not certain at this time. Most colleagues, I believe, consider Resin AW-2 by itself to be too brittle (*FSJ, Table 5-2*). Some years ago we investigated the brittleness of MS-2 and AW-2 each mixed with 48-centipoise viscosity-grade poly (n-butylmethacrylate).[3] The results indicate that rather high viscosity grades are needed if a significant reduction in brittleness is to be achieved (*Figure 18.3*). We have also found that such mixtures do not aid fundamentally in reducing the tendency of poly(n-butyl methacrylate) to crosslink and become difficult to remove.

The degree of brittleness that we should tolerate in a protective coating for easel paintings remains an open question.

APPEARANCE

GLOSS

Under the heading of appearance in *FSJ*, gloss is the principal topic discussed, primarily 'contrast gloss', the change in reflectance at two different angles of viewing. Tests of glossiness, a quality influenced chiefly by the smoothness of the upper surface of a varnish, should not be carried out on glass plates or other smooth-surfaced supports, for this will do little or nothing to reveal the ability of the coating to conform to surface irregularities, the phenomenon

illustrated in *FSJ Figure 6-2*. Canvas-pattern-embossed cardboards supplied to the amateur painter are useful in bringing out this quality. When these are painted flat black with India ink or a matt paint and later varnished with various formulations, the degree of 'blackness' that the coatings appear to have when viewed in indirect light (a function of the diffusely scattered light) provides a convenient and practical indication of glossiness.

Contrast gloss is measured instrumentally by determining the reflectance at the specular angle and one

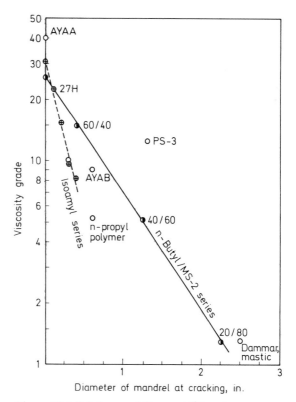

Figure 18.3 Brittleness of films at 21°C and 50% R.H. as a function of their viscosity grade (From FSJ Figure 5.2 p. 128)

other. Less satisfactorily, perhaps, the reflectance of a surface can be measured in a spectrophotometer that has a light-diffusing sphere; the tristimulus Y value may be determined first with, and then without, inclusion of the specular component.

SCATTERING POWER

One aspect of the appearance of picture varnish which has not been formally discussed to date is the scattering of light that may occur, not primarily from the surface but throughout the bulk of the film, the result of the presence of substances that possess a refractive index which is different from that of the principal vehicle: 'matting agents' such as wax or silica.

A measure of scattering may be made by casting a film of the varnish at given thickness (no more than

ance of fresh dammar and mastic varnishes. I believe now that this may not be the case. We have recently measured the colour of coatings freshly applied to sheets of window glass, using a Leres recording spectrophotometer equipped with a digital tristimulus integrator (manufactured by Kollmorgen Corp., Color Systems Division, Attleboro, Massachusetts 02703). Tristimulus values were determined by placing the coated glass on top of a barium sulphate white reference-standard in the sample port (specular component excluded). The resulting colour differences between the uncoated and coated window glass are summarized in *Table 18.1.*

There is noticeable colour in all the natural-resin varnishes. One reason that the colour is apparent, of course, is that the light must pass through the varnish twice before being perceived. Perhaps the best quality dammar may be on the border of perceptible yellow-

Table 18.1. YELLOWNESS OF VARNISHES EXPRESSED AS CHROMATICITY (Δc) AND COLOUR (ΔE) DIFFERENCE OF VARNISHES PLACED OVER BARIUM SULPHATE WHITE (VALUES RELATIVE TO THE SLIGHTLY GREENISH WINDOW GLASS UPON WHICH THEY WERE COATED).

Varnish	Hunter Colour Difference		McAdam Colour Difference	
	Δc	ΔE	Δc	ΔE
Paraloid B-72*	0·07	0·10	0·15	0·20
Poly(vinylacetate) Vinac B-15	0·10	0·11	0·15	0·18
Paraloid B-67	0·18	0·34	0·33	0·64
Elvacite 2046	0·16	0·30	0·33	0·60
Elvacite 2046 + 2% U.V. absorber	0·27	0·31	0·44	0·54
'Just perceptible' colour, approximately	—	0·60	—	1·00
Pale dammar varnish	1·98	1·98	2·93	2·93
Old dammar	3·58	3·82	5·40	5·95
Proprietary mastic picture varnish	3·70	3·72	5·45	5·49
Lab. preparation of mastic	5·20	5·21	7·84	7·86

*'Paraloid' is a trade name employed by the Rohm and Haas Company in Europe; 'Acryloid' is used in the U.S.A.

50 microns) and measuring its ability to scatter light diffusely when placed over a black surface. This is conveniently done in a spectrophotometer having a light-diffusing sphere and the capability of measuring the reflectance of the varnish 'with specular component excluded'. The scattering power, or opacity, of such a coating is measured by the increase in diffuse reflectance compared to that of the black background alone, expressing the result either in terms of the increase in the tristimulus Y value, or in the 'colour weight', that is, the increase in the total tristimulus values, $\Delta(X + Y + Z)$, suggested by Gall.[4] Preliminary measurements on the Leres spectrophotometer suggest that most matt varnishes will exhibit ΔY's below 4, $\Delta(X + Y + Z)$'s between 5 and 13 (difference between the non-specularly reflected light from the matt varnish coated on black glass, and that of the black glass alone).

COLOUR

Yellowness is not extensively discussed in *FSJ. I* ventured the opinion (p. 143) that, at a thickness of 25 microns, colour had little to do with the appear-

ness when fresh, but none of the synthetic coatings is coloured, even when an efficient ultraviolet absorber is added.

In reporting the yellowness in *Table 18.1,* the Hunter L, a and b colour-difference equation was used, as well as the McAdam No. 6 spacing.[5,6] One McAdam unit is intended to be one unit of perceptible colour difference. The value of ΔE (net colour difference) is greater than Δc (chromaticity difference) by the amount of light scattered by the varnish; thus, Δc is the better indication of the relative colour in the series.

For purposes of the research programme a number of years ago, we drew up a specification for the colour-stability of varnishes as prepared in the bottle. We specified that a sample of colourless synthetic-resin varnish, when placed in sealed Pyrex glass tubes with air filling half of the tube's volume and exposed to sunlight, must not discolour more than a Gardner Color Standard 1 ($K_2Cr_2O_7$ scale)[7] during two months of exposure outdoors in summer, facing south. The experimental varnish, 27H, formulated in a non-aromatic petroleum (*FSJ* p. 208), met this standard, but it is admittedly a high one.

CROSSLINKING AND OTHER PROCESSES OF AGEING

OXIDATION: A FUNDAMENTAL EVENT

We usually attribute the deterioration of organic coatings largely to oxidation, but conservation scientists have not particularly stressed the firm evidence we have that this is indeed the case. Thomson has reported the increases in the carbonyl and hydroxyl absorption bands in the infrared spectra of a number of resins, clearly demonstrating that oxidation is taking place.[8] Our laboratory has measured the gain in weight of dammar and mastic resins.[9]

The major role that oxygen plays in crosslinking is demonstrated in the following experiment: in the carbon-arc fadeometer, poly(isoamyl methacrylate) coatings sealed under oxygen in Pyrex tubes were observed to become 50% insoluble in 30 hours exposure; in contrast, samples sealed under argon showed no signs of crosslinking even after 630 hours. A commercial sample of poly(n-butyl methacrylate) became insoluble twice as fast under oxygen as it did under argon.

The less dramatic result in the case of the n-butyl polymer may have been due to a difference in its purity or freedom from initial stages of oxidation. Samples of this polymer several years old have been found to crosslink much more rapidly than freshly prepared specimens, whether under an inert atmosphere or not. (This observation has important implications which must be explored in the future; see section on 'Thermal degradation' below).

There is little question that exposure to near ultra-violet radiation generally speeds up the oxidation. For example, tests of exposure under ordinary glass, with and without Plexiglas UF1 ultra-violet filters, have demonstrated repeatedly that radiation between 330 and 400 nm hastens the loss of solubility of dammar, mastic and poly(butyl methacrylate) coatings.

CROSSLINKING FILM THICKNESS

Indirect evidence that oxygen assists in the cross-linking process is provided by the fact that, in the initial stages, the extent of crosslinking is markedly dependent upon film thickness. Typical results are shown in *Figure 18.4a.*

One may suggest that the decrease in insoluble matter in the thicker film is due to absorption of the radiation, but this should make the curve fall more sharply as the thickness increases.[10] Data obtained in the carbon-arc fadeometer behave in this manner (*Figure 18.4b*), perhaps because short wavelength radiation is involved. However, acrylic polymers are highly transparent to the near ultraviolet component of fluorescent lamplight or daylight-through-window-glass and we believe that the slow rate of formation of insoluble matter under these sources is controlled more by the diffusion of oxygen into the film than by filtration of the ultraviolet.[11]

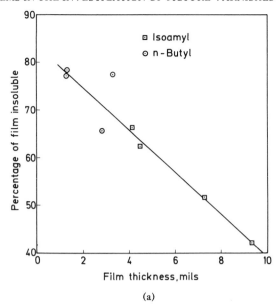

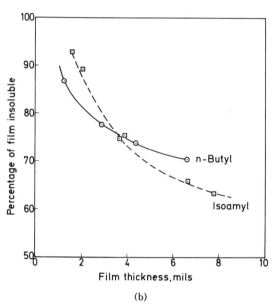

Figure 18.4 (a) Insoluble portion of methacrylate polymers after an exposure at about 1 500 000 foot-candle hours under HO 'Daylight' fluorescent lamps. (b) Insoluble portion of methacrylate polymers after 100 hours in fadeometer as a function of film thickness

When plotting laboratory data on the rate of formation of insoluble matter versus exposure, we have often obtained poor precision in the early stages of change. The reason is now obvious: before crosslinking reaches an advanced state, the percentage of insoluble matter developed in the samples will be sharply dependent upon variations in film thickness.

INFLUENCE OF TURPENTINE ON CROSSLINKING

Turpentine is often used in proprietary varnishes, partly because of the less restricted U.S. health-hazard warnings that are required for it in comparison to petroleum thinners. Turpentine readily oxidizes;

Table 18.2. EFFECT OF ADDED TURPENTINE ON LOSS OF SOLUBILITY IN XENON-ARC FADEOMETER (ORDINARY GLASS FILTER): TWO PROPRIETARY METHACRYLATE VARNISHES COATED ON ALUMINIUM FOIL.

	Per Cent Insoluble Matter			
	Isobutyl Polymer		*n-Butyl Polymer*	
Time of Exposure Hours	*Cast in Toluene*	*Cast in 50/50 Turpentine/ Toluene*	*Cast in Toluene*	*Cast in 50/50 Turpentine/ Toluene*
250	—	—	1	44
450	—	—	2	70
700	—	11	7	—
1050	—	28	50	
1325	—	—	63	
1850	9			
2500	25			
3300	34			

one of our first publications pointed out that the 'active oxygen' (peroxide oxygen) in this solvent markedly increased the weight gain of dammar varnish.[12] This may also be expected to increase the tendency to crosslink, as the following results with two proprietary varnishes demonstrate. Both varnishes in *Table 18.2* were suspected of containing oxidation inhibitors because they took much longer to crosslink than polymers prepared in the laboratory. When turpentine was intentionally added, it apparently generated so much peroxide that the inhibitor was rapidly consumed and crosslinking occurred earlier than otherwise.

MEASUREMENT OF INSOLUBLE MATTER IN SOLVENT-TYPE COATINGS

The presence of insoluble matter that arises because of crosslinking may be conveniently measured by weighing material collected on cotton swabs. Swabs weighing about 100 mg are dried for 1 or 2 hours at 70°C, allowed to cool in a desiccator, and weighed

within a minute of their removal from the desiccator. With the weighed swabs and an appropriate solvent, an area of varnish about ½ to 1½ in square is removed. The swab and its mopped-up coating is again baked for 1 or 2 hours and weighed; the result will give the amount of resin taken up on the swab. The swab with its resinous material is then placed in a weighed glass vial or in a 120-mesh/in wire basket, extracted with solvent under gentle agitation (usually over night), again baked and weighed. For assurance, duplicate determinations are usually run. Solids content determined in this manner has been found to duplicate within ±2% the absolute values of determinations made on films cast and extracted on aluminium foil.

Vials containing previously dried and weighed swabs are often taken on inspection trips and the above technique used to measure insoluble matter in coatings on objects. The condition of the varnishes on a large number of paintings has thus been monitored with the use of as little as 2 to 10 milligrams of sample. Analysis is most successful upon polymers of reasonably high viscosity-grade; films of low mole-

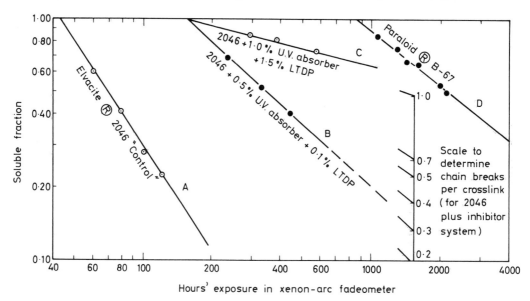

Figure 18.5 Log-log plot of loss of solubility against exposure

cular weight resins such as dammar or AW-2, or these mixed with a low percentage of stand oil, may be friable when baked and yield erratic results.

STANDARD MODE OF REPORTING THE COURSE OF CROSSLINKING

Because crosslinking is a fundamental process to be considered in the evaluation of thermoplastic resins, the establishment of standard methods for observing and reporting its progress are greatly to be desired. An analysis similar to that employed by Charlesby is convenient and appropriate: i.e., plots of the logarithm of the soluble fraction versus the logarithm of the exposure similar to that shown in *Figure 18.5*.[13] Exposure may be in terms of foot-candle hours, microwatts/cm^2/day or simply in terms of time if the intensity of radiation is constant. Solubility determinations may be made on stripped-off samples of film or by weighing cotton swabs as described.

Such a plot reveals at least two essential facts about the process: (1) 'induction time' before crosslinking sets in and (2) evidence of chain-breaking. (The principle governing the slope of such a set of curves is briefly outlined in *FSJ, Appendix C*). As illustrated in *Figure 18.5*, sample B obviously undergoes crosslinking at an inherently slower rate than the control. The markedly different slope for inhibited sample C is a sign that not only has the induction time been increased over that of the control, but considerable chain breaking has been induced. A plot of the data such as that in *Figure 18.5* is convenient, but a more general and objective analysis may be obtained by the method illustrated in *FSJ, Figure 6-3*.

Freshly prepared poly(n-butyl methacrylate) may serve as reference standard for a polymer that readily crosslinks. Samples can be prepared by refluxing a 20% solution of monomer under nitrogen in ethanol, initiated with about 0·3% benzoyl peroxide catalyst based on weight of monomer. After refluxing over night, the polymer is precipitated twice from chilled ethanol solution. Such a preparation has been found to crosslink at virtually the same rate as commercial samples of the n-butyl and isobutyl polymers. A sample of commercial n-butyl methacrylate polymer, or a 50/50 copolymer of n-butyl and isobutyl methacrylate, is always run as a 'control' in our crosslinking experiments.

No coating should be considered for the protection of easel paintings unless it resists loss of solubility (because of crosslinking by near ultraviolet radiation) for a period of exposure at least eight to ten times longer than the above 'control' polymer.

INHIBITION OF CROSSLINKING

Our first publication on the subject demonstrated the possibility of inhibiting crosslinking. This line of research has not been pursued as intensely as others because we have considered our primary objective

to be the search for polymers of intrinsic stability. Nonetheless, it should be reported that combinations of an antioxidant and an ultraviolet absorber have been found that will increase the induction time for the crosslinking of 50/50 copolymers of n-butyl and iso-butyl methacrylate (Elvacite 2046) more than 15x, at a total concentration of the inhibiting substances of less than 2%.[14] Data in *Figure 18.5* are derived from this research.

We are not yet willing to recommend a particular formulation because of the complexities of the inhibition process; one major problem is that antioxidant systems frequently lead to the formation of coloured substances.

Antioxidants will surely play a role in conservation materials of the future. All that is needed is the time in which to carry out the necessary research. We have evidence that at least two commercial acrylic polymers currently contain inhibitors. (*Table 18.2*, 'Influence of turpentine on crosslinking' above.)

THERMAL DEGRADATION

Thus far, most of our tests on the stability of high polymers have been with respect to crosslinking and weight loss upon exposure to visible and near ultraviolet radiation — essentially tests of photo-chemical stability. However, there are also thermal degradation processes to which attention must be given. We find, for example, that poly(n-butyl methacrylate) and poly(isoamyl methacrylate) develop 'butyric' odours on long standing in the container and that such 'old' samples tend to crosslink much more readily. Commercial companies are now putting additives in their products to minimize such tendencies.

In another case, a trifluorochloroethylene copolymer soluble in xylene, Firestone's Exon 461, was found some years ago to be highly resistant to crosslinking, but we had suspicions that such a polymer might liberate hydrogen fluoride or chloride, much as poly (vinylidene) or poly(vinyl chloride) tend to liberate HCl. We obtained little reassurance at the time from an authority on degradation studies and have since discovered that corrosive vapours are indeed liberated in the containers.

Such findings raise more questions at this time than there are answers but I mention them to emphasize the fact that we need to consider thermal as well as photo-induced processes in future investigations of the stability of protective coatings.

STABLE POLYMERS OF REASONABLY HIGH MOLECULAR WEIGHT

Based on accelerated ageing tests, conservation specialists now know that poly(vinyl acetate) and a copolymer of approximately 50/50 methyl methacrylate/ethylacrylate are highly resistant to crosslinking. Rohm and Haas's Paraloid B-72 and Rhoplex AC-34 are examples of the latter copolymer, one that

does not crosslink after more than 1000 hours on aluminium foil in a carbon-arc fadeometer. Based on its resistance to crosslinking and to loss of weight upon exposure to near ultraviolet radiation, we conclude that Paraloid B-72 is the most stable thermoplastic resin, soluble in hydrocarbon solvents, that we have encountered (*FSJ* p. 161).

The following two polymers have little tendency to crosslink but thus far are only being used experimentally. Paraloid B-67 has interested us for some time, but it is a proprietary resin of undisclosed composition and for this reason we have employed it with caution. Its infrared spectrum, solubility grade, and gas chromatographic analysis are similar to that of poly(isobutyl methacrylate), yet its stability is outstanding, as the data in *Figure 18.5* show. The secret of its resistance to crosslinking may be due to a relatively low molecular weight and the presence of an inhibitor.

Years ago, Stuart Raynolds synthesized polymers of tetrafluoropropyl and octafluoroamyl methacrylate at our laboratory and showed them to have high resistance to crosslinking, withstanding 1000 hours on aluminium foil in a carbon-arc fadeometer. We did very little about these findings because the polymers require special solvents and pose problems in wetting and adhesion. Since that time, we have learned that Margaret Watherston of New York City has been experimenting with the sealing and isolating properties of a proprietary water-repellent resin of similar composition. We have been happy to advise her of the high stability of the perfluoromethacrylate polymers.

Ethylene/vinyl acetate (EVA) copolymers appeared on the market in 1961. Certain of these are remarkably soluble in 'mild' hydrocarbon solvents, and those having more than 40% vinyl acetate content are resistant to crosslinking owing to a more dominant tendency to chain break.[14] In a real sense, then, they are not as stable as the above resins, yet this tendency might be taken advantage of in the selection of polymers for protective coatings in the future. An intentionally selected tendency to chain break is certainly one way in which to minimize the danger of a polymer becoming insoluble in time.

CONCLUSION

These remarks are intended to bring our technical knowledge of durable thermoplastic polymers up-to-date and to add further to the tests and standards by which they may be objectively compared.

References

[1] Feller, R. L., Stolow, N. and Jones, E. H., *On Picture Varnishes and Their Solvents,* rev. ed., Press of Case Western Reserve University, Cleveland (1971).

[2] Feller, R. L. and Bailie, C. W., 'Solubility of Aged Varnishes Based on Dammar, Mastic and Resin AW2, *IIC-Amer. Group Bull.,* **12**, No. 2 (1972), 72–81.

[3] Feller, R. L., 'New Solvent-Type Varnishes', *Recent Advances in Conservation,* Butterworths, London (1963), 172 (*Table 1*).

[4] Gall, L., 'The Hiding Power of Pigments in Paints and Printing Inks', *Farbe und Lack,* **72** (1966), 955.

[5] Judd, D. B., *Color in Business, Science and Industry,* J. Wiley, New York (1952), 260 (*equation 32b*).

[6] McAdam, D. L., 'Specifications of Small Chromaticity Differences', *J. Optical Soc. Amer.,* **33** (1943), 18–26; and Davidson, H. R. and Friede, E., 'The Size of Acceptable Color Differences', *op. cit.,* **43** (1953), 581–9.

[7] Gardner and Sward, *Physical and Chemical Examination of Paints, Varnishes, Lacquers, and Colors,* 12th ed., Bethesda, Md. (1962), 24 (*Table 8*).

[8] Thomson, G., 'New Picture Varnishes', *Recent Advances in Conservation,* Butterworths, London (1963), 181–182.

[9] Feller, R. L., 'A Note on the Exposure of Dammar and Mastic Varnishes to Fluorescent Lamps', *IIC-Amer. Group Bull.,* **4**, No. 2 (1964), 12–14; and 'The Deteriorating Effect of Light on Museum Objects', *Museum News,* Technical Supplement No. 3, June 1964.

[10] Thomson, G., 'Topics on the Conservation Chemistry of Surfaces', *Application of Science in Examination of Works of Art,* Museum of Fine Arts, Boston (1967), 78–85.

[11] Jellinek, H. H. and Lipovac, S. N., 'Diffusion-Controlled Oxidative Degradation of Isotactic Polystyrene at Elevated Temperatures. II. Kinetics and Mechanism', *Macromol.,* **3**, No. 2 (1970), 237–242.

[12] Feller, R. L., 'Dammar and Mastic Varnishes — Hardness, Brittleness, and Change in Weight upon Drying', *Stud. Conservation,* **3** (1958), 162–174.

[13] Charlesby, A., *Atomic Radiation and Polymers,* Pergamon, London (1960).

[14] Feller, R. L. and Curran, M., 'Solubility and Crosslinking Characteristics of Ethylene/Vinylacetate Copolymers', *IIC-Amer. Group Bull.,* **11**, No. 1 (1970), 42–45 (LTDP in *Figure 18.5* stands for dilaurylthiodipropionate).

19
Notes on the Formulation and Application of Acrylic Coatings

ERIC C. HULMER

INTRODUCTION

The IIC 1972 International Congress offered an opportunity to exhibit a selected group of test panels in which synthetic resins had been applied in retouching vehicles and protective coatings. The exhibition was arranged as part of the 'feedback' interrelationship between the scientific investigator, the practitioner, and the curator-collector.

Research on new materials has as its basic objective the replacement of natural materials with synthetic and other man-fabricated substances of improved physical and chemical stability. Varnish has been of major interest because of its preservative and aesthetic importance not only to paintings but also other objects. However, supports and retouching vehicles have also received consideration owing to an increasing realization that many identical materials can be employed both as vehicles and as adhesives.

The following selected materials were represented in the exhibition; their application is not limited to their traditional employment as retouching vehicles and final varnishes — of equal importance are their versatile capabilities as isolator-sealer coatings which provide a foundation for the final protective-aesthetic surface:

1. The basic resins: Poly(vinyl acetate); Paraloid B-67; the methyl methacrylate/ethyl acrylate copolymers of Paraloid B-72, and Rhoplex AC 34 (an emulsion) and casein.[1]
2. The basic additives: wax, silica, and the Du Pont Elvax 40 ethylene/vinyl acetate copolymer.

RETOUCHING VEHICLES

Retouching mediums should be mentioned briefly because they are used in conjunction with the materials in the isolating and final coatings. The basic resins above can be applied in retouching as individual or mixed-layer techniques to produce 'renovating' or 'fragmentary' in-painting over which isolator-sealer, retouching, or protective-aesthetic coatings can be easily applied after a conveniently short drying interval, especially in spray application.

POLYMER-EMULSION VEHICLES

Polymer emulsions of many types may be applied both as isolating and aesthetic layers. With respect to their removal in the future, it may be noted that the non-crosslinking Rohm & Haas Rhoplex AC-34 is soluble in toluene. Perhaps emulsions lend themselves best to a 'lean' type of paint, but they can also be applied at low pigment-volume concentrations as glazes. The addition of casein paints to the acrylic emulsion will occasionally increase wetting and adhesion if difficulty should be experienced.

SOLVENT-TYPE VEHICLES

Poly(vinyl acetate) AYAB reduced with ethyleneglycol monoethylether acetate (Cellosolve acetate) may be used[2] or the following acrylic polymers: Rohm & Haas Paraloid B-72 or Paraloid B-67 (Acryloid is the trade

name used in the United States for these same products.)

Low molecular weight poly(vinyl acetate) AYAB has excellent chemical stability and versatility of application. As a retouching vehicle it encompasses the range of appearance of both the emulsion and spirit types, but because it is above its second order transition temperature under ordinary conditions, it is always isolated with a harder coating such as Paraloid B-67 or B-72 on top.

The acrylic vehicles can be employed at either high or low pigment-volume concentration. Solutions of Paraloid B-67 compare favourably with dammar in handling and gloss. Turpentine can be used with B-67 but is not recommended because a decided 'yellowing' of the solution occurs in a short time and, as reported by Feller in Chapter 18, its presence increases the tendency of certain acrylic polymers to crosslink.

These materials can be formulated and applied to create intermediate or final surfaces of variable mattness or glossiness in both simple and refined stylistic renditions. They can be used for underpainting, glazing, scumbling, cross-hatching, pointillism and blending.

VARNISH COATINGS

Our primary objective is to discuss solvent-type varnishes. Evaluation of synthetic resins by the author over a period of 30 years has narrowed the selection to:

 1. poly(vinyl acetate) AYAB,
 2. Paraloid B-72 and
 3. Paraloid B-67 resins,
together with selective additives of
 1. wax,
 2. silica, and more recently
 3. Elvax 40 ethylene/vinyl acetate copolymer.[3]
Formulations can be composed for retouching, as mentioned, or for isolating, impregnation, sealing, protective and aesthetic coatings in both individual and multiple-layer application. As 'additives', Du Pont Elvax 40 (and even Elvax 150) offer increasingly versatile capabilities in formulation and application.

Paraloids B-72 and B-67 were emphasized in the exhibition because poly(vinyl acetate) has had extensive previous recognition. When properly formulated and applied, solutions of B-72, and especially B-67, compare favourably in appearance with the natural resins. They have the advantage of greater chemical stability and wider versatility, especially when combined with additives.

Application by spraying offers a wider range of possibilities than brushing. Probably the most important advantage is the capability of applying various spray layers to limited areas or complete surfaces as retouching-sealing-isolating foundations for the final protective-aesthetic surface layers. Mixed layer techniques can be developed to provide:

 1. later removal of surface varnish without removing the underlying layers of retouching due

to the retouching-isolating-sealing layers remaining insoluble (this is especially true with PVA underlayers or isolating coatings over retouching: note the high solubility grade of PVA in relation to Acryloid B-67);

 2. impregnation, sealing, or isolation of 'porous' surfaces in preparation for an application of a protective-aesthetic surface layer.

For experimental consideration, the following basic varnish formulations are projected.

 1. *Brush solution, individual resin*: Paraloid B-72 or B-67 at 20% or less solids content.
 2. *Spray solution, individual resin*: the same at 10% or less solids content.
 3. *Spray solutions, mixed*: add to number *2* spray solution above the individual or combined additives of (a) wax, (b) silica, or (c) Elvax 40 or 150 (preferably Elvax 40).

Formulations under *3* offer a variety of finishes, from a durable matt to a moderate gloss. Formulations with the Elvax additives offer a variety of application capabilities for impregnation-adhesive preparatory underlayers or even final surface layer coatings that can be 'rubbed off' almost as rubber cement may be rolled away. Appropriate solvent combinations need to be used to formulate the desired coating systems; thus if one wishes to employ Acryloid B-67 over PVA so that it may be removed in the future, the B-67 must be removed and probably also applied in the 'mildest' petroleum solvent convenient, one with about 25—30% aromatic content.

Formulations containing wax-silica should be warmed and a filter attached to the intake tube in the spray gun; a nylon-fabric mesh will suffice.

MATERIALS FOR VARNISH COATINGS: B-72 AND B-67 SOLUTIONS

 1. *Resin solution*: Rohm & Haas's Paraloid B-72, 40% solids in toluene or xylene. Paraloid B-67, 40% solids in petroleum distillate or mineral thinner having about 30% aromatic content.
 2. *Solvents*: petroleum distillates, di-isopropylbenzene, toluene, VM&P naphtha, xylene.
 3. *Additives*: wax: Bareco Victory microcrystalline wax (m.p. 156—165°); silica: Davison Syloid 308 (Division of W. R. Grace & Co., Baltimore, Md.); Du Pont ethylene/vinyl acetate copolymer of Elvax Grades 40 and 150, preferably the lowest molecular weight grade, Elvax 40.

PARALOID B-72 FORMULATION AND APPLICATION

 1. *Brush*: 20% or less solids; reduce 40% solution with di-isopropylbenzene to slow down evaporation.
 2. *Spray*: 10% or less solids; reduce 40% solution with toluene or xylene.
 3. *Spray additives*: to a quart of number *2* spray solution above add (a) 20—40 grams of wax,

or (b) 5—10 grams of silica, or (c) combinations of wax and silica, preferably less silica, or (d) 10 grams of a toluene gel of Elvax 40.

PARALOID B-67 FORMULATION AND APPLICATION

1. *Brush*: 20% or less solids; reduce 40% solution with a petroleum with about 25 to 30% aromatic content, or with di-isopropylbenzene.
2. *Spray*: 10% or less solids; reduce 40% solution with VM&P naphtha, toluene, or xylene.
3. *Spray additives*: to a quart solution of number 2 above add wax, silica, Elvax 40, as in the Paraloid B-72 additive formulations above.

VARIABLE APPLICATION PROCEDURE: B-72 AND B-67 SOLUTIONS

One can apply these solutions by any of the following procedures:
1. Paraloid B-72 or B-67 as individual coatings of variable gloss (achieved by variations in spraying technique).
2. Paraloid B-72 or B-67 with additives to produce a variety of matt finishes.
3. Paraloid B-72 as a sealer-isolator for a final surface of Paraloid B-67 at high gloss.
4. Paraloid B-72 with wax, silica, or especially Elvax 40 to act as a sealer or isolator for a final high gloss surface of Paraloid B-72 or B-67.
5. Paraloids B-72 or B-67 as a high-gloss base coat for B-72 or B-67 final variable matt surfaces.
6. Paraloids B-72 or B-67 of variable gloss for base, with surface of B-72 or B-67 with Elvax 40 added to create a variety of final matt to gloss surfaces.

SUMMARY: VARNISH COATINGS

A variety of formulation and application methods open extensive opportunities to the conservator for development of new working methods not only regarding the limited materials above but also other new materials being rapidly introduced by our expanding technology. By means of mixed-technique methods, under coats can be devised to permit the build-up of a suitably uniform surface or to permit the removal of the surface coating in the future without affecting the prior retouching-varnish layers. Increased protection is at the same time provided to the original paint surface. All are long-standing objectives in conservation practice.

Acknowledgements

Mr George R. Hann and the Director of the Butler Institute of American Art, Mr Joseph G. Butler, have long encouraged research in application of new coatings. For many years, polymer and solvent systems being tested by the National Gallery of Art Research Project at the Mellon Institute have been evaluated in the field by the author in a continuing 'feedback' exchange of information between the scientific laboratory and the conservation workshops, suggested by Dr Robert L. Feller. A matching fund grant for materials to further these practical-applications tests was made to the Butler Institute of American Art by the National Foundation on the Arts in 1971. Further references and acknowledgements are cited in two 'notes' on the subject that appeared in the *IIC-Amer. Group Bull.* **11**, No. 2 (1971), 132—139; and **12**, No. 1 (1971), 46—47.

References and Notes

[1] Details on the properties of the acrylic polymers may be found in the book *On Picture Varnishes and Their Solvents* by R. L. Feller, N. Stolow and E. H. Jones. The viscosity grade (related to the average molecular weight) and the solubility grade (amount of toluene in mixture with n-dodecane needed to give a clear solution at room temperature) for AYAB, B-72, and B-67 can be seen in *Figure 18.1.* in this volume.
[2] Union Carbide's poly(vinyl acetate) AYAB in mixture with beeswax has been used for inpainting by Mr. Mario Modestini for more than a decade; Mr Paul Kiehart of New Hyde Park, New York, has employed the resin for about the same length of time but without the addition of wax.
[3] Characteristics of various ethylene/vinyl acetate copolymers on the market have been noted by R. L. Feller and M. Curran in the *IIC-Amer. Group Bull.*, **11**, No. 1 (1970) 42—45. Mr Gustav Berger of New York has been employing these resins for some time — see 'The Testing of Adhesives for the Consolidation of Paintings', *IIC-American Group-Technical Papers from 1968 through 1970*, 63—67.

20
Picture Varnishes Formulated with Resin MS2A

HERBERT LANK

INTRODUCTION

RESIN MS2A

MS2A is a modified polycyclohexanone resin with a low residual ketone content[1]. Dissolved in white spirit it produces a stable surface coating. Its handling properties match closely those of mastic and dammar resin varnishes, without the evident disadvantages of these natural resins[2]. In practice MS2A coatings fulfil several desirable criteria: although the resin is slightly yellow, little further discoloration is observed in the dried film[3]. Solubility in mild solvents appears unchanged after a decade.

APPLICATION

After the initial coat has been applied by brushing, further layers should only be applied by spraying. A film of MS2A varnish is slightly brittle. To minimize the risk of abrasion, a final layer containing a proportion of non-yellowing Cosmolloid 80H wax[4] is recommended. A matt varnish with a solids content in the dried film of 40% Cosmolloid 80H wax has also been found satisfactory.

FORMULATING THE VARNISHES

STANDARD SOLUTION (31·25% W/V)

500 gm of crushed MS2A resin are dissolved, at room temperature, in 1100 ml of white spirit[5]. The resin dissolved in a white spirit with a high aromatic content will not form a film when applied by spraying. In such a case, a proportion of standard solution formulated with n-decane in place of white spirit can be added to lower the aromatic content of the varnish.

Continuous stirring for 5—6 hours dissolves the resin completely. The varnish solution as formulated here is designed primarily for spray-application pressures of around 2·5 kg/cm^2.

BRUSHING VARNISH

8 parts per vol. standard solution MS2A
2 parts per vol. white spirit*
1 part per vol. n-butyl acetate

This varnish is brushed thinly on the picture before restoration. The addition of n-butyl acetate ensures even wetting of the paint surface. Subsequent sprayed layers would not form a satisfactory film on the surface, without this initial brush application.

MATT VARNISH FOR SPRAY APPLICATION

270 ml standard solution MS2A
60 gm Cosmolloid wax 80H
1300 ml white spirit

*BS 245: 1965. Petroleum hydrocarbon solvent, a mixture of paraffins, cycloparaffins and aromatics in varying proportions, boiling within the range 150—220°C.

The wax is melted in a water bath with a little of the white spirit. The previously warmed bulk of the white spirit is then added, as well as the varnish.

This varnish, developed by Joyce Plesters at the National Gallery, London, is applied by spraying. It is suitable for modern and Impressionist pictures and should be applied directly to the paint surface. The surface of pictures with matt and semi-matt surfaces is visually unchanged by the application of this varnish. It will therefore not appreciably alter the original surface gloss if it is sprayed over other varnish coatings.

The effect of dulling down a too shiny varnish is best achieved by means of the final varnish described below.

FINAL VARNISH

3 parts per vol. standard solution MS2A
1 part per vol. matt varnish

METHOD OF USE

FOR VARNISH

Inpainting is normally carried out on top of the initial brushed varnish layer. Intermediate thin layers of the standard solution varnish can be sprayed on during the work of restoration, if required. The varnish can be applied over tempera, water-colour and acrylic resin retouchings such as Paraloid B-67, B-72. On completion of the restoration, the picture is first sprayed with a coating of the standard solution varnish. Subsequently the final varnish containing the wax is applied, also by spraying.

If required, the final varnish can be manipulated during spraying to give a wide range of effects, from high gloss to complete matting, by varying the rate of application and the air/liquid ratio. This varnish will not abrade under normal conditions; dust deposits can

be conveniently wiped off with dry cotton wool. Further buffing up or polishing of the dried film does not change the appearance of the coating.

The varnish is not susceptible to blooming, unless applied over a natural resin varnish. This latter procedure is, in any case, unsound. The surface coating is dry to the touch very shortly after it is applied and any small fluffs stuck in the surface can easily be removed. A very slight drop in surface gloss is observed a few days later. It is therefore evident that some of the solvent is retained for a time. No further change has been noted over a period of several years.

FOR RETOUCHING GLAZES

Pigments can be ground into a varnish made by slightly thinning the standard solution with white spirit to make satisfactory retouching glazes over tempera and similar body inpainting. It is not suitable for dense and extensive retouchings requiring a larger proportion of pigment.

References and Notes

[1] MS2A is a reduced (hydrogenated) resin based on the condensation of a cyclic ketone with formaldehyde. It is manufactured and supplied by Laporte Industries Ltd, Organics & Pigments Division, P.O. Box 26, Grimsby, Lincolnshire, U.K.

[2] The properties of dammar and mastic resins are discussed by R. Feller, N. Stolow and E. Jones in *On Picture Varnishes and their Solvents*, Press of Case Western Reserve University, Cleveland (1971), Part III, Chapter 5.

[3] The stability of MS2A is discussed by G. Thomson in *Recent Advances in Conservation*, Butterworths, London, (1963), 'New Picture Varnishes', Appendix 1, p. 183.

[4] Cosmolloid 80H is a synthetic amorphous microcrystalline wax manufactured by Astor Petrochemicals Ltd, 9 Savoy Street, London WC2. Cosmolloid 80H is non-yellowing, neutral and stable with a melting point of 65°C.

[5] The quality of white spirit should be tested before use; BS 245 does not specify the aromatic content.

SOLVENT ACTION

21
Solvent Action

NATHAN STOLOW

INTRODUCTION

Since the IIC Rome Conference of 1961[1] the study of solvent action on drying oil paint films (with reference to cleaning processes in the conservation of paintings) has progressed. Thus the application of the techniques of gas chromatography and pyrolysis chromatography have proved very helpful in identifying the media and in characterizing the extent and nature of leaching processes. Such studies as those of Stolow and Rogers[2,3] have provided further evidence of leaching action in aged drying oil films (both pigmented and unpigmented) and, by means of gas chromatography, have revealed the presence of dicarboxylic acids and lower molecular weight materials in the solvent phase. In the work of Jones[4] further proof was given of leaching action — particularly in films aged under ultraviolet light. The whole matter was reviewed and updated with extensive new data in the section on *Solvent Action* by Stolow in the monograph of Feller, Stolow and Jones[5]. It is intended here to summarize the essential features and conclusions of this work as they apply to our understanding of the action of solvents on paint and varnish films. Also to be included in this study of Solvent Action is the work of Feller[6], dealing with three-dimensional solubility parameters, and the recent work of Rogers[7] on applications of pyrolysis chromatography techniques. The latter paper describes a direct identification technique for drying oil films (pigmented or not) requiring very small samples of material. The controversies over picture cleaning, so marked in the 40s and 50s, have subsided to a large degree with the general acceptance of the fact that solvents can and do act on paint surfaces and thereby leach out soluble components. The extent of such action can be minimized to a high degree by careful manipulations of the conservator. Ruhemann[8] discusses in great detail the empirical cautious approach and defines in his well-documented work the problems and hazards of solvent action on paintings. The combined approach of the laboratory researcher and the scientifically-oriented conservator can reduce to an absolute minimum the solvent action hazards in picture cleaning. The cleaning of paintings can no longer be left to chance, when scientific means now exist not only for the characterization of the medium, but also for measuring precisely the extent of reaction of solvent upon the surface.

The following summary, taken essentially from Feller, Stolow and Jones[5], is presented to develop further an objective understanding of solvent behaviour on the surfaces of paintings.

SOLVENT ACTION

Varnish films yellow and deteriorate with age and thus require removal by cleaning with solvents. The possibility of solvent action upon underlying paint films during cleaning is the subject of much study. The essential medium of oil paintings is linseed oil, which when dry and aged forms a tough three-dimensional structure, but is nevertheless susceptible to solvent attack.

Linseed oil films dry by a polymerization process in which the unsaturated triglyceride molecules com-

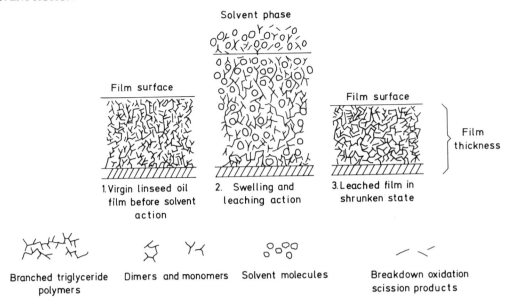

Figure 21.1 Schematic representation of swelling, leaching, and de-swelling processes in aged linseed oil films

bine with the aid of oxygen. At the same time deterioration occurs by splitting or scission at the sites of oxygen linkages in the film structure giving rise to a variety of decomposition products such as dicarboxylic acids (e.g. pimelic or azelaic acids), ketones, aldehydes, alcohols, carbon dioxide and water vapour. These materials, together with unpolymerized triglycerides (composed essentially of stearic and palmitic acid units), form a kind of interstitial plasticizer in the dried linseed oil film. Where pigment is present some modification of the drying process may take place; certain pigments function as catalysts, and others as retarders. The penetration rate of solvent will of course be slower in pigmented films than unpigmented ones. Also the photochemical action of light upon the medium locked in by the pigment may depend on the light-absorbing properties of the pigment itself.

When solvent is brought into contact with a dried linseed oil film the solvent rapidly diffuses into the film causing it to swell. This results in the almost instantaneous loss of soluble or leachable components. After a period of time (usually minutes), the leaching process is almost complete with the film still remaining in a swollen and softened condition. When the solvent is allowed to evaporate, it is observed that the film has lost weight, decreased its volume, become brittle, and increased in density. This is attributed to the leaching of soluble components from the film which are identified with oxidation products, saturated triglycerides, and low molecular weight polymers of the triglycerides. The description of these processes in schematic form is shown in *Figures 21.1* and *21.2*. Repeated solvent contact leads mainly to swelling action. Further leaching depends on the history of solvent action on the film and ageing processes. In tests carried out on varnished paint films the swelling and leaching actions were not measurably reduced. According to film age and type, maximum leaching losses are of the order of 20–50%, about half of these

values being reached in 100 seconds for a solvent such as acetone. See *Figure 21.3* which describes the effect of film age on leaching action. In pigmented films where the drying process is very slow or where film oxidation of the structure predominates (such as films containing iron oxide or titanium dioxide), solubilities of the order of 80% are found. This results in disruption of the paint film and loss of pigment particles. It might be expected that increasing film age would

Supported films

Figure 21.2 Manner of swelling and de-swelling of supported and unsupported films: (a) original film (the top side of film indicated by the serrated line); (b) swelling action caused convex distortion of the unsupported film; (c) de-swelling results in reduced thickness, and concave distortion of the unsupported film

dramatically reduce solubility losses upon solvent contact: however, this has not been found. Paint films up to 300 years old exhibit leaching or solubility behaviour although swelling may be at lower levels than in younger films. Inert solvents such as n-hexane leach less material than such oxygen-containing solvents as acetone, ether, methanol and cellosolve. This applies also to high-swelling, polar-chlorinated solvents such as methylene chloride, ethylene dichloride, or chloroform. However, above a certain threshold degree of swelling, the amount of leaching is not increased significantly, suggesting that the linseed oil film structure is composed of a three-dimensional network entrapping lower molecular weight materials described earlier.

The nature of the leached components has been studied by infra-red spectroscopy and by gas chromatography (*Figure 21.4*), which show that they are unreacted or low molecular weight triglycerides containing palmitic or stearic acid, dicarboxylic acids resulting from oxidation film breakdown processes, along with hydroperoxides, aldehydes, ketones, and alcohols. A semi-quantitative study of the relative amounts of these components appears to confirm the random distribution theory for the various triglycerides in the original oil. The unchanged palmitic and stearic acid triglycerides, along with such dicarboxylic acids as azelaic or pimelic acids, are readily estimated on a quantitative basis by esterification to methyl esters of the leachings. Time studies of leaching action show that the lowest molecular weight species such as alcohols, ketones, aldehydes, are removed first, followed by saturated triglycerides, and, finally, by dicarboxylic acid components. In general it has been

possible, at least by gas chromatography, to analyse the esters of the leachings of oil films dating from the seventeenth century.

The swelling action of unpigmented and pigmented films was studied in some detail by special instrumental techniques. A suitable interpretation of the results can be made by applying the theory of solubility parameters. These numbers range from 5 for fluorocarbons to 23·2 for water and are linked to certain basic solubility properties of solvents in general. Polymeric substances also have solubility parameters and where they match those of the solvent, maximum swelling or solubility can occur. White lead/stand oil films aged up to 14 years have similarly been studied and the solubility parameter of the dried oil is found to be between 9·3—9·5 (see *Figure 21.5*). A total of 56 solvents was tested for swelling action (see *Table 21.1*). Strong swelling solvents are ethylene chloride, trichloroethylene, methylene chloride, chloroform, tetrahydro-

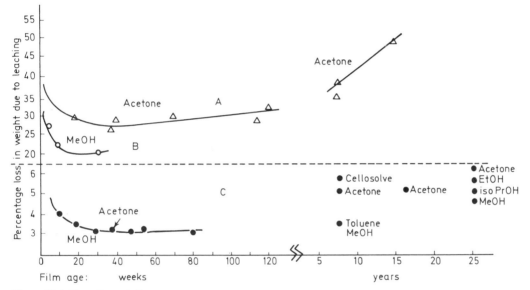

Figure 21.3 The effect of film age (up to 25 years) on the amount of leaching as a result of solvent action (A), (B) Vacuum-bodied stand oil films aged throughout 20—30°C. (C) White lead/stand oil pigmented films aged throughout 20—30°C. In every case the measurement refers to solvent contact for 40 hours to establish the maximum degree of leaching action

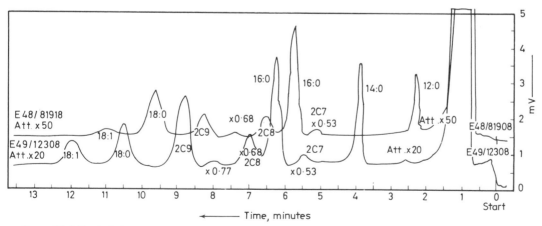

Figure 21.4 Typical chromatograms of methyl esters of leachings of barium sulphate/linseed oil films showing the presence of esters of saturated acids (e.g., 16:0, 18:0), some unsaturated products (18:1) and deterioration products (dicarboxylics, e.g., 2C7, 2C8, 2C9)

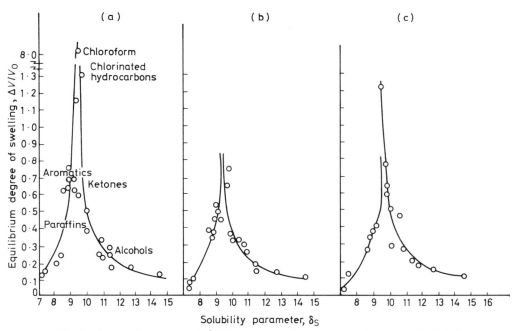

Figure 21.5 The degree of swelling at 22°C in different solvents expressed in terms of solubility parameters. These are previously leached white lead/stand oil paint films aged at 20–30°C for periods of (a) 27 weeks, (b) 7 years, (c) 14 years, The classes of solvents are indicated to show functional activity

furan, cyclohexanone, having solubility parameters in the range of 9·3–9·9 units. Low swelling solvents are those having parameters well below 9·3 or well above. In this category are the petroleum solvents and most of the alcohols. It is emphasized that, regardless of low swelling action, considerable leaching may still occur, such as with methanol. Solvents with intermediate swelling action are acetone, cellosolve, benzene and carbon tetrachloride. The effect of mixing of solvents can also be predicted. Thus solvents chosen from either side of the 'maximum' of the solubility parameter/solvent curve can enhance one another when combined, to give stronger swelling power. This has been observed, for example, when mixing benzene and methanol.

The rate of swelling, or the diffusion of solvents into and from linseed oil films, has been studied in some detail, and found to occur according to Fick's Law. The thickness of film has a profound effect on the time taken for a given amount of swelling to take place, e.g. doubling the thickness increases the time by a factor of four, and *vice versa*. Supported films take longer to reach swelling equilibrium than do unsupported films. The evaporation of solvent from films generally proceeds at a slower rate than the penetration process. The last traces of solvent in the film are very slow to leave, stubbornly retained, and conveniently removed by vacuum evaporation. The calculated diffusion coefficients can be measured for various solvents (as cm^2 per second) with reference to a fixed temperature. Thus for supported white lead/stand oil films of thickness 80–100 μ the diffusion coefficients at 22°C are 16 x 10^{-8} cm^2/sec. for isooctane. In terms of time for half the swelling process to be reached, acetone = 90 sec., isooctane = 2100 sec. In a series of evaporation studies the order of evaporation was:

methylene chloride, tetrahydrofuran, chloroform, ethylene dichloride, benzene, acetone, toluene, xylene (o, m, and p), methanol, methyl cellosolve, ethyl benzene, isopropanol, ethanol, cellosolve, n-propanol, n-butanol, n-amyl alcohol, isooctane, and diethylbenzene. In general, the more volatile the solvent the

Table 21.1. SOLUBILITY PARAMETERS δ_S OF SELECTED SOLVENTS.

Solvent	δ_S	Solvent	δ_S
Varsol	7·0	Benzene	9·2
Shellsol 715	7·0	Diacetone alcohol	9·2
Petroleum ether	7·0	Chloroform	9·3
Isooctane	7·3	Methyl ethyl ketone	9·3
n-Hexane	7·3	Trichloroethylene	9·3
n-Heptane	7·4	Tetrachloroethylene	9·4
Diethyl ether	7·4	Methyl acetate	9·6
V. M. & P. naphtha	7·6	Methylene chloride	9·7
Kerosene	7·6	Ethylene dichloride	9·8
White spirit (BS 245/56)	7·6	Tetrahydrofuran	9·9
Cyclohexane	8·2	Cellosolve	9·9
Methyl isobutyl ketone	8·4	Cyclohexanone	9·9
Dipentene	8·5	Acetone	10·0
n-Amyl acetate	8·5	1,4-Dioxane	10·0
n-Butyl acetate	8·5	n-Octanol	10·5
Shell cyclosol 53	8·5	Pyridine	10·7
Turpentine	8·5	Methyl cellosolve	10·8
1,1,2-Trichloroethane	8·5	n-Amyl alcohol	10·9
Diethyl benzene	8·7	Isobutyl alcohol	11·1
Di-isopropyl benzene	8·7	n-Butyl alcohol	11·4
Cellosolve acetate	8·7	Cyclohexanol	11·4
Methyl n-propyl alcohol	8·7	Isopropyl alcohol	11·5
Ethyl benzene	8·8	n-Propyl alcohol	11·9
n-Propyl acetate	8·8	Dimethyl formamide	12·1
Xylene (o,m,p)	8·8	Ethanol	12·7
Toluene	8·9	Methanol	14·5
n-Butyl cellosolve	8·9	Glycerol	16·5
Ethyl acetate	9·1	Water	23·2

faster is its penetration (and evaporation) into (or from) linseed oil films. The effect of temperature on these factors is very pronounced. An increase of 20°C in temperature increases the diffusion coefficients by 80% or more, and *vice versa*. The amounts of maximum swelling are not significantly affected by temperature as are the rates of attainment of swelling to the maximum or equilibrium values.

CONCLUSION

The conclusions drawn from the various studies are important and far-reaching. The cleaning of a virgin oil paint surface (i.e. one never previously in contact with solvent) will lead to leaching action which is irreversible. This may serve to explain the 'chalky' condition

Figure 21.6 Different modes of solvent action. (a) Slow diffusion, low swelling action, low leaching rate, e.g. isooctane. (b) Moderate rate of diffusion, moderate swelling action, appreciable leaching rate, e.g. methyl alcohol. (c) Fast rate of diffusion, great swelling action, high leaching rate, e.g., ethylene, dichloride, benzene

of some cleaned pictures. While leaching cannot be eliminated entirely, mechanical action upon softened films resulting from swelling can be minimized. Acetone may be used relatively safely if the contact with the surface is minimized, small quantities are used, and adequate time for evaporation is allowed. Repeated solvent application in one area will build up dangerously high concentrations of solvent within the original paint layers so that mechanical action on cleaning may be very damaging. The twin factors of swelling and rate of diffusion should be balanced.

Both can be determined from the data given for the various common solvents. Different modes of action are also given. These include employing a fast diffuser and high sweller such as benzene or ethylene dichloride, a slow diffuser and low sweller such as isooctane or isopropyl alcohol, or in an intermediate situation, a medium fast diffuser and medium sweller such as methanol (see *Figure 21.6*).

Ideally for future safe removal of varnishes from oil paintings it would be necessary to employ varnishes which are removable in solvents having low swelling and diffusing action on the paint film. As long as varnishes such as mastic and dammar are used, the aged films of which require application of oxygen-containing solvents, e.g. ethyl alcohol, acetone, etc., some danger will be experienced through leaching and swelling. In some cases varnish removal should not be attempted at all.

References and Notes

[1] Stolow, N., 'Application of Science to Cleaning Methods: Solvent Action Studies on Pigmented and Unpigmented Linseed Oil Films', *Recent Advances in Conservation*, Butterworths, London (1963), 84–88.
[2] Stolow, N., 'The Application of Gas Chromatography in the Investigation of Works of Art', *Application of Science in Examination of Works of Art*, Museum of Fine Arts, Boston (1967), 172–183.
[3] Stolow, N. and Rogers, G. de W., 'Further Studies by Gas Chromatography and Pyrolysis Techniques to Establish Ageing Characteristics of Works of Art' *Application of Science in Examination of Works of Art*, Museum of Fine Arts, Boston (1972).
[4] Jones, P. L., 'The Leaching of Linseed Oil Films in Isopropyl Alcohol', *Stud. Conservation*, **10** (1965), 119–129.
[5] Feller, R. L., Stolow, N. and Jones, E. H., *On Picture Varnishes and Their Solvents*, revised edn, The Press of Case Western Reserve University, Cleveland (1971), 47–116, 231–234.
[6] Feller, R. L., Chapter 22.
[7] Rogers, G. de W., Chapter 13.
[8] Ruhemann, H., *The Cleaning of Paintings – Problems and Potentialities*, Faber & Faber, London (1968).

22

The Relative Solvent Power Needed to Remove Various Aged Solvent-Type Coatings

ROBERT L. FELLER

SOLVENT MIXTURES HAVING SYSTEMATICALLY INCREASING SOLVENT POWER[1]

In the 1971 edition of Feller, Stolow and Jones[2], there is a suggestion that mixtures of methylcyclohexane, xylene and acetone be used to test the solubility of varnish films — three solvents that may be obtained in high purity. While we have known for some time that the mixtures with acetone in the series are significantly higher in solvent power than those without acetone, there has been some question concerning just how much 'stronger' they might be. Solubility parameters have now been calculated for them on the basis of Teas' triangular-coordinate plots[3,4,5]. Teas' f_d parameters for the three solvents may be found in *Technical Bulletin No. 1206* of the Ashland Chemical

Table 22.1. SOLUBILITY PARAMETERS, f_d (TEAS), OF MIXTURES OF CYCLOHEXANE, TOLUENE, AND ACETONE HAVING SYSTEMATICALLY INCREASING SOLVENT POWER

Volume Per Cent of			Approximate Value of f_d (Teas)
Cyclohexane	Toluene	Acetone	
100	0		96 (weak)
75	25		92
50	50		88
25	75		84
	100		80
	87·5	12·5	76
	75	25	72
	62·5	37·5	68
	50	50	64
	25	75	56
		100	47 (strong)

Company[6]. Solubility parameters are additive on the basis of 'volume fraction' of the solvents.

Toluene and cyclohexane have been substituted for xylene and methylcyclohexane in this series for they give more uniform intervals of f_d, the dispersion-force solubility parameter (*Table 22.1*). Plotting these data in *Figure 22.1*, we observe that the mixtures closely follow a 50/50 balance between dipolar and hydrogen-bonding forces (f_p and f_h). The hydrogen bonding factor, f_h, might have been used in *Table 22.1*, but the intervals of f_d seem to me to be more regularly spaced with respect to the known solvent action of the toluene/acetone mixtures. The particular mixtures chosen are intended only to provide an objective measure of the relative 'strength' of solvent needed to attack a coating; they do not represent the actual mixtures of solvents that a conservator may select to remove a varnish.

SOLVENT POWER NEEDED TO REMOVE AGED NATURAL-RESIN VARNISHES

Just how difficult is it to remove aged dammar and mastic varnishes? In Feller, Stolow and Jones[7], it is stated that a mixture of 25/75 acetone/xylene by volume will not remove thoroughly aged dammar. This mixture possesses an f_d solubility parameter of 75, based on Teas' values.

For many years, Ruhemann referred to a 'safety margin test' for solvent strength, a suggestion formally introduced, we believe, in the *Manual on the Conservation of Paintings* published by the International

Museums Office[8]. In his recent book on *The Cleaning of Paintings*[9], he cited two dozen examples of solvent mixtures used to remove picture varnishes and if their f_d values are calculated, the average is found to be 77·9 ± 4·8 (the mean and standard deviation for 20 values). Perhaps it would not be fair to include four additional examples in which pure acetone was used, but if this is done the average becomes 72·8 ± 12·6. Both values are remarkably close to our figure. In some cases Ruhemann was able to use slightly milder solvents than our data may suggest, but this is not surprising because picture varnishes, such as he was testing, are not likely to be as highly oxidized as the films in our case which were exposed to several hundred hours on aluminium foil in the carbon-arc fadeometer.

We have not yet studied the behaviour of aged varnishes under 're-forming' conditions. Jones' data on 12 year old films[10], however, suggest that even if re-forming were attempted, toluene would still be ineffective on thoroughly aged films.

Ruhemann has employed mixtures of acetone and 'white spirit' in his safety margin test. The locus of solubility parameters for these mixtures is likely to be more linear in *Figure 22.1* than with our series of solvents. Nonetheless, we will continue using the convenient mixtures cited in *Table 22.1* because a 10% error in mixtures such as Ruhemann's will give an error of about ± 5 in f_d, whereas a 10% error among our three solvents would only be about 1·6 between cyclohexane and toluene and about 3·3 between toluene and acetone.

No claim is made for the uniqueness of the solvent series in *Table 22.1*. The triangular solubility parameter system, however, provides a reasonable picture of the relative solvent power for any set of solvent mixtures that may be chosen. The use of only one of the three parameters, while not rigorous, is highly convenient.

RELATIVE SOLVENT POWER NEEDED TO REMOVE VARIOUS SYNTHETIC AND NATURAL RESINS WHEN AGED

Our early studies were involved with the measurement of certain physical and chemical properties of thermoplastic resins. No special effort was made in the beginning to determine which materials were 'better' than others. Information rarely, if ever, systematically gathered before was assembled: measurements of brittleness, solubility, inherent viscosity, resistance to photochemical change, etc. However, having now described a systematic scale of solvent power, the moment seems opportune to compare the 'strength' of solvent needed to remove various synthetic thermoplastic resins in contrast to the traditional solvent-type coatings.

Various coatings about 2 mils thick (50·8 microns) were coated on window glasses and exposed to 'daylight' fluorescent lamps in a room kept at 21°C and 50% relative humidity. Under approximately 800 foot candles of light level, the samples attained temperatures of about 27°C. After about 3 000 000 foot

Figure 22.1 Solubility parameter plot of acetone, toluene and cyclohexane mixtures

candle hours of exposure, the ease of removal in various solvent mixtures was determined, summarized in *Table 22.2*. The results of a few exposures in the xenon-arc fadeometer are also included.

One might elaborate considerably on the findings reported in *Table 22.2*, but perhaps the most important facts to be noted are: first, the relatively 'mild' solvents needed to remove poly(vinyl acetate) and Paraloid B-72, two synthetic polymers that are highly resistant to discoloration, embrittlement and cross-linking. Secondly, the tests suggest that a solvent having an f_d solubility parameter of about 70 ± 3 is needed to remove the aged traditional natural-resin varnishes; coatings based on low molecular weight polycyclohexanone resins (MS2A, AW2, Ketone Resin N) apparently require much the same.

STRENGTH OF SOLVENT NEEDED RELATIVE TO KNOWN SOLVENT ACTION ON LINSEED OR STAND OIL PAINT

We have said elsewhere that we would prefer that xylene (f_d = 83) be the 'strongest' solvent sought in the formulation of picture varnishes for 'oil' paintings[11]. The data in *Table 22.2* indicate that reasonably aged films of poly(vinyl acetate) and Paraloid B-72 require solvents of even higher f_d value than this (that is, solvents 'milder' than xylene).

As films become oxidized, it is known that they usually require 'stronger' solvents to dissolve them[12]. The traditional natural-resin varnishes may be initially soluble in 'mild' solvents, but the data in *Table 22.2* show that, with age, they eventually come to require solvent mixtures having f_d values of between 73 and 67. If one considers Stolow's published data on the swelling of aged films of lead white and stand oil (plotted in terms of f_d in *Figure 22.2*), it is clearly seen that the more oxidized or aged the natural-resin and polycyclohexanone varnishes become, the more

Table 22.2. SOLVENT MIXTURE NEEDED TO REMOVE* AGED SOLVENT-TYPE COATINGS EXPOSED TO 'DAYLIGHT' FLUORESCENT LAMPLIGHT OR XENON ARC LIGHT THROUGH WINDOW GLASS

		Solvent Mixtures Used to Remove Films; Percent by Volume					
	Exposure	*Toluene 40* *Cyclohexane 60*	*60* *40*	*80* *20*	*100* *0*	*Toluene 80* *Acetone 20*	*60* *40*
Approximate Value of f_d		*89·6*	*86·4*	*83·2*	*80*	*73·4*	*66·8*
Aged Protective Coating							
Laboratory prep. Dammar	F						R
Commercial Dammar	F						R
Laboratory prep. Mastic	F						R
Commercial Mastic	F						R
Resin MS2A (Howards)	F,X					R (F)	R (X)
Resin AW2 (BASF)	F,X					R (F)	R (X)
Ketone Resin N (BASF)	F					R[1]	
Proprietary Varnish based on above	F,X					R (F,X)	
MS2A + Linseed Oil	X					R slowly	R
AW2 + Linseed Oil	X						R
Ketone Resin N + Linseed Oil	X						R
Poly(vinyl acetate) AYAF	F			R			
Elvacite® 2045	F,X	R			R (X)[2]		
Elvacite® 2046	F	R					
Paraloid® B-72	F,X	R		R (X) ?	R (X)		
Paraloid® B-67	F,X	R			R (X)		

F = 3 000 000 foot-candle hours of fluorescent lamplight
X = exposed in Xenon Arc Fadeometer 1000 hr, under Window Glass Filter
R = removed
[1] 70/30 mixture preferred
[2] after 550 hr in Xenon Arc Fadeometer

*A coating is considered to be 'resistant to removal' if it is not dissolved or sufficiently swollen to be removed by the gentle friction of a solvent-saturated cotton swab within 1¾ minutes of exposure (FSJ, p. 157). The Table refers to solvent mixtures that will remove the coating in less than this time.

Figure 22.2 Plot of Stolow's data on leached lead white/ stand oil film versus dispersion force solubility parameter (From FSJ Figures 4.15 and 4.17)

they require solvents to remove them that are almost identical with the point of maximum swelling action of the leached stand oil films.

CONCLUSION

The concept of three-dimensional solubility parameters, applied to a series of solvent mixtures, has been used to measure the relative 'strength' of solvent needed to remove aged solvent-type coatings. The present report undoubtedly raises more questions than are answered; nevertheless, it is hoped that the ideas expressed will encourage others to make further objective tests concerning the relative risk of solvent action involved in the removal of various protective coatings[13].

References and Notes

[1] The first seven paragraphs are taken largely from an article by R. L. Feller and C. W. Bailie that appeared in the *IIC-Amer. Group Bull.*, **12**, No. 2 (1972), 72–78.

[2] Feller, R. L., Stolow, N. and Jones, E. H., *On Picture Varnishes and Their Solvents*, revised edn, The Press of Case Western Reserve University, Cleveland (1971), 165 (Note 5).

[3] Teas, J. D., *J. Paint Technol.*, **40** (1968), 19–25.

[4] Crowley, J. D., Teague, G. S., Jr, and Lowe, J. W., Jr, *J. Paint Technol.* **39** (1967), 26.

[5] Feller, R. L., Stolow, N. and Jones, E. H., *op. cit.*, 31.

[6] *Tech. Bull. No. 1206*, 'Predicting Resin Solubilities', Ashland Chemical Company, Columbus, Ohio 43216, U.S.A.

[7] Feller, R. L., Stolow, N. and Jones, E. H., *op. cit.*, 165.

[8] *Manual on the Conservation of Paintings*, International Museums Office, Paris (1940), 129.

[9] Ruhemann, H., *The Cleaning of Paintings*, Praeger, New York (1968).

[10] Feller, R. L., Stolow, N. and Jones, E. H., *op. cit.*, 161.

[11] Feller, R. L., Stolow, N. and Jones, E. H., *op. cit.*, 143.

[12] Feller, R. L., Stolow, N. and Jones, E. H., *op. cit.*, 161.

[13] For more recent data see Feller, R. L. and Curran, M., *Bull. Amer. Inst. Conserv.*, **15**, No. 2 (1975), 17–26.

TECHNOLOGY OF ADHESIVES

23
A Poly (Vinyl Acetate) Heat-Seal Adhesive for Lining

BERNARD RABIN

Weakening of the support in paintings on canvas is usually treated by lining. For centuries, glue-paste was, and still is, a common adhesive for this purpose. In recent years, wax-resin has become increasingly popular as a lining adhesive, especially in the United States where central heating presents particular humidity problems.

Wax-resin adhesives penetrate both the original and the lining canvases. With glue-paste mixtures, the water may occasionally react on the original canvas, causing the paint film to crack, blister and, at times, flake off. Moreover, contemporary artists often use non-traditional methods on their work, such as painting on unprimed canvas. It therefore behoves the restorer to broaden his range of remedial techniques. Where the paint film or fabric support may be affected either physically or aesthetically by moisture or wax penetration, a poly(vinyl acetate) (PVA) heat-seal process was developed, which I shall describe.

For good reason, restorers are reluctant to introduce new materials in their work. The list of paintings damaged by the use of uncertain materials and unproved techniques is sad and long. In view of this, it becomes more important for us to question and investigate any new substance suggested for use in conservation. Various methods of testing by accelerated ageing are not completely satisfactory. The reliable test for ageing ultimately must be how the new material has behaved through the years.

PVA is not new in conservation. Its excellent properties were described by Stout in 1930 at the Rome Conference on Conservation[1], and now, after 42 years, its use is well accepted. There are available varieties of PVA of high purity and known composition, easily defined, controlled and standardized — certainly much more so than the restorer's traditional substances used in the past. Gettens[2] mentions that R. A. Lyon, restorer at the Fogg Museum, Harvard University, used PVA as a lining adhesive for old paintings on canvas. Keck[3] has described the transfer of a small icon to a support of vinyl resin. The latter restoration was done in 1939 and Keck says that no visible change has taken place, after 33 years. Young[4] used PVA as an adhesive in the restoration of leather items and polychrome sculpture after the great flood in Florence in 1966. Lodewijks, at the 1967 Meeting of the ICOM Conservation Committee in Brussels, outlined for the first time the possibilities of PVA heat-seal adhesives in the relining of canvas paintings, but his research apparently was not brought to a final conclusion. This author was unaware of Lodewijks' report[5], which could have saved years of experimentation. However, after four years and more than 100 tests, a successful formula and technique have been developed.

Heat-seal adhesives are bonding agents which achieve an effective solid state and resultant strength by cooling. Prior to heating, a heat-seal adhesive is 100% solid thermoplastic material. Application of heat brings the material to a viscous liquid state. Upon removal of the heat, it once again becomes rigid by simple cooling. Softening is relatively rapid; the resin does not crosslink — the process is reversible.

There are five relatively low molecular weight PVA resins available in the U.S.A. but similar resins are available throughout the world[6]. The five, manufactured by the Union Carbide Company, are:

AYAC	Softening point 32°C	Intrinsic viscosity 0·11
AYAB	Softening point 44°C	Intrinsic viscosity 0·15
AYAA	Softening point 66°C	Intrinsic viscosity 0·30
AYAF	Softening point 77°C	Intrinsic viscosity 0·56
AYAT	Softening point 86°C	Intrinsic viscosity 0·69

A thermoplastic adhesive which is near or below its second order transition temperature should exhibit little tendency to cold flow. The second order transition temperature of AYAA is reported to be 21°C and that of AYAC, 16°C. Skeist[7] reports a minimum heat-seal temperature of 60°C for AYAA, 1·5 sec. dwell-time at 60 lb per sq. in.

We have found that a mixture of AYAA and AYAC gives the properties sought. (Resin AYAB was not available except as a solution in acetone). The resin combination flows lightly under the heat and pressure of the hot-table, but has little tendency to flow at room temperature. The formula for the heat-seal coating finally selected is: 454g AYAA plus 454g AYAC dissolved in 1·4 litre of toluene. The PVA solids require about two days to dissolve at room temperature, assisted by occasional stirring. To one litre of the PVA mixture are added 4g (one teaspoonful) of Multiwax No. 445[8], melted in 50ml of toluene. This amounts to about 0·03% (by weight).

A new canvas is prepared as in other linings (pre-shrunk and stretched tight). It is then sized with a solution made of 50% Rohm and Haas's Rhoplex AC34 and 50% water (see *Figure 23.1*). This neutral acrylic emulsion is brushed on the new linen and allowed to dry for 24 hours. (Rhoplex AC33 has also been used successfully). The dried, sized canvas is lightly sanded and the residual dust removed. One coat of the PVA formula is brushed on and dried for 24 hours. A second coat is brushed on and allowed to dry for 48 hours. During this time, most of the toluene evaporates from the coating (see below). This two-step procedure is carried out because the acrylic emulsion size permits a layer of PVA to build up in a readily controllable thickness. Neither markedly penetrates into the new lining.

The reverse side of the original canvas must be dust-free. This is placed over the treated new linen, which is then placed on the table, having first been covered with glassine paper. An additional sheet of glassine paper is placed over the face of the painting, then the rubber diaphragm. The table is heated to 60°C and the rubber diaphragm is evacuated to a convenient low pressure. If a hot-table is not available, sealing can be done manually with a hot iron, the painting being face down. Bonding takes place as a result of the PVA adhering to the top fibres of the linen threads of the original canvas.

As can be seen from *Figure 23.2*, the residual concentration of toluene no longer changes rapidly after about 12 hours. However, if the adhesive is heat-sealed before 48 hours, its properties may vary noticeably and result in poorer control of the system's behaviour. If it should be found desirable to reduce further the amount of residual solvents, the composition of the formula can be altered appropriately by heating the lining canvas briefly on the hot-table before the pain-

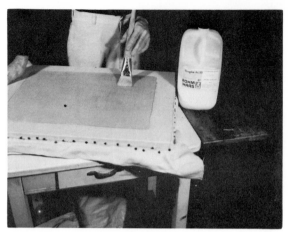

Figure 23.1 Sizing the canvas

Figure 23.2 Loss of solvent at 25°C with time. The thermoplastic adhesive consisted of 50/50 AYAC/AYAA in toluene plus 0.3% microcrystalline wax

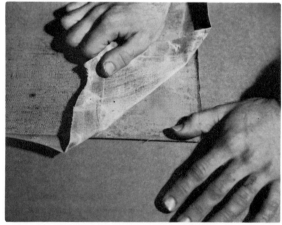

Figure 23.3 Pulling away the lining

166

Figure 23.4 **Self Portrait** *by Thomas Rossiter, showing paint and ground losses*

Figure 23.5 Detail of Figure 23.4

Figure 23.6 **Flower Girl** *by Carl Henning-Pedersen, showing efflorescence of sodium sulphate*

Figure 23.7 Detail of Figure 23.6

ting is placed in contact with it. If it becomes necessary to remove the lining in the future, the lining applied with this adhesive can be pulled away as is done to remove paste linings (see *Figure 23.3*), or it can be lifted off with the application of xylene at the point of adhesion. An important feature of the process is that, upon removal in the future, the PVA adhesive and acrylic will be retained almost entirely on the new lining canvas, leaving the original canvas practically free of adhesive. When slightly greater adhesion is desired, the proportions of AYAC and/or wax can be increased.

Described below are two examples using PVA heat-seal linings.

SELF PORTRAIT BY THOMAS ROSSITER (1818–1871)

Oil painting on canvas: size 24 in x 20 in.

The ground contained chalk and white lead. To clean the painting, its owner had washed the surface with soap and water. The unhappy results left the picture with a pattern of pinhead-size paint and ground losses (see *Figures 23.4, 5*). Paste lining obviously could not be used because of the subject's previous experience with moisture. Wax lining was rejected because of the possibility of more paint-loss caused by the penetrating wax-resin.

FLOWER GIRL BY CARL HENNING-PEDERSEN

Gouache on a ground of chalk (dolomite?) plus some zinc white and titanium white (both anatase and rutile): size 39 in x 29 in.

A crystalline efflorescence of sodium sulphate was taking place in the ultramarine blue (see *Figures 23.6, 7*). (Feller advises that sodium sulphate is often an impurity in poorly prepared artificial ultramarine[9]). The paint layer had cracking, cupping and cleavage. Paste lining could not be used as the moisture might contribute to further efflorescence. Wax lining would have altered the appearance of the gouache.

Cleavage was set flat with local treatment with PVA emulsion and the painting was lined with the PVA heat-seal adhesive. When completed, two thin coats of Acryloid B72 were spray-applied as a protective varnish.

CONCLUSION

It is not our intention to suggest that PVA lining replace paste or wax-resin linings. We do consider, however, that today it has become necessary to increase our library of tools to meet some of the unique problems encountered. There certainly are other resin and plasticizer systems that will yield results as satisfactory as the systems described. However, the present formula is based upon polymers of proved long-term stability and well-defined properties, available from manufacturers in a number of countries. The two molecular-weight grades of resin in the mixture are such that the properties of the mixture can be varied in a controlled manner by varying the proportions of the ingredients. The small addition of microcrystalline wax increases tack, yet it is so minute that it does not lead to staining of the paint or original canvas. Besides this, the adhesive system has the added advantage of a controlled degree of adhesion that permits the lining canvas to be removed in the future while leaving scarcely a trace of adhesive upon the work itself.

Acknowledgement

Technical assistance was contributed by the National Gallery of Art Research Project at the Mellon Institute, Pittsburgh, Pa., under the direction of Dr Robert L. Feller, as part of their programme in the application of new materials in conservation.

References and Notes

[1] League of Nations, Office International des Musées, *Les Dossiers de l'Office International des Musées, 2. Documents sur la Conservation des Peintures*, Paris (1933).
[2] Gettens, R. J., *Tech. Stud. Fine Arts*, 4 (1935), 15–27.
[3] Keck, S., *Tech. Stud. Fine Arts*, 9 (1940), 11–20.
[4] Young, W. J., personal communication.
[5] Lodewijks, J., 'Heatsealing Useful for Relining of Paintings', *Preliminary Report to ICOM Committee for the Care of Paintings*, Brussels, Sept. 1967.
[6] Feller, R. L., Stolow, N. and Jones, E. H., *On Picture Varnishes and their Solvents*, rev'd. ed., Press of Case Western Reserve University, Cleveland (1971), Appendix E.
[7] Skeist, I., *Handbook of Adhesives*, Reinhold, New York (1962), 353.
[8] Product of Sonneborn Sons Inc., m.p. 74°C, penetration test ASTM D1321-54T25 (35).
[9] Private communication.

24
Formulating Adhesives for the Conservation of Paintings

GUSTAV A. BERGER

Indications that the methods and materials used in conservation of paintings were sometimes harmful to the objects being preserved, as well as the need to find better ways for the treatment of modern paintings, induced the Samuel H. Kress Foundation to finance research for a new adhesive system. The research was conducted by the author in cooperation with the Conservation Center of New York University Institute of Fine Arts.

New developments in adhesive technology seemed promising for use in conservation. To find which materials and/or adhesive systems would best suit our purposes, we had to do the following:

1. Define the requirements of conservation.
2. Evaluate the characteristics of the new materials and check for possible hazards in their application.
3. Test to what extent the materials found to be safe would fulfil the requirements of conservation.

Using our own experience and that of other conservators, we tabulated the shortcomings of the currently used adhesives (*Table 24.1*) according to the desirable qualities listed by Leene[1], Werner[2], Rosenqvist[3] and others. On the basis of this information we then defined the characteristics of an ideal adhesive:

1. *Adhesion* — The adhesive bond should be strong enough to withstand the stresses to which the bonded materials are usually exposed.
2. *No continuous chemical interaction* — The chemical effects, if any, of the adhesive on the art objects should be limited to the time of application, and should not adversely affect the object.
3. *No structural interaction* — The adhesive itself should have a minimum of shrinkage or expansion, and should not cause the adhered materials to shrink or expand. It should not be harder than the materials it bonds so as not to destroy them in case of imposed stress. A certain degree of plasticity and elasticity is desirable to allow long-term absorption of stresses within the bonded materials[4].
4. *Compatibility* — The adhesive should not stain or otherwise change the appearance of the objects to be bonded. It should be either similar to the objects in texture and appearance (and should not change its appearance for the longest possible time), or sufficiently compatible with materials which can make the glue-line inconspicuous through overpainting or other covering.
5. *Durability* — An adhesive which will conform to the previously stated conditions longer than other adhesives will be superior to the others. Chemical and physical stability of the adhesive while in contact with the bonded surfaces is therefore a prerequisite for a durable bond.
6. *Applicability* — The mode of application of the adhesive should not endanger the objects to be bonded.
7. *Reversibility* — The adhesive and the bonded parts should be safely separable, should the need arise.

TECHNOLOGY OF ADHESIVES
ADHESIVES FREE OF VOLATILE SOLVENTS

Experience has taught conservators to avoid adhesives containing solvents, particularly water, because of the contractions and expansions resulting from impregnation and drying (*Figure 24.1*). In our research, we therefore tried to develop adhesives which would, at the time of activation, be basically free of evaporating solvents and which would not depend on volatile solvents for their adhesive action. The advantages of this type of adhesive are:

1. No solvents to damage or otherwise affect the materials to be bonded.
2. No shrinkage caused by evaporation of solvents[2].
3. Instant firm bond to porous and non-porous surfaces.

All 'solvent free' adhesives have the same system of bond-forming: the solidifying of a liquid in contact with the surfaces to be bonded. In its simplest form this is the hot-melt, or solder, and its bonding action is described below.

A hot-melt adhesive is basically a molten material which is attracted to the surfaces to be bonded. This quality, called 'wetting', is the ability of a liquid to be attracted to a solid surface. The intermolecular forces of mutual attraction between adhesive and adherend act over very small distances only, and they require very close contact for their activation. The liquid hot-melt comes into close contact with the surfaces to be bonded, wets them, but can be easily displaced. Upon cooling, it solidifies, gains structural strength and ties the bond. The strength of the bond depends on the structural strength of the con-

TABLE 24.1. SHORTCOMINGS OF CURRENTLY USED ADHESIVE SYSTEMS

Character-istic	Glue Paste	Wax Resin	Microcrystalline Wax	Resin Emulsions	Evaluation of Beva* by the Same Criteria
Adhesion	Does not wet certain oil paint films.	Low structural strength.	Lowest structural strength of all adhesives tested.	Some do not wet oil paint films well enough.	Excellent to most surfaces, best adhesion to oil paint films of all the adhesives tested. Excellent structural strength.
Chemical interaction	None known.	Affects oil paint and canvas[27,29].	None known.	Some emulsifiers are known to interact.	None known.
Structural interaction	Aqueous vehicle harmful. Some glues are too hard, all have moisture movements.	Swells some oil paints and makes them susceptible to abrasion[15,29]	Might make some oil paint films more soluble or enhance the action of solvents[29].	Aqueous vehicle may cause swelling, shrinkage or other harm.	Could happen in case of impregnation if too hard an adhesive is formulated; however, Beva can be applied without impregnation.
Compati-bility	Good for oil. Stains absorbent paintings.	Stains absorbent materials. Wax film prevents subsequent use of every other known adhesive.		Staining by emulsifier and solvents.	Excellent, colourless, transparent, very light staining even when impregnation is required. Can be used without impregnation.
Durability	Seems to oxidize slowly, loosing adhesion.	Seems to crystallize and oxidize.	Excellent.	From excellent to bad depending on emulsion.	Excellent stability shown in ageing tests which has not as yet been proved in practical application (developed in 1970). Safety margin because of large increase in adhesive strength.
Applica-bility	Shrinkage and softening of painting by aqueous vehicle. Haste in application due to drying.	Heat at application detrimental.		Dangers of aqueous vehicle.	Widest range of applicability of any adhesive: can be used as solvent type (cold) contact adhesive, or heat-activated at any temperature between 20 − 100°C; permits application with or without impregnation.
Rever-sibility of laminate	Difficult	Excellent	Excellent	Very difficult to impossible.	Excellent
Reversi-bility	Impossible, yet probably harmless in most cases	Impossible[29]	Impossible[29]	Almost impossible.	Reversibility of impregnation difficult, but less than in the case of waxes because of greater solubility. However, impregnation is used in extreme cases only.

*Author's own formulation (*Appendix 1*).

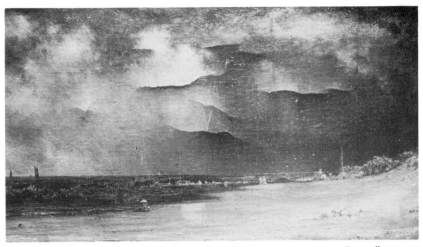

Figure 24.1 Martin Heade (American 1819–1904), Storm, Narangansett Bay, *oil on paper, mounted on canvas, 25 × 45 cm, c.1870. Mounted on canvas with glue paste, the paper expanded and the subsequent drying caused tension stress. Upon ageing, the paper could no longer support the stress and cracked in patterns similar to those of drying oil paint. The photograph shows the painting six months after being wax-lined by a competent conservator – the cracks reappeared (Photograph by Lawrence J. Majewski)*

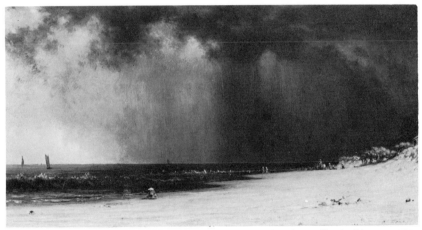

Figure 24.2 Same painting as in Figure 24.1, one year after it was lined with Beva 371, a strong adhesive which did not introduce any new tensions into the mounting process and eliminated the damage. (Photograph by Geoffrey Clements)

necting solid rather than the molecular forces of 'wetting' which are its prerequisite.

Like a ship that needs a proper anchorage, a good anchor and a strong chain to hold it safely in place, a good adhesive bond requires proper anchorage – a clean and firm surface, a good anchor, provided by its ability to wet the surfaces to be bonded, and a strong chain, formed by the structural forces of the adhesive.

The structural strength of resins depends on the quality of the molecules, their form and size. The organic polymers which form adhesives usually consist of long-chain molecules. These long-chain molecules can be visualized as microfibrils, thin fibres forming a felt. The strength of the felt depends on the strength and the length of its fibres. The larger the

molecules, the longer the fibrils, and for this reason high molecular weight resins have high structural strength. Regrettably, for the same reason, the inner friction between the long-chain molecules is higher when they are dissolved or molten. Thus, in polymers of the same type (e.g. polyethylene), polymerization to larger molecular size brings, with increased structural strength, a simultaneous increase in melt and solution viscosity, melting temperature and melt index.

Combinations of high molecular and low molecular weight resins enable us to improve the structural performance of the mixture without a proportional increase in melt temperature/viscosity. The low molecular weight resin acts as a solvent, or lubricant, between the molecular chains when the mixture is

molten; it lowers the melt viscosity, and often acts as a wetting agent. Upon cooling, the high molecular weight microfibrils supply the structural strength whilst the low molecular weight resin provides rigidity as a stiff but rather brittle filler.

WAX-RESIN ADHESIVES

Table 24.1 shows that wax-resin mixtures, the only hot-melts used by conservators, do not fulfil all the requirements for an ideal adhesive. However, wax-resin adhesives have many desirable qualities, listed by Stout and Gettens[5]. Impregnation with wax serves to fill all the voids of the painting and to engulf into one body of wax all loose particles which would otherwise interfere with adhesion, including those which might have escaped our notice. However, our first tests already showed that impregnation with structurally weak adhesives makes it impossible ever to achieve a firmer bond than that of the first impregnating adhesive[6,29]. As in any other chain, the total strength of an adhesive chain cannot exceed the strength of its weakest link. Therefore, impregnation with a structurally weak resin leaves the painting in a weakened condition.

Impregnation with wax-resin mixtures is considered essential for the treatment of certain paintings. Since the structural strength of wax-resin mixtures is often insufficient (*Figures 24.1* and *24.2*) we directed our first efforts to reinforce them.

We tried to increase the structural strength of waxes by adding resins of greater elasticity and rigidity. Our efforts were helped by the development of copolymers of polyethylene especially prepared for the reinforcement of wax-resin adhesives. Copolymers of polyethylene with vinyl acetate and other copolymers and terpolymers make a wide range of selections possible[7]. Addition of these high molecular weight resins to wax-resin mixtures raises the viscosity of the mixtures. No more than 10% of copolymers (by weight) can usually be accommodated within our temperature/viscosity limits (maximum 200–300 Brookfield centipoises at 65°C). The viscosity can be reduced by adding double the weight of oil-free paraffin (65°C m.p.) to the copolymer. Microcrystalline wax has a lower degree of compatibility than paraffin, and therefore raises the viscosity of the melt, or makes the resulting mixture brittle upon cooling. More information on ethylene copolymers can be found in the bulletins of the firms producing these resins[8,9,10,11,12]. This literature was extensively used by the author in his attempt to formulate new adhesives.

We found our own reinforced wax-resin mixture, 350 (*Appendix 1*) useful in cases where wax-resin adhesives were indicated for the treatment of an art object. Formula 350 has two–three times the peel strength of conventional wax-resin mixtures, and a much higher rigidity and elastic recovery. However, 350 still contained beeswax, which our tests showed to be potentially detrimental to canvas and certain paint films[13,14,15,29]. Attempts were made to replace beeswax with microcrystalline wax known to be free of such hazards, and to find resins capable of reinforcing it. These attempts have been fruitless so far because of the limited compatibility of microcrystalline wax with most resins.

Waxes and other high molecular weight polymers have no sharp melting points but rather a melting range. A high molecular weight polymer capable of withstanding the stresses inherent in some paintings at 35°C and of being liquid at 65°C (melt/viscosity 200–300 centipoises) is, to our knowledge, yet to be produced. For this reason our research on hot-melt adhesives was suspended. Since the application of hot melts requires the often hazardous heating of paintings, and always results in impregnation (not permissible for many art objects), it was decided to look for an entirely new adhesive and a new approach to fulfil the requirements of modern picture conservation[6,16].

MODERN ADHESIVE SYSTEMS

Pressure-sensitive and contact adhesives have become popular in the last 30 years. They were thought unsuitable for the consolidation of paintings for the following reasons:

1. To wet surfaces at room temperature, pressure-sensitive and contact adhesives must have at least one liquid component. In order to obtain contact with the surfaces to be bonded, they must deform at low pressure and must have sufficient flow to retain the wet-out position after removal of pressure. However, a liquid cannot form a structurally sound bond; it deforms under stress and the bonded surfaces float apart.

2. Liquid components of an adhesive have the tendency to migrate into the bonded materials. They frequently strain, soften or interact with the bonded materials, while the adhesive from which they migrate loses its plasticizers and becomes brittle (*Figure 24.6*).

3. Since both pressure-sensitive and contact adhesives are designed to provide an instant bond, they do not allow for any adjustments of the parts to be bonded.

Whilst the first two limitations could be overcome (by using contact adhesives in solutions which form gels), the third limitation makes contact cements unsuitable for most applications in conservation. In most glueing operations, and especially in conservation, it is almost impossible to put the surfaces to be bonded precisely together without further adjustment. Thus, this instant bond of contact cements and of pressure-sensitive adhesives severely limits their usefulness to us. Therefore, no development of adhesives of this type was attempted.

Figure 24.3 Thang-ka Shante Krodha (Collection of the Museum of National History, New York), gouache and tempera on silk, 66·7 x 47 cm. The silk was too weak to support its own weight and a large area was broken into little pieces, shown in the box. In the background, the Dacron (terylene) screen impregnated with Beva 371, ready for mounting. (Photograph by Lawrence J. Majewski)

Figure 24.4 The little pieces are arranged in place and heatsealed to the impregnated screen, beginning with the area of greatest loss. (Photograph by Lawrence J. Majewski)

Figure 24.5 The mounted thang-ka. Done in cooperation with the Conservation Centre of the Institute of Fine Arts of New York University. (Photograph by Lawrence J. Majewski)

SOLVENT APPLIED HEAT-ACTIVATED OR HEAT-SEAL ADHESIVES

The structural weakness of hot-melt adhesives could not be overcome without raising the temperature for suitable melt viscosity to levels which are dangerously high for paintings. However, with solvent application the viscosity could be reduced to such a degree that application at room temperature becomes possible, thus eliminating the dangerous heating of paintings[17]. Since heat sealing is performed only after most of the solvent has evaporated, even non-porous materials can be effectively bonded, and there is less shrinkage than in any other bonding system (*Figures 24.2 and 24.6*).

Heat-seal adhesives are solid at room temperature, and become contact or pressure-sensitive adhesives at elevated temperatures. Since they are elastic solids, the dangers of cold flow and staining by migration are eliminated. They are dry to the touch and can be stored without danger of anything sticking to them (they are 'non blocking'). Such adhesives were first recommended for use on textiles by Leene[1] and Beecher[18], and later used as lining adhesives by Lodewijks[19] and Berger[20,28].

The heat-seal bond is formed by using a high molecular weight polymer for structural strength together with one of low molecular weight. At activation- or seal-temperature, the low molecular weight resin changes into a low viscosity liquid which dissolves the high molecular weight resin and wets the surface to be bonded. The activation temperature can be easily adjusted by the choice of the low molecular weight resin or mixtures of low molecular weight resins. The highly viscous liquid formed by the solution of the high molecular weight resin in the low molecular weight resin forms an instant, strong bond, which does not require any prolonged heating and holds the parts together without pressure or clamping (*Figures 24.3, 4, 5 and 6*).

Because of the high viscosity of solvent-free adhesives, they would not penetrate or stain even the most porous materials when not directly applied (*Figures 24.5, 6, 8, 10 and 11*).

The high molecular weight resins which formed the basis for our formulations, and which were to supply them with structural strength, were well known to us from our attempts to reinforce wax-resin mixtures. They are soluble in low-aromatic hydrocarbons which are normally harmless to paintings[21], and therefore could be safely applied and removed in solution. Their compatibility with wax was an added advantage because they could combine with any wax used in previous consolidations. Moreover, the addition of wax to our formula would protect it from irreversible cross-linking.

At the outset, high solubility of the polymers was considered desirable for solvent application. The ability of resins to form low viscosity solutions at elevated temperatures is essential for impregnation (when impregnation is required). Impregnation is still the only known way to consolidate flaking and cracked paint films. The adhesive in such cases must penetrate into the cracks and crevices which are the points of incipient flaking of the painting in order to readhere all loose particles.

We concentrated our first experiments on Elvax 40 and Elvax 150 (*Appendix 1*) which form low viscosity solutions. A further lowering of solution viscosity was achieved by selecting Ketone N (*Appendix 1*) as the low viscosity resin, or flux agent. Of all the resins tested, Ketone N proved to be the most stable low viscosity resin. However, its softening

Figure 24.6 Mountings of delicate textures and tissues. The top half of the paper tissue and paper towel is adhered with Beva to Mylar, while the bottom half is loose. No difference between the two parts can be detected, which proves that no pressure was exerted and no shrinkage resulted. The samples can easily be removed from the Mylar without damage, using vapours of naphtha, toluene or acetone. (Photograph by Orrin H. Riley)

point of 75–85°C (DIN) is still too high for our applications. Thus, a resin with a lower melting point of about 65°C had to be added. No completely satisfactory resin of this kind has been found as yet. Venice turpentine, elemi and preferably Canada balsam could be used, though we prefer Cellolyn 21 (*Appendix 1*) because it is solid at room temperature. Effective mixtures without resin plasticizer are possible by using an evaporating solvent, such as naphtha, to lower the melting point temporarily (Beva 321). However, the low quantity of 5% of resin plasticizer incorporated in some of our mixtures showed little detrimental effect in our tests.

Since my grant barely sufficed to formulate one adhesive, it was decided to concentrate on one of minimum viscosity to make it useful not only for lining of paintings but for consolidation of flaking paint as well. The larger part of each component of this adhesive is soluble at room temperature, making it a very satisfactory solvent-applied adhesive for instant consolidation and strong attachment of facing paper without expansion of the paper (*Figure 24.9*).

Beva 300 is an adhesive which conforms to all the requirements we established at the beginning of our research, except for crosslinking. It seems to have the highest peel strength and best resistance to creep

Figure 24.7 Marc Chagall, Paris Through the Window, *oil on canvas, 211 x 218 cm, 1913. Photograph before treatment using transmitted light coming from the reverse side of the canvas: the stretcher elements are visible. (Photograph by Orrin H. Riley)*

Figure 24.8 Same painting as in Figure 24.7, after treatment. Lining done with Beva 371, in cooperation with Orrin H. Riley, Chief Conservator, Guggenheim Museum, New York (Photograph by Orrin H. Riley)

Figure 24.9 Jules Pascin, oil on both sides of decaying cardboard, 100 x 70 cm. The two paintings were separated using a Pellon fibreglass facing adhered with Beva 400 (demonstrating the reliability and strength of this adhesive)

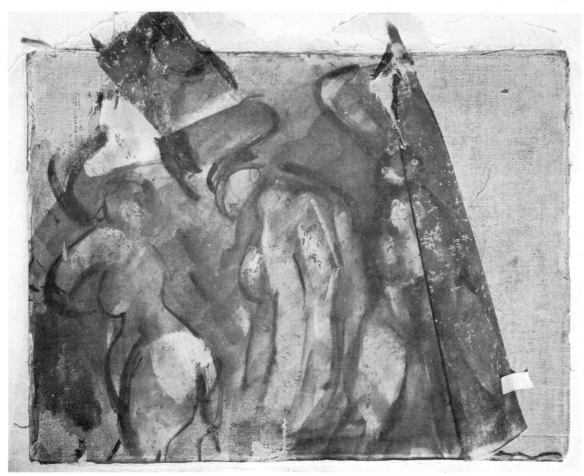

Figure 24.10 Georges Rouault, Bathers, gouache on paper mounted on canvas, 40 x 60 cm. The paper was buckling and developing tears. Upon removal from the mounting canvas, a similar gouache was found on the reverse side of the paper. It is shown in the photograph with parts of the canvas still attached. Done in cooperation with Claudio Rigosi, Conservator, New York

(a) (b)

Figure 24.11(a) and (b) Same painting as in Figure 24.10. Reverse side of the Rouault after mounting with Beva 371 on Mylar 200-A. The lined painting is fully visible, and the colour-change minimal. The signed side is a mirror image of the same group in a slightly changed version, and seems to be a free tracing of this gouache. Note the reflection on the Mylar (arrow). Done in cooperation with Claudio Rigosi

(a) (b)

(c) (d)

Figure 24.12 The separation between application and activation makes Beva adhesives especially suited for the lining of large paintings. (a) Facing a large painting. Since Beva is non-aqueous, it can be applied on large pieces of facing paper without causing folds or tensions. (b) Application to a large painting. No distortions caused by heat or humidity. (c) Application of Beva 371 to the interleaf. (d) Heat-sealing days or weeks after application of Beva (painting by Gerritsz Cuyp)

of all the adhesives described in this paper. Because polystyrene (*Appendix 1*) does not seem to have very good wetting properties, Beva 300 seemed sometimes to fail, and to give a slightly erratic performance in the tests. The addition of Cellolyn 21 (*Appendix 1*) solved this problem, and led to the adhesive designated Beva 400, which is our favourite formulation for strong facings. The addition of 5% resin plasticizer seems to have little effect on peel strength and creep.

CROSSLINKING TESTS

Since materials which by themselves do not cross-link sometimes do so when combined, tests for crosslinking were done after the formulation of our adhesives. We considered these tests to be of great importance because the strong adhesives we formulated would be very dangerous if proved irreversible. When used as a paint consolidant and impregnating resin it would be disastrous if the substrate or paint support was transformed by a crosslinking adhesive into a piece of insoluble plastic. Eight different adhesives using formulae 285–300 as a model were formulated by substituting resins which we knew to be

effective and stable. These eight adhesives were mixed with oil-free paraffin (65°C m.p.) and chlorinated paraffin (*Appendix 1*) in different proportions. Half of the specimens were exposed to heat ageing (54°C ±2) for one year, the other half to artificial sunlight for 300 hours (ASTM D 795-65T). The effect of the substitutions and additions on adhesive strength and crosslinking before and after ageing was studied before selecting the best combination, Beva 371 (*Appendix 2* and *Table 24.2*). The adhesive strength of Beva 371 is only 50% that of Beva 300 (*Appendix 2*) but it still has more than ten times the strength of the best conventional wax-resin mixtures[22]. Beva 371 showed less tendency to crosslink than did AW2, Rembrandt varnish, and the best acrylic varnishes[23]. It contains 10% (of the solid part of the formula) of oil-free paraffin to ensure that it will stay removable forever. Its activation temperature of 65°C can be temporarily lowered to 40–50°C with small amounts of solvents. Beva 371 is colourless, transluscent to transparent, and adheres to most known materials (it can therefore be used for transparent mountings in the case of paintings done on both sides of the canvas or paper (*Figure 24.10, 11*). The use of Beva 371 for exceptional mounting problems has been reported[24,25,26].

177

TECHNOLOGY OF ADHESIVES

Beva 371 was formulated especially for the impregnation of paintings, and therefore only those resins were used which form low viscosity solutions even at room temperature. In subsequent tests we found that low viscosity adhesives could be formed with resins which are insoluble at room temperature (or almost insoluble) by using suspensions in solvent naphtha or high boiling point petroleum solvents. As a matter of fact, such suspensions have a much lower viscosity than solutions permitting application at very high percentages of solids to the liquid vehicle.

We are in the process of developing thin, self-supported high viscosity Beva films for lamination and reinforcement of paper, especially for pastels and gouaches. Application and removal of such films from fragile textiles and paper without impregnation or staining can be easily accomplished. This opens the way to protective coatings for old paper, textiles and absorbent paintings on unprimed materials.

In other developments, impregnation of fibrous materials with some resins has shown promising results. Several of these resins, or combinations of these resins with other substances, have considerably strengthened brittle fabrics and protected them from decay in the ageing kiln[27].

Because of their compatibility with Ketone N and MS2A (Appendix 1), EVA copolymers make an excellent solid plasticizer for these varnish resins. The compatibility of EVA copolymers with waxes permits introduction of considerable quantities of wax into varnishes to prevent crosslinking. By doing so, we have been able to formulate effective glossy and matt varnishes which are permanently removable with mild solvents. These mixtures have intermediate qualities between low molecular weight varnishes and high molecular weight, high viscosity varnishes. Such qualities were first described as desirable by Thomson[4], and we found their handling properties very promising, especially in spray applications.

Thus the research for a special adhesive for the consolidation of paintings has borne additional fruits. However, none of them can be used unless a comprehensive testing system for new materials and their effects on art objects is used. I consider my work in designing such tests much more important than its results — a new adhesive and new insight into the interactions between the materials we deal with in conservation[14]. Since 1972, when this report first appeared, additional uses of Beva adhesives have been found by practising conservators[30-4].

Acknowledgements

The author wishes to thank the Samuel H. Kress Foundation for financing his research for two full years. The trust of Miss Mary M. Davis, Executive Vice-President of the Kress Foundation, nurtured this research from its inconspicuous beginnings and provided encouragement in many difficult moments.

Special thanks to the technical staff of the numerous American firms who generously provided technical literature, free samples and countless hours of free expert advice. To all those who helped, too numerous to mention by name, gratitude is expressed.

APPENDIX I: FORMULATIONS

(For details on the materials and their sources see Appendix 2).

FORMULA 350: A WAX-RESIN HOT-MELT ADHESIVE

parts by weight

Beeswax	8	1600 g
Resin (Dammar, Ketone N., resin ester or equivalent	2	400 g
Paraffin	2	400 g
Elvax Resin grade 250	¾	150 g
Elvax Resin grade 210	¼	50 g
Plasticizer (Piccolastic A-75, Elemi, Venice turpentine or Cellolyn)	1	200 g
Total	14	2800 g

Melt beeswax and paraffin, add Elvax slowly, stir until dissolved, add resins last.

This hot-melt was developed from Beva formulations using the experience of our tests from 1 to 300.

GENERAL FORMULATION FOR BEVA HEAT-SEAL ADHESIVES

Heat-activated adhesives which are soluble in low aromatic petroleum solvents can be formulated in the following proportions:

From 40% to 80%, preferably 55% to 70%, ethylene copolymers (a mixture of several copolymers can be used to advantage).

From 20% to 50%, preferably 30% to 50%, hydrocarbon resins of a melting point between 80 and 100°C, or mixtures of several hydrocarbon resins.

From 5% to 15%, hydrocarbon resin of 50–60°C m.p. (can be omitted).

From 10% to 20%, non-polar, oil-free wax, such as paraffin (65°C m.p.) dissolved or suspended in mixtures of aromatic and non-aromatic hydrocarbons to adjust viscosity and drying time.

BEVA 300

parts by weight

Elvax Resin grade 150	3
Piccolastic A-75	1
Piccopale 100 H-2	1
A-C Copolymer 400	1

Dissolve Elvax in toluene (3:1), dissolve all other resins in solvent naphtha (3:1); heat in water-bath above cloud point, then mix. (Allow to cool very slowly to reduce viscosity.)

WARNING: Beva 300 crosslinks, and should be used for facings only.

BEVA 321

For purists who do not want to use Cellolyn 21

parts by weight

Elvax Resin grade 150	18
Ketone N	8
Toluene	36
Solvent naphtha (pure benzine)	11

Dissolve in water-bath then add the following:

A-C Copolymer 400	6
Solvent naphtha (pure benzine)	12

Dissolved in water-bath, and

Paraffin (oil-free, 65°C m.p.)	3
Solvent naphtha Dissolved in water-bath	6

Heat above cloud point, stir together, allow to cool slowly.

WARNING: This adhesive can only be used on a vacuum hot-table while it still contains some solvents. In solventless form its activation temperature is too high for most paintings. It is unsuitable for hand ironing.

BEVA 400

(For strong facings)

parts by weight

Elvax Resin grade 150	3	600 g
Piccopale 100 H-2	1	200 g
Piccolastic A-75	1	200 g
Cellolyn 21	¼	50 g
Toluene	6	1200 g
Solvent naphtha (pure benzine)	2	400 g

Dissolve in water-bath, then add:

A-C Copolymer 400	1	200 g
Solvent naphtha (pure benzine)	2	400 g

Heat above cloud point and stir into above mixture; allow to cool.

WARNING: Beva 400 evolved from Beva 300 and can only be used for facings because it crosslinks.

BEVA 371 b – 38% SOLIDS

Each of the following three groups should be separately dissolved in water-bath.

Elvax Resin grade 150	500 g
Ketone N Resin	300 g
Cellolyn 21	40 g
Toluene	1000 g
Solvent naphtha (pure benzine)	250 g

Dissolved in water-bath, then add:

A-C Copolymer 400	170 g
Solvent naphtha (pure benzine)	300 g

Dissolved in water-bath

Paraffin (oil-free, 65°C m.p.)	100 g
Solvent naphtha (pure benzine)	250 g

Dissolve in water-bath.

Heat all solutions above cloud point and stir well together; allow to cool very slowly.

To retard drying, 'odourless' paint thinner (purely aliphatic petroleum solvent) or other petroleum solvents of high boiling point may be added.

For impregnation and consolidation of flaking paint, Beva 371 and other Beva adhesives should be thinned with aliphatic or low aromatic naphthol spirits of high boiling point, such as Amsco 310–338, Amsco 247–290 (one part of Beva to four parts of spirits).

This mixture should be heated in a water-bath above cloud-point before use, and should be kept warm during use.

Whiting ground in a similar mixture (using more aromatic solvents) to paint or putty consistency makes an excellent water-free elastic gesso which, after drying, can be worked with carving tools and sandpaper, and accepts any type of covering paint because of its porosity.

APPENDIX 2: THE MATERIALS USED AND THEIR SOURCES

A-C Copolymer 400 – an ethylene vinyl acetate copolymer (EVA), vinyl acetate content 14–16%, soften-

ing point 83°C (ASTM E 28–58 T), acid no. zero. Produced by Allied Chemical, Plastics Division, P.O. Box 365, Morristown, New Jersey, U.S.A.

Beeswax — a natural product consisting of about 80% ceryl myristate. It also contains esters of cerotic acid, c. 13% acids and a few percent hydrocarbons. The acids (acid no. c. 20) are mostly cerotic acid, neocerotic acid, montanic acid, melissic acid.

Beva 371 — as per formula given, is supplied in both prepared and dry form by Adam Chemical Co., P.O. Box 15, Spring Valley, N.Y. 10977, U.S.A., and by Lascaux, Promenadengasse 14, CH-8001 Zurich, Switzerland.

Cellolyn 21 — a phthalate ester of technical hydroabietyl alcohol. It is a very pale, tacky resin, softening point 65°C, acid no. 8.
Produced by Hercules Incorporated Pine & Paper Chemicals Dept., Wilmington, Delaware, U.S.A.

Dammar — a natural product containing volatile oil, resins and small amounts of acid (acid no. 20 to 40).

Elemi — a natural product which varies widely depending on its source. Fresh elemi is a solution of resins in an ethereal oil. Part of the resin may be in crystalline form. Phellandrene and dipentene are obtained by distilling elemi (acid no. 1 to 40).

Elvax 40 — Medium-low viscosity resin with excellent solubility in many organic solvents, melt index 45–70, percentage of vinyl acetate 39–42, tensile strength 650 psi (ASTM D 1708), softening point 93°C (ASTM E 28).

Elvax 150 — Medium viscosity resin with high specific adhesion to non-porous surfaces, high solubility in organic solvents, melt index 38–48, percentage of vinyl acetate 32–34, tensile strength 850 psi (ASTM D 1708), softening point 116°C (ASTM E 28).

Elvax 210 — Melt index 365–440, percentage of vinyl acetate 27.2–28.8, tensile strength 300 psi (ASTM D 1708), softening point 82°C (ASTM E 28).

Elvax 250 — Melt index 22–28, percentage of vinylacetate 27.2–28.8, tensile strength 1400 psi (ASTM D 1708), softening point 137°C (ASTM E 28).
Produced by E. I. Du Pont De Nemours & Co., Electrochemicals Dept., Wilmington, Delaware 19898, U.S.A.

Ketone N — is a condensation product of cyclohexane, acid no. less than 1.0.
Produced by BASF, Badische Anilin & Soda Fabrik A.G., Ludwigshafen am Rhein, Germany; and BASF Corp., P.O. Box 181, Parsippany, New Jersey 07054, U.S.A.

Paraffin — oil-free, 65°C m.p., available by the name 'Essowax 4610'.
Supplied by Humble Oil and Refining Company, Hutchinson River Parkway, New York, N.Y., U.S.A.

Piccolastic A-75 — is a polystyrene resin; it has an acid no. of less than 1.0.
Produced by Pennsylvania Industrial Chemical Corp., (PICCO), 120 State St., Clairton, Pa., U.S.A.

Piccopale 100 H-2 — purely aliphatic, hydrocarbon resin.
Produced by PICCO, 120 State St., Clairton, Pa., U.S.A.

Venice turpentine — a natural product which, according to Stout and Gettens, consists of 63% resinous acids, 20% terpenes, 14% resins and 3% other constituents (acid no. 65–100).

References and Notes

[1] Leene, J. E., 'Restoration and Preservation of Ancient Textiles, and Natural Science', *Recent Advances in Conservation*, Butterworths, London (1963), 190–191.
[2] Werner, A. E., 'Consolidation of Fragile Objects', *Recent Advances in Conservation*, Butterworths, London (1963), 125–127.
[3] Rosenqvist, A. M., 'New Methods for the Consolidation of Fragile Objects', *Recent Advances in Conservation*, Butterworths, London (1963), 140–144.

Table 24.2. SOLVENTS USED IN THE BEVA FORMULATIONS

Name of Solvent	Evaporation Rate : Toluene = 1	Initial BP	Dry End Point	Kauri Butanol Number	Aromatic	Aromatic Composition % Paraffin	Naphthane	C_8 and above Aromatics
Toluene	1·00	110	111	105	100	0	0	0
VM&P Naphtha (Benzine)	0·45	113	143	34	9·5	72·8	17·7	7·7
Odourless Mineral Spirit	0·03	179	190	28	0	84	16	0
Mineral Spirits	0·06	156	198	36	15	49	34	15
Amsco Solv B 2351	0·12	137	190	73	70	15	14	52·5

Data copied from: Amsco Solvents/Chemical Polymer Emulsions, Hotmelt Adhesives, Amsco International, 1345 Avenue of the Americas, New York, N.Y. 10019, U.S.A.

Pure Mineral Spirits is an adequate retarder. My favourite retarder is a mixture of Amsco Solv B and VM&P Naphtha in proportion 1:4 or 1:3 (1 part of Amsco Solv B to 4 or 3 parts of VM&P Naphtha). Xylene can also be used as a retarder.

[4] Thomson, G., 'New Picture Varnishes', *Recent Advances in Conservation*, Butterworths, London (1963), 176–184.

[5] Stout, G. and Gettens, R. J., 'The Problem of Lining Adhesives for Paintings', *Tech. Stud. Fine Arts*, 2 (1933), 81–104.

[6] Berger, G A., 'Weave Interference in Vacuum Lining of Pictures', *Stud. Conservation*, 11 (1966), 180 (footnote 13).

[7] Copolymers of polyethylene are made by almost every large producer of synthetics in the world. They are compatible with most waxes and soluble in low aromatic hydrocarbons. Not only copolymers with vinyl acetate (EVA) but ethylene ethylacrylates (EEA), ethylene iso-butylacrylates (EIBA), and many others are produced. Some may have special advantages for our applications which remain to be tested.

[8] *Elvax, Vinyl Resins*, Du Pont de Nemours and Co. Inc., Electrochemical Dept., Wilmington, Del., U.S.A., Form A-70567.

[9] *A-C Polyethylenes and Copolymers for Papercoatings*, Allied Chemical Corp., Plastics Division, P.O. Box 365, Morristown, N.J., U.S.A., PC-1 to PC-11.

[10] *Ethylene Copolymer Resins (Zetafax)*, Dow Chemical Company, Midland, Michigan 46840, U.S.A., Form No. 170–231. Production of *Zetafax* has since been discontinued.

[11] *The PICCO Valuable Collection of Synthetic Resins*, Pennsylvania Industrial Chemical Corp., 120 State St, Clairton, Pa., U.S.A., Form No. PPN-066-A; also *Evaluation of PICCO Resins with Ethylene Vinyl Acetate Co-polymers* (PPN-063) and *Hot Melt Copolymers for the Paper Industry* (PPN-015). This technical bulletin lists most of the ethylene copolymers available in the U.S.A.

[12] Hercules Powder Company, 910 Market St, Wilmington, Del. 19899, U.S.A., Forms No. 900–62 A, 900–41 F and 900–77.

[13] Werner, A. E., 'Synthetic Waxes', *Museums J.*, 57 (1957), 3–5 (the author states that natural waxes can form harmful products through hydrolysis).

[14] Berger, G. A., 'The Testing of Adhesives for the Consolidation of Paintings', *IIC-Amer. Group Technical Papers, 1968 through 1970*.

[15] Berger, G. A., 'Some Effects of Impregnating Adhesives on Paint Films', *IIC-Amer. Group Bull.*, 12 (1972), 25–45b. Reprinted with author's additions by the Conference on Comparative Lining Techniques, Greenwich, London, 1974.

[16] Berger, G. A., letter to the Editor, *Stud. Conservation*, 16 (1971), 26.

[17] Brachert, T., 'Probleme bei der Doublierung von Leinwand Bildern', *Maltechnik*, 71 (1965), 80–81.

[18] Beecher, E. R., 'Reinforcing Weakened Textiles with Synthetic-Fibre Net', *Recent Advances in Conservation*, Butterworths, London (1963), 195–6.

[19] Lodewijks, J., 'Heatsealing Useful for Relining of Paintings', *Preliminary Report to ICOM Committee for the Care of Paintings*, Brussels (1967).

[20] Berger, G. A., report to the Samuel H. Kress Foundation, 28 April 1967.

[21] Feller, R. L., Stolow, N. and Jones, E. H., *On Picture Varnishes and Their Solvents*, rev'd ed., Press of Case Western Reserve University, Cleveland (1971), Part 3: 'Resins and Properties of Varnishes'. 119–167.

[22] Berger, G. A., 'Testing Adhesives for the Consolidation of Paintings', *Stud Conservation*, 17 (1972), 173–194.

[23] Feller, R. L. and Curran, M., 'Solubility and Crosslinking Characteristics of Ethylene/Vinylacetate Copolymers', *IIC-Amer. Group Bull.*, 11 (1970), 42–45.

[24] Berger, G. A., 'Application of Heat-Activated Adhesives for the Consolidation of Paintings', *IIC-Amer. Group Bull.*, 11 (1971), 124–128.

[25] Riley, O. H. and Berger, G. A., 'New Developments in the Conservation of Works of Art', *Art J.*, 31 (1971), 37–40.

[26] Riley, O. H. and Berger, G. A., 'New Solutions for Modern Problems', *Museum News*, 1 (1973).

[27] Berger, G. A. and Zeliger, H. I., 'Effects of Consolidation Measures on Fibrous Materials', *Bull. Amer. Inst. Conserv.*, 14 (1973), 43–65. Reprinted with author's additions by the Conference on Comparative Lining Techniques, Greenwich, London 1974.

[28] Berger, G. A., 'Heat-Seal Lining of a Torn Painting with Beva 371', *Stud. Conservation*, 20 (1975), 126–151.

[29] Berger, G. A. and Zeliger, H. I., 'Detrimental and Irreversible Effects of Wax Impregnation on Easel Paintings', *4th Triennial Meeting of ICOM*, Venice, 1975 75/11·2–1 – 75/11·2–16.

[30] Buck, R. D. and Merrill, R., 'Honeycomb Core Construction for Supporting Panels', *Bull. Amer. Inst. Conserv.*, 12 (1972), 65–67.

[31] Raft, K. and Raft. A., 'Beva 371, ein neues Klebemittel für Restauretoren', *Maltechnik/Restauro*, 1/73 (1973), 31–39.

[32] Scott, K. O., 'New Treatment for an Old Textile Problem', *Bull. Amer. Inst. Conserv.*, 14 (1974), 168–171.

[33] Berger, G. A., 'Lining of a Theatre Curtain by Picasso—Conservation Report', *4th Triennial Meeting of ICOM*, Venice, 1975, 1–2.

[34] Renshaw-Beauchamp, R. B., 'Another? Use for Beva 371', *Bull. Amer. Inst. Conserv.*, 15 (1974), 59–60.

25
An Evaluation of Glues for Use in Paper Conservation

NORBERT S. BAER, NORMAN INDICTOR AND ABRAHAM JOEL

INTRODUCTION

In a recent paper[1] the applicability of several glues for use in paper conservation was discussed. In that work thick samples of glues were applied to paper strips, then laboratory aged at 100°C for periods of up to 16 days. The uniformly bad performance of glues under these conditions was not unexpected and led to the more significant problem of developing a proper evaluation technique for such systems (e.g. paper-adhesive, paper-size, canvas-resin) as are frequently encountered in conservation practice. For example, though separate techniques for the evaluation of paper permanence[2,3] and adhesives[4] have been established, there has been little investigation of the interaction of these materials as components of an adhesive-artifact system. As part of a programme to develop such evaluative techniques, a series of experiments using varying methods of laboratory ageing has been undertaken. This report presents the results of experiments designed to compare the laboratory ageing under varying temperature conditions. Examined are model paper-adhesive systems aged at 21°, 60°, 80°, and 100°C.

EXPERIMENTAL

MATERIALS AND METHODS OF APPLICATION

All paper samples were Whatman chromatography paper No. 1, basis weight 87 g/m^2, thickness 0·16 mm, medium flow rate, supplied in $\frac{1}{2}$ in x 300 ft rolls, cut in 6in lengths. The four commercial adhesives tested are listed in *Table 25.1* with source of supply and concentration conditions prior to application. Total solids reported were obtained by evaporation at 100°C for 24 hours.

The procedure for applying the glues and cements to the paper consisted of brushing the adhesive on a single side of the test paper and permitting solvent evaporation in a controlled atmosphere (21 ± 1°C, 50% relative humidity) for 24 hours. A loaded $\frac{3}{4}$ in brush was brought back and forth over the paper sample for a total of five strokes. For the preparation of glues on glass slides the same brushing procedure was used.

AGEING OF SAMPLES

The treated and untreated samples were placed in an oven at various temperatures (21°, 60°, 80° and 100°C) for periods of 1, 5, 9, 16 and 50 days. On the completion of each ageing period six replicate paper samples and specimens on glass slides were removed and equilibrated at 21 ± 1°C, 50% relative humidity, for 24 hours.

FOLDING ENDURANCE TESTS

Measurements were performed on a Tinius-Olsen Model No. 2 Instrument (also known as MIT folding test meter) according to ASTM method D2176-63T. A dead weight of $\frac{1}{2}$ kg was used in all tests. Results are reported as the average of six measurements together

Table 25.1. GLUES AND CEMENTS EXAMINED

Designation	Supplier	Condition of Use[a]		Solids as Used	Suppliers' Comments
Best Test Paper Cement	Union Rubber & Asbestos Co. Trenton, New Jersey 08606		As supplied	15%	Hexane solvent, natural crepe rubber, small quantities of piccopale, bondogen and vegetable oil deodorants
Yes Stikflat	Gane Bros. & Lane 1335 West Lake Street Chicago, Illinois 60607	L[b]	100:100	36%	G.B.L. dextrin, water, glucose, thiourea, glycerin, Dowicide A (sodium-o-phenylphenate), phosphoric acid
		H	As supplied	71%	
849 Sta-flat	S. Schweitzer Co. 1314 W. 21st Street Chicago, Illinois 60618	L	100:100	34%	Completely soluble vegetable base adhesive
		H	As supplied	67%	
Ganes Flexible Glue	Gane Bros. & Lane 1335 West Lake Street Chicago, Illinois 60607	L	44:100	24%	Water, hide glue, Dowicide A, defoamer, phenol, glycerin. Supplied in solid form.
		M	79:100	35%	
		H	148:100	47%	

[a] Parts adhesive as supplied to parts water (by weight).
[b] L, M, H denote light, medium, heavy coats respectively.

with standard deviation. All tests were performed in a constant temperature/humidity room ($21 \pm 1^{\circ}$C, 50% relative humidity).

pH MEASUREMENTS

A universal pH indicator solution (Harelco Wide Neutral Range Indicator Solution) was applied to the brushed side of test strips according to the procedure described by King et al.[5]. The uncertainty associated with each pH measurement is ± 0.5 pH unit. No readings could be taken at long ageing times at high temperatures where the colour of the adhesive interfered with the indicator colour. Measurements of pH with surface electrodes were generally unsatisfactory because of clogging of the electrode membrane[6,7].

COLOUR CHANGES

The colour of the test strips was compared with that of the standard Munsell colours under incandescent 'Tensor lamp' illumination[8]. Values are reported for the brushed side.

REFLECTANCE

The reflectance was measured at 457 nm with a Bausch and Lomb Color Analyzer Reflectance Attachment on a Spectronic 20 Colorimeter. Results are reported as the average reading for at least three samples. These averages have an uncertainty of $\pm 2\%$ units[2]. Values are reported separately for the brushed and unbrushed sides.

REVERSIBILITY

Qualitative observations of the reversibility of the aged adhesive mounted on glass slides were made in water and toluene. Specimens were immersed for 0.5 and 1 hour periods, removed, and probed with a glass rod. The solvent temperature was maintained at $21 \pm 2^{\circ}$C.

RESULTS AND DISCUSSION

FOLD ENDURANCE

Tables 25.2 to 25.5 present data on fold strength for three different commercially available glues and one cement at a variety of concentration conditions, artificially aged at 21°, 60°, 80° and 100°C for periods of up to 50 days.

Beginning at five days of artificial ageing, a generally detectable decrease in fold strength is observed. As would be expected for most chemical reactions, the rate of fold strength diminution increases with increasing temperature. At 100°C, 50 days of artificial ageing (Table 25.5) gave a depletion of fold strength beyond that of the untreated paper; whereas at 21°C, 50 days of ageing (Table 25.2) produced marked fold strength weakening, below that of the original application (four of the eight systems showed fold strength depletion greater than that of the untreated paper). At shorter ageing times (one and five days) increased strength was often observed, corresponding to chemical set or solvent evaporation. Such increases in fold strength were most noticeable at low temperatures. The tendency of more heavily applied adhesive-paper systems to retain fold strength longer may also be

noted (cf. Ganes Flexible Glue in *Tables 25.2, 3* and *4*).

The clearest distinctions that may be drawn among the various adhesives tested occur upon initial application. The variation observed in fold strength seems to depend even more on the kind of adhesive applied than on the amount of it applied (compare *Table 25.1* with the results of *Tables 25.2* to *25.5*).

As oven ageing time and temperature increase, the distinctions among the adhesives tested become markedly less. The fact that no simple relationship exists between fold strength and the amount of adhesive applied (column 1, *Tables 25.2* to *25.5*) suggests that the different samples contain molecules of considerably different rheological properties.

It is easily seen from *Tables 25.2* to *25.5* that an Arrhenius activation energy plot (here, a plot of the logarithm of fold strength versus reciprocal absolute temperature) would not generally be appropriate for these data since the changing fold strength undoubtedly arises from a multiplicity of mechanisms (e.g. solvent evaporation, oxidation, degradation, chemical set, etc.) some of which tend to weaken and others to strengthen the system. In the limit (at higher temperatures and longer ageing times) the data tend to fit this type of plot better.

REFLECTANCE

Tables 25.6 to *25.9* provide a sampling of reflectance values measured for adhesive samples aged at $21°$, $60°$, $80°$ and $100°C$ for periods of up to 50 days. Measurements were made on both the brushed and the unbrushed sides of the papers. The salient feature of these data is the near constancy of values obtained at $21°$ and $60°$ (*Tables 25.6* and *25.7*) as compared to the monotonic decreases achieved with increasing ageing time and increasing temperature (*Tables 25.8* and *25.9*). The poor correlation of these results overall with those obtained for fold strength suggest that reflectance changes cannot be used for these adhesives as a measure of adhesive deterioration. Molecular

Table 25.2. DOUBLE FOLDS TO RUPTURE[a] FOR ARTIFICIALLY AGED (21°C, 50% RELATIVE HUMIDITY) PAPERS TREATED WITH GLUES AND CEMENTS

Ageing Time	0 days	1 day	5 days	9 days	16 days	50 days
Adhesive						
Untreated	60 ± 15	60 ± 15	60 ± 15	60 ± 15	60 ± 15	60 ± 15
Best	140 ± 35	96 ± 17	142 ± 60	69 ± 16	79 ± 30	39 ± 11
Yes (L)[b]	180 ± 43	68 ± 11	138 ± 46	29 ± 6	28 ± 7	28 ± 5
Yes (H)	302 ± 137	99 ± 45	268 ± 136	74 ± 38	167 ± 175	199 ± 103
Sta-flat (L)	2388 ± 1624	318 ± 176	722 ± 305	27 ± 12	18 ± 12	36 ± 11
Sta-flat (H)	232 ± 93	5 ± 5	85 ± 99	12 ± 10	11 ± 5	36 ± 14
Ganes (L)	4147 ± 895	3243 ± 1066	706 ± 250	666 ± 248	338 ± 188	232 ± 66
Ganes (M)	5174 ± 1646	1455 ± 564	703 ± 199	705 ± 428	187 ± 73	88 ± 32
Ganes (H)	3446 ± 1225	2096 ± 587	1474 ± 491	914 ± 420	2565 ± 870	2131 ± 385

[a]Refers to the paper adhesive system.
[b]L, M, H denote light, medium, heavy coats respectively. See *Table 25.1* for explanation.

Table 25.3. DOUBLE FOLDS TO RUPTURE[a] FOR ARTIFICIALLY AGED (60°C, 10% RELATIVE HUMIDITY) PAPERS TREATED WITH GLUES AND CEMENTS

Ageing Time	0 days	1 day	5 days	9 days	16 days	50 days
Adhesive						
Untreated	60 ± 15	58 ± 20	61 ± 15	61 ± 16	51 ± 6	60 ± 15
Best	140 ± 35	171 ± 68	153 ± 13	63 ± 19	71 ± 42	62 ± 12
Yes (L)[b]	180 ± 43	52 ± 20	160 ± 22	26 ± 5	23 ± 6	29 ± 7
Yes (H)	302 ± 137	218 ± 120	444 ± 96	260 ± 126	153 ± 49	210 ± 121
Sta-flat (L)	2388 ± 1624	254 ± 89	391 ± 346	7 ± 3	4 ± 3	4 ± 2
Sta-flat (H)	232 ± 93	80 ± 64	129 ± 72	21 ± 8	54 ± 19	35 ± 36
Ganes (L)	4147 ± 895	3263 ± 643	632 ± 196	584 ± 252	271 ± 162	233 ± 99
Ganes (M)	5174 ± 1646	4414 ± 2499	848 ± 182	1412 ± 160	484 ± 176	255 ± 203
Ganes (H)	3446 ± 1225	1763 ± 838	3596 ± 777	1911 ± 1003	1286 ± 460	1893 ± 476

[a]Refers to the paper adhesive system.
[b]L, M, H denote light, medium, heavy coats respectively. See *Table 25.1* for explanation.

Table 25.4. DOUBLE FOLDS TO RUPTURE[a] FOR ARTIFICIALLY AGED (80°C, < 10% RELATIVE HUMIDITY) PAPERS TREATED WITH GLUES AND CEMENTS

Ageing Time	0 days	1 day	5 days	9 days	16 days	50 days
Adhesive						
Untreated	60 ± 15	60 ± 11	70 ± 24	56 ± 19	57 ± 14	21 ± 3
Best	140 ± 35	99 ± 16	149 ± 53	53 ± 17	35 ± 2	20 ± 7
Yes (L)[b]	180 ± 43	44 ± 8	132 ± 32	17 ± 5	13 ± 3	11 ± 2
Yes (H)	302 ± 137	152 ± 15	280 ± 55	56 ± 35	53 ± 49	17 ± 9
Sta-flat (L)	2388 ± 1624	116 ± 55	222 ± 155	1 ± 1	1 ± 1	1 ± 1
Sta-flat (H)	232 ± 93	27 ± 21	23 ± 14	0	8 ± 4	3 ± 2
Ganes (L)	4147 ± 895	4431 ± 1042	780 ± 217	265 ± 122	107 ± 73	36 ± 33
Ganes (M)	5174 ± 1646	6173 ± 1414	1037 ± 193	861 ± 374	67 ± 51	212 ± 158
Ganes (H)	3446 ± 1225	2407 ± 1315	2131 ± 428	2144 ± 1560	5587 ± 311	1711 ± 441

[a]Refers to the paper adhesive system.
[b]L, M, H denote light, medium, heavy coats respectively. See *Table 25.1* for explanation.

Table 25.5. DOUBLE FOLDS TO RUPTURE[a] FOR ARTIFICIALLY AGED (100°C, < 10% RELATIVE HUMIDITY) PAPERS TREATED WITH GLUES AND CEMENTS

Ageing Time	0 days	1 day	5 days	9 days	16 days	50 days
Adhesive						
Untreated	60 ± 15	55 ± 10	68 ± 22	56 ± 16	48 ± 18	34 ± 4
Best	140 ± 35	88 ± 16	62 ± 30	30 ± 7	24 ± 7	15 ± 4
Yes (L)[b]	180 ± 43	25 ± 7	56 ± 12	5 ± 2	4 ± 1	3 ± 1
Yes (H)	302 ± 137	81 ± 61	71 ± 80	3 ± 3	1 ± 1	1 ± 1
Sta-flat (L)	2388 ± 1624	17 ± 11	31 ± 22	1 ± 0	1 ± 1	1 ± 1
Sta-flat (H)	232 ± 93	2 ± 1	3 ± 1	0 ± 1	2 ± 1	2 ± 1
Ganes (L)	4147 ± 895	1900 ± 832	1698 ± 1006	36 ± 26	12 ± 5	1 ± 1
Ganes (M)	5174 ± 1646	3533 ± 976	250 ± 194	111 ± 94	17 ± 10	1 ± 0
Ganes (H)	3446 ± 1225	1183 ± 578	1802 ± 773	168 ± 115	52 ± 49	2 ± 2

[a]Refers to the paper adhesive system.
[b]L, M, H denote light, medium, heavy coats respectively. See *Table 25.1* for explanation.

Table 25.6. REFLECTANCE (%) AT 457nm OF ARTIFICIALLY AGED (21°C, 50% RELATIVE HUMIDITY) PAPERS TREATED WITH GLUES AND CEMENTS

Ageing Time		0 days	1 day	5 days	9 days	16 days	50 days
Adhesive							
Untreated	a.s.[b]	89	89	89	89	90	87
	p.s.	88	89	88	89	89	87
Best	a.s.	87	88	88	87	87	84
	p.s.	87	88	87	87	86	85
Yes (L)[a]	a.s.	88	89	88	89	89	88
	p.s.	89	88	88	89	88	89
Sta-flat (L)	a.s.	81	82	82	82	81	80
	p.s.	82	83	82	82	80	80
Ganes (L)	a.s.	80	83	79	82	82	82
	p.s.	80	82	78	82	82	81

[a]L denotes light coat. See *Table 25.1* for explanation.
[b]a.s. denotes adhesive side; p.s. denotes paper side.

changes producing coloured matter accompanying embrittlement at higher temperatures are doubtless more pronounced (i.e. involve greater quantities of coloured material) than initial changes at lower temperatures which may result from simple evaporation of solvent with little chemical change. It is interesting that even in the apparent absence of chemical change, at lower temperatures, the fold strength decreases to the same levels at which obvious chemical change takes place. The rheological properties of the several adhesive materials tested are apparently unacceptable even in the absence of the effects of age.

COLOUR AND pH

Tables 25.10 to 25.13 give a sampling of colour and pH values observed on the brushed side of paper-adhesive systems subjected to artificial ageing conditions (21°, 60°, 80°, 100°C) for up to 50 days.

All samples show discolouring upon artificial ageing. As might be expected discoloration is more pronounced for samples heated at higher temperatures. The glues behaved in an essentially similar way showing somewhat more pronounced discoloration than the cement.

Table 25.7. REFLECTANCE (%) AT 457nm OF ARTIFICIALLY AGED (60°C, 10% RELATIVE HUMIDITY) PAPERS TREATED WITH GLUES AND CEMENTS

Ageing Time		0 days	1 day	5 days	9 days	16 days	50 days
Adhesive							
Untreated	a.s.[b]	89	89	89	89	90	87
	p.s.	88	89	88	89	89	87
Best	a.s.	87	88	86	86	86	71
	p.s.	87	87	86	86	86	75
Yes (L)[a]	a.s.	88	89	88	88	88	84
	p.s.	89	89	88	88	88	83
Sta-flat (L)	a.s.	81	82	82	81	80	78
	p.s.	82	82	81	81	81	79
Ganes (L)	a.s.	80	83	80	82	81	80
	p.s.	80	82	79	83	81	80

[a]L denotes light coat. See Table 25.1 for explanation.
[b]a.s. denotes adhesive side; p.s. denotes paper side.

Table 25.8. REFLECTANCE (%) AT 457nm OF ARTIFICIALLY AGED (80°C, < 10% RELATIVE HUMIDITY) PAPERS TREATED WITH GLUES AND CEMENTS

Ageing Time		0 days	1 day	5 days	9 days	16 days	50 days
Adhesive							
Untreated	a.s.[b]	89	89	89	89	90	87
	p.s.	88	89	88	89	89	87
Best	a.s.	87	86	81	67	59	37
	p.s.	87	87	83	68	70	55
Yes (L)[a]	a.s.	88	88	81	74	62	33
	p.s.	89	88	80	75	68	49
Sta-flat (L)	a.s.	81	82	81	81	79	74
	p.s.	82	81	81	81	78	74
Ganes (L)	a.s.	80	81	77	79	75	67
	p.s.	80	82	77	78	74	63

[a]L denotes light coat. See Table 25.1 for explanation.
[b]a.s. denotes adhesive side; p.s. denotes paper side.

Table 25.9. REFLECTANCE (%) AT 457nm OF ARTIFICIALLY AGED (100°C, < 10% RELATIVE HUMIDITY) PAPERS TREATED WITH GLUES AND CEMENTS

Ageing Time		0 days	1 day	5 days	9 days	16 days	50 days
Adhesive							
Untreated	a.s.[b]	89	89	89	89	90	87
	p.s.	88	89	88	89	89	87
Best	a.s.	87	85	64	52	46	39
	p.s.	87	83	66	59	51	43
Yes (L)[a]	a.s.	88	48	38	33	29	12
	p.s.	89	57	49	42	39	23
Sta-flat (L)	a.s.	81	81	77	74	75	66
	p.s.	82	82	78	75	75	68
Ganes (L)	a.s.	80	78	53	55	46	25
	p.s.	80	77	50	52	44	23

[a]L denotes light coat. See *Table 25.1* for explanation.
[b]a.s. denotes adhesive side; p.s. paper side.

Table 25.10. COLOUR[a] AND pH[b] OF ARTIFICIALLY AGED (21°C, 50% RELATIVE HUMIDITY) PAPERS TREATED WITH GLUES AND CEMENTS

Ageing Time	0 days	1 day	5 days	9 days	16 days	50 days
Adhesive						
Untreated	white N9/ 5—6	white N9/ 5.5—6	white N9/ 5.5—6	white N9/ 5.5—6	white N9/- 10YR9/1 5.5—6	white N9/- 10YR9/1 5.5—6
Best	white N9/ 5—6	white N9/ 5—6	white N9/ 5—6	white N9/ 5—6	white N9/ 5—6	light yellow N9/ 5
Yes (L)[c]	white N9/ 5—6	white N9/ 5—6	white N9/ 5—6	white N9/ 5—6	white N9/ 5—6	white N9/ 5—6
Sta-flat (L)	light yellow-brown 10YR9/1 6—7	light yellow-brown 10YR9/1 6—7	light yellow-brown 10YR9/1 6—7	light yellow-brown 10YR9/1 6—7	light yellow-brown 10YR9/1- 10YR8/1 6—7	light yellow-brown 10YR9/1- 10YR8/1 6—7
Ganes (L)	light yellow-brown 10YR9/1 6—7	light yellow-brown 10YR9/1 5—6	light yellow-brown 10YR9/1 5—6	light yellow-brown 10YR9/1 5—6	light yellow-brown 10YR9/1 10YR8/1 5	light yellow-brown 10YR9/1 10YR8/1 5

[a]Munsell colours observed under 'Tensor' incandescent illumination. Subjective colours are also given.
[b]pH estimated with indicator solutions.
[c]L denotes light coat. See *Table 25.1* for explanation.

Table 25.11. COLOUR[a] AND pH[b] OF ARTIFICIALLY AGED (60°C, 10% RELATIVE HUMIDITY) PAPERS TREATED WITH GLUES AND CEMENTS

Ageing Time	0 days	1 day	5 days	9 days	16 days	50 days
Adhesive						
Untreated	white N9/ 5—6	white N9/ 5.5—6	white N9/ 5.5—6	white N9/ 5.5—6	white N9/- 10YR9/1 5.5—6	white N9/- 10YR9/1 5.5—6
Best	white N9/ 5—6	white N9/ 5—6	white N9/ 5—6	white N9/ 5—6	white N9/ 5—6	light yellow 5Y8/2 5—6
Yes (L)[c]	white N9/ 5—6	white N9/ 5—6	white N9/ 5—6	white N9/ 5—6	white N9/ 5—6	light yellow N9/- 2.5Y9/2 5—6
Sta-flat (L)	light yellow-brown 10YR9/1 6—7	light yellow-brown 10YR9/1 6—7	light yellow-brown 10YR9/1- 10YR8/1 6—7	light yellow-brown 10YR9/1- 10YR8/1 6—7	light yellow-brown 10YR9/1- 10YR8/1 6—7	light yellow-brown 10YR9/1- 10YR8/1 6—7
Ganes (L)	light yellow-brown 10YR9/1 6—7	light yellow-brown 10YR9/1 5—6	light yellow-brown 10YR9/1- 10YR8/1 5—6	light yellow-brown 10YR9/1- 10YR8/1 5	light yellow-brown 10YR9/1- 10YR8/1 5	light yellow-brown 10YR9/1- 10YR8/1 5

[a]Munsell colours observed under 'Tensor' incandescent illumination. Subjective colours are also given.
[b]pH estimated with indicator solutions.
[c]L denotes light coat. See *Table 25.1* for explanation.

Table 25.12. COLOUR[a] AND pH[b] OF ARTIFICIALLY AGED (80°C, < 10% RELATIVE HUMIDITY) PAPERS TREATED WITH GLUES AND CEMENTS

Ageing Time	0 days	1 day	5 days	9 days	16 days	50 days
Adhesive						
Untreated	white N9/ 5—6	white N9/ 5.5—6	white N9/ 5.5—6	white N9/ 5.5—6	white N9/ 10YR9/l 5.5—6	white N9/ 10YR9/1 5.5—6
Best	white N9/ 5—6	light yellow N9/- 5Y9/1 5—6	light yellow 5Y8/1 5—6	yellow 5Y8/2 5—6	yellow 2.5Y8/6 5—6	yellow 2.5Y8/6 N.R.
Yes (L)[c]	white N9/ 5—6	white N9/ 5—6	yellow N9/- 10YR8/6 5—6	yellow N9/- 10YR7/6 N.R.[d]	yellow-brown 2.5Y8/4 N.R.	yellow-brown 10YR7/6 N.R.
Sta-flat (L)	light yellow-brown 10YR9/1 6—7	light yellow-brown 10YR9/1 6—7	light yellow-brown 10YR9/1- 10YR8/1 6—7	light yellow-brown 10YR9/1- 10YR8/1 6—7	light yellow-brown 10YR9/1- 10YR8/1 6—7	light yellow-brown 10YR9/1- 10YR8/1 6—7
Ganes (L)	light yellow-brown 10YR9/1 6—7	light yellow-brown 10YR9/1 6—7	light yellow-brown 10YR9/1- 10YR8/1 5—6	light yellow-brown 10YR9/1- 10YR8/1 5	light yellow-brown 10YR9/1- 10YR8/1 5	light yellow-brown 10YR9/1- 10YR8/1 5

[a]Munsell colours observed under 'Tensor' incandescent illumination. Subjective colours are also given.
[b]pH estimated with indicator solutions.
[c]L denotes light coat. See *Table 25.1* for explanation.
[d]N.R. denotes no reading. Colour of adhesive masks colour developed by indicator.

Table 25.13. COLOUR[a] AND pH[b] OF ARTIFICIALLY AGED (100°C, < 10% RELATIVE HUMIDITY) PAPERS TREATED WITH GLUES AND CEMENTS

Ageing Time	0 days	1 day	5 days	9 days	16 days	50 days
Adhesive						
Untreated	white N9/ 5–6	white N9/ 5.5–6	white N9/ 5.5–6	white N9/ 5.5–6	white N9/- 10YR9/1 5.5–6	white N9/- 10YR9/1 5.5–6
Best	white N9/ 5–6	yellow N9/- 5Y9/2 5–6	yellow 5Y8/4 5–6	yellow 2.5Y8/6- 2.5Y7/6 N.R.	yellow 2.5Y8/6- 2.5Y7/6 N.R.	yellow 2.5Y8/6- 2.5Y7/6 N.R.
Yes (L)[c]	white N9/ 5–6	yellow 2.5Y8/6 5–6	yellow-brown 10YR7/6 N.R.[d]	brown-yellow 10YR6/10 N.R.	brown-yellow 10YR6/10 N.R.	brown 10YR5/8 N.R.
Sta-flat (L)	light yellow-brown 10YR9/1 6–7	light yellow-brown 10YR9/1 6–7	light yellow-brown 10YR8/1 6–7	light yellow-brown 10YR8/1 6–7	light yellow-brown 10YR8/1 6–7	light yellow-brown 2.5Y9/2 6–7
Ganes (L)	light yellow-brown 10YR9/1 6–7	light yellow 10YR9/1- 2.5Y8/2 5–6	yellow-brown 2.5Y8/4- 10YR8/5 N.R.	yellow-brown 2.5Y8/4- 10YR8/6 N.R.	yellow-brown 10YR8/6 N.R.	brown 10YR6/6 N.R.

[a]Munsell colours observed under 'Tensor' incandescent illumination. Subjective colours are also given.
[b]pH estimated with indicator solutions.
[c]L denotes light coat. See *Table 25.1* for explanation.
[d]N.R. denotes no reading. Colour of adhesive masks colour developed by indicator.

Values of pH given in *Tables 25.10* to *25.13* in most cases show little change with increased ageing time or increased temperature. In several cases, at elevated temperature, discoloration of the adhesive made it impossible to discern the colour of the indicator. In no measured case did the pH fall below that of the untreated paper. It is most likely that the pH measured is principally that of the surface.

CONCLUSIONS

None of the adhesives evaluated in this report appear to be acceptable for paper conservation. Both the embrittlement that occurs leading to poor fold strength properties and the colour which arises in the systems require unfavourable evaluation. Even samples subjected to the mildest conditions (21°C, 50% relative humidity) showed appreciable alterations in properties over the 50-day time-period of our tests. In all cases it must be noted that the paper-adhesive systems showed much greater alteration in properties than the untreated paper and that in most cases the paper-adhesive system reached a point in diminished property that was worse than the paper alone.

In most evaluations of paper or paper-supported systems, artificial ageing, when performed, consists of oven heating at 100°C. In the present study, artificial ageing at lower temperatures supports the conclusions reached at higher temperatures. Although subtle mechanistic distinctions might be made, consonant with various property changes that occur in adhesive-paper systems, the effects that are eventually observed at low temperatures are observed more rapidly at high temperatures.

Preliminary reversibility studies performed on glass slides indicate that the glues are all fairly easily removed in water, but that Best Test Paper Cement was not reversible in either water or toluene. Other studies currently under way in our laboratory include a study of the effects upon paper supports of the removal of adhesive; and the effects of humidity and light on paper and paper-supported systems.

Acknowledgement

This project is supported by a grant from the National Endowment for the Arts in Washington, D.C., a Federal Agency.

References and Notes

[1] Phelan, W., Baer, N. S. and Indictor, N., 'An Evaluation of Adhesives for Use in Paper Conservation', *IIC-Amer. Group Bull.*, **11**, No. 2 (1971), 58–75.
[2] *TAPPI Standards and Suggested Methods*, T453 su-70,

'Effect of Heating on Fold Endurance (Relative Stability of Paper)'.

[3] Wilson, W. K. and Herbert, R. L., 'Evaluation of the Stability of Recorded Papers' *Tappi*, **52**, No. 8 (1969), 1523–1529.

[4] W. J. Barrow Research Laboratory, *Polyvinyl Acetate (PVA) Adhesives for Use in Library Bookbinding, Permanence/ Durability of the Book – IV* (1965).

[5] King, A., Pelikan, A. and Falconer, W. E., 'The Use of the Archivists Pen and Universal pH Solution for Estimating the Surface pH of Paper', *Stud. Conservation,* **15** (1970), 63–64.

[6] Indictor, N., Baer, N. S. and Phelan, W. H., 'An Evaluation of Pastes for Use in Paper Conservation', *Restaurator*, **2,** No 2 (1975), 139–149.

[7] Joel, A., Indictor, N., Hanlan, J. F. and Baer, N. S., 'The Measurement and Significance of pH in Paper Conservation', *IIC-Amer. Group Bull.,* **12**, No. 2 (1972), 119–125.

[8] *Munsell Book of Color,* Munsell Color Company, Baltimore, Md. (1929–1970).

WORKS OF ART ON PAPER AND PARCHMENT

26
History and Prospects for Analysis of Black Manuscript Inks

MONIQUE de PAS AND FRANÇOISE FLIEDER

INTRODUCTION

It is impossible to ignore the changes brought about by certain inks and the problems which they continually present for curators, archivists and restorers. These degradations generally take two forms:

1. corrosion of the support, sometimes transformed into a veritable lacework;
2. progressive fading of the writing.

These two phenomena are intrinsically linked to the nature of the ink used, as well as the inevitable reactions between the ink and the support.

It was necessary, in order to resolve these problems, to acquire a solid understanding of the material 'ink'. This same information may perhaps guide the historian in dating manuscripts and identifying their origins. We have therefore assembled and studied a large number of documents dealing with this subject from both an historical and a scientific point of view.

Next we asked ourselves which ink appeared first and up to what time it was in general use; in what place and at what moment of time another kind of ink appeared; if there was simultaneous use of several kinds of ink and if one positively supplanted the others. Of course, certain documents which have not been examined up to the present time may well modify our conclusions in the future.

Since the subject is a vast one, we thought it advisable to limit ourselves provisionally to two principal categories; carbon inks and iron-tannate inks. Coloured inks, sympathetic inks, modern inks, printing inks have been deliberately ignored for the moment, though they may occasionally be mentioned in the bibliography.

HISTORY

From earliest times, man has sought to express himself, using as a support the most diverse materials: stone, wood, metal, silk, papyrus, skins, parchment, paper. The messages he transmitted have come down to us in a wide variety of forms: carvings, hieroglyphics, engravings, etc. However, the form most familiar to us is writing, traced with a compound leaving coloured markings on the various supports. This substance is called *ink*.

When precisely did ink first appear in history and what was its composition? It will, it seems, be very difficult to be certain about this.

APPEARANCE OF INKS BASED ON LAMP BLACK

According to Guareschi[57], the use of ink on papyrus goes back in Egypt to 2500 BC. This was an ink made with lamp black, mixed with oil or gum.

As far as China is concerned, certain authors, such as Mitchell[110], Guareschi[56] and Margival[103], date the appearance of the first ink about 2600—2500 BC.

'The historians of the Celestial Empire ascribe the invention of ink to Tien Tchen, who lived in the reign of Houang-ti, 2697—2597 BC.' (Jametel[71]).

According to Guareschi[57], Mitchell[112] and Champour[27] (the last two taking their inspiration from the writings of Jametel[71]), the ink used then was very different to the one we know: 'It was a sort of lac which was applied on silk by means of a bamboo stick . . .' Later, the lac was replaced by a black stone which was moistened with water. We do not know as yet what this stone was, but research is in progress which may perhaps resolve this problem.

From 220 to 160 BC, ink began to be made with lamp black produced by burning lac and fir-wood charcoal. This ink was sold in the form of a ball and its ease of use soon made it preferred to the stone of the ancients.

To obtain ink from lamp black or from a carbonized product, it was necessary to use a binding medium. This substance was of prime importance because it determined the quality of the ink itself. In former times, glues made from rhinoceros horn, staghorn (introduced into China by the Koreans), and later from oxen and fish, were used. Jametel[73] states, however, that 'the Chinese sometimes used for writing a black substance which they obtained from the intestines of a fish . . . which must have been the cuttlefish'.

In more recent times, Vitruvius, the Roman engineer and architect, gives a recipe based on lamp black[169]. This black was obtained in a kind of closed oven in which pitch was burnt. The soot collected in a pipe adjoining the oven and this was mixed with gum. Dioscorides[36] gives a similar recipe for ink based on soot mixed with gum. This preparation had, moreover, according to Dioscorides, the power of healing wounds! We also find in Pliny (Book XXXV, Chapter 25, passage entitled 'Atramentum') a detailed formula for ink prepared from lamp black and mixed with gum, which is then dried in the sun.

In a work written in 1025, Ibn Badis[7] — a patron of the arts and of artists, born at Al-Mansuriyyah near Kairouan (1007—1061) — was already making a distinction between inks based on soot (Chapter 2) and inks based on tannin (Chapter 3). China ink, Indian ink, Koufa ink, Persian ink, Iraqi ink are in the first category; there are, however, differences in the choice of the basic material used to obtain the soot, generally vegetable matter. Gum arabic was very often used as a binding medium; white of egg was used more specifically in Iraq. Levey[84] has noted in the words of Maïmonide — a Jewish philosopher and doctor of the twelfth century who lived in Egypt — a recipe for ink based on carbonized substances, which could be erased:

'Take carbon black obtained from crushed grape skins, lamp black obtained from oil, for example olive oil, pitch, colophony, Mix them all with powdered charcoal, add gum arabic and honey. Form it into flat cakes. When these cakes are dissolved in water, a fine black liquid is obtained, which can be erased. In two or three years, it fades and then disappears leaving no trace.'

To sum up, the most ancient inks seem to have been carbon inks, prepared from lamp black, the binding medium being oil, gum or glue, as in China. They appeared in solid form (an ink stick, which was diluted with a solvent at the instant of writing, as in China) or in the form of a more or less viscous suspension. The differences thus lay in the choice of the binding medium, in the substances to be burnt (oil, pitch, resin, wood, plants, etc.) and in the more or less sophisticated techniques of manufacture. For example, lamp black was obtained very differently in different places. It is indisputable that the Chinese possessed a very advanced technology. The ovens used for combustion were specially constructed and the smoke was directed through a number of compartments in which the soot was deposited. The most sought after ink was made from an impalpable smoke which was deposited at the furthest end of the oven. The operations required to make China ink were very numerous and, for more detailed information, one must refer to the works of Jametel[70], Julien[74,75], Champion[25], Mitchell[109] and Champour, Malepeyre and Villon[27].

In the West, apart from the manuscripts of Vitruvius, Dioscorides and Pliny, there is apparently no other reference to carbon inks. It seems, then, that in the Far and Near East the use of these inks was very widespread, while in the West this sort of ink was practically unknown. We must point out, however, that the data we have collected concerning the manufacture of inks in the West for the period from the first to the eleventh century are very limited.

DEVELOPMENT OF IRON INKS

According to Margival[104] and Partington[122], Philon de Byzance (second century BC.) mentions an iron-tannate ink: 'writing with an infusion of galls is invisible when it dries but, moistened with a solution of vitriol, it becomes black'.

Theophilus (eleventh century?) gives a recipe for ink based on tannin to which iron sulphate is added. The tannin is obtained by soaking hawthorn wood in water, which has the effect of draining the wood of its tanning substances.

In Ibn Badis (1025), mentioned above, the iron-tannate inks described are the standard ones: a solution of tanning products to which vitriol is added. The tannin used was extracted from gall-nuts, produced by an insect (Cynips quercus folii) which bores small holes in oak leaves in which to lay its fertilized eggs. An excrescence (gall) forms around the eggs. The most sought after gall-nuts, because they are the richest in tannic acid, are those collected before the eggs hatch. Numerous gall-nuts have been used (from Aleppo, from the Levant, from Turkey, from Smyrna, from China, etc.) and also other vegetable products, such as valonia, oak-bark, myrobalan, dividivi, sumac, algarroba. The vitriol came from distant countries like Egypt, Cyprus and Persia (Levey[84]).

Certain Arab authors state in their manuscripts that there existed several kinds of vitriol. Al Razi

(tenth century) cites as many as five different colours. Levey[87] mentions them all and supposes that the one used for the manufacture of ink was green vitriol or iron sulphate. There is clearly confusion amongst the authors of this period on the subject of vitriol: blue vitriol or green vitriol are mentioned indiscriminately in recipes for ink. This is probably due to the considerable impurity of the products then in use.

From the twelfth century, in the West, documents on the manufacture of ink, particularly iron-tannate inks, are more numerous. We may mention Albert le Grand (1193–1280)[1], Gerolamo Ruscelli (or Alessio Pedemontano)[139], Jean-Jacques Wecker de Basle who gives us in the chapter entitled 'The Secrets of Writing'[173] a multiplicity of recipes taken from Giovanni Batista Porta and Alessio Pedemontano; and finally, in 1619, Petro Maria Canepario[20], a professor of medicine at Venice. He devoted four of the six chapters of his book to ink; he gives numerous data on vitriols and the basic materials used in his time for the manufacture of ink. The edition of his work which we were able to study dates from 1660. We also know from Mitchell[111] that in 1393 the *Ménagier de Paris* described an ink based on iron and gall-nuts. He also mentions a recipe[111] taken from the *Liber Illuministarum* (1500): 'Integra sit galle, media sit uncia gummi Vitriola quarta. Apponas octo falerni'.

The rigid classification of inks into two categories would be very convenient but in reality things are not so simple, since there was continual overlapping between the two. In the works of Ibn Badis, we find inks made from carbonized products to which are added gum arabic, white of egg and ground gall-nuts, and tanning products. Was it realized at that time that the addition of gall-nuts made inks more permanent? Davids[34] tells us besides that in the time of Pliny the Younger a mixture of carbonized substances and iron sulphate was used. According to Thompson[161], in the Middle Ages iron inks were often mixed with lamp black, probably to obtain a better density.

DEVELOPMENT OF INKS IN RELATION TO THE GROWTH OF CHEMISTRY

The seventeenth century is a milestone; it is really from this time onwards that the manufacture of inks begins to abandon empiricism and to enter a more scientific phase.

1663: The English scientist, Robert Boyle, attempts for the first time to explain the reactions which are produced when vitriol is added to infusions of gall-nuts.

1666: Otto Tachen tries to make inks by a combination of salts of copper, silver and mercury with a solution of gall-nuts.

1645–1743: Nicolas and Louis Lemery study inks and particularly sympathetic inks.

1737: Hellot describes the procedure for manufacturing a sympathetic ink from cobalt salts.

1748: William Lewis draws up a list of products to be used, with their proportions, to obtain a long lasting ink.

1792: Ribeaucourt continues the experiments of Lewis by modifying the proportions given by the latter. He published his results in his *Dissertation on Ordinary Ink*.

From 1831 to 1837 in France, numerous Commissions deliberated to establish the composition of a stable and indelible ink. We know that, at a certain period, extracts of campeachy (a tropical wood) were added to the tannic substances. The heart-wood is finely shredded, then ground to a fine powder. This is fermented and the solution obtained (Chabrie[24]), under the action of various metallic salts, gives a dark-coloured precipitate. By re-dissolving this in acid, a solution is obtained which has all the properties of ink. Nevertheless, campeachy was never used alone for this purpose[78].

From the experiments of Starck (1842) it was found that no ordinary ink based on iron and campeachy was truly indelible. These researches were approved by the Commission de l'Académie des Sciences de Paris.

1856: Discovery of alizarin ink by Leonhardi. The novelty of Leonhardi's discovery lay in the idea of keeping the iron salt in solution with an excess of acid. This addition of acid would explain the large number of manuscripts of this period completely eaten away by the ink, the drawings of Victor Hugo for example. The colour of the ink was rather pale; this disadvantage was remedied by the addition of indigo, as well as a small quantity of an extract of madder, to give a 'temporary' coloration to the ink. The latter was not perfectly black, but it became black when the writing was exposed to the air. The term 'alizarin ink' derived from the fact that madder contains alizarin. It should be stressed that, later on, the addition of madder, which was not essential, was omitted, but the ink kept this erroneous commercial appellation.

Around 1860: appearance of the first aniline inks, which were rather unstable to air and light.

1873: Coupier and Collin make a black ink with indulin and a red one with eosin.

1879: Kwaisser and Hufak use methyl violet. At the same time, nigrosin and other colouring substances were used which do not, in fact, give a truly black colour but rather a very intense blue coloration.

Following the discovery of these new inks, Professor Koester of Bonn, in 1879, alerted the German government to the danger of using these unstable substances for official documents. Thus it was that, around 1888, laws were established to control the use of these inks. Numerous tests and experiments were made for this purpose by Schluttig and Neumann.

We shall not discuss the manufacture of inks from the start of our own century, because the twentieth century marks the full flowering of the industrial age and most of the recipes are protected and even patented. We may mention several works containing valuable information about these formulae, in particular those of Champour, Malepeyre and Villon[26], Guareschi[55], Keghel[77], Margival[101,102,105], Mitchell[109].

SCIENTIFIC STUDY OF INKS

THE BEHAVIOUR OF INKS IN THE COURSE OF TIME

Having summarized the milestones in the history of ink through the ages, we may turn to the behaviour of this material as a function of its composition and its support.

Bonaventura[18] sets out in a very clear manner the characteristics of carbon inks. They are not solutions, but suspensions, which appear in the form of an intensely black ink, not subject to discoloration in the course of time, resistant — because of the chemical inertia of carbon — to oxidation, to reduction or to variations of acidity. Moreover, it has one valuable characteristic: that of containing no substance injurious to paper. On the contrary, these inks can be easily scratched out and removed from the support, using mechanical agents. Why? The gum arabic-carbon mixture, even in the liquid form needed for writing, does not penetrate the parchment or the fibres of the paper. It is simply deposited on the surface of the support; scraping is sufficient to make it disappear. Bonaventura thinks that this phenomenon may perhaps have led the ancients to add to China ink iron sulphate which, subsequently changing into ferric sulphate and various other iron oxides, gave an ink which was difficult to erase, except perhaps on the surface. This hypothesis would accord well with the one we have already mentioned as to the composition of certain inks made with a mixture of China ink to which iron sulphate was added.

The iron-tannate inks behave differently. They are obtained, as we know, by the action of a ferrous salt on a tanning substance. In the majority of cases, gall-nuts were used as the tanning substance and, much later, were replaced by pure gallic acid, a crystallized product obtained from numerous vegetable products. When gallic acid is used, the product formed is colourless. On contact with the air, there is oxidation, with formation of a black precipitate which is a ferric complex. In addition, an ink thus prepared ends by decanting. To remedy this disadvantage, gum arabic is added, since the mucilaginous substances which it contains aid the precipitate to remain within the liquid by increasing the viscosity of the medium. Mucilaginous substances encourage the growth of moulds, which are reducing agents and bring about a discoloration of the ink. This disadvantage is remedied by adding an antiseptic.

How is it that certain old documents written in iron-gall ink have kept their black colour, while others, on the contrary, have turned maroon or reddish-yellow, and still others have eaten away their support?

Lewis was the first to suggest that too great an excess of iron sulphate caused the traces of ink to turn brown and that, on the other hand, an excess of gall-nuts did not give a sufficiently intense black.

Bonaventura[18] takes up Lewis's hypothesis and thinks that the changes in tone are due to the varying proportions of the basic constituents. According to which product is in excess, the behaviour of the ink varies: a surplus of ferrous sulphate would bring about yellowing of the writing in the long term, because of chemical changes.

Barrow[9] demonstrates that, for two inks prepared with the same ingredients with equal amounts of ferrous sulphate, the higher the content of tannic substances the greater the quantity of sulphuric acid formed and thus the more widespread the damage to the support. This sulphuric acid can be neutralized wholly or in part by the alkalinity of parchment, for example, or by the alkaline salts contained in certain old papers.

In our opinion, one of the causes of alterations of the support by the ink is the change in products in excess, which releases mineral acids. It is very clear that these changes are accelerated by the poor conditions in which certain documents are kept: humidity, temperature, light, bacteria, fungi.

METHODS FOR THE CHEMICAL IDENTIFICATION OF INKS

Given the considerable number of products entering into the composition of inks, their analysis will be difficult. Nonetheless, this work has already had the attention of a number of researchers.

Chabrie[24] and Villavecchia[167], in their treatises on analytical chemistry, devoted a chapter to ink, specifically as concerns its composition. Various colorimetric tests, giving qualitative data, are described: ink diluted with sulphuric acid takes on a red coloration if it contains campeachy, a yellow coloration if it contains gall-nuts and iron, etc.

Much later, the appearance of chromatography further extended our field of investigation. Some early experiments were made in this respect by Moloster in 1957[114], Sannie[143], and Iwasaki[68] on paper chromatography.

Police laboratories, seeing how useful such methods could be to them, used paper chromatography in their criminological research (Pougheon[129], Raju, Bannerjee and Iyengar[131], Somerford[151], Susumu[154], Swarup[155]).

It is obvious that in all the experiments mentioned above, chromatography was not used to identify the precise nature of the various constituents of the inks but as a method for comparison.

Paper chromatography continued to be used, improving, however, the precision of the results by the choice of more and more specific eluents and developers. However, this technique was little by little replaced by a more up-to-date method: thin-layer chromatography (Druding[38], Mura-Silva[116], Perkavac and Perpar[124], Purzycki, Szwarc and Owoc[130], Verma, Mulk and Rai[166]). This technique has enormous advantages over paper chromatography: speed, smaller samples, wide range of specific adsorbents from cellulose to organic gels. A little later, another method of chromatography was tried, using as support a special porous glass (MacDonnel[98]); this variant seemed to give a better separation for modern inks than did thin-layer chromatography.

It has also been attempted to improve the separ-

196

ation of the constituents by using not only the separating power of the adsorbents and eluents but also that of the electric field, a technique known as 'electrophoresis'. Electrophoresis (Thompson[162]) has been carried out on various supports, such as paper, gel and porous glass (MacDonnel[97]).

Experiments with electromagnetophoresis (consecutive use of electric current and the magnetic field) have been tried (Gavreau, Miane and Calaora[50]).

It should also be noted that gas chromatography techniques have been applied to the identification of certain ellagitannin derivatives (Nelson and Smith[117]). There are two categories of tannins: condensed tannins and the hydrolysable tannins more specifically used in the manufacture of inks. The latter are subdivided into gallo-tannins and ellagitannins which give, by hydrolysis, gallic acid and ellagic acid respectively. It would be interesting to know if this method is applicable to the analysis of gall-nut tannins, the basic material in the manufacture of inks.

All these experiments have been carried out on modern inks. Our work will consist in seeing if these methods can be used in the analysis of ancient inks, by the selection of the appropriate eluents, supports and reagents. A systematic study will be undertaken on samples of ink of known composition prepared according to the numerous recipes taken from the literature. A card-index of about a hundred recipes for ink containing gall-nuts, from various periods, has already been compiled and will allow us to begin our work. The same methods, applied to samples of ink of unknown composition, will allow us, by comparison, to determine the components of the sample under study.

DEVELOPMENT OF TECHNIQUES FOR THE RESTORATION OF CORRODED OR FADED INKS

The restoration of graphic documents is difficult because it constantly comes up against the problems posed by inks. Whether it is a matter of bleaching, deacidification, stain removal or whatever, one must always take account of the behaviour of the inks with respect to the various solvents and chemical products used. To these problems is added that of the restoration of the inks themselves, under the two headings which we have already mentioned.

As far as the problem of the acidity of inks is concerned, few definitive results have been obtained, to our knowledge. Experiments on neutralization which have been tried have given only temporary results.

The various institutes and centres of research have tended to concentrate their attention on inks obliterated or faded by time. The problem is two-fold:

1. to render vanished writing temporarily visible in order to read rapidly or photograph the complete text;

2. to revive the faded writing of a manuscript with the aim of recovering its original state and keeping it in that condition for as long as possible.

Ultraviolet fluorescence has been used successfully to read vanished texts. In 1956, Fabiani[44] applied this already-known technique to a particular case. This was a manuscript dating from 1578; one of the folios showed a yellowish trace on the white background, caused, it was thought, by the migration of acid from the ink of the succeeding (and completely perforated) folio. This phenomenon is well known by the name 'ghost writing'. It was possible to elucidate the trace by ultraviolet fluorescence and the missing text was thus recovered.

Still using optical methods, Longo and Bozzachi in 1955[91] tried successfully to render visible writing hidden under a layer of purpurin (a colouring matter contained in madder), the other side of the document being virgin. Because it was impossible to use chemical methods for fear of destroying the document, they turned to a process already used to reveal writing hidden under layers of gummed paper. The principle is as follows: the document is immersed in a liquid having the same refractive index, so as to make the paper transparent. The folio was placed so that the side covered with purpurin faced the liquid; thus the document became transparent and the hidden writing appeared in reverse.

While, for historians, the simple reading of vanished writings is valuable, the permanent revelation of a text remains a very considerable problem for all curators of manuscripts. Some of our colleagues have undertaken research on this subject.

1953: Santucci[144] publishes a method for reviving iron inks which had faded naturally or as the result of cleaning. He converted the iron ions remaining in the paper fibres into black iron sulphide by means of ammonium sulphide. Since this compound is not very stable, he had to fix it with a lead salt; the lead sulphide thus obtained unfortunately browned the support.

1957: Bonaventura[18] reviews all the methods for reviving inks and returns to the technique described by Santucci.

1958: Ouy[121] describes a method for revealing writing which has been totally obliterated and is not visible under ultraviolet. He uses gaseous ammonium sulphide. The results were good in the short term, but ephemeral. There was one notable improvement: later, the text was readable under ultraviolet. Ouy's findings provide good confirmation of the hypothesis of Santucci, namely that iron changed into iron sulphide will oxidize in the course of time, changing into a colourless compound if it is not fixed with a lead salt.

1963: Santucci and Wolff[145] return to the work which they had undertaken on the conversion of iron into sulphide, improving their techniques. The manuscript, having been treated with ammonium sulphide, is rinsed with ammonia or water. Also, they use a basic lead acetate instead of a neutral lead acetate or nitrate. To avoid blackening of the support, they took care to finish the treatment with numerous rinsings with acetic acid and with water to drive off the the residual lead ions as far as possible. They conclude that their methods are not applicable in a standard way but are adaptable to particular cases.

197

CONCLUSION

We may conclude from this brief account that the development of ink through the ages has been very slow. In fact, between the period several thousand years before our own time and the beginning of the twentieth century there were only two main categories: carbon inks and iron-tannate inks, with, in certain cases, overlapping between the two.

It was not until the middle of the nineteenth century, with the discovery of 'alizarin' and aniline inks, that the techniques of manufacture and the materials used underwent major modifications. Iron tannate, as well as the carbonized substances, were not abandoned, however, but still enter into the manufacture of contemporary manuscript inks, synthetic organic substances being added only to increase their permanence.

Knowing, from the published texts, the substances entering into the composition of inks, we can now attempt their identification. For carbon inks, the analyses will be relatively easy. But the same cannot be said for iron-tannate inks: while the identification of iron, thanks to microchemistry, is comparatively simple, the analysis of the various tanning substances used will be more complex. However, certain techniques specifically hold our attention: thin-layer chromatography, gas chromatography and electrophoresis.

For restoration, it is clear that this work can only be undertaken with a perfect understanding of the residual constituents of the ink, as they are found on documents. The initial components have undergone changes of all kinds; thus we must know as precisely as possible the elements which remain as well as the secondary reactions which can be produced following treatment. Failure to recognize the substrate runs the risk of bringing about an irreversible and final deterioration of the documents.

Bibliography

[1] Albert le Grand, *De Cose Minerali et Mettaliche*, Book V, translated by Pietro Lauro, Venice (1557), Chap. II: 'Nature e Sostantia degli Attramenti'.

[2] Alexander, S. M., 'Medieval Recipes Describing the Use of Metals in Manuscripts', *Marsyas*, 12 (1966), 34—51.

[3] Allen, A. H., *Commercial Organic Analysis*, 5th ed., P. Blakinton's Son & Co., Philadelphia (1927), 205—267.

[4] Angelucci, A., *Del Materiale e degli Strumenti per Scrivere Usati degli Antichi*, Meisner, Milan (1882).

[5] Archambeaud, P., 'L'Encre au Cours des Ages', *La France Graphique* (1955).

[6] Astle, T., *The Origin and Progress of Writing*, 2nd ed., London J. White (1803 in 4th ed.)

[7] Badis, I., *Book of the Staff of the Scribes and Implements of the Discerning with a Description of the Line, the Pens, Soot Inks, Lacs, Gall Inks, Dyeing and Details of Bookbinding* (1025); see Levey[87].

[8] Barrow, W. J., 'New Non-Acid Permanent Iron Ink', *Amer. Archiv.*, 10, no. 4 (October 1947), 338.

[9] Barrow, W. J., *Manuscripts and Documents: Their Deterioration and Restoration*, University of Virginia Press, Charlottesville, Va. (1955), 17.

[10] Barrow, W. J., 'Black Writing Ink of the Colonial Period', *Amer. Archiv.*, 11 (1948), 291—307.

[11] Benetti, E., 'Ravivamento d'Inchiostro e Rivelazione Fotografica di Scrittura Sbiadita', *Boll. I.P.L.*, 13 (1954), 145—148.

[12] Benetti, E. and Santucci, L., 'Rigenerazione dei Documenti. I—II. Nuovi Metodi di Rivelazione degli Inchiostri a Base di Ferro nei Documenti Carbonizzati', *Boll. I.P.L.*, 14 (1955), 45—48.

[13] Berthelot, M., *Histoire des Sciences. 3. La Chimie au Moyen-Age*, Paris (1893).

[14] Bhargava, K. D., *Repair and Preservation of Records*, National Archives of India, New Delhi (1967), 53 pp.

[15] Blagden, C., 'Some Observations on Ancient Inks, With a Proposal of a New Method of Recovering the Legibility of Decayed Writings', *Phil. Trans*, LXXVII (1787), part II, 451—457.

[16] Blanchet, A., 'A Propos de l'Encre de la Petite Vertu', *Bull. Soc. Hist. Paris*, 82e et 83e Année, 1955—1956, Paris (1958), 41—46.

[17] Boguslawska, K., 'Chromatographic Analysis of Ink', *Prace Inst. Celuloz, Papier*, 6, No. 2 (1957), 17—21.

[18] Bonaventura, G., 'Smacchiamento dei Manuscritti e Rivelazione delle Scritture', *Boll. I.P.L.*, 16 (1957), 26—34.

[19] Brown, C. L. and Kirk, P. L., 'Differentiation of Inks by Electro-Chromatophoresis', *Mikrochim. Acta*, Autr., (1956), 1729—34.

[20] Canepario, P. M., *De Atramentis Cujuscumque Generis Opus Sane Novum, Hactenus a Nemine Promulgatum, in Sex Descriptiones Digestum*, London, (1660) xvi—568 pp. in 4th ed.

[21] Carrel, A. A., *Contribution à l'Identification des Encres en Criminalistique*, Trévoux, Lyon (1934), 115 pp. (thesis).

[22] Carvalho, D. N., *Forty Centuries of Ink*, Banks Law Publishing Co., New York (1904).

[23] Celse, A. C., *De Re Medica*, Book 8, Didot Jeune, Paris (1772).

[24] Chabrie, C., *Traité de Chimie Appliquée*, Vol. II, Masson et Cie Ed., Paris (1908), 433—448.

[25] Champion, P., *Industries Anciennes et Modernes de l'Empire Chinois*, Eugène Lacroix Librairie Editeur, Paris (1869).

[26] Champour, Malepeyre and Villon, *Nouveau Manuel Complet de la Fabrication des Encres*, nouvelle édition entièrement refondue par A. Chaplet, Encyclopédie Roret, Paris (1927).

[27] Champour, Malepeyre and Villon, *op. cit.*, p. 128.

[28] Chen Ki Souen, *Manuel Elémentaire du Fabricant d'Encre de Chine* (1398); see Jametel[70].

[29] Church, A. H., *The Chemistry of Paints and Painting*, 3rd ed., Seeley and Co. Ltd., London (1901).

[30] Colwall, D., 'An Account of the Way of Making English Green-Copperas', *Phil. Trans.*, XII (1678), 1056—1059.

[31] Cunha, G. M., *Conservation of Library Materials*, Scarecrow Press Inc., Metuchen, N.Y. (1967).

[32] Cunha, G. M. and Cunha, D. G., *Conservation of Library Materials*, Vol. I, Scarecrow Press Inc., Metuchen, N.Y. (1971).

[33] Cunha, G. M. and Cunha, D. G., *Conservation of Library Materials*, Vol. II, Scarecrow Press Inc., Metuchen, N.Y. (1972).

[34] Davids, T., *The History of Ink, Including its Etymology, Chemistry and Bibliography*, T. Davids and Co., New York (1860).

[35] Desmarest, L. and Lehner, S., *Manuel Pratique de la Fabrication des Encres*, 3rd ed., Gauthier-Villars et Cie Ed., Paris (1923).

[36] Dioscorides (Pendanius), *Les Six Livres de Pedacion Dioscoride d'Anazarbe. De la Matière Médicinale*, trans. Martin Matthée, Thibault Payan, Lyon (1559); Book V, Chap. 6 'Encre à Ecrire'.

[37] Dodwell, C. R. (trans), *Theophilus, The Various Arts*, Thomas Nelson and Son, London (1961), 34—35 ('De Encausto').

[38] Druding, L. F., 'Thin-layer Chromatography Separation of Ink Pigments', *J. Chem. Educ.*, 40 (1963), 536.

[39] Du Halde, P., 'Of the Paper, Ink and Pencils, also of the Printing and Binding the Chinese Books', *The General History of China, Including an Exact and Particular*

Account of their Customs, Manners, Ceremonies, Religion, Arts and Sciences, 4 vols., London (1736), Vol. II, 415–436.

[40] *Edinburgh Review*, 'The Recovery of Lost Writings', **48** (1828), 348.

[41] Ehrle, 'Della Conservazione e del Restauro dei Manuscritti Antichi', trans by Rostagno, *Rivista dell Biblioteche e degli Archivi*, **IX** (1898) 15–16.

[42] Ehrle, 'Per il Restauro dei Manuscritti', trans. by Rostagno, *Rivista dell Biblioteche e degli Archivi*, **XXII** (1911) 71–74.

[43] Erastov, D. P., 'Potentialités des Methodes Electronographiques dans l'Etude des Documents', *Documents, U.S.S.R. Academy of Sciences* (1965), 132–44.

[44] Fabiani, M. L., 'Rivelazione di Una Tracia di Scritto Mediante Fluorescenza all'Ultravioletto', *Boll. I.P.L.*, **15** (1956), 212.

[45] Franke, H., *Kulturgeschichtliches über die Chinesische Tusche*, Verlag der Bayerischen Akademie der Wissenschaft in Kommission bei der C. H. Beck'schen Verlagsbuchhandlung, Munich (1962), 158 pp.

[46] Gallo, A., 'Il Restauro dei Manuscritti e dei Documenti Antichi', *Accad. e Bibl.* **I** (1928).

[47] Gallo, A., *Le Malattie del Libro, le Cura ed i Restauri*, Mondadori, Milan (1935).

[48] Gallo, A., *Patalogia e Terapia del Libro*, Raggio, Rome (1951).

[49] Gauveret, J. and Ceccaldi, P. F., 'Recherches sur la Détermination de l'Age des Documents Manuscrits à l'Encre Ordinaire. La Validité de la Méthode de Mezger', *Rev. Inter. Crim. Police Tech.*, **XIII** (1959), 318–323.

[50] Gavreau, V., Miane, M. and Calaora, A., 'Electromagnetophorèse', *Compte Rendu*, **256³** (1963), 3680–1.

[51] Gerassimova, N. G. and Ponomareva, Z. V., 'Protection des Inscriptions de Galle de Fer pendant le Blanchiment des Gravures et des Dessins', *VCNILKR*, **19** (1967), 92–101 (English summary).

[52] Ghersi, J., *Formulaire Industriel*, new ed., Gauthier-Villars, Paris (1913), 170–190 (chapter on 'Les Encres').

[53] Giacosa, P., 'Un Ricettario des Sec. XI Esistent nell'Archivio Capitolare d'Ivrea', *Memoire della Reale Accademia delle Scienze di Torino*, Series 2, **XXXVII**, Loescher, Turin (1886).

[54] Gouillon, *Traité Méthodique de la Fabrication des Encres*, Garnier Frères, Paris (1906).

[55] Guareschi, R., *Gli Inchiostri da Scrivere*, Hoepli, Milan (1915).

[56] Guareschi, R., *op. cit.*, 1.

[57] Guareschi, R., *op. cit.*, 2.

[58] Guignet, 'Encres à Ecrire', *Encyclopédie Chimique*, publiée sous la direction de M. Frémy, Vol. X, Dunod, Paris (1888).

[59] Gulik, R. H. van., 'A Note on Ink Cakes', *Monumenta Nipponica*, **III** (1955–56), 84–100.

[60] Haldat, C. N. A., *Recherches Chimiques sur l'Encre, les Causes de son Altérabilité et les Moyens d'y Remédier*, Impr. de J. R. Vigneulle, Nancy (1802), 45 pp.

[61] Hamman, B. L., 'Non-destructive Spectrophotometric Identification of Inks and Dyes on Paper', *J. Forensic Sci.*, **13** (1968), 544–56.

[62] Haslam, E., *Chemistry of Vegetable Tannins*, Academic Press, London and New York (1966).

[63] Heess, W., 'Historical Review and Systematic Guide for Judging the Age of Writing', *Arch. Kriminol.*, **101** (1937), 7–37.

[64] Ilomets. T. and Bender, M., 'Etude des Encres et des Colorants par Chromatographie sur Papier et Electrophorèse', *Tartu Rükl. Ulik. Taimet, S.S.S.R.*, **235** (1969), 162–70, bibl.

[65] *Inks, Amer. Archiv.*, **I**, 55, 76, 142, 147; **II**, 9; **III**, 7, 102, 109, 209, 212; **IV**, 130; **X**, 106, 338, 345; **XI**, 291.

[66] Casey, R. S., 'Inks', *Encyclopaedia Britannica*, Vol. 12 (1964), 36–1.

[67] Israeli, I.d', *Curiosities of Literature*, Vol. 2, Boston Edition, 180: essay on 'Origin of the Materials of Writing'.

[68] Iwasaki, S., 'Identification of Inks with Paper Chromatography', *Kagaku to Sôsa*, 9 (1956), 1–3.

[69] Iyengar, N. K. and Maiti, P. C., 'Determining the Age of

[70] Jametel, M., *L'Encre de Chine, son Histoire et sa Fabrication d'Après des Documents Chinois*, trans. of the book by Chen Ki Souen[28], Paris, Ernest Leroux Editeur. (1882).

[71] Jametel, M., *op. cit.*, Introduction, X.

[72] Jametel, M., *op. cit.*, Introduction, XXIV.

[73] Jametel, M., *op. cit.*, Introduction, XXIX.

[74] Julien, S., 'Procédés des Chinois pour la Fabrication de l'Encre', *Annal. Chim.*, **LIII** (1833), 308–315.

[75] Julien, S., *Industries Anciennes et Modernes de l'Empire Chinois, d'Après des Notices Traduites du Chinois* (Accompagné de Notices Industrielles et Scientifiques par Paul Champion), Paris, Eugene Lacroix (1869), 254 pp.

[76] Kantrowitz, M. S. and Gosnell, E. J., 'Alkaline Writing Ink', *Tech. Bull. No. 25*, Government Printing Office, Washington, D.C. (1947).

[77] Keghel, M. de, *Les Encres, les Cirages, les Colles et leur Préparation*, series: *Bibliothèque Professionnelle*, publiée sous la direction de René Dhommée, Librairie J. B. Baillière et Fils, Paris (1927).

[78] Keghel, M. de., *op. cit.*, 38.

[79] Koopmans, H., 'Scheikundig Onderzoek van Inktschrift', *Chem. Weekbl. Nederl.*, **55** (1959), 109–14.

[80] Kwei, T., 'Chinese Ink Sticks', *China J. Sci. Art*, **24** (1936), 9–15.

[81] Laurie, A. P., *Pigments and Mediums of the Old Masters: Inks, Recipes*, MacMillan, New York (1914).

[82] Lehner, S., *Manufacture of Inks*, trans. with additions by W. T. Branut, Baird and Co., Philadelphia, Pa. (1892).

[83] Lemery, N., *Cours de Chymie*, 11th ed., revised, corrected and enlarged by the author, Jean-Baptiste Delespine, Paris (1730).

[84] Levey, M., 'Some Black Inks in Early Mediaeval Jewish Literature', *Chymia*, 9 (1963), 27–31.

[85] Levey, M., 'The Manufacture of Inks, Liquids, Erasure Fluids and Glues — A Preliminary Survey of Arabic Chemical Technology', *Chymia*, 7 (1961), 57–72.

[86] Levey, M., 'Mediaeval Arabic Bookmaking and its Relation to Early Chemistry and Pharmacology', *Amer. Phil. Soc., New Series*, 52 (1962).

[87] Levey, M., *op. cit.*, 16, note 88.

[88] Lewis, W., *Expériences Physiques et Chimiques sur Plusiers Matières Relatives au Commerce et aux Arts*, 3 Vols., trans. by M. de Puisieux, Chez Desaint Librairie, Paris (1768).

[89] Lin, T., 'Chinese Method of Writing and Painting with Ink' (Das Schreiben und Malen mit Tusche in China), *Graphis*, I(1945), 314–319.

[90] Longo, L.,'Eliminazione di Scritture e Macchie di Inchiostro Bianco su Carta Nera, Esperimenti su L'Eliminazione di Scritture e Macchie di Inchiostro Rosso', *Boll. I.P.L.*, 5 (1946), 88–89.

[91] Longo, L. and Bozzachi, B., 'Rivelazione Ottico-Fotografica di Scrittura Nascosta sotto uno Strato di Porporina', *Boll. I.P.L.*, 14 (1955), 152–154.

[92] Longo, L., Manganelli, F. and Martins, J. L., 'Sperimenti su un Metodo di Pulitura di Carte Manoscritte Imbrunite', *Boll. I.P.L.*, 18 (1959), 143.

[93] Loumyer, G., *Les Traditions Techniques de la Peinture Médiévale*, Brussels and Paris, Librairie Nationale d'Art et d'Histoire, G. Van Oest et Cie Editeurs (1920).

[94] Lowy, A. and Campbell, C. H., 'Method of Restoring Inked Documents', *U.S. Patent 2 182 672* (5 December 1939).

[95] Lublinsky, V., 'Notions Bibliothéconomiques de la Renaissance, Un Texte Oublié de Grapaldo', *Bib. Hum. Ren. Trav. Doc.* 29 (1967), 633–47.

[96] Lucas. A., 'The Inks of Ancient and Modern Egypt', *Analyst*, 47 (1922).

[97] MacDonnel, H. L., 'Porous-Glass Electrophoresis', *Anal. Chem.*, 33 (1961), 1554–5.

[98] MacDonnel, H. L., 'Porous-Glass Chromatography', *Nature*, 189 (1961), 302–3.

[99] 'Manuscript Marking Ink Being Tested', *Amer. Libr. Assoc. Bull.*, 56 (1962).

[100] 'Manuscript Marking Ink', *Amer. Libr. Assoc. Bull.*, 56 (1962).

Inks', *Int. Crim. Police Rev.* (English ed.), **24** (1969), 246–51.

101 Margival, F., 'Les Encres', Encyclopédie Scientifique des Aide-Mémoire, No. 419 B, Gauthier Villars, Masson et Cie, Paris (1912).

102 Margival, F., Encres Usuelles, Desforges, Girardot et Cie, Paris (1928).

103 Margival, F., op. cit., 11.

104 Margival, F., op. cit., 14.

105 Margival, F., Encres Spéciales, Nouvelle Collection des Recueils de Recettes Rationnelles (1928).

106 Martin, G., La Physico-Chimie des Encres, Editions Estienne (1961).

107 Mitchell, C. A. and Heptworth, T. C., The Production and Properties of Printing, Writing and Copying Inks, C. Griffin and Co., London (1916).

108 Mitchell, C. A. and Ward, T. J., 'Sediments in Ink and Writing', Analyst, 57 (1932), 760–770.

109 Mitchell, C. A., Inks: Their Composition and Manufacture, Including Methods of Examination and a Full List of British Patents, C. Griffin and Co. Ltd, London (1937), 408 pp.

110 Mitchell, C. A., op. cit., 4.

111 Mitchell, C. A., op. cit., 6.

112 Mitchell, C. A., op. cit., 20.

113 Mitchell, C. A. and Wood, D. R., 'Action of Moulds on Ink in Writing', Analyst, 63 (1938), 93–148.

114 Moloster, Z., Contributions à l'Identification des Colorants par Chromatographie sur Papier. Différentes Applications, Faculté des Sciences de l'Université de Paris (20 December 1957) (thesis).

115 Munson, L. S., 'The Testing of Writing Inks', J. Am. Chem. Soc., 28 (1906), 512–516.

116 Mura-Silva, C., 'Chromatographic Study of Colouring Materials and its Application to the Study of Inks', Annales Fac. Quim. Farm. Univ. Chile, 15 (1963), 189–191.

117 Nelson, P. F. and Smith, J. G., 'Gas Chromatography and Infra-red Spectroscopy of Trimethylsilyl Ethers of Some Phenols Related to Lignin and Ellagitannins', Tappi, 49 (1966), 215–18.

118 'Note (a) on the Method Employed at the Public Record Office to Restore Faded Writing', Archives, 2 (1949), 38.

119 O'Hara, C. and Osterburg, J. W., An Introduction to Criminalistics, MacMillan, New York (1952).

120 Ordway, H., An Evaluation of Chemical Methods for Restoring Erased Writing Ink, Swindon Press, London (1954).

121 Ouy, G., 'Histoire Visible et Histoire Cachée d'un Manuscrit', Le Moyen-Age (1958), 115–138.

122 Partington, J. R., A History of Chemistry, Vol. I, Part I, MacMillan and Co. Ltd, London, and St Martin's Press, New York (1970), 205.

123 Pedemontano, A. (or Gerolamo Ruscelli), De Secretis Libri Septem, 3rd ed., apud P. Pernam Basilea (1568 in 8th ed.).

124 Perkavac, J. and Perpar, M., 'Analysis of Writing Ink by Paper and Plate Chromatography', Kem. Ind. (Zagreb), 12 (1963), 829–33.

125 Pfeil, E., 'Paper Chromatography of Ink Pigments', Chem. Unserer Zeit, 3 (1969), 58–60 (in German).

126 Plenderleith, H. J., La Conservation des Antiquités et des Oeuvres d'Art, Editions Eyrolles (1966), 400 pp.

127 Pliny the Elder, De Rerum Natura (Histoire Naturelle), Book XXXIV, Société d'Edition Les Belles Lettres, Paris (1953).

128 Porteres, R., 'Encres et Tablettes à Ecrire de Fabrication et d'Utilizations Locales à Dalaba-Fouta-Djalon', République de Guinée, Notes Afric. No. 101 (1964), 28–9.

129 Pougheon, S. and Moloster, Z., 'Contribution à l'Etude des Encres des Documents Manuscrits par la Chromatographie sur Papier', Rev. Inter. Crim. Police Tech, XII (1958), 207–212.

130 Purzycki, J., Szwarc, A. and Owoc, M., 'Thin Layer Chromatography and Impregnated Papers in the Analysis of Inks', Chem. Anal. (Warsaw), 10 (1965), 485–9 (in Polish).

131 Raju, P. S., Barnerjee, R. C. and Iyengar, N. K., 'Comparisons of Inks by Paper Chromatography', J. Forensic Sci., 8 (1963), 268–85.

132 Rammstedt, 'Tinte und Tusche', Chem. Tech. Neuzeit, 2, Aufl. V. Bd. Enke, Stuttgart (1932).

133 'A Receipt for Making Writing Ink', Gentleman's Magazine, XXIII, (1753), 212.

134 Reeners, W., 'Thin Layer Chromatographic Investigation of Ball Point Pen Refills', Z. Anal. Chem., 216 (1966), 272–4 (in German).

135 Revue des Produits Chimiques du 15 Décembre 1925, 'Composition des Encres à Ecrire', Paris.

136 Rhodes, H. T. F., 'The Oxidation of Ferrous Iron in Iron Gall Inks', Chemistry and Industry, 59 (1940), 143–145.

137 Ribeaucourt, 'Dissertation sur l'Encre Ordinaire à Ecrire', Annal. Chim., XV (1792), 113–160.

138 Rupert, F. F., 'Examination of Writing Inks', Ind. Eng. Chem., 15 (1923), 489–493.

139 Ruscelli, G., see Pedementano, A.

140 Ruska, J., 'Bd. of al-Razi's "Sirr-allAsrar" ', Quellen u. Studien zur Geschichte der Naturwissenschaften und der Medizin, 6 (1937), 88.

141 Sannie, C. and Amy, L., 'Recherches sur l'Analyse de l'Encre des Documents Manuscrits. I. Méthode Générale d'Analyse Quantitative. Application aux Encres au Campèche – Chrome', Ann. Méd. Légale, 18 (1938), 401–9; and Arquivos de Medicina Legal et Identificacâo, 8 (1938), I (First Latin-American Conference of Criminology).

142 Sannie, C. and Rose, P., 'La Détermination de l'Age des Tracés. Manuscrits à l'Encre', paper presented at the IIe Congrès International de Médecine Légale, Brussels–Liège, 25–28 July 1947.

143 Sannie, C. and Moloster, Z., 'Recherche sur l'Analyse de l'Encre des Documents Manuscrits. II. Chromatographie de Partage sur Papier', Rev. Intern. Crim. Police Tech., VI (1952), 154–167.

144 Santucci, L., 'Rigenerazione dei Documenti. I. Stabilizzazione Mediante Sali Piombosi degli Inchiostri a Base di Ferro Ravvivati con Solforo di Ammonio; II. Descrizione del Metodo', Boll. I.P.L., 12 (1953), 69–76.

145 Santucci, L. and Wolff, C., 'Rigenerazione dei Documenti. IV. Solfurazione e Fissagio degli Inchiostri Ferrici: Valutazione dell' Efficacia. Stabilità ed Effeto sulla Carta', Boll. I.P.L., 22 (1963), 165–190.

146 Schluttig, O. and Neumann, G. S., Die Eisengallustinten, V. Zahn & Jaensch, Dresden (1890).

147 Schmitt, C. A., 'The Chemistry of Writing Inks', J. Chem. Educ., XXI (1944), 413–414.

148 Secrets Concernant les Arts et Métiers, nouvelle édition revue, corrigée et considérablement augmentée, Vol. I, Amable Leroy Imprimeur-Librairie, Lyons (1804).

149 Simonelli, G., 'Inchiostro', Enciclopedia Italiana, XVIII (1949), 966–969.

150 Smalldon, K. W., 'The Comparison of Ink Dyestuffs Using Minimal Quantities of Writing', Forens. Sci. Soc. J. (G.B.), 9 (1969), 151–152 (bibliography).

151 Somerford, A. W., 'La Comparaison des Encres par Chromatographie', Rev. Intern. Politique Crim., 59 (1952), 170–173.

152 Steckoll, S. H., 'Inks Used in Writing the Dead Sea Scrolls', Nature, 220 (1968), 91–92.

153 Sung, Y., Chinese Technology in the Seventeenth Century, trans. by T'ien-kung K'ai Wy, London (1966).

154 Susumu, I., 'Identification of Inks by Paper Chromatography', Sci. Crim. Det. (Japan), 8 (1955).

155 Swarup, N. T., 'Paper Chromatographic Investigations of Inks, Dyes and Lipstick', Arch. Kriminol., 126 (1960), 26–32.

156 Tergolina, U. and Gislanzoni, B., 'Formule Mediaevali per Materiale Scrittorio', Boll. I.P.L., 1 (1939), 155–160.

157 Testi, G., 'Malattie e Restauri dei Libri', Accad. e Bibl., VII (1933) 162–166.

158 Testi, G., 'Note e Saggio di una Bibliografica sulle Materiale Scrittorie', Archivi, Archivi d'Italia e Rassegna Internazionale degli Archivi, III (1936), 180–187.

159 Testi, G., 'Una Poesio des 1753 in Lade dell'Inchiostro', Boll. I.P.L., 7 (1948), 104–105.

160 Theophilus, Schedula Diversarum Artium, chapter entitled 'De Encausta'; see Dodwell[37].

[161] Thompson, D. V., *The Materials and Techniques of Mediaeval Painting*, George Allen and Unwin, London (1956), 84.

[162] Thompson, J. W., 'The Identification of Inks by Electrophoresis', *Forensic Sci. Soc. J.*, 7 (1967), 199–202.

[163] Tsien, T. H., *Written on Bamboo and Silk. The Beginnings of Chinese Books and Inscriptions*, The University of Chicago Press, Chicago, London (1962), 233 pp.

[164] Usai, A. and Corazzi, L., 'Quantitative Chromatographic Identification of Qualitatively Equal Blue Inks for Ball Pens', *Rass. Chim.*, 12 (1960), 28–9.

[165] Vaultier, R., 'The History of China Ink', *Papetier*, special Fall issue (1957).

[166] Verma Mulk, R., and Rai, J., 'Identification of Dyes Used in Various Types of Inks by Thin-Layer Chromatography', *Chromatogr.-Electrophor. Symp. Int. 4th 1966* (1968), 549–54.

[167] Villavecchia, V., *Tratto di Chimica Analitica Applicata*, 2 vols (1936), chap. XVI, 862–874.

[168] Vitolo, A. E. and Ventura, R., 'Analytical Investigations on Handwriting with Ball Pen Inks', *Med. Legale e Assicuraz*, 3 (1955), 1271–82.

[169] Vitruvius, *De Architectura; Architecture ou Art de Bien Bastir, romain antique: mis de Latin en Francoys par Ian Martin Secrétaire de Monseigneur le Cardinal de Lenoncourt pour le Roy très Chrestien Henry II* (1547), book VII, chap. X, 108 *verso*, 109 *recto*.

[170] Waters, C. E., 'Inks', *Circular C 413*, National Bureau of Standards, Washington, D.C. (1936).

[171] Waters, C. E., 'Inks', *Circular C 426*, National Bureau of Standards, Washington, D.C. (1940).

[172] Wattenbach, W., *Das Schriftwesen in Mittelalter*, Leipzig 3rd ed., Akademische Druck. v. Verlagsanstalt, Graz (1958).

[173] Wecker de Basle, J. J., *Les Secrets et Merveilles de Nature, Recueillis de Divers Auteurs en 17 Livres*, Rouen (1608), book 14, chap. II, 688–709.

[174] Weiss, H. B., 'The Writing Masters and Ink Manufacturers of New York City, 1737–1820', *Bull. New York Pub. Libr.*, LVI (1952), 383–94.

[175] Witte, A. H., 'The Examination and Identification of Inks', *Method Forensic Sci.*, 2 (1963), 35–77.

[176] *Workshop Receipts*, Spon and Chamberlain, New York (1903); the article on 'Ink' is signed by R. Irvine.

[177] Zimmerman, E. W., 'Colored Waterproof Drawing Inks', *Ind. Eng. Chem.*, 25 (1933), 1033–1034.

[178] Zimmerman, E. W., Weber, C. G. and Kimberly, A. E., 'Relation of Ink to the Preservation of Written Records', *J. Res. N.B.S.*, 14 (1935), 463–468.

[179] Zimmerman, E. W., 'Iron Gallate Inks – Liquid and Powder', *Research Paper R.P. 807*, National Bureau of Standards, Washington, D.C. (1935).

27
The Technique of Old Writings and Miniatures

VERA RADOSAVLJEVIC

INTRODUCTION

Several recent meetings of the Conservation Committee of the International Council of Museums (ICOM) have dealt with the question of the technique of mediaeval manuscript illumination. All the reported work was based on data acquired from Western European manuscripts. In the present work, the research has been extended to the examination of individual Slavic (Russian and Serbian) recipes, as well as to collections of Armenian and Azerbaijan recipes, as typical examples of instructions for the art of miniature painting in the Near and Middle East. The aim of this work was to establish a list of inks, pigments and binding media used in these regions, the similarities or distinctions in the methods of making them and the procedures used to temper them. Simultaneously, other data were collected that could have an influence on the technique of writing, illuminating, chemical analysis of pigments and media, or on the conduct of conservation.

The sources of the Western recipes were the well known manuscripts of Eraclius[1], *Anonymus Bernensis*[2], Theophilus[3], Jehan le Begue[4], *De Arte Illuminandi*[5], the *Strasburg MS.*[6], Cennino Cennini[7], the *Bolognese MS.*[8], the *Illuminir-Buch* by Bolz[9], the *Paduan MS.*[10] and the *De Mayerne MS.*[11], as well as the individual recipes which could be acquired from some other old manuals[12].

As a source of Russian technique, the collection of recipes reprinted and published in 1906 by Simoni[13] was used. It contains Russian recipes from the fifteenth to the eighteenth century and some Serbian

ones of the sixteenth and seventeenth centuries.

The manual of the Serbian archbishop Nectarie, written in Russia at the end of the sixteenth century[14], served as a source of Serbian technique. This contains important information about illumination in the Slavic countries, and is based, as the author himself says, on Greek experience.

For studying the recipes of the Near and Middle East, we used the collection of 100 Armenian recipes from the fourteenth to the eighteenth century, translated into Russian by Aratiunian[15], the manuscript of Sadik-beg-Afshar[16], who was a famous Azerbaijan poet and miniaturist of the sixteenth century, and several other individual recipes published by Kaziev[17].

As a source of Greek recipes, we used two different copies of the manuscript by Dionysios of Furna[18] and some recipes from the *Lucca MS.*

BLACK AND BROWN INKS

From all the material studied about the preparation of inks, the following inferences were drawn.

From the chemical point of view, the inks used in Europe, the Near and Middle East can be divided into two basic types, carbon inks and tannin inks. There are also mixtures of these.

The carbon inks were dispersions of carbon acquired from soot gathered above burning candles and sanctuary lamps, or by carbonizing vine twigs, kernels of peach and almond, etc. These inks were also made, particularly in the East, from the black pigment produced by carbonizing cereals such as

barley and rice.

Extracts of some plants such as hawthorn, according to Theophilus and Audemar, and extracts of galls or bark of alder, according to a Russian manuscript of the seventeenth century, were used instead of water, so that the colour of these inks originated from carbon, tannins and other coloured ingredients, most frequently quercetin.

One of the Eastern recipes of the tenth century contains data about gallotannate inks. In the Russian literature it can be found that they were used there from the eleventh century. In the twelfth century, according to the Western recipes studied, tannins obtained by extraction from galls were in wide use. In the Slavic and Eastern recipes studied, inks were also produced from galls; however, the Slavic recipes often mention the bark of alder, oak, elm, (a Russian recipe also mentions blueberries), as supplements to galls, or as the only sources of tannins. In several Eastern manuscripts, the bark of walnut trees or pomegranate was also used.

Only a few Slavic recipes say that the concentrated extracts were used as inks. Iron was added to most of them, either pure, rusted, or as a sulphate. To slow down the oxidation of ferrous into ferric salts, vinegar was usually added, but, according to the Slavic recipes, substances which could ferment into acids, such as honey and kvas*, were added instead of vinegar which was at that time either too expensive or not available at all. According to some of them, addition of acid was completely omitted.

There were also inks with many other components such as henna, aloes, saffron, indigo, rose water, verdigris and refined sugar, that changed the colour of the ink, its shade or density, or simply gave it an odour. Certainly, most inks of this type were from the East, since the recipes for their preparation can be found in many Eastern manuals, while the European manuals, though containing most of the commonly used recipes, do not mention them.

As media, gums were used almost exclusively, while gelatin was used in certain rare cases. Sometimes a medium was not used at all.

PIGMENTS

The same pigments used for preparing the coloured inks for writing were used for painting illuminations and miniatures. The difference is only in their use and the technique of their application.

The mineral pigment most used, in the East and the West, was vermilion. Essentially there is no difference between natural cinnabar and artificially prepared vermilion.

In Europe, minium was prepared by heating white lead as the initial raw material. In the East it was procured by a slightly different method, starting from elementary lead which was first heated and gradually mixed with vinegar and sal ammoniac. The

*A fermented drink made of malt, rye and water.

resultant mixture was heated so that, in fact, white lead was obtained and was then converted into minium by further heating. This method is not mentioned in the European recipes studied. The only exception is the recipe in the *Nurnberg MS.*[12], a treatise about dyeing textiles in Germany in the fifteenth century, which refers to the making of minium through an oxide by a simple melting and oxidation of lead with no other reactions.

The most commonly used pigments of organic origin are the pigments made from trees of the *Leguminosae* family (brazil-wood, sandalwood, campeachy-wood). It cannot always be said with certainty which of these was particularly used because all of them were simply called 'red wood'. Chemically the difference is not important, because the pigments made from them were very similar in composition and properties.

Paints were prepared by a simple extraction from the powdered wood, with water, lye, glair, limewater, wine, gum-water, and were used like that, with no further processing. White lead, chalk, crushed egg shells and similar substances were often added to the pigment in order to give it body.

Extraction also served to obtain lakes, precipitating them with alum.

The Western recipes for preparing these pigments are very numerous and varied, while there are fewer Slavic and Eastern ones (there are in general very few Slavic recipes preserved), but it can be inferred from them that all these processes were applied there, too. There are very slight differences, e.g. according to Western recipes, soapwort was not used for extraction, while according to the Eastern ones, it was used. In Western recipes a variety of white substances were used to give body to the pigment, while from the Slavic and Eastern recipes studied it may be seen that only powdered egg shells were used.

There was no Western recipe about the direct use of madder for illumination. Georgievski, however, on the basis of his studies of Russian recipes, introduces it into the list of pigments used in Russia for illuminations. In one Armenian manuscript of the seventeenth century there were three recipes but, according to them, madder was used not as a red pigment but for mixing with blue in order to obtain a purple pigment.

The recipes about dragon's blood and its use in illumination could be found only in the Western treatises. None could be found in the Eastern ones but really, considering its very limited use, the data about whether or not it was in use are not of any importance for the technique of illumination.

The most important red pigments for illumination that were obtained from insects are kermes and cochineal. They were obtained from the insects *Coccus illicis, Coccus polonicus, Margarodes polonicus, Coccus cacti.* Here, too, there were slight differences in their production. In the West, kermes was obtained indirectly from the cloth dyed with it, while this method is not mentioned in the Eastern recipes. On the other hand, according to the manual of Dionysios and an Armenian recipe, soapwort and *Radix sumbuli*

were used for making 'carmine', which is not mentioned in the Western recipes studied.

Ultramarine and azurite are natural mineral pigments which are mentioned in the Western, Eastern and Slavic recipes. The methods of preparation for illumination are basically the same because they are based on the same principles.

The blue pigment of plant origin most often mentioned is indigo, obtained either from the indigo plant or from woad. There are no other data about blue pigments in the Slavic and Eastern manuscripts examined, though there are data about their use in the Western recipes, e.g. folium, blueberries, lacmus.

Similarly, for the green pigments, it can be seen from the recipes and other literary data studied that green earth and malachite, iris green, and the green from violets were used in the West as well as in the East. There are no data in the Eastern recipes about sap green or the green from honeysuckle. This, however, cannot be interpreted as meaning that they were not used but only that these recipes were not preserved to our times (or, if they were preserved, that we had no access to them), because it is thought that some Western recipes — though they could not be found in the Eastern ones studied — are of Eastern origin.

It can be said that the complex green pigments were prepared in a similar way, by mixing orpiment with indigo or ultramarine, verdigris with iris green or saffron, orpiment with iris green or juices of various herbs.

The artificial inorganic green pigment most often used in the West and the East was verdigris. There was an essential difference in its production. In the West, in fact, it was always an acetate, with ingredients such as chlorides, tartrates, or, in viride rotomagense, the derivatives of fatty acids. According to the Slavic or Armenian recipes, too, it could be an acetate, but it could also be made from sour milk and cheese, so that it represented a mixture of caseinates, or lactates of copper with casein. This recipe cannot be found amongst the numerous data about verdigris and other green pigments in the Western treatises.

The inorganic yellow pigment which is most often mentioned in the painters' treatises, whatever its origin, is orpiment. In addition, yellow ochres are mentioned, and occasionally massicot, the later only in the European recipes studied. Realgar is mentioned more in the Eastern ones. Certainly the most widely-used yellow organic pigment for illumination was obtained from saffron. Pigments from curcuma, celandine, rhubarb and gamboge-gum were less used. The Western treatises also mention pigments from yellow weed and buckthorn which are not mentioned in the Eastern recipes. Most probably these recipes are not preserved, because both plants grow in some of these territories. Both in the East and in the West, the gall of oxen or big fish such as carp, pike and eels, was used.

The substitute for antique purple often used in the Middle Ages in the West was *folium id est lacmus.* According to the German manuals, blueberry juice could also be used. Various mixtures of red and blue pigments were used in both the West and the East. Sometimes the blue pigments were covered with a thin layer of transparent red extracts of red wood or lac.

In general the most widely used white pigment was white lead, which was produced in the East by a shorter process than in Europe. In Europe, the same method of making white lead, by the action of acetic acid on lead in the presence of carbon dioxide, has been used since before Christ up to our own times. In the East, lead was heated in order to convert it into an oxide, which was then treated with acetic acid and ammonium chloride. The product obtained was then heated in order to obtain white lead. Chemically there is no difference: it is still a basic carbonate. Egg shells were also in general use, but in much smaller quantities than white lead.

The inks mentioned above were usually used as black pigments.

All the recipes studied from the Near and Middle East contain descriptions of work with powdered gold, while the Slavic and Western European recipes also contain data about laying leaf (with or without mordant or grounds) as well as the method of laying gold by attrition. In the East, there are data about strewing freshly-glued areas with powdered gold. This method is mentioned in Europe only when tin is substituted for gold powder.

Imitations of gold were very numerous and very similar in the recipes of both sources. These were the pigments that derived their colour from egg yolk, orpiment, saffron, gall, rhubarb or celandine. The metals used were tin, silver, copper and mercury.

BINDING MEDIA

The media used were always the same: gums, glair, gelatin, resins occasionally, egg yolk and casein only exceptionally. The media were used pure at first; later they were increasingly used in mixtures.

Verdigris was very often mixed with vinegar, regardless of where it was used.

Additives to the media that served to maintain the plasticity of the paint layer were also the same: honey, sugar, sugar candy, juice of euphorbia, fig or pomegranate. Realgar, camphor and alum served to prevent putrefaction.

SUPPORTS FOR ILLUMINATION

In order to examine miniatures, as with any other complex painting, we must consider the supports on which they were made.

Paper and parchment served this purpose for centuries, in the West and the East. The manufacturing processes and preparations for illumination were, for centuries, very similar. Probably the most interesting of these was the treatment of paper in order to prevent blotting of inks and paint. For this purpose, there

were very similar processes in use: covering with a solution of glue, alum, starch (obtained by cooking wheat or rice flour), or a mixture of glue and starch.

EQUIPMENT AND THE TECHNIQUE OF ILLUMINATION

The equipment for illumination and writing comprised a stylus, a calamus (reed pen), and various brushes that were most often made of squirrel hair but also of the hair of other animals such as martens, weasels, sables.

Calami and inkpots were usually carried at the waist. Inks and pigments were kept in the hollow horns of animals.

Pestle and mortar were used for breaking up large pieces of mineral. Plates and mullers of marble, porphyry, serpentine or other hard stones were used for grinding.

Teeth of various animals, e.g. wolves, dogs, cows, calves, wild boar, etc., were used for polishing gold.

On the basis of the manuscripts and the Western European and Slavic recipes studied, it can be inferred that the sequence of operations was as follows:

1. After the paper or parchment was prepared for work and the text was written, the composition was outlined with a stylus. The contours were drawn very lightly and could be erased with a piece of bread and changed according to requirements.
2. Next, the contours were drawn with black or coloured ink, thus finishing the drawing.
3. After the drawing was finished, the areas to be gilded were first painted throughout the book, whatever the technique used.
4. The next operation was the laying on of the first layers of paint, pure or mixed. The rule was to finish with one colour throughout the manuscript and then to start with another one. The illuminations on parchment usually had a ground of white lead. Under the naked parts of the body, a green ground was laid. The greenish shade could also be made by adding green colour to the flesh colour.
5. After application of the first layer with a somewhat denser paint composed of the pigment and white (chiefly white lead) the second layer was applied. After that, pure white or pure pigment was used to give prominence to some parts and make others recede. For definite modelling and outlining, indigo and dark pigments were used.
6. The next stage was the retouching of outlines which had been partially covered during the painting.
7. Usually the last operation was the painting of various ornaments on gold (or silver) with black or red ink, and finishing the extremely fine details with gold, which could not be done by laying gold leaf but had to be done with a feather.
8. In a certain number of miniatures, after painting was finished, 'varnishing' was carried out to complete the work. For this purpose, gum arabic or glair or a mixture of both was used, never varnishes.

As with any other paintings, the work on the miniatures, especially on the initials and ornaments, could be simplified and some operations omitted. However, the sequence of the remaining operations was always that given above. Thus, the ornaments and miniatures were often done only with the pure colours, without any further painting. Sometimes, however, they were done according to all the rules for painting miniatures.

CONCLUSION

If one compares the list of pigments and media used, the methods of their production and application, from the earliest days of illumination to the times of the most recent work, the conclusion drawn for European miniature technique, that it did not change significantly either with time or by place, can be extended also to the technique used in the Slavic regions and in the countries of the Middle and Near East.

It can be said that the ancient Greek and Roman methods, transferred by tradition, were only supplemented and spread throughout Europe by the Byzantine artists, because the same pigments and the same methods described in the *Lucca MS.*, whose Byzantine origin is undoubtedly proved, can be found in *Mappae Clavicula*, written somewhere in the North. The recipes of Eraclius, written in Italy where an undoubted Byzantine influence could be felt, are consistent with the recipes of *Mappae Clavicula* and of Theophilus, written in Germany. The treatises by Cennino Cennini and *De Arte Illuminandi* show perfect agreement with the recipes of Dionysios of Furna. The collection of copies by Jehan le Begue unites the recipes of southern, northern and central Europe. It can also be ascertained for the German recipes that they are all derived one from another and that they are essentially the same as the Italian recipes. Hence they stem directly or indirectly from the Byzantine tradition.

The mere fact that the Balkan peninsula was a part of the Byzantine Empire makes it clear that the Byzantine artistic tradition deeply influenced the technique of the miniature painting of the south Slavic peoples and, through the Greek recipes and the Nectarie manual, Russian miniature painting as well.

It can also be seen from the works written in the East about the miniatures of the Near and Middle East, Azerbaijan, Iran, Middle Asia and Turkey, as well as from the recipes of these countries that have been studied, that there is an agreement between the materials and paint-preparing processes in these countries and the materials and processes used in Europe.

This is completely understandable, because a

great number of pigments were imported from the East during the Middle Ages and because many treatises were translated into Latin directly from the Arabic languages.

For centuries, the choice of pigments and media was the same and their use depended mainly upon the artist's taste and resources. Sometimes one pigment was in fashion, sometimes another. Thus, for instance, Eraclius mentions pigments made from plants only as additional pigments, while for the authors of *De Arte Illuminandi*, the *Strasburg MS.*, and Bolz they have the significance of basic pigments.

To what extent these instructions were complied with, only chemical and microscopic analysis will decide, but considering that the manuals served as the basis for work both for individuals and for whole scriptoria, there had to be some reflection in practice.

Differences that stemmed from the use of different kinds of plants are almost negligible, since their colouring matters are limited from the chemical point of view to the same groups of colouring compounds. The only process that can be found in the Eastern and Slavic manuscripts while it cannot be found in the Western treatises is the making of verdigris with sour milk. However, this cannot be considered as an essential difference as regards the technique of miniatures considered in general.

The choice of materials and technique was limited by the supports on which the miniatures were painted and the aim they served, as well as by the dimensions of the support on which they had to be painted. This is the reason why the differences that exist in the miniature paintings of this or that age, from one region to another, are based principally on variations of artistic expression and style and not on the materials used or the methods of preparation of paints or media.

The surviving written or illuminated manuscripts confirm that such a selection of paints, media and techniques was entirely justified, and undoubtedly prove the profound knowledge of the chemistry and properties of materials possessed by the old master illuminators.

References and Notes

[1] *Manuscript Irakliia ob Iskusstvakh i Kraskakh Rimlian,* VIII—IX vv., translated by A. V. Vinner and N. E. Eliseeva, VTSNILKR, Moscow (1961).
Merrifield, M., *Original Treatises on the Arts of Painting,* Dover Publications, New York (1967), Manuscripts of Eraclius, Vol. I, 183—257.

[2] *Anonymus Bernensis,* VCNIKLR, Moscow (1961), 60—66.

[3] Teofilo, *Zapiska o Raznykh Iskusstvakh,* translated by A. A. Morozov and S. E. Oktiabreva, VTSNILKR, Moscow (1963). Theophilus, *The Various Arts,* translated by C. R. Dodwell, Thomas Nelson and Son Ltd., London (1961).

[4] Merrifield, M., *op. cit.,* Tabula de Vocabulis Sinonimis et Equivocis Colorum, Vol. I, 1—45; Experimenta de Coloribus, Vol. I, 47—111; Manuscripts of S. Audemar, Vol. I, 116—165; Manuscripts of Archerius, Vol. I, 259—279; Jehan le Begue, Vol. I, 281—321.

[5] *De Arte Illuminandi,* translated by D. V. Thompson and J. R. George Heard Hamilton, Yale University Press, New Haven, and Oxford University Press, London (1933).

[6] Berger, E., *Beiträge zur Etwickelungs-Geschichte der Maltechnik,* III Folge, Verlag Georg D. W. Callwey, Munich (1912), 167—190.

[7] Cennini, C., *Le Livre de l'Art ou Traité de la Peinture,* translated by V. Mottez, L. Rouart et J. Watelin Editeurs, Paris (1911).

[8] Merrifield, M., *op. cit.,* Bolognese Manuscript, 341—599.

[9] Bolz, V., *Illuminierbuch,* Georg D. W. Callwey, Munich (1913) (first published in 1549).

[10] Merrifield, M., *op. cit.,* Paduan Manuscript, Vol. II, 647—717.

[11] Berger, E., *Beiträge zur Entwickelungs-Geschichte der Maltechnik,* IV Folge, Verlag von Georg D. W. Callwey, Munich (1901), 98—336.

[12] For example:
Merrifield, M., *op. cit.,* Marciana Manuscript, Vol. II, 603—640; Brussels Manuscript, Vol. II, 766—841.
Das Nürnberger Kunstbuch, reprinted in Ploss, E. E., *Ein Buch von Alten Farben,* Impuls Verlag, Heidelberg and Berlin (1962).
Some recipes from the *Lucca Manuscript, Mappae Clavicula, Liber Illuministarius,* etc. reprinted in Berger, E., *op. cit.,* or Roosen-Runge, H., *Farbgebung und Technik Frühmittelalterlicher* Buchmalerei, II, Deutscher Kunst Verlag (1967).

[13] Simoni, P. K., *K Istorii Obikhoda Knigopistsa, Perepletchika Ikonnago Pistsa Pri Knizhnom i Ikonnom Stroenii. Materiali Dlia Istorii Tekhniki Knizhnogo Dela i Ikonopisi, Izvlechenye iz Russkikh i Serbskikh Rukopisei* XV—XVIII v. vyp. I, SPB (1960).

[14] Petrova, A. N., *Tipik o Tserkornom i o Nastenom Pisme Episkopa Nektaria is Serbsago Grada Velesa, 1599 Goda i Znachenie Ego V Istorii Russkoi Ikonopisi Zapiski Imperatorskago Russkago Arkheologcheskago Obshchestva,* Tom XI, vypask I i II, 1—59, St Petersburg (1899).

[15] Arutiunian, A. Kh., *Kraski i Chernila po Drevne — Armianskim Rukopisiam,* SOVNARKOME Arm. SSR, Erevan (1941).

[16] Sadik-beg-Afshar, *Ganum ös Sövär (Traktat o Zhivopisi),* translation, comments and notes by A. Iu. Kaziev, AN Azerbaidzhanskoi SSR, Baku (1963).

[17] Kaziev, A. Iu., *Khudozhestvenno-Tekhnicheskie Materialy Srednevekovoi Rukopisi,* Izdatel'stvo A. N. Azerbaidzhanskoi SSR, Baku (1966).

[18] *Erminiia Ili Nastavleny V Zhivopisnom Iskusstvie Sostavlennoe Ieromonakhom i Zhivopistsem Dionisiem Furnografiotom,* 1701—1733 god., Porfiriia, Episkopa Chichirinskogo, Kiev (1869).
Durand, P., *Manuel d'Iconographie Chrétienne Grecque et Latine,* Burt Franklin, Research and Source Works Series 45, New York.

28

Conservation Methods for Miniature Paintings on Parchment: Treatment of the Paint Layer

G. Z. BYKOVA, A. V. IVANOVA AND I. P. MOKRETZOVA

Figure 28.1 An example of typical damage to Greek miniatures — the 'peeling' and flaking of the paint layer from the parchment (detail of miniature cut from a fourteenth century Psalter, Leningrad Public Library, gr.269, f.1r)

The treatment of miniature paintings in manuscripts in our Laboratory was preceded by a detailed study of their technique, not only theoretically (by studying mediaeval treatises) but by examining numerous illuminated manuscripts in the museums and libraries of Moscow, Leningrad, Yerevan, Tbilisi and other cities in the U.S.S.R. Western and Byzantine miniaturists (as well as Russian, Armenian, Georgian and Balkan) used in their work approximately the same materials — pigments and binding media (mainly white of egg and various kinds of glue). The principal technological distinction in their work is shown in different methods of laying gold and, what is more important, in the preparation of parchment. The Western parchment makers in their final operations treated the parchment with pumice and rubbed chalk into it. This made the surface look velvety and matt and led to better absorption of pigments and ink into the parchment. The Greek masters, on the other hand, thoroughly polished their parchment and made its surface look brilliant by treating it with white of egg and flax seed. That is why the thick paint layer of the Greek miniaturists does not have enough strength of adhesion to the parchment and tends to flake away easily (*Figure 28.1*). It is obvious, therefore, that the conservation of mediaeval miniature painting is a problem of the reinforcement of a flaked and pulverized paint layer, as well as flaked fragments of gold. It is particularly urgent for Greek and the technologically similar group of manuscripts.

The conservation practice was preceded by labour-consuming experiments and by the manufacture of many sorts of samples, to select the best materials and

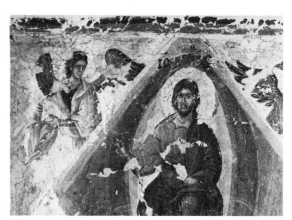

Figure 28.2 The Apostle Judas. *A miniature from Gospels and Epistles (Leningrad Public Library, gr. 101, vol. II, f. 49r). The photograph was taken during treatment. The left part is already treated with VA 2EHA, the right part is left untouched. There is no visible change in appearance*

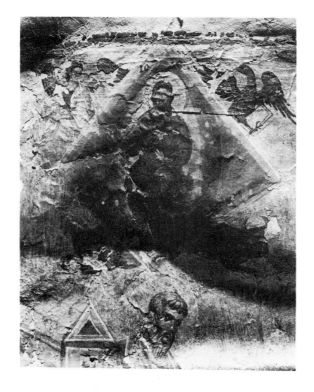

Figure 28.3 *Details of miniatures from the same manuscript (vol. I, f. 10v): (a) before treatment (b) after treatment (5% VA 2 EHA was applied)*

develop technological methods. Finally, after testing a great number of compounds, it was decided to use two of them: the soluble fluoroplasts (F-26L, F-6H) and an aqueous dispersion of a copolymer of vinyl acetate with 2-ethylhexyl acrylate (VA 2EHA). Nearly all kinds of damage in manuscript painting can be divided into two groups: pulverization of the paint layer deprived of medium, and flaking of the paint layer. In the first case, consolidation is needed; in the second, reattachment to the parchment. Depending on the character of the damage, one of the above materials is used. The films based on fluoroplasts are recommended only for consolidation of the pulverized paint layer. VA 2EHA, a compound distinguished by high elasticity and adhesion, proved to be especially effective for adhering numerous fragments of flaking paint to smooth and deformed parchment.

We started our conservation practice on Byzantine miniatures in 1967. The damaged manuscripts came from the Manuscript Department of the Leningrad Public Library. At first, the remains of miniatures in some detached parchment fragments were treated. Then there was serious conservation treatment of the so-called Trebizond Gospels (gr. 21, ninth—tenth century). The thin and friable paint layer contained a large quantity of white lead (ceruse), was pulverized (but did not flake away) and was therefore consolidated with 1% fluoroplast F-26L; the flaking parts were treated with 3% VA 2EHA.

A more complicated problem was the treatment of miniatures in the twelfth century Greek Gospels (gr. 101). The twelfth century miniatures of this two volume manuscript were repainted in the thirteenth century after the remaining part of the original had been covered with a very thick ground, so that in some parts the parchment was thinner than the paint layer. This fact, as well as incorrect binding (eighteenth century), had caused a considerable deformation of the parchment, which appeared to be the reason for serious damage to the paint and gold layers. The miniatures were then treated with an aqueous dispersion of VA 2EHA, which is distinguished not only by very good adhesive properties but also by the fact that it gives practically no shrinkage.

For straightening the deformed parts of the parchment, it was decided not to use the polygraphic press, which can damage the paint surface. These parts were straightened by the method of 'distant moistening' of parchment through numerous sheets of filter-paper. Then it was pressed by 'local weight', i.e. with small sandbags.

It must be noted that each case should be treated individually. Material for the treatment and its concentration must be chosen depending on the character and degree of the damage.

Until now the results of the treatment have proved to be satisfactory: the paint layer is firmly attached to the parchment; the colours have not changed in tone and all the miniatures have kept their original matt appearance (*Figures 28.2, 3a* and *b*).

29
Test Methods for Determining the Effect of Various Treatments on Paper

WILLIAM K. WILSON

INTRODUCTION

It is possible in this presentation only to touch on the procedures that might be useful for the evaluation of paper after special treatments. Fortunately, many useful standard methods are available for the testing of paper. The challenge is to select meaningful tests and interpret and judge the significance of the data.

Paper is usually made from wood pulp or, to a lesser extent, cotton, although many other kinds of fibres, including synthetic fibres, are used for papermaking. Cotton and linen fibres consist almost exclusively of cellulose of various chain lengths. Fully-bleached wood pulp consists of cellulose and 'other carbohydrate material'. The latter varies with the wood species and may include several sugar monomer units such as xylose, galactose, arabinose, and others, combined chemically to form the hemicelluloses.

The generally accepted formula of a cellulose chain is shown in *Figure 29.1.* Cellulose may be considered a condensation polymer of glucose with one molecule of water split out for each glucose unit. Thus, a molecule of anhydroglucose is bracketed in *Figure 29.1.* as the monomer unit of cellulose. It should be noted that the anhydroglucose units alternate 'up and down' in cellulose; when they do not alternate the product is not cellulose but starch. Thus, the building unit of cellulose is the disaccharide cellobiose, whereas the building unit of starch is maltose.

Wood contains approximately 30% lignin, and unbleached wood pulps contain lesser amounts depending on the method of isolation. In spite of millions of dollars of research effort, the structure of lignin has not been determined. Neither has the chemical relationship between cellulose and lignin been clarified.

CHEMICAL METHODS

Among the chemical methods that may be used for evaluation of changes in cellulose and paper are acidity, functional group content, copper number, viscosity,

Figure 29.1 Generally accepted formula of cellulose chain

210

and alkali solubility. The significance of these tests is not always clear, as extensive, systematic studies of variables affecting the stability of paper have not been made.

Acidity probably is the most important, and least understood, of paper tests. Acidity in paper may arise from at least three different sources:

1. Carboxyl groups in the cellulose and hemi-cellulose.
2. Papermaker's alum (aluminium sulphate).
3. Sorption of acidic gases during storage.

Carboxyl groups in cellulose normally exist in the salt form[1].

Acidity may be measured as pH of a water extract or as titratable acidity. pH has been used for years as a qualitative index of stability of paper. Several standard pH test methods are available[2,3,4,5,6]. There is no way of relating the pH of a water extract to the pH of a sheet of paper. An attempt has been made to do this for cotton by extrapolating pH values at successive dilutions to the equilibrium moisture content of cotton at room temperature[7].

pH may be determined either by hot extraction or by cold extraction methods. Alum, through hydrolysis, causes the hot extraction pH value to be lower than the cold extraction pH. The presence of certain wet strength resins brings the two values closer together, and the hot extraction value may actually be higher than the cold extraction value. For the restorer, a cold extraction method is the only practical approach. Although standard methods for determination of pH are destructive, several non-destructive contact methods, based on cold extraction, have been suggested[8,9,10,11]. The method of Huber[11], while not a standard, shows excellent promise as a routine non-destructive method. This method isolates the specimen in a set-up that excludes carbon dioxide.

Extract and contact methods do not give equivalent values, and the values do not correlate well when plotted against each other. A plot of some data from Flynn and Smith[9] is given in *Figure 29.2.*

It has been suggested* that a conservator, as the first step in a washing procedure, could weigh a document, soak it for one hour in a quantity of distilled water that maintains the paper : water ratio prescribed by the standard method, and measure the pH of the extract. This would indicate whether deacidification was necessary.

Such an approach may also be used to estimate the titratable acidity in paper. If this analysis becomes necessary, it is desirable to follow the titration with a pH meter instead of titrating to an indicator end-point. This allows some judgment to be made concerning the strength and composition of the acids.

Browning[12] presents an excellent discussion on acidity and measurement of acidity in his book, *Analysis of Paper.*

Many methods for determination of carboxyl which may be present in deteriorated paper as a result

*By Robert Organ, Smithsonian Institution, Washington, D.C.

of oxidation, are available, and two have been standardized[13,14]. These are based on the methylene blue method of Davidson[15] and the simple titration method of Karin Wilson[16]. The former is very sensitive and does not require an acid pre-treatment of the sample, but it requires the preparation of a calibration curve and the availability of a colorimeter or spectrophotometer. The Karin Wilson method is not as sensitive, but only the simplest of laboratory equipment is required.

There is really no satisfactory method for the estimation of aldehyde in cellulose and paper. Possibly

Figure 29.2 pHw (water spot test) plotted against pHe (TAPPI Standard T435)

the best approach is to determine the carboxyl content before and after oxidation with chlorous acid[17].

Copper number is a classical method that has been used for many years for the determination of reducing (aldehyde) groups in cellulose. It is empirical in nature, and the test result depends on the type of aldehyde[18]. It can be useful if one recognizes its limitations. Several standard methods are available[19,20,21].

An occurrence that must not be overlooked results from the solubility of cellulose fragments, whether in treatment during a restoration process or in an analytical determination. Aldehyde and carboxyl groups are more likely to occur in the shorter chain fragments. Some weight loss always occurs during chemical treatments, but this may be beneficial. During deacidification treatments, much of the discoloured material is removed and the appearance of the paper is greatly improved.

Functional group content and changes in functional group content may be given different interpretations. High values for aldehyde and carboxyl are an indication of the presence of degraded cellulose, and of extensive yellowing that is likely to occur. Aldehyde and carboxyl exert a synergistic effect on yellowing[22]. A high aldehyde content may contribute to crosslinking[23]. Information has been obtained on the effect on the stability of paper[1] of aluminium and calcium, attached

Table 29.1. ALDEHYDE AND CARBOXYL CONTENT OF PURIFIED COTTON PAPER AFTER IRRADIATION WITH A 253·7 NM LIGHT SOURCE.*

Relative Radiation[†]	Aldehyde, moles per gram	Carboxyl, moles per gram
0	0·37 x 10⁻⁵	0·63 x 10⁻⁵
1·09	1·43	1·23
2·18	2·27	1·51
4·35	2·70	1·60
6·52	3·27	1·58
9·57	4·46	2·11
13·05	6·51	2·64
19·58	8·47	2·65

*Flynn, J. H., Wilson, W. K., and Morrow, W. L., 'Degradation of Cellulose in a Vacuum with Ultraviolet Light', *J. Res. NBS* **60**, (1958) 229.

†$Nh\nu/g$, where N is Avogadro's number, h is Planck's constant, and ν/g is the frequency of the incident radiation.

to the carboxyl group, but the effect of other metals has not been studied.

As an example of the usefulness of functional group information, data on changes in functional group content of cellulose during irradiation are given in *Table 29.1*.

The viscosity of cellulose solutions is a function of the molecular weight (degree of polymerization). Several solvents for cellulose have been developed and standard methods based on cuprammonium hydroxide[24] and cupriethylenediamine hydroxide[25,26,27] are available. At first glance, it would appear that viscosity should be one of the most valuable tests available for estimating the effects of various treatments on paper. However, there are so many chances for error that test data could be very misleading. Unless the restoration laboratory has at its disposal the services of a research chemist who is experienced in measuring the viscosity of cellulose solutions and in interpreting the data, this approach should not be attempted.

Alkali solubility is a useful test for evaluating changes in cellulose and paper. The original alkali solubility test was for the determination of alpha cellulose, which is the portion of cellulose that is in-

soluble in strong sodium hydroxide solution under controlled conditions. The soluble portion contains the so-called beta and gamma cellulose, and these consist of degraded cellulose and, in the case of wood pulp, most of the hemicellulose fraction. The alpha cellulose determination has been replaced by simpler alkali solubility tests that employ a range of sodium hydroxide concentrations, depending on the purpose of the test. ISO methods for alkali solubility[28] and alkali resistance[29] are available, and alkali solubility methods have been standardized in most countries[30,31,32].

Although alkali solubility has many ramifications, and the meaning of the data depends on the method used, it is principally a function of the amount of short-chain carbohydrate material in the sample. Alkaline solutions may cause chain breaks and increase the amount of short-chain material if aldehyde is present in the 2- or 3-position in the anhydroglucose ring[33]. After treatments that remove some short-chain cellulose, the alkali solubility value decreases. Treatments that cause further degradation increase the alkali solubility.

An example of the use of the alpha cellulose test to show the importance of temperature control during irradiation is given in *Table 29.2*. The changes are much greater when the temperature is not controlled. The effect of pH on thermal stability is obvious with both the soda-sulphite and rag papers. When the temperature was controlled, pH appeared to have no effect on the decrease in alpha cellulose during irradiation.

PHYSICAL METHODS

As the data from physical tests depend on the moisture content of the paper and, therefore, the relative humidity, all physical testing must be performed in a controlled atmosphere. This is discussed later in 'Effect of moisture content of paper on physical tests'.

Common physical tests used for the evaluation of paper include tensile strength, elongation, bursting strength, tearing strength, and folding endurance. Wet strength is a less frequently used, but useful, test.

Table 29.2. CHANGES IN ALPHA CELLULOSE CONTENT OF PAPERS DUE TO IRRADIATION WITH A CARBON ARC, WITH AND WITHOUT TEMPERATURE CONTROL. PAPERS WERE IRRADIATED FOR 17 HOURS AT A DISTANCE OF 25 CM FROM THE ARC.*

Sample	pH, Cold Extraction	Alpha Cellulose %	Decrease in Alpha Cellulose percentage	
			Sheets Freely Suspended; No Temperature Control	Temperature of Sheet Maintained Near 30°C
1-Soda-sulfite	4·8	76·0	54·7	3·6
2-Soda-sulfite	6·1	74·8	31·2	3·8
3-Old rag	6·8	92·3	4·5	1·1
4-Old rag	9·4	92·8	3·7	1·3

*Lanner, H. F. and Wilson, W. K., 'Photochemical Stability of Papers', *J. Res. NBS* **30**, (1943) 55.

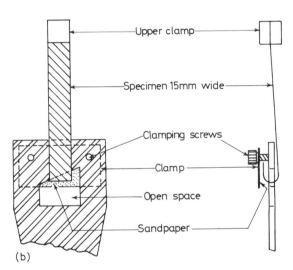

Figure 29.3 Sketches of (a) the Finch device for determining the edge tear of paper and of (b) the modification developed for testing laminated papers

Two types of tearing strength are identified for paper, edge tear and internal tear. Internal tear is measured after a cut has been made in the specimen[34,35]. Edge tear is a measure of the force required to start a tear[36,37]. The edge tear of plastics films is far greater than the internal tear. The edge tear of paper is higher than the internal tear, but the ratio is not nearly as great as for plastics films.

Although the Finch edge tear method[36,37] works for paper, it cannot be applied to plastics films that show an appreciable elongation. The Finch device was modified at NBS, as shown in *Figure 29.3*, so it could be used for both film and paper[38]. All edge tear tests are empirical, as the design of the device determines how much of the specimen can take part in elongation before failure.

Data on the effect of lamination on physical properties are given in *Table 29.3*[38]. The advantage of using tissue in addition to cellulose acetate film is shown by the three-fold increase in internal tear from paper to the laminate of paper, film, and tissue. A large increase in tensile strength is also evident.

The data in *Table 29.3* on edge tear and internal tear are not directly comparable. Although expressed in grams, internal tear is a function of energy. In order to make a direct comparison between edge tear and internal tear, it is necessary to mount the edge tear device in a recording load-elongation machine and obtain a trace of load against elongation as the specimen elongates, tears at the edge, and continues to tear internally.

Although tensile strength at break and elongation at break can be measured on simple testing machines, far more information can be obtained on a recording load-elongation machine. Typical load-elongation curves for paper in the machine direction and cross machine direction are shown in *Figure 29.4*. The area under a load-elongation curve is a function of the energy required to break the specimen, and is designated tensile energy absorption. Standard methods

Table 29.3. PHYSICAL PROPERTIES OF VARIOUS COMBINATIONS OF PAPER, CELLULOSE ACETATE FILM, AND TISSUE.

Tensile Strength kg/15 mm strip	Edge Tear g	Internal Tear g	Elongation at Break %
Two sheets of film, laminated 3·7	2100	9·9	26
Tissue only 2·1	–	12·0	2·3
Film and tissue, laminated 10·0	415	29·0	3·7
Paper only 2·7	135	26·8	2·2
Film and paper, laminated 5·4	3550	37·9	5·4
Film, tissue and paper, laminated 13·2	475	84·6	3·7

are available for tensile strength, elongation to break, and tensile energy absorption[39,40].

Bursting strength is commonly considered to be a function of tensile strength and elongation in the strongest direction of the paper. It is a very simple test[41,42], but probably not one that a restoration laboratory would use unless a test instrument were readily available.

Folding endurance is a very popular test that has been used for about 50 years to indicate changes, especially degradation, in paper. A variety of standard[43,44,45] and nonstandard methods are available. In order not to become involved in a lifetime of research on the folding endurance of paper, one should select a particular test method and use it exclusively in order to obtain comparable results. The fold machine should be kept in good condition. It is desirable to draw a current of air across the specimen to minimize local changes in relative humidity due to generation of heat during operation of the machine.

For years a decrease in folding endurance during natural or artificial ageing has been taken to indicate

Figure 29.4 Typical load-elongation curves for paper in the machine direction (MD) and in the cross direction (CD)

depolymerization[†] of cellulose. Crosslinking also occurs, and this can be followed by measuring the tensile strength of wet specimens[46,47,48]. Both depolymerization and crosslinking can cause embrittlement and decrease the folding endurance. Papermaker's alum promotes crosslinking, and several wet strength resins have been developed especially to produce wet strength in paper.

OPTICAL METHODS

Although many optical methods are available for the evaluation of the appearances of paper, reflectance is

[†]A reduction in the average length of the cellulose chains.

by far the most important. One can measure reflectance over the visible spectrum with a reflectance spectrophotometer, or in selected parts of the spectrum with a simpler instrument. Reflectance in the blue is measured most often in the U.S. by a $45°-0°$ directional instrument[49], and in Europe by a diffuse reflection instrument[50]. Although strong differences of opinion exist with respect to the merits of the two instruments, one should make certain that proper standards are available and use whichever instrument is at hand.

An instrument that measures the reflectance of an area 0·2 mm in diameter recently appeared on the market[51]. Thus, reflectance of both ink and paper

Table 29.4. REFLECTANCE, %, OF PAPER AND IMAGE OF CARBONLESS COPIES BEFORE AND AFTER EXPOSURE TO A CARBON ARC.*

Sample	Area Measured	Un-aged	Exposed to Carbon Arc
Paper 1	paper	90	80
	ink	52	56
Paper 2	paper	84	80
	ink	35	34

*Data supplied by Mr James L. Gear, Preservation Officer, National Archives and Records Service.

may be measured. This instrument was used to obtain data on changes in reflectance of paper and of the written image of samples of carbonless copy paper after exposure to the radiant energy of a carbon arc. The data in *Table 29.4* show that changes may occur in both the paper and the image. The eye cannot always distinguish the differences.

EFFECT OF MOISTURE CONTENT OF PAPER ON PHYSICAL TESTS

Moisture affects the physical properties of the fibres in paper and the bonding between the fibres. As the moisture content of paper depends on the relative humidity of the atmosphere, all physical testing must be done under standard conditions of temperature and relative humidity. Two variables that should be controlled are:

1. Variation of the relative humidity from standard conditions.
2. The condition of prior storage of the sample immediately before it is brought to standard test conditions.

A plot of moisture regain (moisture content based on the dry weight of the sample) for cotton at $25°C$ against relative humidity is given in *Figure 29.5*[52]. This figure shows that there are at least two moisture content values for each relative humidity, depending on whether standard test conditions are approached from

Figure 29.5 Sorption isotherm for scoured and dried cotton at 25°C[52]. (Reproduced from the book Moisture in Textiles *by J. W. S. Hearle and R. H. Peters (1960) p.19, with the permission of the publishers, Butterworths, and the Textile Institute)*

a high or a low relative humidity. Standard methods for conditioning require that the paper be pre-conditioned at a low relative humidity[53,54,55].

The rate of change of physical properties of paper with moisture content varies greatly depending on the property[56, 57]. Folding endurance shows the greatest rate of change followed by moisture content, elongation, tear, tensile, and burst[57] in that order.

ACCELERATED AGEING OF PAPER

Neimo[58] has listed 58 references to laboratory conditions, some of which are duplicates, that have been used for the accelerated ageing of cellulose and paper. Temperatures range from 22 to 160°C, the relative humidity from 1 to 100%, and the time from one hour to 280 days. Most of the systems were open, but some were closed.

Luner[59], Browning and Wink[60], Wilson and Hebert[61], and Richter and Wells[62] have discussed the variables associated with the accelerated ageing of paper, and have made suggestions concerning conditions that must be controlled in accelerated ageing methods. All agree that during ageing, moisture should be present in the specimens and that the temperature should be below 100°C.

At present in the U.S. the only standard method for the ageing of paper is oven-ageing at 105°C[63,64]. This is not considered suitable for restoration laboratories. Browning and Wink[60] and Richter and Wells[62] suggest a 'closed tube' approach at 90°C and 85°C, respectively, although Richter and Wells suggest that lower temperatures would be preferable. In both cases, the tubes were filled with paper that had been equilibrated at 23°C and 50% relative humidity. The tubes can then be placed in an oven or in an oil bath for ageing, and the paper will retain its moisture content during ageing. Either of these approaches should be suitable for a restoration laboratory.

A study of the accelerated ageing of experimental papers[1] has shown that oxidation, hydrolysis, yellow-ing, and crosslinking occur to different extents depending on the presence or absence of oxygen and moisture. Aluminium attached to the carboxyl groups in cellulose is very deleterious to the stability of paper. Therefore, *papermaker's alum or other aluminium salts should be avoided in restoration work.*

STATISTICAL EVALUATION OF DATA

It has been said that 'a microscope is only as good as the head above it'. This applies also to statistical techniques. The best approach is for the scientist and statistician to work as a team in designing the experiment and obtaining and analysing the data. If the services of a statistician are not available, the experimenter must rely on books on practical statistics[65,66].

The number of specimens that is considered necessary to establish a test result within reasonable (confidence) limits is usually mentioned in standard methods, and the current trend is to include measures of precision[67].

With paper, where no two sheets are ever exactly alike, proper sampling is a very important aspect of an experiment. A sufficient number of sheets should be taken so that the sampling is representative, and specimens for each test should be taken, if possible, from each sheet.

A laboratory guide on the quality control of materials is available from ASTM[68]. This manual contains a wealth of useful information on the practical application of statistical techniques and the presentation of data. A book entitled *Experimental Statistics* is available from the U.S. Government Printing Office[69]. The January 1972 issue of the *Journal of Quality Technology* is a memorial to Dr William J. Youden, and the technical papers are all reprints of his writings[70].

References and Notes

[1] Parks, E. J., unpublished data, National Bureau of Standards, Washington, D.C.

[2] 'Hydrogen Ion Concentration (pH) of Paper Extracts (Hot Extraction Method)', *TAPPI T435*, Technical Association of the Pulp and Paper Industry, One Dunwoody Park, Atlanta, Georgia 30341.

[3] 'Hydrogen Ion Concentration (pH) of Paper Extracts (Cold Extraction Method)', *TAPPI T509*.

[4] 'Hydrogen Ion Concentration (pH) of Buffered Paper Extracts', *ASTM D778*, American Society for Testing and Materials, 1916 Race Street, Philadelphia, Pa. 19103.

[5] 'pH of Aqueous Extracts of Paper', *SCAN-P14:65*, Scandinavian Pulp, Paper and Board Testing Committee, Drottning Kristinas Väg 61, Stockholm, Sweden.

[6] British Method for Determination of pH of Paper Extracts, *B.S. 2924*.

[7] Wakeham, H. R. R. and Skau, E. L., 'Determination of the pH of Textile Materials', *Ind. Eng. Chem., Anal.* **15**, No. 10, (1943) 616.

[8] Hudson, F. L. and Milner, W. D., 'The Use of Flat-Headed Glass Electrodes for Measuring the pH of Paper', *Svensk Papperstidning* **62**, No. 3, (1959) 83.

[9] Flynn, J. H. and Smith, L. E., 'Comparative pH Measurements on Papers by Water Extraction and Glass Electrode Spot Tests', *Tappi* **44**, No. 3, (1961) 223.

[10] Stamm, A. J., 'Determination of pH of Wood and Paper', *Forest Prod. J.* **11**, (1961) 310.

[11] Huber, O., 'Measurement of pH Values on Paper Surfaces', *Papier* **18**, (1964) 45.

[12] Browning, B. L., *Analysis of Paper*, Marcel Dekker Inc., New York (1969).

[13] 'Carboxyl Content of Cellulose', *ASTM D1926*.

[14] 'Carboxyl Content of Cellulose', *TAPPI T237*.

[15] Davidson, G. E. F., 'The Absorption of Methylene Blue', *J. Textile Inst.* **39**, (1948) T65.

[16] Wilson, K., 'Bestämning av Karboxylgrupper i Cellulosa', *Svensk Papperstidning* **51**, (1948) 45 (in Swedish).

[17] Head, F. S. F., 'The Reduction of the Aldehyde Groups in Periodate Oxycelluloses by Sodium Borohydride', *J. Textile Inst., Transactions* **46**, (1955) T4000; Davidson, G. F. and Novell, T. P., 'The Oxidation of the Aldehyde Groups in Periodate Oxycelluloses by Chlorous Acid', *J. Textile Inst.*, **46**, (1955) T407.

[18] Lidman-Safwat, S. and Theander, O., 'Determination of Carbonyl Groups in Modified Celluloses: A Comparison of the Borohydride and Copper Number Methods', *Svensk Papperstidning* **61**, (1958) 42.

[19] 'Copper Number of Paper and Paperboard', *TAPPI T430*.

[20] 'Copper Number of Paper and Paperboard', *ASTM D919*.

[21] 'Copper Number of Pulp', *SCAN-C22:66*.

[22] Rapson, W. H. (ed.), *The Bleaching of Pulp*, Monograph No. 27, TAPPI, Atlanta, (1963) 283.

[23] Schur, M. O. and Levy, R. M., 'Influence of Oxidation of Pulp on Wet Strength', *Tech. Assoc. Papers* **30** (1947) 203; *Paper Trade J.* **124** (2), (1947) 43.

[24] 'Cuprammonium Disperse Viscosity of Pulp', *TAPPI T206*.

[25] 'Cupriethylenediamine Disperse Viscosity of Pulp', *TAPPI T230*.

[26] 'Intrinsic Viscosity of Cellulose', *ASTM D1795*.

[27] 'Viscosity of Cellulose in Cupriethylenediamine Solution (CED)', *SCAN-C15:62*; 'Preparation of Cupriethylenediamine (CED) Solution', *SCAN-C16:62*.

[28] 'Determination of Alkali Solubility of Pulp', *ISO Recommendation R692—1968*. International Organization for Standardization, 1 rue de Varembé, Geneva, Switzerland.

[29] 'Determination of Alkali Resistance of Pulp', *ISO Recommendation R699—1968*.

[30] 'Solubility of Pulp in Sodium Hydroxide at 20°C', *TAPPI T235*; 'One Percent Caustic Soda Solubility of Pulp', *TAPPI T212*.

[31] 'Solubility of Cellulose in Sodium Hydroxide', *ASTM D1696*.

[32] 'Alkali Solubility of Pulp', *SCAN-C2:61*.

[33] Davidson, G. F., 'The Effect of Alkalis on the Molecular Chain Length of Chemically Modified Cotton Celluloses as Shown by Fluidity Measurements on the Derived Nitro-Celluloses', *J. Textile Inst.* **29**, (1938) T195.

[34] 'Internal Tearing Resistance of Paper', *TAPPI T414*.

[35] 'Internal Tearing Resistance of Paper', *ASTM D689*.

[36] 'Edge Tearing Resistance of Paper', *TAPPI T470*.

[37] 'Edge Tearing Strength of Paper', *ASTM D827*.

[38] Wilson, W. K. and Forshee, B. W., *Preservation of Documents by Lamination*, NBS Monograph No. 5 (1959).

[39] 'Tensile Breaking Strength of Paper and Paperboard', *TAPPI T404*; 'Tensile Breaking Properties of Paper and Paperboard', *TAPPI T494*.

[40] 'Tensile Breaking Strength of Paper and Paperboard', *ASTM D828*.

[41] 'Bursting Strength of Paper', *TAPPI T403*.

[42] 'Bursting Strength of Paper', *ASTM D774*.

[43] 'Folding Endurance of Paper', *TAPPI*: MIT Tester *T511*; Schopper Tester *T423*.

[44] 'Folding Endurance of Paper', *ASTM*: MIT Tester *D2176*; Schopper Tester *D643*.

[45] 'Folding Endurance of Paper Determined by the Köhler-Molin Tester', *SCAN-P17:66*.

[46] 'Wet Tensile Strength of Paper and Paperboard', *TAPPI T456*.

[47] 'Wet Tensile Breaking Strength of Paper and Paper Products', *ASTM D829*.

[48] 'Wet Tensile Strength of Paper and Paperboard. Determined with a Pendulum Tester', *SCAN-P20:67*.

[49] 'Brightness of Paper and Paperboard', *TAPPI T452*.

[50] 'Brightness of Paper and Paperboard', *SCAN-P3:62*.

[51] Kidder Optical Character Tester, Kidder Press Co. Inc., 279 Locust St, Dover, New Hampshire 03820, U.S.A.

[52] Hearle, J. W. S. and Peters, R. H., *Moisture in Textiles*, The Textile Institute/Butterworths, London; Interscience, New York (1960).

[53] 'Standard Conditioning and Testing Atmospheres for Paper, Board, Pulp Sheets, and Related Products', *TAPPI T402*.

[54] 'Conditioning Paper and Paper Products for Testing', *ASTM D685*.

[55] 'Conditioning of Paper and Paperboard for Testing', *SCAN-P2:61*.

[56] Wink, W. A., 'The Effect of Relative Humidity and Temperature on Paper Properties', *Tappi* **44**, No. 6, (1961) 171A.

[57] Crook, D. M. and Bennett, W. E., *The Effect of Humidity and Temperature on the Physical Properties of Paper*, The British Paper and Board Industry Research Association (1962).

[58] Neimo, L., 'Accelerated Heat Ageing of Cellulose', *Paperi Ja Puu* **46**, (1964) 7.

[59] Luner, P., 'Paper Permanence', *Tappi* **52**, 5 (1969) 796.

[60] Browning, B. L. and Wink, W. A., 'Studies on the Permanence and Durability of Paper', *Tappi* **51**, 4 (1968) 156.

[61] Wilson, W. K. and Hebert, R. L., 'Evaluation of the Stability of Record Papers', *Tappi* **52**, 8 (1969) 1523.

[62] Richter, G. A. and Wells, F. L., 'Influence of Moisture in Accelerated Ageing of Cellulose', *Tappi* **39**, 8 (1956) 603.

[63] 'Effect of Heating on Folding Endurance (Relative Stability of Paper)', *TAPPI T453*.

[64] 'Relative Stability of Paper (Effect of Heat on Folding Endurance)', *ASTM D776*.

[65] Bauer, E. L., *A Statistical Manual for Chemists*, Academic Press, New York and London (1971).

[66] Spiegel, M. R., *Theory and Problems of Statistics*, McGraw-Hill, New York, Toronto, Sydney (1961).

[67] 'Precision Statement for Test Methods', *TAPPI T1206*.

[68] 'ASTM Manual on Quality Control of Materials', *STP 15* (Jan. 1951).

[69] Natrella, M. G., *Experimental Statistics*, National Bureau of Standards Handbook, No. 91 (Aug. 1963). Available from the Superintendent of Documents, U.S. Government Printing Office, Washington, D.C. 20402, U.S.A.

[70] *Journal of Quality Technology* (Jan. 1972). Enquiries regarding subscriptions or membership should be directed to Robert W. Shearman, ASQC Executive Director, Plankinton Building, 161 West Wisconsin Avenue, Milwaukee, Wisc. 53203, U.S.A.

30
The Work of the Biology Laboratory, Istituto Di Patologia Del Libro, During the Ten Years from 1961 to 1972

FAUSTA GALLO

INTRODUCTION

It is not easy to present in a condensed yet at the same time detailed manner the topics which have been examined in, and the criteria which have governed the research of the Biology Laboratory, Istituto di Patologia del Libro, Rome, during the last ten years, research which has to a certain extent been directed by the special events which have particularly concerned the book world in Italy — events to which we should like briefly to refer.

The heavy damage inflicted on valuable library collections by the floods which struck Florence and Venice on 4 November 1966 drew the attention of the world to libraries as cultural institutions and forced librarians and biologists to face demanding problems connected with the disinfection, restoration and conservation of thousands of books immersed in water and mud and on which micro-organisms could have found ideal conditions for their development.

In addition, recent developments in science and technology have confronted librarians and book pathologists with many questions concerning the possibilities and the limitations of the application, in a library environment, of modern technological developments, synthetic materials and chemical products with fungicidal and bactericidal properties.

And finally, the frequent and profitable contacts, both national and international, which have occurred during the last ten years between the research workers of the Institute on the one hand and librarians and restorers on the other, have served to draw the attention of the former to the existence of certain practical problems requiring solution, and of the latter group to scientific research which has as its aim the better restoration and conservation of books.

These events, these questions and the new problems which arise continuously during our daily work, have naturally influenced and even directed our work from 1961 until 1972 on the following topics:

1. Research into the micro-organisms which attack library materials.
2. Research into the resistance of some library materials towards biological attack.
3. Action of certain disinfectants on book-damaging micro-organisms.
4. Survey of the biological agents which damage libraries and library materials and the means for preventing and curing such damage.
5. Contribution of the Biology Laboratory to the restoration carried out after the flood in Florence, 4 November 1966.

RESEARCH INTO THE MICRO-ORGANISMS WHICH ATTACK LIBRARY MATERIALS

The severe and often irreparable damage which books suffer as a result of microbiological attack is in some cases encouraged or to a certain extent determined by well-defined factors. In other cases, however, the causes of such damage are not yet well understood, and for that very reason deserve to be studied in greater depth for a better appreciation of the mechanisms which regulate the development of

217

the infections and infestations in paper, parchment, and leather. For these reasons we have felt it opportune to dedicate one sector of our work to the study of these problems, a study which divides itself into two parts.

1. Research into the microbiological alteration of paper and parchment.
2. Enquiry into the microbiological content of library atmospheres.

RESEARCH INTO THE MICROBIOLOGICAL ALTERATION OF PAPER AND PARCHMENT

In the field of the microbiological flora of books we have carried out two enquiries, one into the microbiological alteration of paper and the other into the particular colour changes found with parchment.

MICROBIOLOGICAL ALTERATION OF PAPER

A programme of research into the damage that certain fungal species commonly found in library materials cause to old paper of diverse composition and to modern paper of pure cellulose only, has been in progress now for two years. This work, the first results of which have already been communicated to the Consiglio Nazionale delle Ricerche (National Research Council, Italy), has brought to light interesting aspects of the alterations — at microscopic level — in the paper fibres due to the mycetes. These changes are frequently accompanied by a diffusion of colour in more or less extensive areas around the nucleus of the fungal colony, by changes in the colour of such pigmentation during the various stages of development and by changes in the pH of the paper. During the course of the work carried out up to now, using predetermined ambient conditions, it has been possible to control experimentally the stages of development of the fungi. It has become very evident that prompt and effective intervention is necessary on all occasions when library materials suffer microbiological attack, in order to avoid irreversible structural alteration of the paper fibres, over and above the chromatic alterations which are the more obvious signs of the attack.

MICROBIOLOGICAL ALTERATIONS IN PARCHMENT[11]

Taking as a whole the subject of microbiological damage to library materials, the particular field of damage to parchment is the one most ignored by researchers, as is shown by the paucity of literature on the subject. In fact this problem merits a certain priority in as much as cases of attack are often encountered in libraries and archives. The coloured marks — reddish, violet, brownish, etc. — which are encountered with remarkable frequency on precious skin manuscripts have been, up to now, little

studied and in many cases neither the micro-organisms which cause the colour development nor the factors which favour their growth have been identified.

These reasons led us to begin work (in collaboration with Dr Alicja Strzelczyk of the University of Torun, who spent several months in the Biology Laboratory) on this type of flora and, in particular, that which causes red or violet colour changes on parchment and that which develops on new parchment employed for restoration.

This research has enabled us to reveal interesting information about the chromatic and structural changes caused by the schizomycetes and mycetes on old and on new parchment. Also, examinations carried out using a Wood filter have revealed maculae of suspected microbiological origin, unseen by incandescent light, and differences in the fluorescence shown by damaged and undamaged material.

This work has on the one hand given an idea of the microbial flora which develop on old and new parchment, and on the other hand permits us to say that these red and violet colours so frequently observed, above all on the more ancient manuscripts, show qualities not previously observed which would merit further study, both biological and chemical.

Such studies would permit both a determination of the factors favouring the development of the infection and also provide knowledge of the chemical structure of fungal and bacterial pigmentation and the changes which this undergoes with time.

ENQUIRY INTO MICROBIOLOGICAL CONTENT OF LIBRARY ATMOSPHERES[5]

As the literature shows, bacterial and fungal spores are present in dust everywhere and particularly in that of library atmospheres. Therefore we have undertaken surveys to find out which species are most commonly found in restoration and conservation areas and also whether there are changes, both qualitative and quantitative, in this content over the years. These surveys, carried out in the various sections of the Restoration Department, Istituto di Patologia del Libro, and also in the Vallicelliana Library, Rome, have shown the presence in the ambient dust of microbial agents, many of which are specific for paper, parchment and leather, and have thereby confirmed that one of the principal causes of infection of library materials is the spores of these agents which are deposited upon the books and the shelves by convection currents, gravity, etc.

RESEARCH INTO THE RESISTANCE TOWARDS BIOLOGICAL ATTACK OF SOME LIBRARY MATERIALS

The severe infection and infestation which are frequently found in books restored in the past with imperfect techniques and materials susceptible to attack by biological agents have convinced us of the

need to test the resistance to such agents of some synthetic materials which could find applications in the library field and especially during restoration. We have therefore had in operation since 1959 a programme of research which will continue and which during the last ten years has investigated the following:

1. A 'paper' made from synthetic fibres.
2. Some sizing adhesive materials, used alone and with the addition of fungicides.
3. Two plastic films.

All the testing has been carried out using the appropriate international standards (Tappi and Afnor) and the Block technique (that is, keeping the material under investigation for extended periods of time — 20–52 weeks at elevated temperatures and relative humidities (20–30°C, R.H.75–100%) after inoculation with suspensions of fungal spores).

TESTS ON A 'PAPER' OBTAINED FROM SYNTHETIC FIBRES[3]

Among the synthetic materials investigated by us, 'papers' obtained from synthetic fibres (Perlon, Dacron, Nylon, etc.) have been particularly interesting for some of their properties — washability, fold resistance, etc. To one of these materials we have devoted some time. The work undertaken was to compare traditional papers made from vegetable fibres with a material of Swiss manufacture, Syntosil, with respect to their resistance towards microbiological agents. It has shown that the latter is much more resistant than the former. The results obtained, taken together with their special characteristics mentioned above, warrant synthetic papers being considered rather seriously since they could probably be employed in the library field for certain special uses (catalogue cards, special documents, etc.).

TESTS ON SIZING/ADHESIVE MATERIALS, ALONE AND WITH THE ADDITION OF FUNGICIDES[1a,b,d]

A problem always under discussion and not free of unknown quantities is the sizing of paper. The consequences which this could have and the evaluation of the positive and negative aspects of the matter have led us to carry out a series of tests both on gelatin, which was largely employed in the past, and also on the following commercial products:

Vinavilol 2-98 poly(vinyl alcohol) — low viscosity, high hydrolysis.
Glutofix 600 hydroxyethyl methyl cellulose.
Calaton CA ⎫
Calaton CB ⎬ N-methoxymethyl nylon.
Maranyl N-hydroxymethyl nylon.
Aquapel 364 dialkyldiketene.
Aquapel 380 emulsified form of dialkyldiketene.
PVP = poly(vinyl pyrrolidone).

In order to be able to evaluate to what extent these products change the resistance of library materials to biological agents, the tests were carried out both on different paper samples of diverse composition and on the same papers after treatment with the sizing compounds.

The tests showed that all the materials, whether synthetic or animal in origin, when kept in unfavourable conditions, can be degraded by the biological agents which most frequently attack paper. But the results show that on paper treated with synthetic sizes the micro-organisms develop at a higher relative humidity than on unsized paper or on that treated with gelatin. From this it can be concluded that sizing, if carried out with suitable materials such as Glutofix, can increase the resistance of library materials towards fungal and bacterial attack.

Among the above-mentioned products, that which most clearly showed a protective influence was Glutofix 600, a hydroxyethyl methyl cellulose which does not easily constitute a food for micro-organisms.

Some of the above products, besides exerting a positive influence from the biological point of view, can also slow down the physical and chemical deterioration of paper, as Zappalà and Santucci[14] have shown. The results obtained during the work, results in accordance with those of other European workers (Belaya, Beyakova, Kowalik et al., Yabrova), led us to experiment further to find out whether certain chemical compounds which have fungicidal and bactericidal properties would, if added to the sizes, serve to protect the paper against microbiological attack when it is stored in unsuitable conditions, particularly high temperatures and relative humidities.

Therefore two parallel series of tests were carried out in the Biology and Chemical Laboratories to examine the possibilities and limitations of the use of the following materials:

o-phenyl phenol ⎧ Topane (I.C.I.)
⎨ Dowicide 1 (Dow Chemical Company)

2,2′-dihydroxy-5,5′-dichlorodiphenylmethane — Preventol GD (Bayer A. G.)
lauryldimethylcarbethoxymethylammonium bromide — Cequartyl BE (Melle Bezons et Cie)
salicylanilide — Shirlan (Light and Company)
sodium salt of 2-methoxy-5-chlorobenzeneboronic acid — synthesized in the Chemical Laboratory of the Institute and not previously used for the treatment of library materials.

These tests have shown that some of these compounds, at certain concentrations, inhibit the development of paper mycetes. However, as the chemical tests showed, not all the fungicides examined are persistant in their action and above all, not all the concentrations which are needed from the biological point of view are safe for the paper.

The problem of which protective fungicides could be employed during sizing could not be considered solved on the basis of the work carried out in the Institute, in that none of the above-mentioned

materials possesses the necessary requirements to ensure long and perfect conservation. Therefore, given our present state of knowledge, and while waiting until further research produces new fungicides which could find applications in this field, we think it essential that, for sizing paper, *only* those synthetic materials be employed that are notably resistant towards biological attack.

TESTS ON PLASTIC FILMS[1c]

The use of plastic films based on cellulose acetate for lamination of paper during restoration led us to undertake some testing to decide whether these materials changed the resistance of library materials towards biological attack. We have investigated two materials — one of German origin, Ultraphan HK, and the other American, 0088 Matte Film. The tests were carried out on the films alone, on paper made from pure cellulose and on the same paper after the plastic films had been applied to it. The results showed that:

1. Lamination notably increases the resistance of the paper to bacterial and fungal attack.
2. On the whole, the resistance of the plastic itself diminishes when it is applied to the paper.
3. Of the two types investigated, the American Matte Film was less susceptible to attack than the Ultraphan.

These results and the evidence found in the technical literature show that the choice of a good laminating film is fundamental for preventing physical, chemical and biological changes in material subjected to this procedure.

ACTION OF CERTAIN DISINFECTANTS ON BOOK-DAMAGING MICRO-ORGANISMS

Besides the work on fungicides for sizing materials, described above, we have thought it opportune to carry out some work on the efficiency of two antibiotics, Nystatin and Griseofulvina, and on the action of some alcohols against the micro-organisms which develop on books.

TESTS ON NYSTATIN AND GRISEOFULVINA[2]

The multiple applications which antibiotics have found during the last decades, and the cases of mycosis, sometimes found among people handling books, convinced us of the need to study the sensitivity of certain paper fungi, pathogenic to man, towards these two compounds.*

*Nystatin, produced from *Streptomyces noursei*, has the formula $C_{46}H_{75}N_{10}$, and Griseofulvina, a fermentation product of *Penicillium griseofulvum*, *P. nigricans* and *P. raistrickii*, has the formula $C_{17}H_{17}O_6Cl$.

They were in fact found to be active towards numerous mycetes which develop with considerable frequency on library materials.

The satisfactory results obtained led us to consider the possible applications of antibiotics in general, and these two in particular, in the field of library disinfection. In fact, the broad spectrum of activity of some of these and their low toxicity would probably allow their easy application in the fight against the micro-organisms of paper, parchment and leather. Naturally the possibilities and limitations of the use of antibiotics warrant a close and accurate study in order to ascertain their safety for library materials and the techniques which would permit their wide-scale use.

TESTS ON THE EFFICACY OF ALCOHOLS AGAINST PAPER MICRO-ORGANISMS[13]

During restoration, when it is not possible to wash them in aqueous solutions, both paper and skin manuscript leaves are immersed in ethyl alcohol. Paper from books showing active micro-biological attack is frequently subjected to such treatment, and the books are sometimes not subsequently disinfected.

These considerations, the difficulties encountered (above all by small workshops) in using disinfection chambers, and the need to ascertain whether the material subjected to such non-aqueous washing is still infected afterwards, convinced us of the need to see what action two alcohols, ethanol and butanol, have upon the microbial flora of books.

The tests carried out with the two alcohols show that, at given concentrations, they do act upon numerous mycetes but, in a high percentage of cases, show themselves to be inactive towards schizomycetes present in the samples examined.

The results obtained showed that these two alcohols, ethanol and butanol, through their detersive action and their efficacy towards numerous fungoid species, can afford some assistance in the treatment of library materials, but not sufficient to obtain a satisfactory disinfection of damaged paper. Washing with alcohol could be useful, within certain limits, when a disinfection cell is not available, but such washing cannot be considered a substitute for gaseous treatment, such as ethylene oxide or formaldehyde, which are, in our present state of knowledge, the most effective means of counteracting micro-organisms on library material.

SURVEY OF BIOLOGICAL AGENTS WHICH DAMAGE LIBRARIES AND LIBRARY MATERIALS AND THE MEANS FOR PREVENTING AND CURING SUCH DAMAGE

In the last decade, research workers in many countries have been studying the biological agents which cause damage to library materials and the means for prevent-

ing and curing such damage. The results of these studies have been numerous articles published either in specialized reviews or in journals of general biology, microbiology or entomology. The occasional difficulties encountered in obtaining these publications and the need to bring to the attention of librarians knowledge of certain biological problems which are relevant to the conservation of library materials (and without which exchange of information a fruitful collaboration between entomologist, biologist and library personnel would not be possible), led us to produce, periodically, surveys on the present state of knowledge, in particular:

ASPECTS OF THE PREVENTIVE AND CURATIVE MEASURES TAKEN AGAINST THE MICRO-ORGANISMS DAMAGING TO BIBLIOGRAPHICAL MATERIALS[4]

This review, 37 pages long and containing 96 references, was published in the *Bollettino* of the Institute in 1963 and sent to the ICOM Meeting in Leningrad in 1963.

INSECTS AND MICRO-ORGANISMS, ENEMIES OF LIBRARIES[7,8]

This work, intended above all for librarians, was published, in German, in 1966 in the journal *Papiergeschichte* and in 1967 in Italian, in the *Bollettino*. Part of the material contained in this review was also presented during the Course on the Conservation of Library and Archive Materials, organized by the International Centre for Conservation, Rome, in October 1967.[6,10]

DISINFECTION OF BOOKS WITH ETHYLENE OXIDE[12]

This review, 34 pages long and containing 20 references, was published in 1971 in the *Bollettino*.

CONTRIBUTION OF THE BIOLOGY LABORATORY TO THE RESTORATION CARRIED OUT AFTER THE FLOOD IN FLORENCE, 4 NOVEMBER 1966[9]

In the last months of 1966 and throughout 1967, the Biology Laboratory, together with the other laboratories of the Institute, collaborated actively in the recovery of the contents of the following libraries, archives and cultural centres damaged in the flood in Florence:

Biblioteca Nazionale Centrale
Biblioteca della Facoltà di Scienze Politiche
Biblioteca della Facoltà di Giurisprudenza
Biblioteca della Facoltà di Lettere
Archivio di Stato
Archivio Notarile
Gabinetto Vieusseux

One of the most serious problems which arose during the work of recovery was that of preventing the development of bacterial and fungal growths which could have irreparably damaged the books, etc. Measures were taken to prevent this occurrence both for the books sent to the industrial driers and also for those dried at room temperature in the libraries themselves. Although these proved effective it was decided, both to prevent growth of those attacks actually observed on the books, and also because the mud and filth left on the books was an ideal terrain for later micro-organic growths, to carry out disinfectant treatment. The enormous number of books damaged in the flood made it imperative that the method chosen be rapid, effective, thorough and, naturally, harmless to the materials treated. Following advice from the Biology and Biochemical Laboratories of the Institute it was decided to carry out the process using vacuum chambers and ethylene oxide gas, which not only complied with the requirements given above but is a procedure which has been widely employed in France and Poland, both in laboratories and also in libraries and archives.

The Biology Laboratory followed closely for many months the disinfection work in Florence and carried out many control checks, during the course of which it was possible to ascertain that, in order to destroy the microbial flora on the books, it is necessary to maintain the temperature and relative humidity between certain limits and to employ a concentration of the ethylene oxide of 500 gm/cubic metre.

The adoption of these measures has prevented any biological degradation of the books and has allowed the restoration to go ahead in the knowledge that, in spite of the many years required for the purpose, the books will eventually be brought back close to their original condition.

CONCLUSIONS

In the last ten years, workers in many countries have made a notable contribution in research and experience to the biological problems connected with the restoration and conservation of books. This work has, on the one hand, allowed the identification of some of the insects and micro-organisms which damage paper, parchment, etc., of the factors which encourage their growth and of the best methods of combating them, and, on the other hand, has brought to light new and complex problems which still await solution, among which we would like to mention the following:

1. As far as the microbial flora of books is concerned it is interesting to mention that so far not all the micro-organisms which produce changes on, above all, parchment, have been identified nor have all the mechanisms which encourage or determine the several processes of biological degradation of library materials.
2. The research carried out to determine the bio-

logical resistance of adhesives, sizes, etc. has so far been carried out almost exclusively on commercial products whose exact composition is not always provided by the manufacturer; for this reason it is not always possible to predict their biological susceptibility and the effect they might have with time on the library materials.

It would be much more sensible to be able to carry out such testing on pure chemical compounds or at least on known mixtures produced by laboratories involved with the study of problems connected with book restoration.

3. And finally it must be said that in the field of insecticides, fungicides and bactericides, employed to prevent and to counteract the biological agents which damage paper, parchment, leather, etc., there are still many problems left unsolved, principally those concerned with the standardization of the methods and techniques to be adopted when using the more common fumigants.

From all that has been said it will be evident that, in spite of the enormous progress made during the last decade in this particular field, much uncertainty still exists on fundamental aspects of the work, which needs to be resolved in order to protect our libraries from microbiological attack.

References

[1] Gallo, F., 'Ricerche Sperimentali sulla Resistenza agli Agenti Biologici dei Materiali Impiegati per il Restauro dei Libri':

[a]III. 'Saggi su Alcuni Collanti Organici e Sintetici', *Boll. I.P.L.* **20** (1961), 191–213.

[b]IV. 'Saggi su Polivinilpirrolidone, Calaton, Maranyl e Aquapel', *Boll. I.P.L.* **23** (1964), 37–47.

[c]V. 'Saggi su Films Plastici e Considerazioni sulle Loro Caratteristiche', *Boll. I.P.L.* **24** (1965), 95–105.

[d]'Saggi su Collanti Puri o Addizionati di Fungicidi', *Boll. I.P.L.* **28** (1969), 9–47.

[2] Gallo, F. and Gallo, P., 'Prove di Sensibilità al Nystatin e alla Griseofulvina di Alcuni Miceti Carticoli Patogeni per l'Uomo', *Boll. I.P.L.* **20** (1961), 221–36.

[3] Gallo, F., 'Saggi Biologici su una Carta Ottenuta con Fibre Sintetiche', *Boll. I.P.L.* **21** (1962), 158–66.

[4] Gallo, F., 'Contenuto Microbico dell'Aria e Infezioni Contro i Microrganismi Dannosi al Materiale Bibliografico ed Archivistico', *Boll. I.P.L.* **22** (1963), 29–66.

[5] Gallo, F., 'Contenuto Microbico dell'Aria e Infezioni Secondarie dei Libri', *Boll. I.P.L.* **23** (1964), 1–18.

[6] Gallo, F., 'Nota sulla Conservazione del Microfilm', *Boll. I.P.L.* **24** (1965), 107–110.

[7] Gallo, F. and Gallo, P., 'Bücherfeindliche Insekten und Mikroorganismen', *Papier Geschichte*, **16** (1966), 7–18.

[8] Gallo, F. and Gallo, P., 'Insetti e Microganismi Nemici dei Libri', *Boll. I.P.L.* **26** (1967), 143–90.

[9] Gallo, F., 'Moderni Metodi di Prevenzione e di Lotta Contro gli Agenti Biologici Dannosi ai Libri', *Atti della XLIX Riunione della Società Italiana per il Progresso delle Scienze* (Siena, 23–27 September 1967), Vol. II, 1141–1150.

[10] Gallo, F., 'Gli Agenti Biologici Nemici delle Biblioteche – Metodi di Prevenzione e di Lotta', *Annali della Scuola Speciale per Archivisti e Bibliotecari dell'Università di Roma*, **9** (1969), 107–36.

[11] Gallo, F. and Strzelczyk, A., 'Indagine Preliminare sulle Alterazioni Microbiche della Pergamena', *Boll. I.P.L.* **30** (1971), 71–87.

[12] Gallo, F. and Gallo, P., 'Disinfezione dei Libri con Ossido di Etilene e Formaldeide', *Boll. I.P.L.* **30** (1971), 35–69.

[13] Gallo, F., 'Trattamento con gli Alcooli dei Materiali Librari Danneggiati dai Microorganismi', *Boll. I.P.L.*, **30** (1971), 123–134.

[14] Zappalà-Plossi, M. G. and Santucci, L., 'Resistenza e Stabilita della Carta. VII. Indagine sulla Collatura', *Boll. I.P.L.*, **28** (1969), 97–117.

31
Some Aspects of the Chemical Research in the Istituto Di Patologia Del Libro

MARIAGRAZIA ZAPPALA-PLOSSI

The appropriate restoration and good conservation of library materials require:

1. The identification of the degrading factors;
2. The determination of the nature and of the dynamics of the degrading processes;
3. Research into procedures to make good the damage incurred, or at least to stop further damage;
4. Elimination of the deteriorating agents.

It is obvious that all this requires chemical and biological research of considerable complexity, especially when it is appreciated that every sequence of investigation has to be applied, in turn, to materials as different from one another as paper, papyrus, parchment, leather, inks, synthetic materials, etc.

The main field of work in the Chemical Laboratory during the last few years has been the study of cellulose degradation, since this represents one of the more important aspects of the general problem of the deterioration of library materials, the conservation of which is the primary responsibility of the Institute.

Cellulose is naturally primarily interesting because it is the principal component of paper. It could be objected that such a study will not completely resolve the problems of the restoration of paper. However, given that cellulose forms almost the only constituent of old papers, a study in depth of this material represents one of the more important tasks of the Institute. It is known that even the best of papers degrades more or less slowly with time under the influence of degrading factors, oxidative, hydrolytic or otherwise, but quantitative information on the subject is scarce. In particular, it is not known precisely how much each one of these natural degrading factors, taken singly, contributes to the total deterioration. There are also those degrading factors that could be called artificial in as much as they act upon the paper as a consequence of man's intervention, following certain restoration processes carried out on library materials. By this we mean bleaching, sizing, treatment with fungicides or insecticides, etc.

If, for paper, much still remains to be clarified, for parchment the situation is even worse, since this material has been very little studied. Manuscripts on parchment, even if they represent only a small fraction of the total library patrimony, are some of the most precious and rare, whether considered historically or artistically. Even in the field of the most empiric restoration, knowledge is scarce.

The many problems which the Chemical Laboratory has investigated in the last few years, and is still investigating, can be divided for greater clarity into:

1. Chemical degradation of cellulose;
2. Improvements in deacidification;
3. Effect of sizes on paper;
4. Effect of fungicides on paper;
5. Miscellaneous.

CHEMICAL DEGRADATION OF CELLULOSE

In a first enquiry, Santucci[1] studied the effect of certain bleaching methods upon paper, and the subse-

quent deterioration of its cellulose. In particular, he examined bleaching with sodium hypochlorite and chloramine-T. The most important result from these experiments was additional confirmation of the need for thorough water-washing of paper containing degrading residues after such procedures. In fact, when, after bleaching with chloramine-T, the paper was washed in running water, the paper was left virtually unharmed, while it was rapidly and extensively degraded when left unwashed. In the latter case, the paper was considerably more damaged than after bleaching with hypochlorite, which is a much more vigorous bleach than chloramine-T. However, after treatment with hypochlorite, all the samples were washed with running water.

Measurements of degree of polymerization showed that cellulose chains had been shortened and the differences between the treated and untreated samples increased with ageing. In conclusion, the use of hypochlorite as bleach would be found acceptable only on paper of good initial quality (for the tests described, only paper made from pure cellulose and in a good initial state of preservation was employed).

At this point the problem arises of whether the results obtained with experimental papers are equally valid for old paper, that is, where the cellulose is already more or less degraded. To clarify this point a comparative study was begun on the effect of bleaching agents on new paper, and on the same paper but after its prior artificial ageing. The intention was to fill in some gaps in the published data, with the idea of producing a more complete picture, even if necessarily still with gaps in it, of the effect of the individual degrading agents and the possible mechanism for the cellulose degradation.

With this aim in mind, the first priority was an artificial ageing procedure involving the action of both heat and moisture. In addition, it seemed desirable to employ procedures more accurate than those previously employed, which required the use of saturated salt solutions to maintain the required relative humidity at a given temperature. With the selected method, the humidity necessary for a rapid hydrolysis (of the cellulose) comes from the cellulose itself, kept at $100°C$, in a tube, after having been conditioned at $23°C$ and 50% R.H. In fact, from the absorption isotherms for cellulose[2,3,4] and from experimental data, it can be calculated that cellulose conditioned in this manner contains about 6% water. On passing from $23°C$ to $100°C$, water is lost in the amount which is necessary to establish a new equilibrium at the higher temperature.

Therefore 1 g paper of pure cellulose, conditioned as described above and then enclosed in a container of 100 ml capacity, should give about 42% relative humidity. Correspondingly it ought to be possible to observe a certain change of level (in mm) in a mercury manometer attached to the same closed tube, a change in level due in part to the heating of the air contained inside the tube with the paper. Heating the tube, with and without preconditioned paper, has allowed the verification of these predictions.

The work is not yet complete but nevertheless it is possible to mention that during the preliminary stages something of considerable importance has come to light, that has apparently so far gone without mention in the standard procedures for accelerated ageing. The cellulose which is introduced into a normal oven, controlled at high temperature, for artificial degrading is initially in equilibrium with a certain ambient relative humidity. If the oven is not of the hermetically sealed type, then the relative humidity inside it will be much lower than that of the surrounding atmosphere. Naturally the cellulose placed inside must lose water in order to reach equilibrium with this new ambient relative humidity. But this process requires an unpredictable time during which the cellulose undergoes a hydrolytic degradation process at a speed correspondingly greater than that which occurs once this new equilibrium has been reached. It is possibly for this reason that lack of consistency has been observed in the results obtained by different workers in degradation during this initial period. There is therefore good reason for not relying excessively upon results obtained when employing periods of artificial ageing which are short (48 or 72 hours).

In addition, a pre-conditioning of samples at room temperature is recommended in a relative humidity such that the samples take up the same quantity of water as they would be expected to contain at the temperature of ageing. Finally, from all this, it can be concluded that the method of artificial ageing more likely to reproduce the results of natural ageing will be that in which the paper, whatever temperature is employed, has the same water content as it would have at ambient temperature[5,6].

IMPROVEMENTS IN DEACIDIFICATION PROCEDURES

For many years, the Barrow process, in its diverse forms, has been practised throughout the world. However, it is important to realize that Barrow, during the experiments carried out to evaluate these processes, never once carried out chemical analysis (other than pH measurements) but only physical testing. In addition, the exact concentration of the bicarbonate solutions was not adequately described. Also, the possible different absorption of salts by diverse types of paper has not been studied, so that, for the different solutions recommended by Barrow, it is not known how much paper could safely (and adequately) be treated with a given volume of solution. It is not surprising, therefore, that considerable variations in the solution concentrations are encountered, and also in the pH values of the papers treated, too many of which appear too high for good conservation of the paper.

For these reasons it seemed imperative that the problem be studied systematically. In the first place every source of variation linked with the magnesium bicarbonate solution concentration was eliminated by weighing out exactly a quantity of magnesium carbonate which could then be completely converted

into the soluble magnesium bicarbonate by carbon dioxide, that is, working now at concentrations below saturation. This has brought the following advantages:

1. It is possible to see immediately when the solution is ready, since it then becomes clear (with no suspended solid);
2. It is no longer necessary, for this same reason, to wait until the solid in suspension settles and then to siphon off the clear liquid;
3. The time required for the solution preparation is much shorter;
4. There is a slowing-down of the changes in solution concentration through reversion of the soluble bicarbonate into insoluble carbonate;
5. Less carbon dioxide gas is required for the preparation.

At the present moment in the Institute, we are using a solution 0·022 N in concentration of magnesium bicarbonate, obtained by weighing out 150 g of basic magnesium carbonate ($3MgCO_3Mg(OH)_23H_2O$), adding 228 litres of tap water and then passing carbon dioxide gas through the mixture until the solution becomes clear*.

At the same time, a mixed solution of calcium and magnesium bicarbonates was investigated, in order to see how much of the buffering salts was absorbed by paper. It must be underlined that this is an important factor in as much as the behaviour of the paper with time is largely dependent upon the quantity of alkali present in the paper.

It has been found that the ash content of the paper samples after treatment with the solutions gives a reasonable indication of the quantity absorbed.

Next it was thought useful to make an accurate check on the variations with time of the titration and the pH of a solution prepared as advised by Barrow, that is, dissolving the two carbonates of magnesium and calcium by passing carbon dioxide through a suspension in water. The pH of the solution altered from 7·4 to 9·2 and the concentration from 0·20 N to 0·03 N in about 45 days in an open dish, after which the values obtained remained constant.

There is another point which requires clarification, on which we are also working: the neutralization capacity of a given volume of solution, that is to say, how much acid paper can be treated before the solution concentration drops appreciably.

The work on deacidification procedures has not been limited solely to the classic Barrow ones but has been extended to others. In particular we have considered the problem of the deacidification of documents which, through the solubility of their inks or for some other reason, cannot be treated with aqueous solutions. For this reason our investigations have included the hydroxide/methanol treatment proposed by Baynes-Cope[7] as well as the alcoholic solution of magnesium acetate (mentioned by Barrow[8]) and the magnesium methoxide (R. D. Smith) method. Barium hydroxide is also being used in aqueous solutions to try and discover any differences in behaviour between aqueous and alcoholic methods.

Following the standardization of procedures, investigation of the ultimate effects of these treatments was carried out at different ageing temperatures and relative humidities up to 70%. The properties measured included pH, brightness, average degree of polymerization and carbonyl group contents. Furthermore, treatments were tried both on a pure cellulose, neutral paper and on samples of the same paper made very acid by sizing with alum and rosin (extraction pH: 4·5 cold, 3·5 hot).

At the present stage of our investigations, the following interesting observations can be reported:

1. The behaviour of the treated paper on ageing is dependent both on the amount of alkali absorbed and on the particular reagent or solvent; in other words, it is not peculiar to the Barrow process but may result, more or less, from any of the reagents examined;
2. The stability of very acid paper samples, none of which had a pH higher than 8·7 after deacidification, was enhanced by any of the treatments examined, at any degree of environmental moisture during accelerated ageing;
3. When neutral, unsized paper samples were treated with aqueous solutions containing magnesium bicarbonate, they degraded faster than the untreated samples in 'dry' ageing, but slower in the presence of high humidity, the rate depending on the amount of alkali absorbed. Alcoholic magnesium acetate gave poor results with both ageing procedures.

This work is not yet complete, but it would appear that some more thought ought to be given to the significance of ageing methods. It is fortunate that results favourable to deacidification were obtained from 'moist' ageing, since an accelerated ageing where paper is allowed to retain most of its internal humidity seems to adhere better to the conditions prevailing in natural ageing. Nevertheless, we think it is desirable to have more information about the effect of moisture on degradation and about the mechanism of such processes.

SIZING MATERIALS

The importance of sizing as the final stage in the restoration of books and documents has long been recognized. In the last few years the chemists in the Institute have carried out various researches both into the traditional gelatin size and also into some synthetic sizes[9,10].

In a first enquiry[9], it was seen how certain synthetic sizes and in particular polyvinyl alcohol (Vinavilol 2—98) could easily replace gelatin, being

*Shortly after this was written, the Chemical Laboratory recommended deacidification with a 0.012N solution of calcium bicarbonate in distilled water, prepared in a similar way. Later on, an investigation was started on the use of a simple solution of calcium hydroxide; which is still in progress[18].

above all immune to biological attack. Then, later, the work was taken up again[10], this time in two parts: first of all, the characteristics of the compounds were studied, that is, their solubility, pH, melting point, infra-red and ultraviolet spectra, both before and after ageing. In the second part, the behaviour of the compounds when applied to paper was studied, looking at the ease of removability of the compounds from paper, and the changes in the degree of polymerization of the paper and its physical properties (resistance to tearing and double fold) when treated with the sizes, again both before and after ageing.

The compounds investigated in this second enquiry were, in addition to gelatin, hydroxyethyl methyl cellulose (Glutofix 600), high hydrolysis polyvinyl alcohol (Vinavilol 2–98), N-methoxymethyl nylon – soluble nylon – (Calaton), and an acrylic resin (Paraloid B-72).

The tests carried out followed the Tappi and Afnor standards. With the aim of coordinating the work of this enquiry with that which had in the meantime been carried out in the Biology Laboratory it was thought opportune to evaluate also the joint influence of size and a fungicide on the pH, degree of brightness, and degree of polymerization of the paper, before and after ageing. As fungicide in this work, Preventol GD (or Dichlorophen) in an alcoholic solution at 0·5% concentration was chosen, since this had shown itself in another[11] programme of work to be the best among those examined; the results of these enquiries showed that, at the concentrations employed, none of the sizes contributed to the degradation of Whatman No. 1 during ageing. When deacidified paper was employed, there were some variations, both increasing and decreasing the degradation.

The optical effect of all the sizing materials was sufficiently good.

In conclusion, from among the sizes examined, satisfactory data were obtained from tests with Glutofix 600 and Vinavilol 2–98. Gelatin was more noticeably altered than the synthetic, and this was most obvious in the ease of removability of the sizes from the paper after ageing.

In the same study, Paraloid B-72 was tested for its reinforcing ability, although this compound has been principally studied and employed for protecting inks during bleaching[12]. It was found that Paraloid B-72 slows down the action of hypochlorite on inks but only within certain limits. During the work, however, Paraloid B-72 was found[12] to have useful protective properties for the entire leaf during treatment with hypochlorite – in other words, the samples treated with Paraloid B-72 were not so subject to tearing during the immersion treatments as were the untreated samples.

After the work on the sizing materials[10], it was concluded that protective reinforcement of very weakened printed documents with Paraloid B-72 is advisable *provided that the compound is removed after bleaching,* since the action of the hypochlorite changes the Paraloid B-72 into a substance dangerous to the paper.

FUNGICIDES

The problems of fungicides became even more pressing after the flood in Florence and the consequent necessity to protect an enormous quantity of books against microbiological attack.

After the first emergency treatment, that is, drying in the proper environment (control of temperature, humidity and air-flow), a study was made of the various compounds available commercially. It was necessary to find a way of protecting the library material that was both long-lasting and satisfactory, in that there was persistent fungicidal action; and a substance that was safe both for the library material and for people[10,11]. In addition, the Laboratories of the Institute have attempted the synthesis of new compounds[13] with characteristics potentially more adapted to the particular demands of library material protection.

The compounds examined were chosen either because they had already received some attention regarding their application to paper or because of some special characteristics which made it likely they would be suitable in this field. Substances known to be irritant or toxic were not considered further.

Those materials studied were the following, with the commercial name in brackets:

1. β-naphthol
2. o-phenylphenol (Topane; Dowicide 1)
3. sodium salt of o-phenylphenol (Topane WS)
4. 2,2'-dihydroxy-5,5'-dichlorodiphenylmethane (Dichlorophen; Preventol GD; DDM; DDDM; G-4)
5. sodium salt of 2,2'-dihydroxy-5,5'-dichlorodiphenylmethane (Dichlorophen sodium salt; Preventol sodium salt)
6. 2-methoxy-5-chlorobenzeneboronic acid
7. sodium salt of 2-methoxy-5-chlorobenzeneboronic acid
8. salicylanilide (Shirlan)
9. lauryl dimethylcarbethoxy methylammonium bromide (Cequartyl BE)

From the combined chemical and biological investigations carried out on both the compounds themselves and their solutions, as well as on samples of paper treated with these solutions, it was found that only the alcoholic solution at 0·5% of Dichlorophen or Preventol GD possessed the necessary properties, even though not completely. That is, while chemically speaking the results obtained were acceptable, the yellowing produced on the paper, although slight, could not be ignored. In addition, the fact that this material has to be used in alcohol means a separate treatment for the paper, that is, the fungicide could not be added to, for example, the sizing solution. Also, paper must not be alkaline before application of the fungicide, which precludes its use after deacidification processes.

The use of Cequartyl, because of its surfactant properties, can have an effect upon the inks, weakening their adhesion to the paper. Also, from the DP measurements, it can be seen that the degrading effect

of Cequartyl BE is above the acceptable limits, even when using a neutralized solution. It could be that the compound undergoes slow hydrolysis, liberating acid and perhaps also undergoing some change in the cation.

The preliminary experiments with β-naphthol were abandoned when it was discovered that paper treated with the material became distinctly pink in colour after a few months, an effect certainly totally unacceptable for documents of value.

The persistence of the compounds examined was not satisfactory. In fact, only the Cequartyl BE, Dichlorophen (and its sodium salt) and sodium o-phenylphenol were left in sufficiently high concentration after three days at 100°C.

A confirmation of these accelerated tests was obtained from the analysis of some paper samples treated with an alcoholic solution at 5% of o-phenylphenol, prepared in the Biblioteca Nazionale Centrale, Florence. These paper samples were kept between the pages of different books for 9—10 months at room temperatures, and when they were later analysed were found to contain from 33—36% of the original fungicides content.

At the end of this first series of tests, there was only a partial solution of the problem of providing permanent antifungal protection for paper materials. In fact, only the Dichlorophen in alcohol at 0·5% concentration possessed sufficiently the required properties of fungicidal activity, chemical stability, reversibility, persistence and a low effect upon the paper properties, that is, pH, degree of brightness and DP. A fungicide which has the great merit of being soluble in water, Cequartyl BE, has been shown to be chemically unstable and what is worse, not inert towards the cellulose.

MISCELLANEOUS

The procedure for reviving faded ferro-gallate inks previously published[14,15,16] has been modified. The innovation introduced made the regeneration of the ink, brought about by the sulphide, more permanent through a reaction with lead ions. In the latest publication[17], the main change involved the introduction of a basic lead acetate bath, instead of the lead nitrate or neutral lead acetate. At the same time, the different periods of treatment necessary and the best concentrations were investigated. The authors themselves advise, however, that the regeneration of inks be carried out only in exceptional circumstances since the procedure, besides being somewhat lengthy, is not entirely free from risks.

Recently, different types of new papyrus, intended for the possible restoration of old deteriorated papyrus, have been investigated[18]. Tests on their stability

have been carried out to try to ascertain their suitability for this purpose but, until now, not with satisfactory results.

Since it has been observed that surface pH measurements on parchment and leather do not provide an exact indication of their acidity/alkalinity, an attempt is being made to modify the method and so obtain more reliable results.

References

[1] Santucci, L., 'Resistenza e Stabilità della Carta. VI. Degradazione per Trattamento con Ossidanti. Effetto della Laminazione con Acetilcellulosa', *Boll. I.P.L.* **25** (1966), 51.
[2] Urquhart, A. R. and Williams, A. M., 'The Moisture Relations of Cotton. The Taking Up of Water by Raw and Soda-Boiled Cotton at 20°C', *J. Text. Inst.,* **15** (1924), t138.
[3] Urquhart, A. R. and Williams, A. M., 'The Moisture Relations of Cotton. The Absorption and Desorption of Water by Soda-Boiled Cotton at 25°C', *J. Text. Inst.,* **15** (1924), t433.
[4] Urquhart, A. R. and Williams, A. M., 'The Moisture Relations of Cotton. The Effect of Temperature on the Absorption of Water by Soda-Boiled Cotton', *J. Text. Inst.,* **15** (1924), t559.
[5] Browning, B. L. and Wink, W. A., 'Studies on the Permanence and Durability of Paper. I. Prediction of Paper Permanence', *Tappi,* **51** (1968), 156.
[6] Richter, G. A. and Wells, F. L., 'Influence of Moisture in Accelerated Ageing of Cellulose', *Tappi,* **39** (1956), 603.
[7] Baynes-Cope, A. D., 'The Non-aqueous Deacidification of Documents', *Restaurator,* **1** (1969), 2.
[8] Barrow, W. J., *Permanence/Durability of the Book. III. Spray Deacidification,* W. J. Barrow Research Laboratory, Richmond, Va., U.S.A.
[9] Santucci, L., 'Resistenza e Stabilità della Carta. III. Effetto dei Collanti, con Particolare Riguardo a Gelatina e Alcool Polivinilico', *Boll. I.P.L.* **20** (1961), 141.
[10] Zappalà-Plossi, M. and Santucci, L., 'Resistenza e Stabilità della Carta. VIII. Indagini sulla Collatura', *Boll. I.P.L.* **28** (1969), 97.
[11] Triolo, L., di Trapani, R. and Santucci, L., 'Resistenza e Stabilità della Carta. VII. Trattamento con Composti Fungicidi', *Boll. I.P.L.* **27** (1968), 207.
[12] Soto y Galvez B., di Trapani, R. and Santucci, L., 'Effetti Protetivi del Paraloid sulla Carta durante il Trattamento con Ossidanti', *Boll. I.P.L.* **28** (1969), 87.
[13] Santucci, L., 'Un Nuovo Composto Boro Organico: l'Acido 2-metossi-5-cloro-benzenboronico', *Boll. I.P.L.* **19** (1960), 82.
[14] Santucci, L., 'Rigenerazione dei Documenti. I. Stabilizzazione Mediante Sali degli Inchiostri a Base di Ferro Ravvivati con Solfuro di Ammonio', *Boll. I.P.L.* **12** (1953), 69.
[15] Benetti, E. and Santucci, L., 'Rigenerazione dei Documenti. II. Nuovi Metodi di Rivelazione degli Inchiostri a Base di Ferro nei Documenti Carbonizzati', *Boll. I.P.L.* **14** (1955), 45.
[16] Santucci, L., 'Rigenerazione dei Documenti. III. Sul Trattamento delle Macchie di Ruggine', *Boll. I.P.L.* **18** (1959), 146.
[17] Santucci, L. and Wolff, C., 'Rigenerazione dei Documenti. IV. Solfurazione e Fissaggio degli Inchiostri Ferrici: Valutazione dell'Efficacia, Stabilità ed Effetto sulla Carta', *Boll. I.P.L.* **22** (1963), 165.
[18] Santucci, L. *et al.,* unpublished data.

32
The Repair of the Wall Charts from the Cloister at Ephrata, Pennsylvania

MARILYN KEMP WEIDNER

INTRODUCTION

The Historical and Museum Commission of the Commonwealth of Pennsylvania took possession of the Cloister at Ephrata, Pennsylvania, in 1941, after lengthy negotiations with the Seventh Day Baptist Congregation which represented one of the most unique religious experiments in Colonial America. This eighteenth century cloister was the first Protestant Monastery established in America and one of the earliest settlements in the interior of the state. It was the òutcome of the desire of a group of German immigrants to live a spiritual life and to practise their religious beliefs as they saw fit. They had come to America as refugees from the religious persecution of the small, mystical religious sects in the Rhenish Palatinate in Germany.

The formal organization of the Cloister took place in 1732. By 1745 the Cloister was on the verge of being a profitable industrial complex with mills which supplied the countryside, making the Cloister practically self-sufficient, and giving it a reputation that had spread far and wide. It had become a centre of culture with both a music school and a writing school and was known and visited by dignitaries from all over the colonies and Europe.

This paper concerns the effort to preserve the remains of the large *frakturschriften* or *fraktur* charts from the Cloister. These decorative writings of inspirational thoughts and passages from the Bible were hung in the chapel and rooms of the Cloister and ranged in size from almost two and a half feet to over four feet. Although, in the literature, the Cloister has been des-cribed as having its walls covered with the *frakturs*, today only 13 of the large *fraktur* charts are known to exist. This conservator has had the privilege of work-ing on them since 1961 and finished the last one in 1972.

The materials used to make these *frakturs* were very simple — an iron-gall ink on all-rag paper. The outline of the letter or design was drawn in ink and then either filled in solidly with ink or with one of the decorative repeat patterns common in the *frakturs*. The iron-gall ink used was originally quite black but over the years has turned brown. On one *fraktur* the ink has faded out almost completely. The ink was composed of rainwater, gum arabic, gall nuts and copperas (a ferrous sulphate). The high acidity of the ink has caused the destruction or extreme brittleness of the paper beneath it in many areas.

The condition of each *fraktur* differed consider-ably depending on the treatment it had received since it was executed. The *frakturs* had all been mounted in one way or another — some on cloth, some on book papers which were glued to panels consisting of wooden strainers with cross-pieces with wooden slabs inserted in the areas between the cross-pieces, and one was glued directly to a wood panel. It is this last *frak-tur* that we will discuss in detail. The Cloister flourished for less than 50 years and had started to decline by the end of the American Revolution in the late eigh-teenth century. Since then these *frakturs* were all exposed to extreme conditions of neglẹct, of humidity and temperature changes, and to attack by insects and vermin. It is a wonder that anything remains of them at all. Indeed, they were all but given up for lost over

70 years ago when one author described their condition as disintegrating and crumbling into dust[1]. Photographs taken by the same author around 1898, when compared with the photographs taken in 1961, show the extensive losses that occurred in many of the *frakturs* during those ensuing years.

PRESERVATION

When the preservation of the *frakturs* was begun in the early 1960s the *fraktur* with the simplest problem was chosen as the first to be worked on. This was the smallest *fraktur* mounted on cloth. The second *fraktur* chosen was a very large one, also mounted on cloth, but with literally hundreds of missing areas both large and small. This second *fraktur* determined the routine of treatment that was to be used on the following *frakturs*.

This routine of treatment can be outlined step by step:

1. After unframing, the surface of the *fraktur* was dry-cleaned with a large, soft sable brush. This removed the surface dirt and foreign matter such as insect remains.

2. While working on the first *fraktur* it soon became apparent that the ink had a tendency to be friable — that is, to powder off the surface when abrasion was used on the reverse to remove the glue. There was also the tendency for water rings to form in the paper when it was wetted. All subsequent *frakturs* were therefore 'fixed' by impregnating the surface with a synthetic resin[2]. The resin was dissolved in a solvent and brushed onto the surface of the paper. Not only did this prevent the loss of any ink and the formation of water rings during the subsequent rebacking but it also darkened the inked areas. Since the original colour of the ink was a black which had faded and turned brown, this darkening or increase in the contrast between the dark letters and the light paper was considered desirable. The amount of resin left in the paper was not, however, sufficient to change the reaction of the paper to water.

This step of fixing the ink must be recognized as an irreversible change. For even though the attempt is made to remove the resin afterwards, it cannot be completely removed. This step was not decided on lightly but only after considering the extreme brittleness of the paper support, which made it imperative that it be supported during the removal from the panel.

3.a. The *frakturs* that were adhered to wood panels had to be faced completely. Silk chiffon was used as the facing material. The silk chiffon was adhered to the surface of the *fraktur* with a second synthetic resin adhesive[3]. The facing and the facing adhesive could then be removed with a solvent that did not affect the resin used to 'fix' the ink.

b. The *fraktur* was removed from the panel by inserting a sharp knife between the paper support and the panel and cutting and forcing the separation between the two surfaces. Often this meant cutting into the wood wherever the adhesion was particularly strong.

As mentioned previously, there were great variations in the way the *frakturs* were adhered to these wood panels. Generally the adhesive was a hard, thick, white, casein adhesive — insoluble in water. In all cases the additional backings and the adhesive had to be completely removed from the reverse of the paper support before any further treatment could be done.

4.a. Those *frakturs* which had been mounted on cloth were reinforced on the front with small patches of pressure-sensitive tape which were later removed with petroleum benzine.

b. The cloth was removed from the reverse of the paper support by carefully tearing the cloth away in strips. After the cloth was removed the thick, brown glue had to be scraped off the reverse of the paper. It was decided it was safer to remove the glue dry, rather than to use moisture, because the paper of the *frakturs* when wetted became extremely weak.

5. Once the *fraktur* was separated from the backing and the reverse of the paper support was perfectly clean the next step could be followed. This was to patch the tears and apply inserts in the missing areas.

On the first and second *fraktur* treated the inserts were cut from a rag paper as close in appearance (thickness, texture and laid lines) as possible to the paper of the *fraktur*. But while working on the second *fraktur* it soon became obvious that this method[4] could not be continued for two reasons. The first was that this method of cutting out the insert to fit into each missing area was too time-consuming because of the extensive losses. The second was that even though the insert paper was very close in appearance to that of the paper of the *fraktur* the expansion of the two papers when wetted was quite different. And, in the areas of the large inserts, this caused serious problems during the application of the final paper backing.

Therefore, a new and far better method was worked out using a heavy, long-fibred Japanese paper. On the reverse of the *fraktur*, which is placed face down on white blotting paper or over a light box, the sheet of Japanese paper was laid over the missing area. The shape of the missing area was drawn on the Japanese paper with a small, wet brush. The Japanese paper could then be pulled apart at the water line and when the paste was brushed on the extended fibres at the edges of the insert it could be laid in place to fill the missing areas. This Japanese paper has a flexibility and pliability which is different from the harder, smoother Western papers. The Japanese papers used are made specifically for mounting purposes and are generally free of the fillers and sizes commonly used in our fine papers, which normally are destined to be used for writing or printing and therefore require different characteristics.

The tears were also patched with a suitable Japanese paper and again the frayed edges of the patches were achieved by means of the 'water cut'. This prevents the hard edge of a patch showing through on the surface of the *fraktur*.

The only adhesive used during this step and for all

Figure 32.1 A line is drawn along the edge of the ruler with a bone knife that had been dipped in water. The edge of the paper is pulled away, leaving the long fibres frayed at the edge

Figure 32.2 Applying paste

Figure 32.3 Mounting on paper

Figure 32.4 Pounding the layers of paper together

Figure 32.5 The drying panel

subsequent work on the *frakturs* was a wheat starch paste[5]. This paste is freshly made for this work by the conservator and is used weak (thin) or strong (thick) depending on the immediate needs for each *fraktur*.

6. Those *frakturs* where the paper was particularly weak were then backed with a layer of Japanese paper. No attempt was made at this point to flatten the *fraktur*. The backing paper was allowed to conform to the wrinkled and cockled surface of the original paper support. But it was made certain that a complete adhesion between the two papers had been achieved.

7. The next step was to remove the patches of pressure-sensitive tape or the silk chiffon from the face of the *fraktur*. This was done with the appropriate solvent either by saturating the surface with the solvent or by immersing the piece (if it was small enough) in a solvent bath. Excess resin was also removed at this point by washing the surface of the *fraktur* with the solvent on a cotton swab.

8. The *fraktur* was now ready for the final backing. The Japanese mounting paper was prepared: wherever there would be seams the edges of the paper were frayed by means of the 'water cut' (*Figure 32.1*).

9. The *fraktur* was placed face down on a sheet of thin Japanese paper on a clean, smooth glass surface. Water was sprayed or brushed over the reverse of the *fraktur* to relax the fibres of the paper and to allow the entire *fraktur* to lie flat.

10. The paste, which had been thinned to the desired consistency, was then brushed onto the first section of the mounting paper (*Figure 32.2*). The paste must be brushed on as evenly and smoothly as possible. The mounting paper was picked up, holding one edge with a wooden ruler or stick, and then laid down on the reverse of the *fraktur* allowing about 1½ in of the mounting paper to extend beyond the edge of the *fraktur* (*Figure 32.3*). The next section of the mounting paper was then covered with paste and laid next to the first section on the *fraktur* attempting to make a seam so that only the frayed edges of the mounting papers were overlapped. This process was continued until the entire *fraktur* was backed.

11. A large, long and stiff-bristled Japanese brush, made specifically for this purpose, was then used to pound the layers of paper together. Every inch of the *fraktur* was pounded with a steady stroke which assures the complete adhesion of the various layers of the backing (*Figure 32.4*). This also serves to push the inserts to the front surface of the *fraktur*.

An article in the April 1972 issue of *Tappi* entitled 'The weak link in paper dry strength' discusses the increase in strength of paper due to wet-pressing. I believe the Japanese pounding technique achieves the same bond.

The strength of paper depends on the strength of the individual fibres as well as the strength of the bonds between the fibres. Bonds between fibres arise from the hydrogen bonding that occurs between hydroxyl groups on the surfaces of fibres which are physically in contact. I quote from the *Tappi* article:

'a primary effect of heavily wet-pressing a sheet of paper is an increase in its tensile strength. Increased pressure on the wet sheet forces adjacent fibres into more intimate contact and thus increases the eventual degree of bonding between the fibres'.

12. The extended edges of the mounting paper are now covered with a thicker layer of paste in preparation for the drying and flattening on the drying panel.

The traditional Japanese drying panel consists of a wooden core covered with as many as seven layers of paper each applied in different but very particular ways. A less effective but still satisfactory panel had been made of a large piece of thick plywood covered on both sides with several layers of good, thick paper.

13. The *fraktur*, still wet, was then picked up and pasted to the drying panel at the extended edges of the mounting paper. The paper, which had been expanded by the water, now proceeds to dry out. As it dries the paper contracts and all wrinkles and cockles are removed (*Figure 32.5*).

An important consideration in drying and flattening paper in this manner is that the humidity in the area of the drying panel must remain fairly high and constant. If the paper is allowed to dry out too fast or too much, the paper support will contract too far. If this happens there is the danger of splitting at the edges of the mounting paper or even through the object itself. When dried out properly the *fraktur* can remain on the drying panel for weeks and the subsequent inpainting be carried out on the panel.

14. The *fraktur* was now ready for inpainting. Only obvious losses were filled in. Where there were indications that a border had existed this was restored. The inpainting was done in either sepia ink or watercolour.

15. The *fraktur* was removed from the drying panel and reframed.

THE CASE HISTORY

> Die Lib ist unsre Kron und hel
> ler Tugend Spigel,
> Die Weissheit unsere Lust u. reines Gottes-Sigel
> Das Lamm is unser Schatz, dem wir uns anver-
> trauen
> Und folgen seinem Gang als reineste Jungfrauen.
>
> (O love is now our crown, it mirrors bright our virtue,
> And wisdom is our goal, which grants us God's own blessing.
> The Lamb is now our prize, we give ourselves to Him,
> And follow in His path, we virgins chaste, amen[6]).

The *fraktur* (*Figure 32.6*) was entirely adhered directly to a wood panel which was in three sections. The sections of the panel had pulled apart tearing the paper support. The paper support was brittle and torn throughout. Many areas of the paper were missing. It was badly stained throughout due to the adhesion of

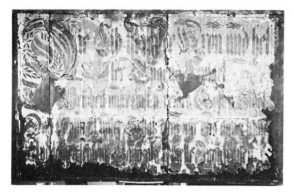

Figure 32.6 Before treatment. Size of fraktur: 27in x 45½in

Figure 32.7 Applying the facing

Figure 32.8 Separating the paper from the wood

Figure 32.9 Reverse of section, bottom centre, after removal from the wood panel

Figure 32.10 Lower left-hand corner cleaned, backed and facing removed

Figure 32.11 Test spots — bleaching

Figure 32.12 After treatment

the *fraktur* directly to the wood. But, in many other areas, the adhesion between the wood and the paper had broken down and the paper was hanging loose. The surface was covered with dirt, debris from plaster walls, and insect remains.

Because of existing tears and seams in the paper support the *fraktur* was divided into six sections and each section removed separately. In the detail in *Figure 32.7* the facing of silk chiffon was being adhered to the paper with a synthetic resin dissolved in a suitable solvent. The paper was cut away from the wood by inserting a sharp knife between the two surfaces and forcing them apart (*Figure 32.8*).

In *Figure 32.9* the facing is still adhered to the face of the paper support. This facing held the loose pieces in place, especially at the edges. These pieces at the edges indicated that a border had surrounded the writing. Where the paper was strongly adhered to the wood it meant cutting into the wood to make the separation. The right half of this section had been scraped clean of the adhesive and wood debris. After the reverse had been cleaned, each section was backed with toned Japanese paper adhered with wheat starch paste. The facing was removed by rolling over the silk chiffon with solvent on a cotton swab. Each section of the *fraktur* was immersed in a solvent bath to remove excess resin.

In *Figure 32.10* the lower left corner had been removed from the panel, cleaned of debris on the reverse, backed with toned Japanese paper, and the facing and as much resin as possible removed. When all six sections had been treated in this way they were carefully realigned and pasted together at the seams.

A test was made to see if the dark stains in the paper support could be removed or reduced by bleaching. *Figure 32.11* shows two test spots. The square on the left shows a whitish film which resulted when the bleach chloramine-T in water was applied to the surface, which still contained some of the synthetic resin used for the facing. The square on the right shows the result after this film was removed with a suitable solvent. The bleach was not applied over the ink.

The *fraktur* was bleached by applying the bleach to the surface with a brush, avoiding the ink. The surface was then repeatedly sprayed with water and blotted in an effort to remove as much bleach as possible.

The *fraktur* was backed with a second layer of Japanese paper, as described previously, and stretch-dried on a drying panel. The inserts were toned with watercolour to blend in with the rest of the *fraktur*. Small areas of loss in the letters were inpainted wherever the loss was obvious and the border was completed at all edges using watercolour (*Figure 32.12*).

References and Notes

[1] Sachse, J., *German Sectarians of Pennsylvania*, 2 vols., printed for the author, Philadelphia (1899).

[2] The resin used to 'fix' the ink was n-butyl methacrylate dissolved in xylene and diluted with petroleum benzine.

[3] Polyvinyl acetate AYAF dissolved in toluene was used as the 'facing' adhesive. The facing and as much of the adhesive as possible were later removed using toluene.

[4] The method used was to place the insert paper beneath the missing area. The outline of the missing area was pricked into the insert paper with a dissecting needle, spacing the needle holes about one-sixteenth of an inch apart:

Cuts are made in the insert paper to the edge of the needle holes and with a tweezer the excess paper is pulled away from the insert leaving a frayed edge. This insert is then placed in the missing area and held in place with Japanese paper patches on the reverse.

[5] The paste is made from an edible wheat starch (AYTEX P) obtained from General Mills, Special Commodities Division, 9200 Wayzata Blvd, Minneapolis, Minnesota 55426, U.S.A. The starch is soaked in water, at least overnight. The excess water is poured off and the wet starch is thinned to a consistency of about 4 parts starch to 20 parts water. It is then cooked in an enamel or Teflon pan for one hour at medium high heat with constant stirring with a wooden spoon to prevent sticking or burning. It is then placed in a glass container and allowed to cool. When ready for use, the desired amount of paste is forced through a (horsehair) strainer. It is thinned by gradually adding small amounts of water and 'kneading' the paste and water together with a stiff brush. The water is added until the desired strength paste is obtained.

[6] Hollyday, G. T., 'The Ephrata Wall-Charts and their Inscriptions', *Pennsylvania Folklife*, XIX, No. 3 (Spring 1970), Pennsylvania Folklife Society Inc., Lancaster, Pa., U.S.A.

33
Conservation of the Collage *Roses* by Juan Gris

ANTOINETTE G. KING

INTRODUCTION

In 1914 Juan Gris did some of the most beautiful of all cubist collages. Two of these hung with uncovered surfaces in the home of Gertrude Stein. They were exposed to the air from the Seine through open windows, heat from a pot-bellied stove and the light from bare bulbs. A photograph taken in 1940 shows the resulting deplorable condition of the lovelier of the two collages, *Roses*. This condition remained substantially the same until part of the Stein collection was acquired in 1969 by a group of close friends of the Museum of Modern Art (*Figure 33.1*). At that time it was examined for conservation treatment.

CONDITION

The collage papers of *Roses* are of two basic kinds: ground wood pulp and purified wood pulp. They include hand-decorated wallpapers, cutouts from cheap magazines, and a newspaper, dated 15 May 1914 on the back. The media for the drawing and painting on these papers are glue tempera, gouache and crayon.

The canvas is rather fine linen with a water-soluble white ground. It is very weak and fragile. The artist signed *Juan Gris* in black oil paint on the reverse. The paint medium for the black and blue background areas is oil.

All the papers were greatly embrittled from acids used in their manufacture, atmospheric pollutants, light, and uncontrolled temperature and humidity changes. A comparison of the back and front of the papers (*Figures 33.2* and *3*) shows clearly, especially in the cup form at the lower left, the amount of discoloration on the surface from photosensitized reactions in both the cellulose and in its impurities. The white tempera design areas are also lighter on the back of the papers. This was probably caused by the paint on the front preventing some of the penetration of light. Also, it may be alkaline.

The glue used as the primary adhesive had broken down and become brittle. Therefore, the collage pieces were gradually detaching from the canvas with consequent ripping and tearing. Several small pieces had fallen off and were lost.

Much of the oil in the paint had been absorbed into the porous ground rendering the paint film very friable. It was lifting and flaking throughout. There were narrow impasto lines around the collage pieces which had largely flaked off as the paper pulled itself away from the canvas. Considerable dirt had settled on the entire surface, darkening it.

TREATMENT

A BRIEF OUTLINE OF THE ENTIRE TREATMENT

The collage papers were removed from the canvas, reinforced and lined. The canvas was taken off its stretcher, the flaking paint was readhered and the canvas was then mounted on a solid support in order to sustain the weight and pull of the collage papers. Then the papers were attached to the canvas. The details of this treatment follow.

234

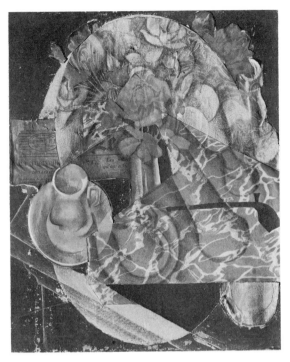

Figure 33.1 *Overall condition of collage prior to treatment*

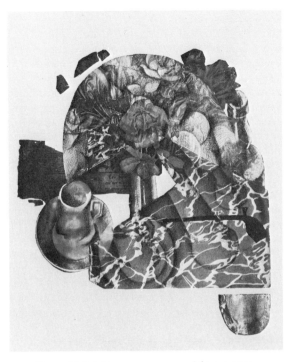

Figure 33.2 *Collage papers removed from canvas*

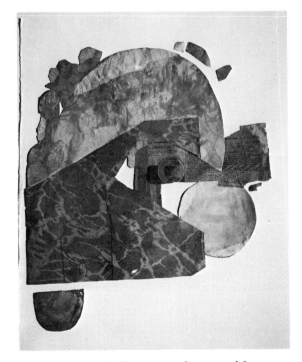

Figure 33.3 **Verso** *of collage papers after removal from canvas*

Figure 33.4 *The entire surface of the canvas after the papers were removed and the canvas inserts were put in place*

REMOVING COLLAGE PAPERS

The collage pieces were lifted off the canvas with a sharp-pointed scalpel and small, flat sculptors' tools. The adhesive was so brittle that it could be fractured away by a gentle sawing motion with these tools. Evidently, however, at some time very early in its history, the top part of the central collage papers, and a small piece of newspaper in the centre left, had fallen forward and been readhered with a very strong, heavy paste. It was impossible to cut through this paste without shattering the fragile paper; enough moisture to loosen the paste would stain the paper. Therefore, a scalpel was slid under the paper and the canvas was cut out in these areas and taken off with the paper. Thus the central part of the collage was removed as one piece. Smaller paper designs at the top and bottom which were not adhered to the central papers were detached separately.

The collage papers were then laid face down. It was now possible to detach the canvas piece which had been cut out, without tearing the paper. Slight moisture was applied to the canvas, one small area at a time, which softened the surface of the paste enough to permit the piece to be lifted off slowly in its entirety. The small newspaper piece was so delicate that the canvas on the back of it had to be removed thread by thread with slight moisture and scalpels.

PREPARING THE PAPERS FOR LINING

The deteriorated glue remaining on the back of the papers was scraped off lightly. The heavy paste in two areas was chipped off with slight moisture, working under magnification.

Tears were mended with thin Japanese mulberry paper and thin pure wheat starch paste; joins in the collage pieces were reinforced in the same way. Areas of loss in the papers, the lower left of the newspaper and a leaf in the centre of the flowers, were filled with rag papers similar in weight and texture to the support papers.

No attempt was made to clean any of the collage papers. The extreme weakness and fragility of the papers and the delicacy of the water-soluble media precluded the use of any dry-cleaning or bleaching agents.

LINING THE COLLAGE PAPERS

The papers were lined with medium weight mulberry paper (*yotsuban*). This *yotsuban* had alkaline fillers. Its pH was 8·4 (cold extraction)[1].

The collage papers were not neutralized and buffered prior to lining, in part because of the dangers inherent in non-uniform expansion and contraction of the different pieces in the central collage unit on wetting, discussed below. Since the papers were extensively light-degraded and the cellulose probably oxidized, the fibres would be further weakened by alkali treatment. Because the papers could not be cleaned, water or solvents used as part of a deacidification process could cause staining. Therefore the conservative compromise of lining the collage papers with alkaline mulberry paper was chosen, rather than risk irrevocable side-effects with wet deacidification.

A piece of *yotsuban* was cut slightly larger than the collage. Water-thin pure wheat starch paste was brushed evenly onto the *yotsuban* with a Japanese pasting brush (*Noribake*). The paste-coated paper was then laid evenly on a blotter, paste side up, to take out excess moisture.

The central collage papers, as one unit, were laid face down on a blotter with smooth, thin *gampi* paper under them as a protective facing. (It is best to handle the papers of a complex collage as one unit if possible. If the paper pieces are lined separately, differing coefficients of expansion with moisture may alter their alignments). The papers were not moistened before lining to relax and expand them for two reasons. There is a great danger if a collage gets wet that the various different types of papers will expand and pull against each other causing creasing and possible tearing. There was a danger of water-staining on the still discoloured papers.

The paste-coated *yotsuban* lining paper was smoothed onto the reverse of the collage with a very slightly dampened Japanese waterbrush (*Mizubake*). The collage and its lining were immediately lifted off the blotters, put face up between two layers of fresh blotters and pressure applied with plate glass and approximately 50 lb of lead weights. The blotters were changed after ten minutes and again in one hour.

The small pieces of the collage were lined separately using the same technique.

THE CANVAS

When the collage papers were removed, a complete preliminary artist's drawing in black and blue oil paint was revealed on the canvas (*Figure 33.4*). The drawing illustrates perfectly the care with which Gris developed the formal structure of his pictures. 'Within the compartments of this framework, Gris included realistic details and separate aspects of whatever was represented. He thus assembled a total image out of static ... aspects and left the spectator to reintegrate the whole for himself by a visual intellectual synthesis'[2].

The glue which had been used to adhere the papers was gently fractured off the canvas surface using slight moisture. The larger canvas piece which had been cut out and salvaged was replaced; a new piece of canvas similar in texture and weight to the piece which had to be destroyed was inserted in the smaller cut-out area. Both were held in place with mulberry paper and polyvinyl acetate emulsion (Schweitzer's No. 5714)[3]. The surface edges of the mends were made even with gesso.

Due to its extreme water solubility and fragility the painted part of the collage could not be cleaned. The canvas was taken off its stretcher and the edges

flattened under weight with moisture. The edges were then taped to a strainer to hold the picture rigid during subsequent work.

READHERING THE PAINT

At this stage a synthetic resin which would reattach the paint and prevent further flaking without changing its appearance had to be chosen. Tiny tests were made along the edges of the canvas to determine what adhesive could be used. Various polyvinyl acetates and acrylics were tried. All of them made this friable paint darker and imparted a shine to the surface. Only a solution of soluble nylon (Calaton CB) 10% (approx.) in ethyl alcohol had no effect on the surface appearance of the paint. This was brushed through the back of the porous canvas. The entire reverse was treated in this way to equalize tensions. Enough of the soluble nylon came through to the surface of the paint to show that penetration was good. Any excess was removed by tamping lightly with cotton swabs dipped in ethyl alcohol.

Polyvinyl acetate (AYAF) in toluene, a stronger adhesive than nylon, was brushed along the edges of a few of the most heavily flaked areas which were still not solidly adhered after the soluble nylon treatment. These edges were already somewhat darker in hue than surrounding sections of blue, so their appearance was not changed.

LINING THE CANVAS

The canvas could not be lined with the standard adhesives for the following reasons:

1. Wax-resin would have penetrated and darkened the paint.
2. Any slight residue of wax-resin on the surface would cause the collage papers to deteriorate in the future.
3. Any water-base adhesive would dissolve the blue paint.
4. A strong synthetic used as a liquid adhesive would change the appearance of the paint, as mentioned above.

Therefore, a dry-mounting technique using a thermoplastic adhesive was decided upon.

A polyester fibre surfacing veil (Pellon), large enough to go around the edges of the panel, was impregnated with polyvinyl acetate emulsion (Texicote)[4]. This was done by laying the Pellon on glass and brushing a solution of two parts Texicote to three parts water on it. The coated Pellon was then allowed to dry. With this brushing technique one side of the Pellon has less adhesive than the other. This side is placed against the canvas; the side with more adhesive is against the panel. Therefore, the Pellon is lightly bonded to the canvas and could be fractured away from it easily should the need arise to reverse the conservation treatment.

The vacuum hot-table was heated to 57°C. A protective sheet of Mylar (polyethylene terephthalate) was stretched on the hot-table. The Texicote impregnated Pellon was placed on the Mylar, the canvas part of the collage laid on this face up and adhered under vacuum pressure. When the lined canvas was cool the protective Mylar was taken off.

PREPARATION OF THE PANEL

A honeycomb panel[5], custom-made to the exact size of the collage, was surfaced with 100% 4-ply ragboard, adhered with polyvinyl emulsion (Schweitzer's No. 5714). Heavy mulberry paper was pasted to the ragboard with wheat starch paste to provide a surface with some tooth.

REASSEMBLING THE ENTIRE COLLAGE

The lined canvas was adhered to the panel with a mixture of four parts heavy wheat starch paste and one part polyvinyl acetate emulsion (Schweitzer's No. 5714). Tests indicated that this would provide a strong enough bond, but one that could be fractured away should the need for removing the collage arise in the future. A sheet of mulberry paper and a blotter were put on the surface of the mounted canvas and the whole construction dried under plate glass and weights for three days.

Pieces of lightweight *yotsuban* paper were cut to the size and shape of the paper collage pieces and adhered to the canvas with wheat starch paste in the

Figure 33.5 The entire collage after treatment

exact positions which the collage papers had occupied. This was done to provide a compatible surface when readhering the collage papers. Again, the whole construction was dried under blotters, plate glass and weights for 24 hours.

Wheat starch paste the consistency of thin sour cream was applied to the *yotsuban* papers in the central collage area. The central collage piece was placed over this and adhered to it by smoothing quickly with the hands through a blotter. Immediately two fresh blotters were placed one on top of the other over the whole panel and weighted with plate glass and 50 lb of lead weights. After ten minutes the blotters and weights were lifted and any small areas of paper that had a tendency to bubble up or lift were pressed into place locally with small pieces of blotter. Again this was done quickly, fresh blotters were put on the surface, and it was re-weighted. It is very important at this stage to keep the picture under even and constant weight so that the papers relax and flatten with complete adhesion. The blotters were changed twice more at one hour intervals. The next day the small paper pieces were reattached using the same technique. The whole collage was dried under this weight for three days.

FINAL TREATMENT

Paper inserts and abraded areas along tears in the papers were inpainted with watercolour. Liquid gesso was brushed into the flaked areas of the paint to make the surface as even as possible. Gessoed areas and tiny paint losses were inpainted with pigment ground in polybutyl methacrylate diluted with petroleum benzine (*Figure 33.5*).

References and Notes

[1] The use of this paper as a lining has been found to raise the pH of a degraded, ground wood pulp paper. Unpublished results, Warren Falconer (Consultant to the Museum of Modern Art, New York), Bell Laboratories, Murray Hill, N.J., U.S.A.
[2] Cooper, D., *The Cubist Epoch*, Phaidon Press Ltd (1970).
[3] Now called No. 403. Phelan, W. H., Baer, N. S. and Indictor, N., 'Adhesives Used in Paper Conservation: A Preliminary Evaluation', *IIC—Amer. Group Bull.*, **11**, No. 1 (1970).
[4] Technique for impregnating Pellon with Texicote worked out by Tosca Zagni, Conservator, Museum of Modern Art, New York.
[5] The panel is constructed of two outer sheets of Masonite with a resin-impregnated Kraft paper honeycomb centre. The edges are a light wood. Made by James J. Lebron Bros., 5719 32nd Avenue, Woodside, L.I., N.Y. 11377, U.S.A.

JAPANESE PAINTINGS AND METHODS

34
Japanese Paintings: Technical Studies at The Freer Gallery of Art

RUTHERFORD J. GETTENS

INTRODUCTION

It is well known among conservators that the great Asian country of Japan has a rich art heritage embracing painting, sculpture, ceramics, metalwork, lacquer and architecture. Not the least of these are the paintings, both religious and secular. The tradition we know begins about the sixth century A.D. when Buddhism came to Japan via China. From those early times only wall paintings, mainly with religious scenes, remain. Painting on paper and silk is known to have been carried on also at this early time but being more perishable only fragments survive. Over the centuries through the Heian and Kamakura periods a great tradition developed that culminated in the Edo period, beginning in 1615 and lasting into the mid nineteenth century. Our attention is focused today on the Edo period in which several schools of painting flourished, notably the so-called Ukiyoe school which produced genre paintings of the 'floating world'. Much has been written about the art of Edo, particularly about Ukiyoe, but most of this is in picture books with short texts that deal mainly with subject matter, lives of the artists and art criticism. Strangely, little has been recorded in Japan or elsewhere about methods and materials. Perhaps it has been a subject too mundane for Japanese taste.

The Freer Gallery owns several hundred paintings of the Edo period, in the form of hanging scrolls, handscrolls, and folding screens. In our holdings, paintings of Ukiyoe predominate. Ukiyoe artists are perhaps most famous for their part in designing woodblock prints but these same artists, including the great names, Utamaro, Hokusai, Hiroshige and others, worked with brush on paper and on silk.

At Freer we have set out to make a catalogue of these paintings, which in addition to art historical comment and style analysis will include technical observations in respect to supports, mediums, pigments, mounting, and physical condition. To do that it has been necessary to examine closely over 300 paintings. An examination form, which is included as a supplement to this paper, is used for recording dimensions, construction, materials of the support, colour range and condition. Special attention is given to the identification of pigments because we want to establish firmly, from authentic works of art, the tradition of their use. We also hope to gain some knowledge of trade intercourse between Japan and other countries in that important historic period; and also the state of colour technology within the country.

To gain precise knowledge of pigments and to produce meaningful statistics, we have had to take tiny samples from most of the paintings which have colour. The method of identification is microscopic and microchemical. The sample, usually no bigger than a dot or a period on this printed page, is lifted with a dissecting needle sharpened to a chisel point. We have tried various methods of sampling but nothing seems to work better than the practised hand with this simple tool under magnification of about x5 with good illumination. We employ a Zeiss operating microscope with built-in vertical illuminator. Multiple samples from the same picture are transferred to a microscope slide engraved with a circle 18 mm in diameter divided into eight numbered sectors, one sample to each

sector. The samples contain within themselves enough glue medium, when touched with a tongue-moistened needle, so that the grains adhere well to the slide. Further to ensure adhesion during the mounting operation, this sample may be fixed to the slide with a tiny drop of ½% gum arabic solution or similar aqueous adhesive. There is not enough adhesive when dry to interfere with subsequent optical examination. During this operation the analyst attempts to break up the tiny paint fragments as much as possible, to disperse pigment particles for microscopic observation. The slide specimen is mounted in the usual way under cover glass with warm Canada balsam or other medium. While still warm, the cover glass is pressed down with a pencil-rubber tip to eliminate bubbles and to make the preparation as thin as possible. It is important, especially for photomicrography, to get the pigment grains in the same plane of focus.

Observations are made microscopically, first with reflected illumination and then with transmitted illumination, using magnifications commonly up to x500, and occasionally up to x1000 with oil immersion objective. With practice nearly all the pigments used by Japanese artists of that time can be recognized by colour, particle characteristics, refractive index in relation to the mounting medium, birefringence, relief and other attributes. The principal problem in mount preparation is to get pigment particles dispersed so they can be observed individually with transmitted illumination. The greatest difficulty is with natural dye pigments. It is possible, with optical examination alone, only to recognize that they are stains without particulate structure, and to guess on the basis of colour, and materials historically available, what they are. In some instances provisional identifications made optically can be confirmed microchemically by dissolving a second tiny sample with acid or alkali under the microscope and testing with suitable reagents for such cations as copper, mercury or lead and for anions like sulphate, arsenate or carbonate. Occasionally when an insoluble or refractory inorganic substance is encountered, it can be identified on a third tiny sample by X-ray diffraction, spectrometric, or other instrumental method of analysis. Experiments have begun with reflectance spectrophotometric methods applied to the surface of the painting. The use of chromatography is also being considered.

Japanese artists painted in watercolour (animal glue medium) on paper and on fine silk fabric. Unfortunately there is not time, except in a most cursory way, to go into details regarding studio techniques and painting equipment. It was all done very simply. The artist sat cross-legged on a *tatami* or straw mat and worked at a low table (*ban-ita*) about 25 cm high. The painting support was laid flat on the table. Larger paintings were done flat on the floor. The artist was surrounded with little porcelain pots and dishes of paint and containers for brushes. Especially important was a stone slab for making black ink from sticks of *sumi*. The paper support, which may have been made from several sheets of paper lap-jointed at the edges with starch paste, was wet and secured at the edges

with more paste to a drying board. On drying it became taut and flat. To make it less absorbent it might have been sized with *dōsa*, which is simply thinned animal glue to which some alum is added to harden the glue and make it less soluble in water. When dry, usually in a few hours depending on the condition of atmospheric humidity, the paper was ready to receive the initial drawing. The paint was applied with sharply pointed bristle brushes held in bamboo ferrules.

The silk support was prepared in a similar way. After it was stretched on a wooden frame and the *dōsa* applied, black ink was applied directly with a variety of brushes, some pointed, some flat. Areas to receive colour were outlined in *sumi* with pointed brushes and the colour area filled in solidly and without shading. Perhaps the best description in English of Japanese techniques of painting is that written for the 14th edition of the *Encyclopaedia Britannica* by Mr Kojiro Tomita, formerly curator of the Far Eastern Department of the Museum of Fine Arts, Boston.

The paintings executed by Japanese masters on thin paper or silk were further backed by paper for mounting as hanging scrolls (*kakemono*), hand scrolls (*makimono*) or folding screens (*byōbu*). This operation was ordinarily not done by the artists themselves but by professional mounters. Beautiful wooden boxes, some elegantly lacquered, were used to store and transport the paintings in the rolled condition. Privately owned paintings were only occasionally brought out to show to guests or for temporary hanging. The hanging scroll was beautifully mounted at the edges with silk brocade and with wooden rollers top and bottom. They were shown on interior walls, suspended for close inspection from a string or thin ribbon. The horizontal hand scroll, which might be 5 to 8 m long, was unrolled at one end and rolled up on the other leaving a convenient open area between the rolls for viewing. The folding screen of two, four or six panels could be folded accordion-style for storage, or opened out and stood in zig-zag fashion as a screen or decorative piece of furniture. All forms were made originally for household or temple use — not for exhibition in museums.

Let us now examine the paintings themselves to see what they can tell us in greater detail about materials.

THE PAPER

Paper, because it was cheaper and easier to prepare, was generally used for the support for *sumi* paintings, for thin colour washes and for quick sketches. Much of the paper was hand made from the inner bark of three species of shrubs that grow in the mountain regions of Japan. These are called *gampi* (from *Wikstroemia sikokiana*), *mitsumata* (from *Edgeworthia papyrifera*) and *kōzo* (from the paper mulberry, *Broussonetia kazinoki*). *Gampi* and *mitsumata* are used for finer textured papers; *kōzo* for coarser and thicker papers. The making of paper by hand from these special fibres is still a thriving cottage industry in

Figure 34.1 Freer Gallery of Art, view of Gallery III showing on the walls, from left to right: a handscroll; two hanging scrolls mounted as panels; a four-fold screen; hanging scroll, mounted as a panel (old style); two hanging scrolls mounted as panels with a two-fold screen between

Figure 34.2 Freer Gallery of Art, view of Gallery V showing six-fold and two-fold screens

Figure 34.3 Freer Gallery of Art, view in storage room showing the method of storing Japanese screens. Each screen is set on a small truck which rolls back into the steel case. This device lessens abrasion on the bottom edge

Figure 34.4 Freer Gallery of Art, view of storage room for Japanese paintings. Unmounted handscrolls are stored in the steel drawers, left. A scroll is spread out on a table for viewing. Panel paintings are stored upright in cabinets, right

Figure 34.5 Freer Gallery of Art, view of the studio for mounting Japanese works of art on paper and on silk. Mr Takashi Sugiura, head of the studio (left), is retouching a painting. Mr Mark Souta (background) and Mr Shigero Mikkaichi are seated on straw mats (tatami) before their work, which is supported on low tables (banita)

Figure 34.6 Mrs Elisabeth FitzHugh examines a Japanese handscroll painting over a light-box mounted on a specially designed work table, which is supported on a truck. The drop-leaves at either end facilitate the examination of long un-mounted paintings by transmitted light. This roll table serves as auxiliary to the main examining table. The shelves beneath permit storage of trays for tools and accessories.

Japan. Dr Stern, Mr Sugiura and I visited in 1970 one of the several paper-making villages, called Kurodani, west of Kyoto, where we witnessed most of the manufacturing processes beginning with stripping bark from finger-sized branches of the paper shrubs to the couching of sheet paper in a vat of pulp.

Paper made from bamboo pulp (tō-shi), called 'Chinese paper', was also used by Japanese painters. Only experts can tell from appearance and feel the sources of different Japanese papers. We have not learned yet to do it from fibre microscopy, but we hope to.

THE SILK

It is generally accepted that silk weaving was invented by the Chinese a few centuries before Christ. From China it was carried across central Asia over the famous Silk Route to Rome and Europe. Silk soon found its way to Japan. The silk fabric we find as a support on most of the paintings is rather loosely woven, with straight warp and chain-link weft. This weave is still used in Japan. There is little we can do microscopically except observe the type of weave, and the coarseness or fineness of the thread.

With time, silk yellows and loses strength. In very old paintings it becomes quite brown.

COLORANTS

Colour and tone on Japanese paintings was provided by about a dozen and a half inorganic pigments and natural dyestuffs. Both natural mineral and artificial inorganics were used. Most colorants had been used for centuries in both the Far and Near East. With the possible exception of a white pigment made from sea shells, none can be considered as unique to Japan. Unfortunately, we have found no good early Japanese sources of information on materials and techniques. A few short papers on pigments and dyes have appeared in this century but there is little information from the direct examination of paintings on paper and silk.

In our pigment investigation we have examined many hundreds of samples by the methods described above. Those mounted on permanent slides are filed for future reference. It would be tedious here to comment on each of the colorants employed, hence I shall reserve that for the supplement to the catalogue that is in preparation. I am unable, moreover, to give meaningful and precise statistics on occurrences because our studies are not yet complete. We can only briefly summarize our findings.

Whites: Three white pigments were known but only one is important and that is *gofun*, a form of calcium carbonate made by grinding sea shells. *Gofun* seems to be unique to Japan where it has been used for centuries and where it is still manufactured for artists' use. It was my privilege also in 1970 with Dr Stern

and Mr Sugiura to visit a *gofun* factory operated by Mr Nakagawa Yosujiro on the edge of the city of Uji between Kyoto and Nara. The factory was surrounded with heaps of oyster shells which we were told were harvested from the Inland Sea and left here to age for a period of 15 years. This I believe was to permit the decomposition and riddance of the organic matter in the shell. The preparation of *gofun* pigment from shell is a fairly simple mechanical process; it involves selection, crushing, grinding and pulverizing in a ball or stamp mill followed by particle size classification by several steps of water levigation. Apparently the shells are not heated or calcined in the process. The finely levigated product is dried out-of-doors in shallow wooden trays and the product is marketed in the form of chips of the dried cake. We were told that *gofun* is also used in the manufacture of dolls and other products. It is cheap to produce compared with heavy metal whites like those made from lead, zinc or titanium and it is not poisonous. In spite of its low refractive index it has good hiding power in aqueous medium. It is not a brilliant white like heavy metal whites but has a pleasing quality. *Gofun* serves as a base for tints especially those made from low-bodied organic colorants like indigo and *enji*. This peculiar white can be identified microscopically in tiny samples by its fibrous structure. The particle character is quite different from other whites. The term '*gofun*' means literally any white pigment or powder and hence in the literature may be applied to other whites.

Another white occasionally found is lead white, especially on paintings of the pre-Edo and early Edo periods. Among the 250 Ukiyoe paintings examined to date at the Freer, only four paintings, all attributed to the painter Eishi (1756–1829) have been found to use lead white. White clay or kaolin is mentioned in the sparse literature on pigments but so far we have not identified it on any painting.

Reds: The principal inorganic reds are vermilion (HgS), red lead (Pb_3O_4) and haematite. The first two were artificially made. The haematite or red iron oxide, is the main colorant in various kinds of coloured earths. An organic red called *enji* was sparingly used. We believe that originally *enji* was made from dried petals of the safflower plant (*Carthamus tinctorius*) sometimes called in the West, dyer's thistle. There is some reason to believe that red from the cochineal insect (carmine red) and lac red from the lac insect of India and Burma might have been used as substitutes. We have not yet found means to differentiate these natural dyes in microscopic samples.

Yellows: There are only three yellows among the traditional colours: gamboge, a resin-like vegetable product produced from several species of trees of the genus *Garcinia* growing chiefly in Southeast Asia; orpiment from the natural mineral arsenic sulphide; and the earth product yellow ochre.

Greens: The copper carbonate mineral malachite is the only green of importance. It has enjoyed wide use in China since earliest times. Pigment was prepared

from lumps of mineral simply by crushing, grinding and pulverizing followed by water levigation for particle size classification. It was commonly produced in three grades, coarse, medium and fine, greatest brightness being given by the finest size product. The coarse variety was used in painting vegetation especially pine trees in landscapes. Sometimes it is used so coarse that a green surface feels like sandpaper. There is a copper green which may not be malachite, whose character has not yet been established. A mixed green employing gamboge and indigo was occasionally used — especially for wood block prints.

We do not find evidence of the artificial green called verdigris; perhaps it was recognized that it is not a stable pigment and also was injurious to paper and silk. It is of interest, however, that areas of malachite paint on many Ukiyoe paintings quite commonly show dark on the back of the painting (when it is still mounted in scroll form). The dark areas are accentuated when viewed in ultraviolet light. There is no evidence of weakening of the silk or paper support in these areas. The making of verdigris for pigment use in Japan was described by Shiichi Tajima in an old (1903) volume on Kōrin School paintings. Copper sheet was treated with acetic acid to produce green copper acetate (sometimes called 'rust'). This is usually called artificial verdigris, as the term verdigris is sometimes applied to malachite. Also we find no evidence of the use of any sort of green earth which was so popular in European tempera painting.

Blues: There were five blue pigments. Azurite, related to malachite chemically, was the commonest. Being scarcer and more expensive than malachite, it had to compete with indigo which was also abundantly used. The glassy blue cobalt pigment smalt enjoyed minor use. During our stay in Kyoto, Stern, Sugiura and I visited the Ishida artists' supply shop where we watched a workman in a back room levigating ground azurite by swirling it with water in a large flat ceramic dish, in the same manner in which it has been done for centuries. Like malachite, azurite is classified in three grades, coarse, medium and fine. We were told by the manager that azurite mineral is in short supply and he asked us to help him in finding some. We know that azurite for pigment purposes has been purchased by the Japanese from copper mines in Arizona.

There is nothing that quite matches coarse malachite and azurite in colour and texture. Modern fine machine-ground pigments do not give the same rich and luminous effect.

In addition there is Prussian blue, a dye-like artificial pigment of high tinctorial power which was invented in Europe in the early eighteenth century. It was such a useful blue, which could be produced cheaply, that its use spread all over the world by mid-century. It appears to have been introduced into Japan probably by Dutch traders because we find it occasionally on paintings by artists of the late Edo period, like Hokusai and Hiroshige; it may possibly have been used earlier.

Ultramarine of fine and even particle size, probably synthetic, has been found on only four paintings, all of nineteenth century date.

Purple and lavender: They were occasionally produced by mixed pigments; for example, indigo and *enji* or smalt and *enji*, and sometimes *enji* alone. Iron oxide can produce a dark purplish red.

Brown: Tones of brown were produced by umber and similar earth pigments. A rich red brown was sometimes made by mixing vermilion and lamp black. There is also evidence of an organic brown, not yet identified.

Black: The only black employed was lamp black which is commonly called *sumi*. The black was mixed with animal glue and cast into cakes or sticks which were used for both painting and writing purposes, the two techniques being hardly distinguishable. A large proportion of paintings of the Edo period were done in *sumi* alone.

Gold and *silver* both in leaf and powder form were used abundantly, especially for the background of screens. The silver unfortunately usually blackens with time. Gold leaf cut in fine strips called *kirigane* was used for special decorative purposes. A paint from gold powder often served for yellow in colour paintings. A gold-coloured copper alloy leaf was also used to form artificial gold powder. There is some evidence for its use on some of the Ukiyoe paintings.

Artificial mineral pigments: In addition to the traditional pigments there is another class which we think has been used exclusively by Japanese artists since about the turn of this century. It appears that in the last decade of the nineteenth century the Ishida Company of Kyoto began to manufacture, for artists' use, a series of artificial mineral pigments they call *jinzō*, meaning artificial. Ishida claims they are the only firm in Japan that makes them. We have not learned the exact formula but they appear to be made in a furnace by fusing a highly leaded glass or frit with more refractory pigments like cobalt aluminate, oxide of chromium, lead antimoniate (Naples yellow) or other metal compounds which were thus incorporated in particulate form throughout the matrix. The glassy body is ground to a powder. Microscopically the particles appear to have a glassy matrix with fine unfused particles distributed throughout. Although moderately resistant to acids, the matrix is sufficiently soluble to yield a rapid test for lead. There appears to be no intent on the part of the manufacturer to deceive artists because these pigments are properly labelled and sold openly. They seem popular because of low cost and they satisfy the artists' liking for coarse pigments which are traditional in Japanese painting. There is danger, however, that these pigments will be used by forgers and in fact we have evidence that this is true. It is important to be able to recognize these artificial pigments when questions of authenticity arise.

Figure 34.7 Mrs Elisabeth FitzHugh is taking a paint sample from a Japanese scroll painting and transferring it to a microscope slide for analysis of the pigment. The area where the sample is taken is strongly illuminated by light directed down through the microscope objective (vertical illumination).

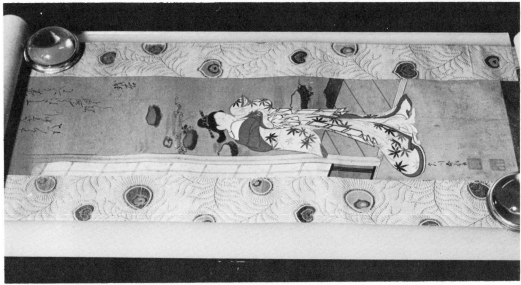

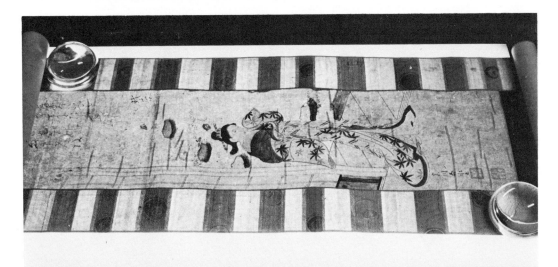

Figure 34.8 The top view (a) shows a Japanese hanging scroll painting in reflected light. The lower view (b) shows it in transmitted light which reveals horizontal paper repair strips applied to the back of the support layer in a previous restoration to reinforce cracks and splits caused by frequent rolling and unrolling of the scroll

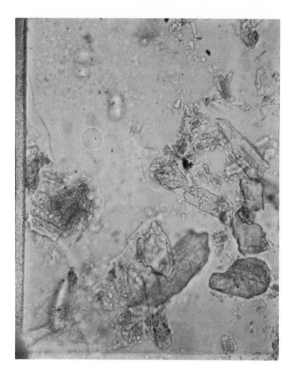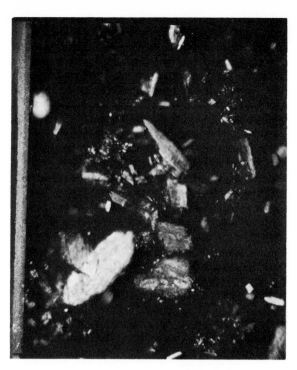

Figure 34.9 Gofun or shell white is still widely used by Japanese painters as a pigment. Here the particles of finely ground oyster shell are quite easily recognized microscopically by their fine and splintery nature, which reflects the organic growth of the shell. The photomicrograph, left (a), shows the characteristics of the particles by transmitted light at x600. At right (b) is approximately the same field in polarized light

Figure 34.10 Oyster shells from the Inland Sea of Japan are piled in heaps outside the Nakagawa Gofun Company plant in Ugi, Japan. They are left there 15—20 years to bleach and mature before they are ground and pulverized into gofun. The shells are collected from the best restaurants in Kyoto and Osaka. The lower brownish half of the bivalve shell is separated by hand from the upper whiter half. The white upper valves are crushed and pulverized to produce the best grade of gofun

THE MEDIUM

So far as we know from tradition and what we can learn from analysis, animal glue was the only paint medium used. It served simply to help lay the pigment and make it adhere. Glue medium was used in such small quantity that, unlike drying oil, it had no optical effect on the pigment. There is enough glue, however, to make the pigment adhere well to the support and we are quite conscious of its presence when we take a sample of paint for pigment identification because, when slightly moistened, the sample seems sticky. We make use of this property to fix the sample on the microscope slide.

CONSERVATION OF JAPANESE PAINTINGS

In conservation of the paintings at Freer we have closely followed Japanese methods which are based on the original methods employed by artists and mounters in creating the pictures. Many years ago we established at the Freer our own mounting studio with a professionally trained Japanese mounter in charge. The studio is now directed by Mr Takashi Sugiura. He supervises a staff of three helpers who all received their apprenticeship in Japan. They work in Japanese style sitting at low tables on a *tatami* covered floor. Most of the tools used were brought from Japan and most of the materials, paper, pigments, brocades and metal leaf come from there also.

Mr Sugiura employs several kinds of Japanese hand-made paper similar to those described above. Starch paste made from wheat flour is the principal adhesive. A sizing of *dōsa* is used for various purposes in the operations. The pigment palette used for retouching is limited and consists entirely of pigments used in the painting tradition. Silk brocades made in Japan which are used for remounting *kakemono* and screens are kept in sizable stock.

Often in the repair of Japanese folding screens new wooden cores have to be made, especially if the old cores are weakened by wood borers or from other causes. New cores are made in our own cabinet shop from well seasoned western sugar pine wood. These cores are covered with several layers of *kōzo* paper using starch paste as adhesive.

The methods used in remounting Japanese paintings are not 'conservation' in the strictest sense but might more properly be called 'restoration' because in the remounting process only the paper layer which carries the design is preserved. The old backing and foundation layers of paper are removed and discarded and replaced with new ones. As mentioned above, the wooden cores found in old screens, if in good condition, are sometimes re-used but usually they are replaced with better materials. In other words the work of art is quite rebuilt.

In our own gallery, for practical reasons, and even contrary to Japanese museum practice, *kakemono* are often dismounted from their paper support and transferred to wooden cores like those made for

screens. This makes the pictures much easier to handle, eliminates rolling and unrolling, which abrades the paint, and makes them less vulnerable to damage by the public. Suitable brocades are used for borders. The remounted paintings are set in frames made from mahogany wood and painted black.

In recent years we have instituted the keeping of better records of examination and treatment. Copies of our record-keeping forms are included as a supplement to this paper.

We have made little attempt to use modern materials in restoration. There seems to be no substitute for good Japanese hand-made paper for the support. The starch and animal glue adhesives fortunately can be used in minimal amounts which is a fundamental principle in good restoration. Fortunately these materials are sympathetic with the tradition and technique of their creation. There is no need for surface 'protective coatings'. They would unbalance colour harmony and destroy the soft textures. The use of Weldwood (urea-formaldehyde) glues in the assembly of the cores seems to be about the only departure from tradition.

The only material that might be disapproved of by conservators is the alum used in *dōsa*. Theoretically the alum should increase the acidity of the paper and hence weaken it over the years. We have no direct evidence that this is true but we intend to investigate it in the laboratory.

In the mounting studio it is essential that the atmospheric humidity be controlled, especially in winter, so that the paper is handleable and the drying rate for adhesives is not too rapid. At Freer where air conditioning holds the temperature at 22·5°C and relative humidity about 50% the year around, the studio and gallery environment seems satisfactory. Before air conditioning was installed at Freer in 1957 the air was much too dry in winter, which caused warping of cores and sometimes the tearing of paintings.

The storage of Oriental paintings is another important matter. Unmounted paintings are rolled, wrapped in cotton muslin cloth and stored in clean pull-drawer metal cabinets. Mounted and framed paintings are stored vertically in specially designed wood and metal cabinets with pull-out racks which minimize scuffing and abrasion.

THE TRAINING OF CONSERVATORS

We feel strongly at Freer that the care and treatment of Oriental paintings must be kept as close to the Oriental tradition as possible. The restorer must acquire a feeling for paper and silk and he must learn many simple operations by doing them repeatedly until they become second nature. Picture mounting is really no different from learning other crafts like fine goldsmithing or tapestry weaving. We want picture mounters who have served a long apprenticeship training in Japan, and they are not easy to find. Even in Japan there is danger that it is a dying craft. It is up to

us in the West to do all we can, even for purely selfish reasons, to try to keep the craft alive. There are not many short cuts. Crash training courses will not turn out competent restorers. The great problem in these modern times is to get young people interested in a career where a long apprenticeship at low pay is required and where high rewards are not certain. This is a serious dilemma.

Bibliography

The literature on materials and methods of Japanese painting, both in English and Japanese, is sparse and widely scattered. There follow a few sources, mostly in English or with English summary, which may interest those involved with the conservation of Far Eastern art:

Akiyama, T., *Japanese Painting,* Skira, 216 pp (1961).

Akiyama, T., 'Painting' in *Studies in Old Art Objects through Optical Methods,* Yoshikawa Kobunkan, Tokyo, (1955) 163–209. (English summary, pp. 16–22).

Akiyama, T., 'L'Emploi du Violet et sa Composition dans la Peinture Japonaise du VIIIe Siècle au XIIe Siècle', *Bijutse Kenkyū* (Journal of Art Studies), **220** (1962), 1–75 (English summary, pp. 1–2).

Gulik, R. H. van, *Chinese Pictorial Art as Viewed by the Connoisseur,* Istituto Italiano per il Medio ed Estremo Oriente, Rome, 537 pp (1958).

Handmade Papers of Japan, IIS Crafts, Tokyo, 128 pp. (1963). Includes an abridged reproduction of one of the old classics of Japanese literature about paper-making by hand, *Kamisuki Choboki* (The Handbook of Paper-Making), originally published at Osaka in 1798, with text by Kokuto Jihei, illustrations by Niwa Tokei.

Harada, J., 'Old Japanese Folding Screens', *International Studio,* **45,** (Dec. 1911) 110–122.

Hunter, D., *Paper-Making: The History and Technique of an Ancient Craft,* London (1947).

Japanese National Committee for ICOM, *Meeting of Experts on the Conservation and Restoration of Oriental Paintings,* Tokyo and Kyoto, 27 November to 13 December 1967, 52 pp. (In English and French).

Nakayama, H., 'Experiments of X-ray Penetration on Japanese Pigments', *Bijutsu Kenkyū* (Journal of Art Studies), **168** (1952), 127–130. (English summary, pp. 1–2).

Oguchi, H., 'Scientific Investigation on Colour Materials in Japanese Painting', *Bulletin of the Faculty of Fine Arts, Tokyo University of Arts,* **5,** (July 1969), 27–82. (In Japanese, with English summary).

Tajima, S., 'Brief Explanation of the Composition and Use of Pigments' in *Masterpieces Selected from the Korin School,* Vol. I, Tokyo, xv-xviii (1903–1906).

Tomita, K., 'Art: Far Eastern Methods' in *Japanese Art:* a selection of articles from the 14th edition of the *Encyclopaedia Britannica,* Britannica Booklet No. 6, New York (1933) 27–34.

Uyemura, R., 'Studies on the Ancient Pigments of Japan', *Eastern Art,* **3** (1931), 47–60.

Weber, C. G., 'Hand Papermaking in Japan', *The Paper Industry and Paper World* (June 1946) 6 pp.

Yamasaki, K., 'The Pigments used in the Wall Paintings' in *Wall Paintings in Daigo-ji Pagoda,* edited by O. Takata, Yoshikawa Kobunkan, Tokyo (1959) 187–257 (English summary pp. 13–14).

Yamasaki, K., 'Chemical Studies on the Eighth-Century Red Lead Preserved in the Shōsō-in at Nara', *Stud. Conservation,* **4** (1959), 1–4.

Yamasaki, K., 'Technical Studies on the Pigments used in the Ancient Paintings of Japan', *Proc. Japan Acad.,* **30,** No. 8 (1954) 781–785.

Yamasaki, K. and Nakayama, H., 'Studies on the Pigments used in the Genji Monogatari Scroll Paintings', *Bijutsu Kenkyū* (Journal of Art Studies), **174** (1953) 229–234. (English summary, p. 8).

Yamasaki, K., 'Pigments Employed in Old Paintings of Japan' in *Archaeological Chemistry: A Symposium* edited by M. Levey, University of Pennsylvania Press, Philadelphia, (1967) 347–365.

APPENDIX 1

RECIPES FOR PASTE AND SIZE USED IN MOUNTING JAPANESE WORKS OF ART IN THE FREER GALLERY OF ART

1. *Flour Paste*

 1 cup wheat starch (125 g) or 100 g
 3 cups water (620 ml) or 500 ml

Stir the starch slowly into the water in a flat metal container. Warm on an electric stove to boiling temperature. Stir with a suspended stick until it thickens to a uniform consistency (about 20 minutes). Larger amounts will require longer cooking. Before use pass through a horsehair sieve with help of a stiff brush and catch in a flat wooden container. Add water to thin. To prevent the paste from spoiling add a few drops of eugenol (oil of cloves) or other preservative.

2. *Dōsa*

 1 stick of animal glue (*nikawa*) (about 4 g)
 200 ml water
 1 g alum crystals

Break glue into small pieces and soak in the water overnight. Warm and stir until uniform consistency. Add the alum and stir until dissolved.

3. *Painters' Medium*

 1 stick animal glue (about 4 g)
 150 ml water

Prepare as with *dōsa* but omit the alum. Thin with water as required. Mix with dry pigments to proper painting consistency.

Examination Record — Far Eastern Paintings

Date: Accession No.

Examined by: Country, Date:

Dimensions: Painting Artist, Subject:

Sketch of Mount:

Non Freer Object:

General Condition

Vault card: _____ o.k. _____ re-examine with curator

Container, wrappings, etc.

Description:

Type of _____ screen _____ fold _____ panel
painting:
 hanging hand album
 _____ scroll _____ scroll _____ leaf

 sketch or _ other
 _____ drawing

Support: _____ paper _____ silk _____ wood

 _____ other

Medium: _____ aqueous _ lacquer _____ other

Paint: _____ ink (*sumi*)

 Colours: _____ blue _____ green _____ red _____ other

 Metal leaf: ___ gold ___ Metal powder: ___ gold

 _____ silver _____ silver

Inscriptions, Colophons:

Seals:

Condition:

I. ACCESSORY SUPPORT

 A. *Screen:* wooden frame:

 wooden core:

 paper lining of core:

 decorative back of screen:

 front border (brocades etc.):

 B. *Scroll:* outside paper backing:

 front border (brocades etc.):

 roller and knobs:

II. SUPPORT

Previous treatment: ___ cut down

 ___ re-mounted

 ___ bleached

 ___ treated with size (*dōsa*)

 ___ strip reinforcement

 ___ patches

 ___ darkened

 ___ abraded

 ___ holes, tears or splits

 ___ stains — water or other

 ___ fire damage

 ___ spots, specks

 ___ back

III. PAINT

Painting proper: ___ re-touched

 ___ abraded

 ___ flaking

Seals, inscriptions, colophons: ___ re-touched

 ___ abraded

 ___ flaking

Examination methods: ___ transmitted light

 ___ ultraviolet light

 ___ binocular microscope

 ___ microscopy

 ___ other

Photographs
 black and white: ___ overall ___ details
 colour: ___ overall ___ details

JAPANESE PAINTINGS AND METHODS
Treatment Record: — Far Eastern Paintings

Treated by: Date begun:

Accession No.: Date finished:

Country, Date: Artist, Subject:

PAINTING ___ repair without removal

 or ___ partial re-attachment

 or ___ complete re-attachment

___ wash

___ bleach

___ strip reinforcement, location:

___ patches, location:

___ size (*dōsa*)

___ retouch, location:
 pigments:

number of layers of paper backing:

ACCESSORY SUPPORT

screen:

wooden
frame: ___ new ___ painted ___ unchanged

wooden
core: ___ new ___ original ___ repaired

paper lining completely ___ original
of core: ___ new

 ___ new over original

decorative back of screen: ___ new ___ original

front borders: ___ new ___ original

scroll:

outside paper backing: ___ new ___ original

front borders: ___ new ___ original

roller: ___ new ___ original

Photographs after treatment:

35
Oriental Mounting Techniques in the Conservation of Western Prints and Drawings

BEN B. JOHNSON

INTRODUCTION

For hundreds of years Oriental paintings have been mounted using techniques which are essentially the same as those used today. The techniques and materials employed in the traditional mounting of Oriental paintings provide many useful ideas which can be applied advantageously in the preservation of Western prints and drawings[1]. The full potential and wealth of knowledge of traditional Oriental methods has not been fully realized because of the difficulty in obtaining first-hand knowledge and experience. The discussion which follows deals with a limited number of materials and techniques that the author has gleaned from the vast repertoires of the Oriental mounter and employed on Western graphic arts.

TOOLS AND MATERIALS

BRUSHES

Of the vast array of beautiful brushes employed by the mounter, there are about five which are most useful to the Western paper specialist (*Figure 35.1*)[2]. The *noribake* is a paste brush made of a combination of lamb and deer hair that provides a firm yet resilient quality designed for applying and spreading paste. The *uwabake* is also a paste brush with longer pure lamb hair. In addition, the softness of the lamb hair makes it useful for smoothing procedures where maximum delicacy is required. The *tsukemawashi* is another type of paste brush which is made of sable hairs

(sometimes badger hairs) and designed so that, when wet, it comes to a keen edge. It can be used in a controlled manner for applying paste to edges during the drying process or for attaching the rollers for the hanging (*kakemono*) or hand (*makimono*) scroll. The *nadebake* is made of dried reeds and is used for smoothing out and in processes where a pounding of the mounting paper is required. The *uchibake* is a heavy brush, also made of dried reeds, which is used in several pounding operations. When an original paper is backed with a second paper for purposes of reinforcement, the backing paper is sometimes pounded to raise the subtle texture of the paper surface and thereby provide a more receptive surface for the original paper. The *uchibake* can also be used for pounding after the backing paper is applied to the original to ensure firm contact between the papers and to release air trapped between the two surfaces. Sometimes in pounding of small or delicate areas the *nadebake* is used.

ADHESIVE

Paste is the adhesive most used in Japanese mountings. The selection of the flour and the preparation of the paste are of utmost importance in achieving a versatile workable paste as required in the various phases of mounting[3]. The wheat flour should be clean, white and pure with no additives which may change its potential adhesive properties or introduce undesirable adulterants[4]. The paste is prepared by placing one part flour in a pan and covering with two parts dis-

253

Figure 35.1 Oriental mounters' brushes and paste strainer

tilled water. Allow to stand for about 24 hours then pour off excess water. Add fresh distilled water to achieve a thin mixture, then heat and bring to the boil. After boiling, reduce heat and simmer for about 45 minutes. A preservative such as a drop of thymol in alcohol or a drop of eugenol may be added. After preparation, the paste must be strained using the *norikoshi* (see *Figure 35.1*), a horsehair strainer especially designed for paste. This process is essential to remove lumps and make a smoother workable paste.

PAPERS

The types and names of Japanese papers which can be used for restoration procedures are so extensive that it would be impossible here to discuss and define all of them. Essentially, comments will be limited to nine papers which the author has found most useful and most easily available[5].

A soft, smooth and extremely thin paper, *usugami*, made of mulberry tissue, has proved to be very effective in repairing minor tears on etchings, engravings and drawings, where substantial reinforcement is not required. It is also useful when minor repairs have to be made where transparency is a requisite. *Tengujo* is a light weight paper also composed of fairly long mulberry fibres. It is most useful for repairing tears and

for use as a temporary facing. The *kizuki-shi* is very similar to the *tengujo* but a little heavier and stiffer and is used for the same purposes. *Misu-gami,* also a fairly light weight paper, is sometimes used by the Japanese mounter for backing purposes. *Mino-gami* is a stronger paper, often used for the first backing of the original paper. Another backing paper which is softer and thinner than the above is *yotsuban* which is also used for backing against the original paper or silk. The *kanaryoshi* is a medium weight paper made of mulberry fibres, which can be used for mending and repairing where moderate reinforcement is required, and in addition can be used for backing of light weight papers. Finally, light and heavy weight *shirikawa* provide substantial backing papers which can be used for Western prints and drawings. They are applied when strong reinforcement is required for repairing tears, flattening creases, and for reinforcing a paper filling of a lost area. In addition to the Japanese papers mentioned above, there is an American paper known as 'tableaux' which has similar properties, but has great strength when wet and is available in large rolls[6].

Generally, when treating Western graphics, careful consideration must be given to the relationship between the backing papers and the original papers in terms of dimension of the original, texture, colour, weight, expansion on wetting and contraction on drying. Since Western papers have such vastly differing

254

Figure 35.2 Internal wooden core for a panel as used for mounting Oriental paintings at the Freer Gallery of Art

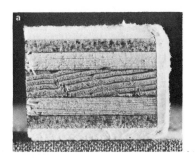

Figure 35.3 Various internal panel structures. (a) Cross-section of a panel composed of a plywood centre, covered with eight-ply rag-board and two layers of Japanese mulberry paper. (b) Core for a light panel showing wooden framework with gussets in the corners and end-grain balsa wood blocks (c) Cutaway view showing wooden framework with aluminium honeycomb material and covered by eight-ply rag-board. (d) Cutaway view showing wooden framework with 'tough-core' honeycomb material (impregnated) and covered by eight-ply rag-board

properties from those found in Oriental paintings the Japanese mounter is usually reluctant to advise the Western paper restorer.

MOUNTING PANELS

The traditional core panel, used by Japanese mounters, is perhaps the best solution to the difficult problem of rigid mounts for prints and drawings. However, because of the tremendous time and expertise required in preparation of such panels, various types of core panels have been tested and evaluated by the author. The discussion below cites some of the materials used in preparation of the experimental panels. These were evolved using the principles of the traditional Japanese core panel as a basis for further development and variations.

The Japanese screen is made by covering a wooden core with many layers of paper in an exact system of overlapping during the pasting procedure. Sometimes as many as five to seven layers of paper are applied[7]. The design of the internal core is noteworthy (*Figure 35.2*). The core is made of a clear wood such as white pine which has little resin content. Note that the internal grid system has an alternating over and under design. This helps prevent warping on expansion and contraction due to humidity changes. Note also that the internal grid members move freely in central channels in the side and end members. Finally, although it is not readily visible in the photograph, the individual sides and end members are bevelled slightly from the outer to the inner edges. This allows for the thickness of the many layers of paper applied over the structure, and prevents a bulge along the inside edge of the wooden frame. Drying boards, which are used for flattening as well as drying prints and drawings that have been backed, function best when made with an internal core as described above, then covered with many layers of smooth-textured mulberry paper. More will be said about the use of the drying board later.

Since it is often impractical to construct the traditional core for routine mounting of prints and drawings, alternative solutions have been devised. The author has experimented with many panel structures in an attempt to develop a substitute for the Japanese core panel which would be faster and easier to prepare. Only a few of these can be discussed here. First a $\frac{3}{4}$ in plywood was used covered with eight-ply rag-board on all sides and then with several layers of medium weight mulberry paper (*Figure 35.3a*). A polyvinyl acetate emulsion was used to attach the rag-board to the plywood and wheat flour paste was used to adhere the paper to the rag-board. The rag-board ensures chemical purity and protection of the original paper from the wood, and the mulberry paper facilitates the reversibility of the mounting should it be necessary. This type of panel functions very well but is excessively heavy in large sizes. In an attempt to lighten the panel but still retain the physical strength and chemical purity, a second style was developed

which is composed of a wooden framework with end-grain balsa wood as core material (*Figure 35.3b*). This is also covered with eight-ply rag-board (using PVA) and then several layers of mulberry tissue. The 'gussets' in the corner add necessary reinforcement to prevent warping of the finished panel. An even lighter panel has been used which has a honeycomb centre of either a tough-core or aluminium core material (*Figure 35.3c and d*). The eight-ply rag-board is adhered directly to the honeycomb using a PVA emulsion. This in turn is covered with several layers of mulberry tissue. In preparation of any of these panels, to prevent warping, the drying must be controlled and even. In addition, when mounting the original work, a paper of similar weight and properties should also be attached to the back of the panel. This helps to maintain a structural and material balance between back and front and reduces the likelihood of warping. This type of panel has been used in dimensions up to about 80 x 105 cm with a thickness of 1·8 cm.

TECHNIQUES

Generally, after the original is removed from former mountings and the back of the original paper has been cleaned and prepared, the initial process is backing with a reinforcement paper using a wheat flour paste adhesive. This is the fundamental operation in Oriental mounting. It reinforces the original paper or silk which is subsequently either mounted on a prepared panel (screen) or, by adding additional backing and decorative border, made into a hanging or hand scroll.

The backing process is perhaps the most useful of all Oriental techniques to the restorer of Western prints and drawings. It affords an opportunity, practically in a single operation, to reinforce the original, remove creases, wrinkles, buckling, flatten the overall plane of the original paper, and mount on a rigid support if desirable. Furthermore, this operation is completely reversible if it is necessary to remove the original from the backing at a future date. The process of backing Oriental paintings can be outlined as follows: the original paper is placed face down on a wooden table and dampened, removing all wrinkles, buckling, etc., and the *uwabake* brush is used to aid in getting the original flat. The backing paper, which is slightly larger and has been chosen so that its weight, colour and texture are compatible with the original, is also dampened and flattened and a paste adhesive applied. The consistency of the adhesive depends on the absorbency of both the original and backing papers, the texture, and the strength of backing desired. After the paste is applied the backing paper is placed on the original and the *nadebake* is used to smooth the backing. When the original materials permit, the *uchibake* is used to pound the two papers together. Finally, the backed original is placed on the drying board, and the two permitted to dry. The ensemble can be dried either face in or face out depending on the surface texture of the original. A small amount of paste is applied to the very edge of the backing paper and adhered to the drying board. After the drying process is complete, a spatula can be run under the thin pasted edge of the backing paper to remove it from the drying board. Further comments on the backing process will be discussed with the case histories which follow.

General repairing of prints and drawings is discussed thoroughly by Plenderleith and others[8], but there is one type of Oriental reinforcement which has been very useful for removing stubborn creases when it is not possible to remount the original paper. This is a technique used to flatten hanging and hand scrolls which have developed cupping[9]. A small patching strip is first made, composed of two strips of mulberry tissue adhered to one another. The larger strip should be about 5 mm and the smaller about 2 mm. The smaller strip is pasted in the centre of the wider one (i.e. ⌐‾‾⌐ cross section). This ensemble is then pasted, with the side of the wider strip against the original paper, along the back of the crease which is to be flattened. Sometimes a mild burnishing of the reinforcement strip from the back aids in removing the crease. This has proved to be a more effective and durable method of removing creases than the traditional single layer strip, especially if the crease is age-set.

CASE HISTORIES

The backing procedure used by the Oriental mounter, as discussed above, is best applied to Western prints or drawings when the original paper support is so badly damaged that considerable reinforcement is required, or when the overall strength of the paper is reduced so that it cannot be matted or hinged safely. The brief case histories which follow will illustrate the types of problem which can be treated utilizing the backing techniques and mounting on a rigid core. In some the original support is so distorted, creased and deteriorated that backing and mounting are essential to restore the surface and prevent future deterioration. Other examples illustrate cases where the original support needs backing to reinforce areas of major damage and tears, thus making the traditional matting and framing processes possible. When modern graphics of exceptionally large size have to be framed and transported, backing and mounting on a rigid support has proved to be the best and safest solution to the problem of protecting the original and providing a means of safe handling and framing. A poster by Toulouse-Lautrec of *May Belfort* (*Figure 35.4*) illustrates the type of print which would benefit from this type of treatment. The conglomerate problem of tears, distortions, creases, and general overall weakening of the paper support can best be treated by backing and mounting.

When the original paper is badly torn, as in the case of a small etching by Herman Struck (*Figure 35.5a*), quite often a simple patching along the torn areas is not sufficient to support the etching during handling, framing and exhibition. In addition to the severe damage which extends across the total width of the

Figure 35.4 Poster by Toulouse-Lautrec of May Belfort *which shows condition problems suggesting a mounting on a rigid panel as a solution to preservation. 79 cm x 60 cm. Private collection, Los Angeles*

a　　　　　　　　**b**　　　　　　　　**c**

Figure 35.5 Small etching, Head of an Old Man *by Herman Struck. (a) Showing severe damage before treatment. (b) After application of backing paper. (c) After treatment. Approximately 6.4 cm x 4.9 cm. Private collection, Los Angeles*

etching, the top left corner of the paper is missing. It should be noted that the cause of this particular damage is that the paper was mounted overall to a pulp cardboard backing which became weak and embrittled with age. The pulp cardboard was subjected to bending, and it broke very easily, tearing the paper at the same time. In the treatment process the etching was first removed from the pulp cardboard backing by soaking in water, deacidified, and then the edges of the tear were carefully aligned. In the border areas a small facing with paste was used along the tear to hold it in place while the mending and backing processes were carried out. With the etching face down, a strip of feather-edged *tengujo* paper was applied using wheat flour paste along the tear. The

etching was backed overall using heavy *shirikawa* paper and the facing was removed. Then it was dried face down on the drying board, after which it appeared as in *Figure 35.5b*. Finally, the printed was matted and hinged in the normal window mat after some minor inpainting along the lines of the tear (*Figure 35.5c*).

Another case is a study of *Nudes* by Henry Moore in crayon and ink on extremely thin paper. Numerous damages, tears, holes, and discolorations were obtrusive and disturbing. The original paper had been adhered to a piece of pulp board and the rubber cement adhesive around the edges had discoloured causing spots and stains (*Figure 35.6* and 7). The treatment process consisted of removing the pulp-wood backing from the original paper, removing the

257

Figure 35.6 Drawing of Nudes *by Henry Moore, ink and crayon on extremely thin paper. Before treatment. 53.3 cm × 38.1 cm. Private collection, Los Angeles*

Figure 35.7 Detail of drawing of Nudes *by Henry Moore showing staining, tears and discoloration along border edges. Before treatment*

Figure 35.8 Drawing of Nudes *by Henry Moore. After treatment*

a

b

Figure 35.9 A large lithograph of The Cyclist *by Toulouse-Lautrec. (a) Before treatment. (b) After treatment. 80 cm × 120 cm. Private collection, Los Angeles*

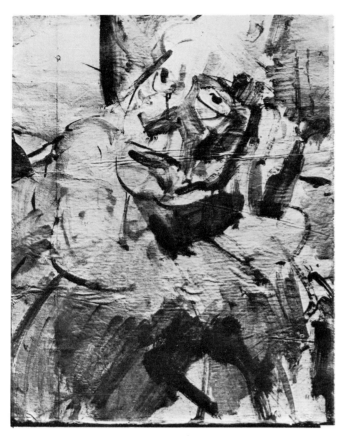

Figure 35.11 The author working with Mr. Takashi Sugiura, mounter at the Freer Gallery of Art, preparing the reverse of the Clown by Rouault for backing

Figure 35.10 The Clown by George Rouault, before treatment. 61 cm × 48.3 cm. Dumbarton Oaks Collection, Washington, D.C.

Figure 35.12 The Clown by Rouault on the drying board after backing

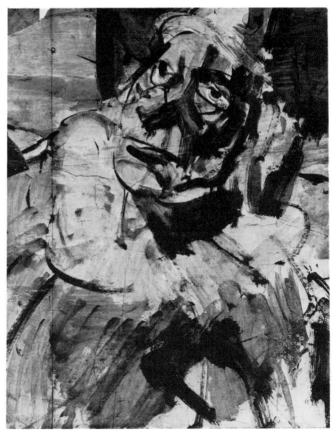

Figure 35.13 The Clown by Rouault after treatment

adhesive residue with solvents, and bleaching the dis-coloured stains around the edges locally using a 4% chloramine-T solution. After deacidification the original paper was backed using a light *shirikawa* paper and wheat flour paste adhesive. The *shirikawa* was chosen in this case because its strength and tonality, which is somewhat whiter than other Japa-nese papers mentioned, was best suited to the thin and slightly translucent original paper. The flattening of the original paper, which is necessary before the application of the backing, was achieved by misting with water until the paper was relaxed and distortion-free. After backing, the drawing was dried face out on the drying board, as some areas of the ink are fragile when damp. Areas where the original paper had been lost, especially in the upper right corner and lower left corner, were inset with a paper that matched the colour and texture of the original paper (*Figure 35.8*). The drawing was then hinged and matted in the con-ventional window mat.

The problems related to a large Toulouse-Lautrec lithograph of *The Cyclist* (*Figure 35.9a*), where the original paper was weakened and damaged, indicated that mounting on a rigid support would be the best solution to facilitate framing, handling and exhibiting the work. The accumulation of surface dirt was removed using a dry-cleaning technique and then the print was washed until most of the water stains were gone and mildly bleached to eliminate the remaining discoloration. The lithograph was deacidified then backed with a heavy *shirikawa* paper, and attached to a honeycomb panel. Some minor spots of inpainting were required. This was carried out in an acrylic medium in some areas, and in others, pastels were used to tone out abrasions (*Figure 35.9b*).

Finally, a *Clown* by George Rouault, in oil on paper, will illustrate another problem which has been solved by the utilization of the Oriental backing tech-nique. This type of painting, oil on paper, cannot be relined using normal wax-resin procedures because of the danger of changes in the character of the paper due to the impregnation of the wax-resin which would alter the aesthetic relationship between the thin oil passages and the light colour of the paper[10]. The paper had been glued to a thin gauze-like fabric which in turn was attached to a conventional stretcher. The results, after approximately 50 years, were creases, wrinkles and general distortions of the original paper to the extent that some of the creases had actually developed into splits and tears in the paper (*Figure 35.10*). After considerable study, it appeared that the best solution was to remove the weakened gauze and accompanying adhesive, to repair and back the original paper with an auxiliary support of heavy *shirikawa* paper and finally to attach it to a rigid honeycomb panel. The painting was first cleaned to remove all discoloured natural resins from the surface, and retouchings where serious damages existed. Then the gauze and glue adhesive were removed from the back. The reverse of the original paper was prepared for backing with an additional piece of Japanese paper (*Figure 35.11*). This consisted primarily of applying

reinforcing paper strips along creases and tears. Since there were no textural or solubility problems, the painting was dried face down on the drying board (*Figure 35.12*). After drying, the backed original was adhered to a honeycomb panel with wheat flour paste and allowed to dry[11]. The panel in this case was com-posed of a honeycomb core covered with $\frac{1}{8}$ in masonite which was in turn covered with eight-ply rag-board using PVA as adhesive. After thorough drying, the painting was varnished with Acryloid B72 in toluene and the losses and damaged areas inpainted using colours ground in an acrylic medium (*Figure 35.13*). This treatment was completed in 1966 and has been observed carefully since that time. No changes in the paper surface or any kind of discoloration have occurred.

Drawings and prints by artists such as Stella, Johns, Rauchenberg, etc., have been treated using the tech-nique of backing and mounting to a rigid honeycomb panel as described above. For Western contemporary graphics which are often extremely large and present problems in framing and preservation, the technique of Japanese backing and mounting on a core panel has been utilized advantageously and successfully. This paper has dealt with a few tools, materials and tech-niques of the Oriental mounter. Only a small portion of his vast wealth of useful knowledge has so far been absorbed and utilized by Western paper specialists. Hopefully in the future with more documentation and study perhaps new adaptations and variations can be applied to problems in the conservation of Western papers.

References and Notes

[1] For general information on the techniques of Oriental mounting see Gulik, R. H. van., *Chinese Pictorial Art as Viewed by the Connoisseur*, Istituto Italiano per il Medio ed Estremo Oriente, Rome (1958).
[2] The brushes shown in *Figure 35.1* are available from Washi-No-Mise, 5116 Saratoga Ave. N.W., Washington, D.C. 20016, U.S.A.
[3] See 'Japanese Paintings: Technical Studies and Conservation at the Freer Gallery of Art' by R. J. Gettens in this publica-tion for the wheat flour paste formula as used at the Freer Gallery of Art.
[4] We use pure wheat flour designated Aytex-P available from General Mills, Inc., Minneapolis, Minnesota 55440, U.S.A.
[5] Some of the papers discussed here are available from Washi-No-Mise (see *Note 2*).
[6] Tableaux paper is available in the United States from the Technical Paper Corp., 25 Huntington Ave., Boston, Mass. 02116.
[7] Philippot, A., Goetghebeur, N. and Guislain-Wittermann, R., 'L'Adoration des Mages de Bruegel au Musée des Beaux-Arts de Bruxelles; Traitement d'un "Tuechlein" ', *Bull. Inst. R. Patrimoine Art.*, 11 (1969), 5—33; for a diagram of the various paper layers, see p. 25.
[8] Plenderleith, H. J. and Werner, A. E. A., *The Conservation of Antiquities and Works of Art*, Oxford University Press, London (1971).
Weidner, M. K., 'Damage and Deterioration of Art on Paper Due to Ignorance and the Use of Faulty Materials', *Stud. Conservation*, 12 (1967), 5—25.

Dolloff, F. W. and Perkinson, R. L., *How to Care for Works of Art on Paper,* Museum of Fine Arts, Boston (1971).

[9] Stout, G. L., *The Care of Pictures,* Columbia University Press, New York (1950), Figure 21, which illustrates this distortion in scrolls.

[10] Rabin, B., 'Problems Related to the Preservation of Rouault Paintings', *IIC-AG Technical Papers from 1968 through 1970* (June 1970), 109–111.

[11] The author has also utilized this technique on several nineteenth century American paintings where the paper support was considerably heavier and the oil paint itself was more opaque and more heavily applied than that of the Rouault.

Index

INDEX

INDEX

266

INDEX

INDEX